RUSSIAN
SILVER
IN AMERICA

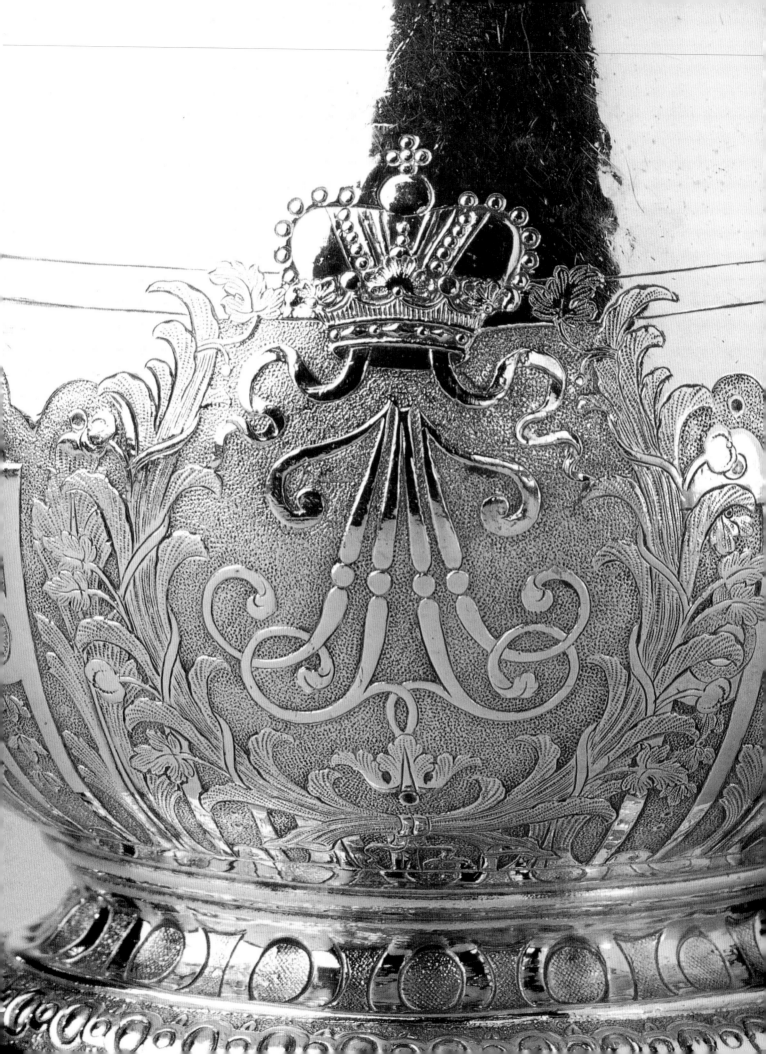

RUSSIAN SILVER IN AMERICA

Surviving the Melting Pot

ANNE ODOM

HILLWOOD MUSEUM AND GARDENS FOUNDATION
WASHINGTON, D.C.

in association with

D GILES LIMITED, LONDON

First published in 2011 by GILES
An imprint of D Giles Limited
4 Crescent Stables, 139 Upper Richmond Road,
London, SW15 2TN, U.K.
www.gilesltd.com

Library of Congress Cataloging-in-Publication Data

Odom, Anne, 1935-
 Russian silver in America : surviving the melting pot / Anne Odom.
 p. cm.
 Includes bibliographical references and index.
 Summary: "Traces the history of Russian silver from before 1700 to 1917, following its fate in
the 1920s and 1930s, when much of it was sold to American collectors and is now found in
many public museums"--Provided by publisher.
 ISBN 978-1-904832-81-2 (hardcover : alk. paper) -- ISBN 978-1-931485-09-8 (softcover : alk.
paper)
 1. Silverwork--Russia--History. 2. Silverwork--Russia--Collectors and collecting--United States--
History--20th century. I. Title.
 NK7156.A1O36 2011
 739.2'309470973--dc22

 2010039243

ISBN (hardcover): 978-1-904832-81-2
ISBN (softcover): 978-1-931485-09-8

For Hillwood Museum and Gardens Foundation:
Curator Emeritus, Hillwood Estate, Museum & Gardens: Anne Odom
Photographs are by Edward Owen (except where noted otherwise)

For D Giles Limited:
Copy-edited and proof-read by David Rose
Designed by Helen Swansbourne
Produced by GILES, an imprint of D Giles Limited, London
Printed and bound in Hong Kong

All measurements are in inches and centimeters;
Height precedes width precedes depth.

Jacket: Selection of Russian silver from Hillwood Estate, Museum & Gardens

Frontispiece: Coffee pot (detail), St. Petersburg, 1735, Nikolai Don or Dom (Nicholaus Dohm,
active 1714–48). Silver gilt, wood, H. 9⅜ in. (24 cm.)
12.10

Copyright page: Tall covered cup (detail), St. Petersburg, 1851, Firm of Sazikov.
Silver gilt, H. 18¼ in. (46.4 cm.), W. 6⅜ in. (16.2 cm.)
Museum Purchase, 2000. 12.625.1–2

CONTENTS

FOREWORD

THE HISTORY OF SILVER is fraught with many uncertainties because of the metal's intrinsic, recyclable value. Over the centuries objects of masterful beauty have been melted in crucibles to mint currency, to pay off debt, or to be used to form new objects to keep up with changing fashions. Therefore we can only guess at the appearance of some phenomenal objects that are alluded to in paintings, books, and letters but lost to us forever. And unfortunately Russian silver suffered even more obliteration in that so much of it was melted down or left Russia following the 1917 Revolution. Most of the scholarly research to date has been undertaken appropriately by the Russians themselves, but very little of it, with the exception of the works on Fabergé and the large Moscow firms, has made its way into English. That is until this publication. Anne Odom, Hillwood Estate, Museum & Garden's Curator Emeritus, has undertaken the momentous task of searching through American museums to glean a better sense of the development of Russian silver from objects that found their way to the shores of America following the Revolution. She begins her survey by reflecting on the first wave of American collectors of Russian silver. This was a colorful assortment of individuals with varied motivations for accumulating such exotic objects—Marjorie Merriweather Post, founder of Hillwood, being one of them. Anne follows their collecting journeys as well as the final disposition of so many of their objects into numerous American art museums. This fascinating context segues into a chronological study of the evolution of Russian silver; its design origins, its craftsmen, and its functions. *Russian Silver in America: Surviving the Melting Pot* provides valuable new information for the general reader as well as for scholars of the decorative arts.

Anne has contributed greatly to the scholarship of Russian decorative arts. She is the author of several books published by Hillwood including *Fabergé at Hillwood* and *Russian Imperial Porcelain at Hillwood* as well as catalogues on Russian decorative art she has written as guest curator for other museums. I am grateful to her for her knowledge, insight and unending enthusiasm. For thirty years Anne has studied the wide-ranging collection of Russian objects collected by Marjorie Merriweather Post at Hillwood, which has led her to a position of a leading scholar of Russian decorative arts in the West.

We are indebted to the Samuel H. Kress Foundation and the Hillwood Museum & Gardens Foundation for providing funding for this beautiful publication. As always Hillwood's Board of Trustees, under the leadership of Mrs. Post's granddaughter, Ellen MacNeille Charles, has been an enthusiastic supporter of the museum's publishing initiatives.

FREDERICK J. FISHER
Former Executive Director
Hillwood Estate, Museum & Gardens

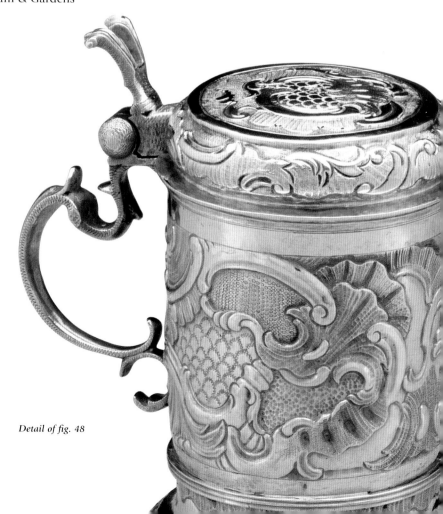

Detail of fig. 48

ACKNOWLEDGMENTS

MEETING MANY CURATORS at a variety of American museums has been one of the great pleasures of this project along with discovering the Russian treasures they have had, for the most part, hidden in their storage rooms. I first worked together with William R. Johnston, curator of European Art at the Walters Art Museum in 1995, to research the Russian enamels in their collection for the exhibition *Russian Enamels: From Kievan Rus to Fabergé*. Bill has always been most generous with pulling objects, more recently Russian silver, for examination.

At Middlebury College Museum of Art I assisted chief curator Emmie Donadio, director Richard Saunders, and registrar Meg Wallace in organizing the exhibition *What Became of Peter's Dream?* in 2003. Silver objects in the collection are included in this project. Edward Kasinec, then chief of the Slavic and Baltic Division of the New York Public Library, directed me to the collection at the Hood Museum of Art at Dartmouth. There Bart Thurber, curator of European Art, and Deborah Haynes, assistant registrar, were most kind to make their collection and files available on more than one occasion.

I explored with Donna Corbin, associate curator of European decorative art at the Philadelphia Museum of Art, the monumental pieces in her collection. Originally Tracey Albainy, a curator of European decorative art at the Boston Museum of Fine Art, assisted me with the wonderful Russian pieces in the Boston collection. After her death Thomas Michie was very helpful in allowing me another look. At the Metropolitan Museum of Art Wolfram Koeppe, a curator in the Department of Sculpture and Decorative Arts, took time from a very busy schedule to let me twice study some of the Metropolitan's beakers and cups. Barry Shifman, Sidney and Frances Lewis Family Curator, and Mitchell Merling, curator of Fabergé, were both very accommodating at the Virginia Museum of Fine Art.

On my many earlier visits to Russia, I have invariably arrived with fistfuls of photographs or photocopies in order to discuss styles, marks, or other details with Russian curators. They have all been very patient with my learning over the years. Marina Lopato at the State Hermitage has been unfailingly kind and helpful, introducing me to some of the intricacies of Baltic and Augsburg silver. Her colleague Larissa Zavadskaia, former curator of Russian silver, showed me around the Hermitage's Russian silver collection. I had the good fortune to have actually been shown the silver in the State Historical Museum for the first time in 1982 by Marina Postnikova-Loseva herself, whom Marvin Ross, Marjorie Post's curator, had also known. Galina Smorodinova, the current curator of Russian silver at the museum, has also discussed my handfuls of photocopies and shown me the collection in more recent years. At the Kremlin Armory, Tat'iana Muntian, Svetlana Kovarskaia, Marina Martynova, and Irina Bobrovnitskaia have shared their thoughts on numerous questions. I am most grateful for the help of all these people.

I owe a great debt to Marvin C. Ross. The name "Hillwood" opened many doors in the Soviet Union because Ross had been there before me and maintained contact with curators into the mid-1970s. Katrina V. H. Taylor had a fine sense for the quality objects in the Hillwood collection, which she displayed in her publication, *Russian Art at Hillwood*. I am very fortunate to have friends and colleagues willing to read parts or the whole of the manuscript: Wendy Salmond has been a long-time reader, sounding board, and valuable critic. Kristen Regina, Liana Paredes, Scott Ruby, and Margaret Nalle were all generous with their time and comments. Yelena Harbick, then at Hillwood, looked at all the Hillwood objects with me and found important supporting material. Ulla Tillander-Godenhielm offered useful advice on marks. My husband, Bill Odom, did not live to see the final manuscript, but he offered many suggestions early in the project. I would also like to thank everyone in the Collections Division at Hillwood for their support, but especially Manuel Rouco and Manuel Diaz for faithfully cleaning Hillwood's silver for a photo shoot, when the watchful eye of Edward Owen, our superb photographer, will catch everything. All three have been incredibly helpful over the years. Kristen Regina, Hillwood's librarian, and her staff have always been responsive to my needs, as were Harry Leich and Eric Frazier at the Library of Congress. I particularly want to thank Gina Raimond for persevering with photo permissions and coordinating the final publication. She has been an enormous help.

That the Trust for Mutual Understanding financed some of the outside photography for this publication has made it possible to include so many little-seen objects. Finally I would like especially to thank Frederick J. Fisher, Hillwood's former director, who has always been extremely supportive of my research projects. This publication, like my others, would certainly not have happened without the support of the Board of Trustees of the Hillwood Museum & Gardens Foundation. I am most grateful to both.

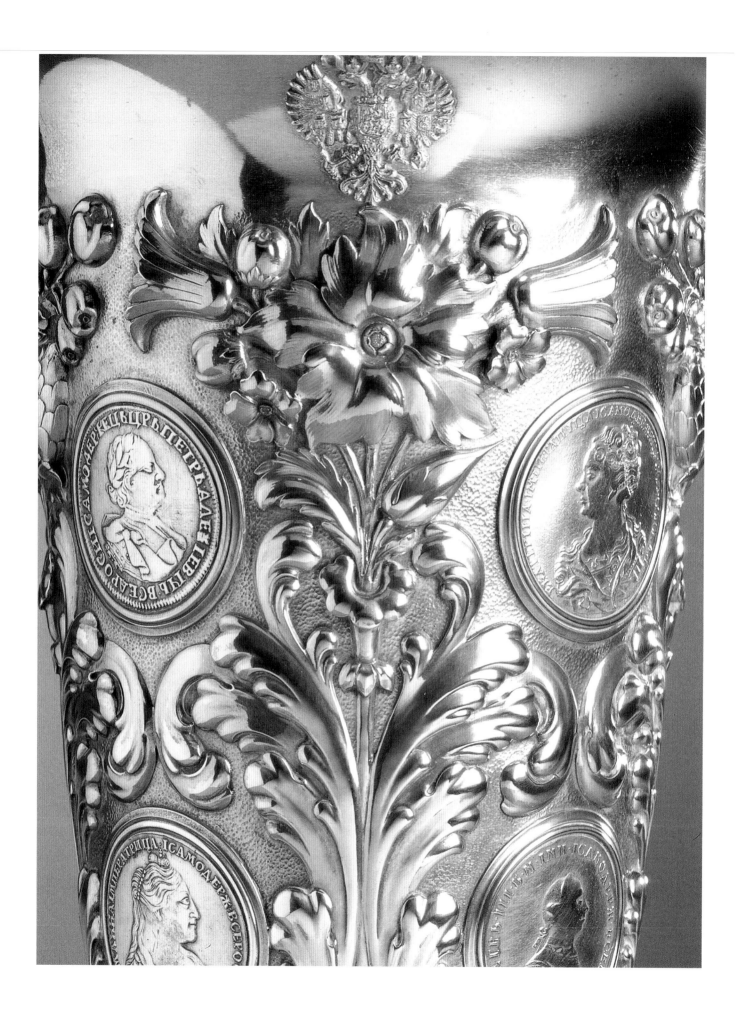

INTRODUCTION

R USSIA WAS ALWAYS on the fringes of artistic developments in Europe, struggling to keep up. As a result throughout its history and still into the twentieth century Russian silver, like its porcelain and glass, was viewed not only as derivative of western European prototypes, but inferior in quality. Even Russian critics held these views, always referring to the seventeenth-century production as "the Golden Age." Westerners have usually preferred the Muscovite styles of the period before 1700 and the reforms of Peter the Great as being more genuinely native and authentic, even though Moscow work (*Moskovskoe delo*), itself, reflected significant Byzantine, Persian and Turkish influences. These same connoisseurs were attracted to the Byzantine/Russian revival of the late nineteenth century as attempts to restore to the art form Russia's true genius. By 1900, however, Russian critics would condemn this revival as the "pseudo-Russian style." Regardless, the Russian style (*russkii stil'*) received high praise at the international expositions throughout the second half of the nineteenth century. Yet Russians never discarded western styles once they had been introduced, and have been remarkably proficient at adapting foreign ornament and forms. By the early twentieth century Russian and western designs were combined into a true *stil' modern*.

Their success has given the Russian luxury arts their enormous vitality and richness, but it has also led to tension between those who favor eastern or western taste and how they actually characterize Russian decoration. These tastes reflect the same tension over the political issues of Russia after 1700—the Westernization of Peter the Great versus the attempt by the Slavophiles to find a Russian way in the nineteenth century. Silver, its use and style, provides a remarkably clear mirror of the cultural

politics of the imperial period. One of the great ironies of Russian silver production is that throughout the imperial period many "Russian" silversmiths, especially in westward-looking St. Petersburg, were foreigners, usually from Germany or Scandinavia, thus blurring the boundary between east and west. In Moscow many more silversmiths were native Russians, who retained traditional designs and techniques much longer than in Peter's new capital city. It is thus not surprising that Moscow was the center of the Russian revival.

West European influences were increasingly powerful in Russian life and culture by the end of the seventeenth century, but the apogee of Western styles was from the reign of Elizabeth I (beginning 1741) through those of Catherine, Paul, and Alexander I, who died in 1825. This period also marked the triumph of Peter's vision of a westernized nation. Beginning with the reign of Nicholas I in 1825, the Russian elite became apprehensive about the potential impact of European revolutions and feared the negative effects of Westernization. They increasingly looked to Russia's Orthodox traditions for guidance, while Russian artists and artisans explored Russia's Muscovite past for inspiration.

Through the study of Russian silver production, it is possible to decode these influences on cultural traditions. Since time immemorial silver and gold have been essential materials for ceremonial vessels, both religious and secular. Shining brightly, silver liturgical vessels could be viewed from a distance, lending a symbolic and theological focus to the religious service.[1] Gleaming *oklady* or silver icon covers, chalices, and other church plate brought hope of a world beyond that marked a sharp contrast to the wretchedness of daily life. Russia's ancestors in Kievan Rus' had adopted Christianity from Byzantium in 988, and with it they brought the forms and ornament of early Byzantine liturgical vessels. One of the aspects of Byzantine church ritual that was said to have most appealed to the Russians was the incredible splendor of the church interior.

Silver was also highly desirable for dining, being hygienic, sturdy, and reflecting the status of the host. Foreign visitors to Russia in the sixteenth and seventeenth centuries referred to tables set with "massie gold,"[2] and a Danish ambassador in 1575 wrote that "on all the tables so many dishes of silver and cups were laid that there was no empty space."[3] The impact of gilded silver covering a linen-draped table glittering under the flickering lights of hundreds of candles was stunning. Tankards, beakers, coffee and tea sets reflected new drinking customs, and the forms of tablewares were dictated by recently introduced foods, especially as Russians adopted French cuisine in the early eighteenth century. Not until the nineteenth century did porcelain really begin to replace silver on the table in Russia, and even then silver was preferred for the main courses and for serving pieces.

Not content with a glittering table, royal hosts also showcased their silver collections on sideboards or buffets. The most famous of these in Russia was in the Faceted Hall

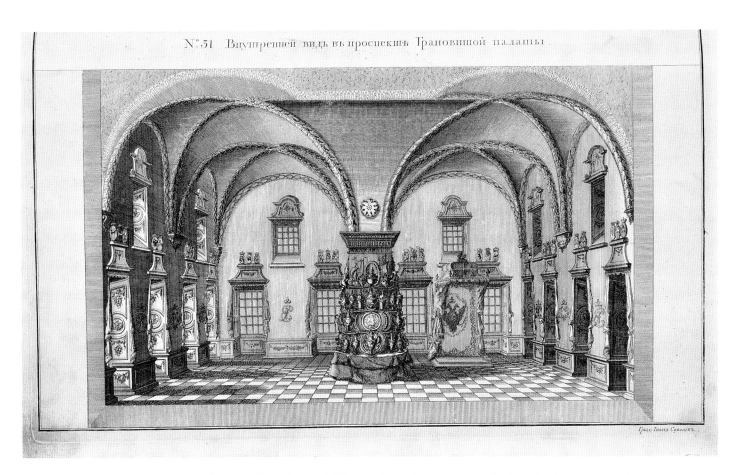

Fig. 1
Faceted Hall interior at the time of the Coronation of Elizabeth I. Engraving from Obstoiatel'noe opisanie torzhestvennykh" poriadkov" blagopoluchnago vshestviia v" tsarstvuiuishchii grad" Moskvu i sviashchennieishago koronovaniia Eia Avgustieishago Imperatorskago Velichestva, vsepresvietlieishiia derzhavnieishiia velikiia gosudarnyi imperatritsy Elisvet" Petrovny samoderzhitsy Vserossiiskoi: ezhe byst' vshestvie 28 fevralia, koronovanie 25 aprielia 1742 goda *(St. Petersburg, 1744).*

in the Kremlin where visiting ambassadors were received and where coronation banquets were held (fig. 1). An Englishman in the mid-sixteenth century described this pyramidal stand for displaying "the Emperours plate, which was so much, that the very cupboard it selfe was scant able to sustayne the waight of it."[4] Konstantin Makovskii's painting *A Boyar Wedding Feast* at Hillwood is an attempt to recreate a boyar's surroundings for a grand seventeenth-century-style banquet (fig. 2). As part of the interior décor, Makovskii included a display of silver on a shelf near the window. Russian boyars followed the example of the tsar with their own displays of silver. General-Admiral Fedor Apraksin, who had traveled to the West with Peter at the time of the Great Embassy (1697–98), put on just such a display for the wedding of Peter's daughter Anna to the Duke of Holstein in 1725.[5] This tradition of display continued until the end of the empire (fig. 3).

Many of these pieces were not intended for use, but were artistic masterpieces, often given as gifts, and meant to be shown off to visiting royalty, ambassadors, and the huge number of guests present at state events such as weddings and coronations. They were "works of art" long before painting and sculpture gained the ascendancy. Queen Elizabeth I of England requested that her ambassador to the court of Ivan IV bring the tsar a "rich standing cup that was the first ever made in England." This not only indicated to Ivan what a unique gift it was, but it ensured that the latest design traveled to Russia to be displayed at court.[6] Soon new ideas about ornament began to percolate as diplomatic and personal gifts, books, and print sources already known in Europe and England became available in Russia as well.

Silver, both foreign and domestic, was among the most valuable of the tsar's and his boyars' holdings and is listed in the inventories of possessions passed down from one generation to another. Silver far exceeds other valuables like gems, jewels, and

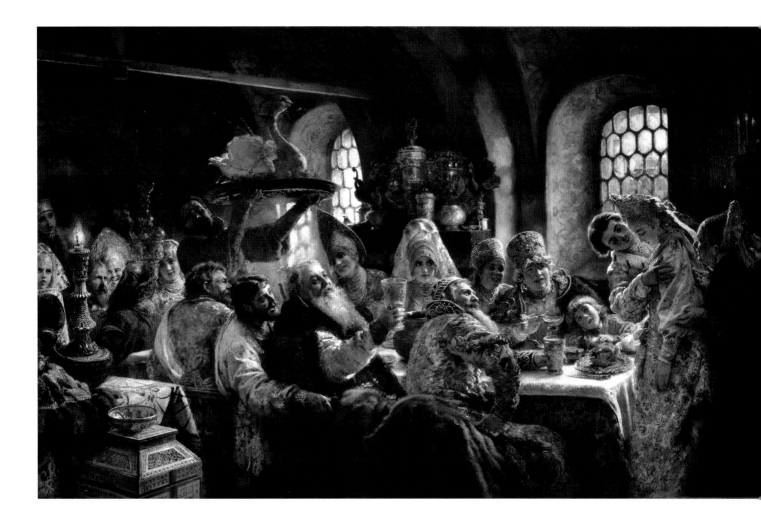

glass, as can be seen from the inventory of goods owned by the prominent boyar Vasilii Golitsyn at the time of his death in 1690.[7] One of the many attributes of artistic silver production over the centuries was that it could be easily melted down and converted to cash, and frequently was, to support wars or to provide the basic material to produce something more fashionable. As an English mother advised her son in 1630, "money spent on strong substantial plate will do more than in your purse."[8] This was accepted practice not only in the West, but also in Russia with eighteenth-century Russian monarchs regularly melting down unfashionable silver.[9] Nicholas I, carrying on this time-honored custom, destroyed some of the famous silver services commissioned by Catherine the Great in order to pay for a new gold service he had ordered in England. For this he was later roundly criticized.[10] It was only in Soviet Russia, however, that silver was melted down for ideological purposes, as the

Fig. 2
A Boyar Wedding Feast,
Konstantin Makovskii (1839–1915)
St. Petersburg, 1883.
Oil on canvas
H. 93 in. (236 cm.),
W. 154 in. (400 cm.)
51.79

Bolsheviks in the 1920s and 1930s were not only determined to use the money to build or buy tractors, railroad cars, and machinery of all kinds and to spread propaganda abroad, but also to wipe out all manifestations of bourgeois and elite culture and church wealth. These financial, fashion, and ideological decisions explain why so little silver remains from certain periods in Russian history.

Russian art in American collections sold by the Soviet government in the 1920s and 1930s reflects the aesthetic policies of the Soviet authorities—what they considered of no artistic value or duplicated in Russian holdings and what could be marketed to an American audience. (Europeans were primarily interested in French, German, or English silver for sale.) The Soviet authorities made their decisions on the basis of antiquity, style, and provenance. Many objects made before 1835 were considered of historical and/or artistic value, and Russian museums could have the pick of a limited number of important pieces, the rest being available for sale. For this reason there are few examples of the finest workmanship in American collections, especially from the seventeenth century and earlier. Even when Russian museums were forced to deaccession works from their collections, the most important artistic and historical examples were usually preserved. What is available in American museums are a multitude of drinking vessels, chalices, icon *oklady* and the remains of tea and coffee sets used not only at court, but also by the nobility, the landed gentry, and wealthy merchants. Before the Revolution, many of these pieces were held in church treasuries and private collections, particularly vulnerable to confiscation and sale. Because so much silver from the period after 1835 was melted down we have to depend on fewer examples of what must have been a monumental amount of nineteenth-century silver, much of it flatware and service plates, but no doubt many fine liturgical vessels and grand centerpieces as well. American collectors were particularly attracted by objects made for members of the former imperial family. (For more details on the fate of Russian silver after 1917, see Chapter 8.)

While this book is about the history of Russian silver, it is also about collecting in America. The goal has been to elaborate on the original history and cultural context of the silver that is in the United States and at the same time understand how it came to be here. After all, Russian art was not a normal thing for Americans to have collected and certainly became an enthusiasm relatively late in our history. The collection of Russian silver at Hillwood Estate, Museum and Gardens, the Washington residence of Marjorie Merriweather Post (1887–1973), is the largest and most comprehensive outside Russia. As with all personal collections, however, there are periods and styles that are underrepresented. By using examples from other collections it is possible to give a more complete view of the art of Russian silver from the seventeenth century up to 1917 and more importantly to make some of the public collections in this country better known.

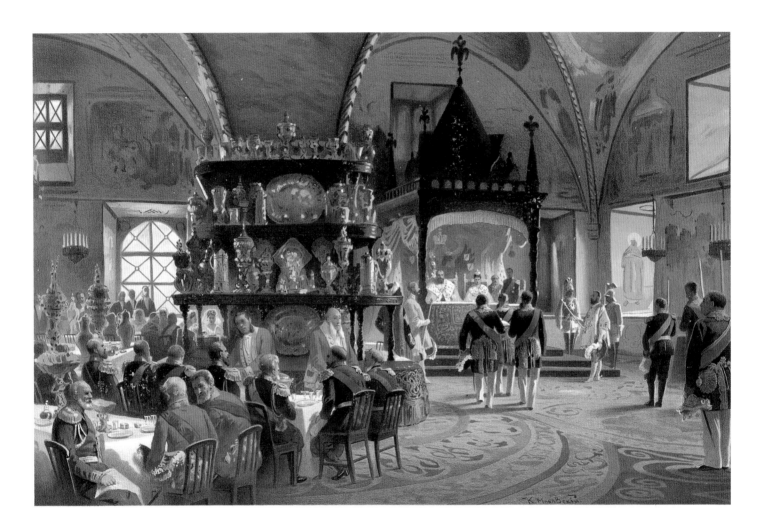

I have made several calculated decisions about the scope of this project. The volume is primarily about silver, but I have included a few gold objects either because their makers were also well known as silversmiths or because they added to the story I wished to tell. Gold boxes and jewelry as *objets de vertu* are outside the scope of this study, although some of the firms discussed, like that of Fabergé, also made them. Russian silversmiths decorated their wares with enamel, niello, and gemstones. I have treated the subject of Russian enamels elsewhere,[11] so have focused here on silver with gilt or niello decoration. The techniques of silver production are better told in other volumes.[12] A glossary and comments on Russian marks are included in the appendix.

Fig. 3
Faceted Hall, Coronation Banquet of Alexander III. Illustration from **Opisanie sviashchennago koronovaniia ikh Imperatorskikh Velichestv Gosudaria Imperatora Aleksandra Tretiago i Gosudaryni Imperatritsy Marii Fedorovny vseia Rossii** *(St. Petersburg, 1883).*

NOTES

1. Philippa Glanville, ed., *Silver: History & Design* (New York: Harry N. Abrams, 1996) provides an excellent introduction to the properties and uses of silver, especially in England.
2. R. E. F. Smith and David Christian, *Bread and Salt: A Social and Economic History of Food and Drink in Russia* (Cambridge: Cambridge University Press, 1984), 114.
3. Quoted in M. V. Martynova, "Russian Jewelry Arts of the Twelfth to the Seventeenth Century," in *Kremlin Gold: 1000 Years of Russian Gold and Gems and Jewels* (New York: Harry N. Abrams, Inc., 2000), 35. Jacques Mageret, who served in Tsar Fedor's army in the 1690s, tells about silver plate he saw in the treasury in *The Russian Empire and the Grand Duchy of Moscovy: A 17th-Century French Account*, trans. and ed. Chester L. Dunning (Pittsburgh: University of Pittsburgh Press, 1983), 37–38.
4. Smith and Christian, 112–13. For more descriptions see T. G. Goldberg, "Ocherki po istorii serebrianogo delo v Rossii v pervoi polovine XVIII veka," in *Stat'i po istorii material'noi kul'tury VII–XIX vv., Trudy XVIII, Vypusk XVIII* (Moscow: Izdanie Gostudarstvennogo istoricheskogo muzeia, 1947), 8 and 9. Russian nineteenth-century historian I. E. Zabelin noted that in the reign of Aleksei Mikhailovich individual members of the tsar's family had their own collections of silver, which they displayed in their rooms when receiving guests. See I. E. Zabelin, *Domashnii byt russkikh tsarei v XVI i XVII stoletiiakh kniga pervaia Gosudarev dvor ili dvorets* (Moscow: Kniga, 1990), 216.
5. See N. V. Kaliazina and G. N. Komelova, *Rosskoe iskusstvo petrovskogo epokhi* (Leningrad: Khudozhnik RSFSR, 1990), no. 48–49. For an illustration, see B. F. Borzin, *Rospisi petrovskogo vremeni* (Leningrad: Khudozhnik RSFSR, 1986), 132.
6. Alfred E. Jones, *Old English Plate of the Emperor of Russia* (London, 1909), xix.

7. L.V. Sadovnikova, "Opyt statisticheskoi obrabotki opisei boiarskogo imyshchestva vtoroi poloviny XVII v." *Istoricheskii muzei – entsiklopediia otechestvennoi istorii i kul'turi: Trudi Gos. Istor. Myzeia* (Moscow, 2000), 444.
8. Quoted in Philippa Glanville, ed., *Silver: History & Design*, 7.
9. Marina Lopato, "English Silver in St. Petersburg," in *British Art Treasures from Russian Imperial Collections in the Hermitage*, ed. Brian Allen and Larissa Dukelskaia (New Haven: Yale University Press, 1996), 126.
10. Baron N. Vrangel', "Iskusstvo i gosudar' Nikolai Pavlovich," *Starye gody* (July–September 1913), 56. Vrangel' notes that Elizabeth I and Catherine II did the same thing, but he considers that "vandalism" to have been "accidental."
11. Anne Odom, *Russian Enamels: From Kievan Rus to Fabergé* (London: Philip Wilson Publishers, 1996).
12. See Philippa Glanville, ed., *Silver: History & Design* and Jessie McNab, *Silver* (Washington, D.C.: Smithsonian Institution, 1981).

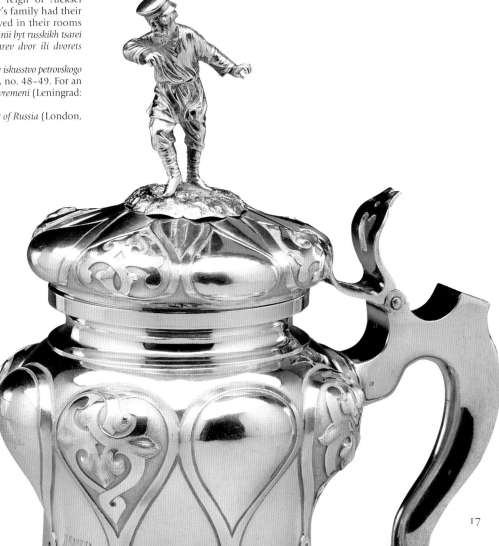

Tankard
St. Petersburg, 1876.
Detail of fig. 121.

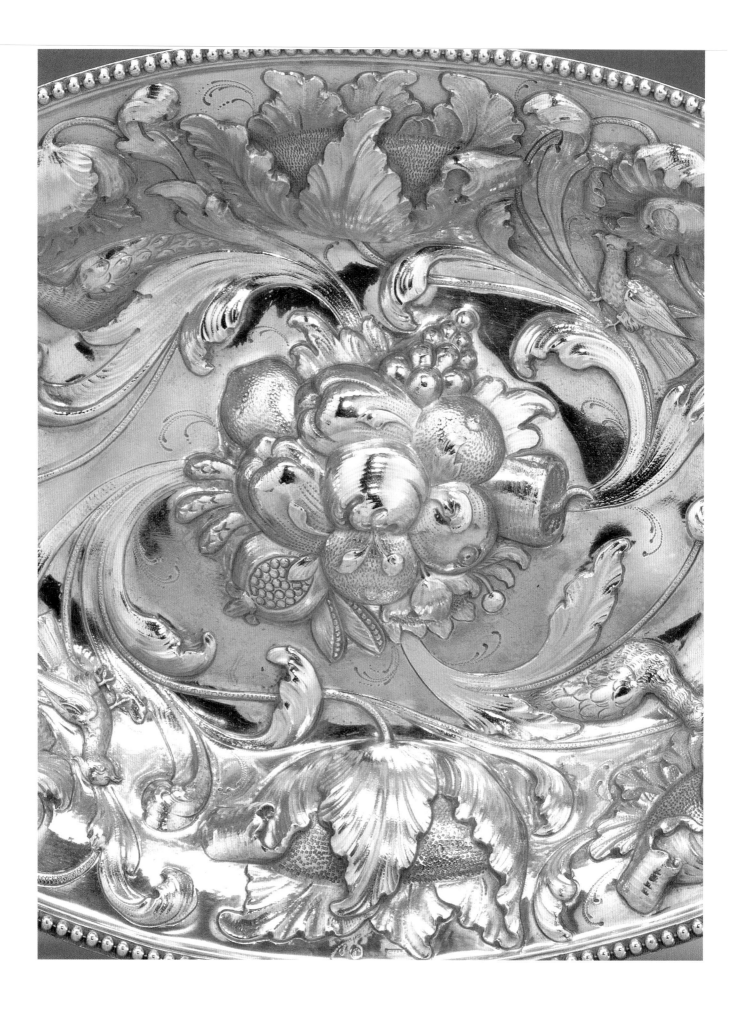

CHAPTER

MAJOR AMERICAN COLLECTORS: CONTRASTS IN TASTE AND FOCUS

THE AMERICAN COLLECTORS of Russian silver form a secondary, yet highly important, theme of this book. Without them, we in the United States would be unable to make a significant study of Russian silver at all. Briefly addressing them and how they assembled their collections may help to explain the choice of examples in this book. The collection formed by Marjorie Merriweather Post (1887–1973) at Hillwood provides the impetus for this work, and Post's story is instructive (fig. 4).

The visitor to Hillwood does not immediately conclude that Post was a collector of silver, as such, although there is plenty to be seen, both in vitrines and on the dining room table (fig. 5). Unlike porcelain, silver was not a passion for her; she had never collected French silver, for example. However, as a celebrated hostess, she certainly delighted in its sparkle in the candlelight on the table and for that purpose she early on acquired service plates and serving dishes of English silver and vermeil, or gilded silver, as well as a grand Austrian centerpiece.

When Post went to the Soviet Union in 1937 as wife of Ambassador Joseph E. Davies, she was not a connoisseur of silver and like most western collectors at that time was unfamiliar with Russian art, not to mention Russian silver. The Davies found that the commission shops, where they could shop for antiques, were pretty well picked over, so it is not a surprise that their first extensive purchases of silver were numerous small and large silver beakers, tankards, and *charki*, found there or in state storerooms in Moscow in 1937–38.[1] Post always liked to mass similar objects, so a whole shelf of silver beakers presented a striking appearance. A 1972 photograph of a case in the Dacha at Topridge (fig. 6), Post's summer camp in the Adirondacks, shows that many

OPPOSITE:
Basin
St. Petersburg, ca. 1790.
Detail of fig. 73.

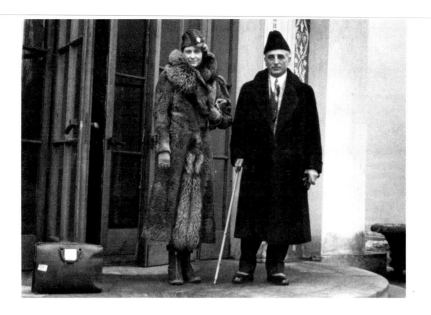

of these beakers were on display there, all lined up on shelves, until Marvin Ross shortly thereafter shipped them to Hillwood in an effort to consolidate her Russian objects. Post had hired Marvin Ross as her curator in 1958 to catalogue her collections. In the 1960s he regularly brought important works of art to her attention and helped her prepare for her home and collection to become a museum.

Post preferred silver decorated with enamel and niello and purchased numerous such Easter eggs, *kovshi*, bowls, and tea sets in Moscow. The beakers, niello souvenir boxes, and chalices Post bought were the survivors of Stalin's policy to melt down silver to be sold as bullion to the West to support communist activities there, as well as to pay for machinery and equipment to speed the industrialization of the country as part of the first Five Year Plan (1927–32). In March 1937, less than three months after he arrived in Moscow, Davies wrote in his diary:

> The "party" in some sections is putting on a drive to destroy all except the most artistic icons, priests' robes, chalices, and the like. It seems a pity that these should be destroyed. I have made a request that we be allowed to purchase some of these sacred relics and I think permission will be allowed us. If we can do so, we will save for ultimate sacred purposes some at least of these beautiful things of the religious life of old Russia.[2]

Permission was granted, and Post described in one of her Moscow scrapbooks finding the chalices:

> During the early days of our stay in Russia—they were clearing State Store rooms to create new museums—to further augment the old ones—So! One day we were taken by Bender to a State Store Room—Fairy tales of robber caves—had nothing on this place room after room with rough board shelves were loaded—great boxes on the floor with lovely silver things tea–coffee pots tankards vodka cups, etc …. It was here that we found the chalices looking like pewter—filthy dirty all pushed under a kitchen table—We were allowed to poke & dig—& pile what we wished together & the commission would *sit* (they were in full outside attire, caps and mufflers complete) drink tea—smoke—yell at each other & eventually we would have a price—Chalices—old—new—jeweled—or not—were a ruble a gram—weighed on a feed store scale.[3]

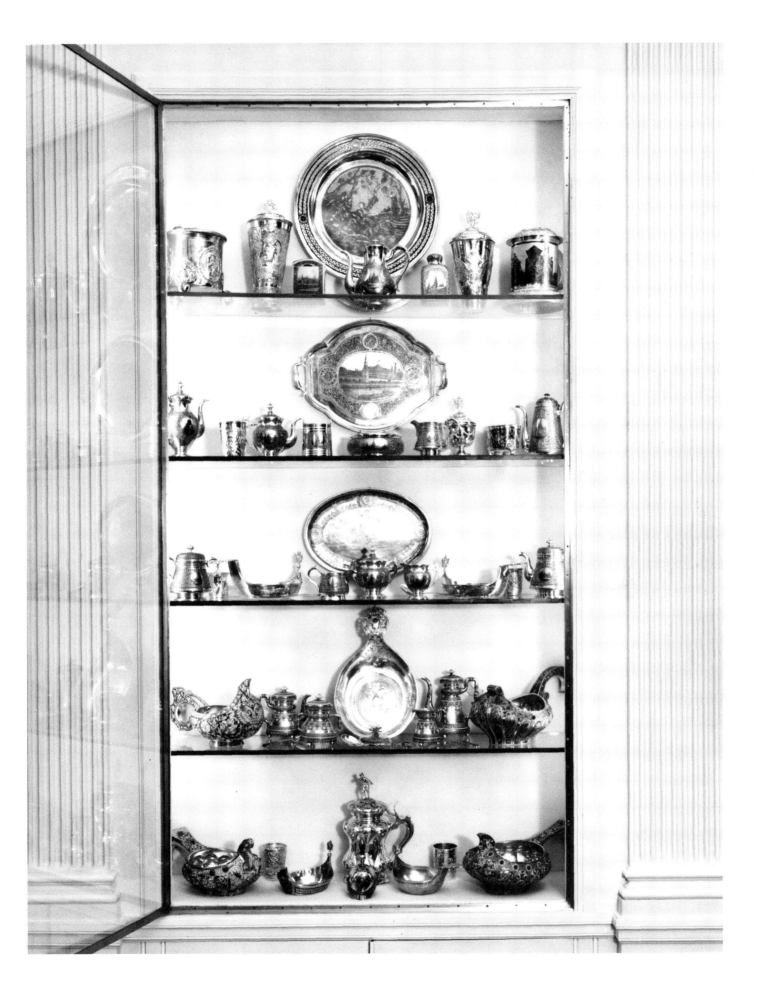

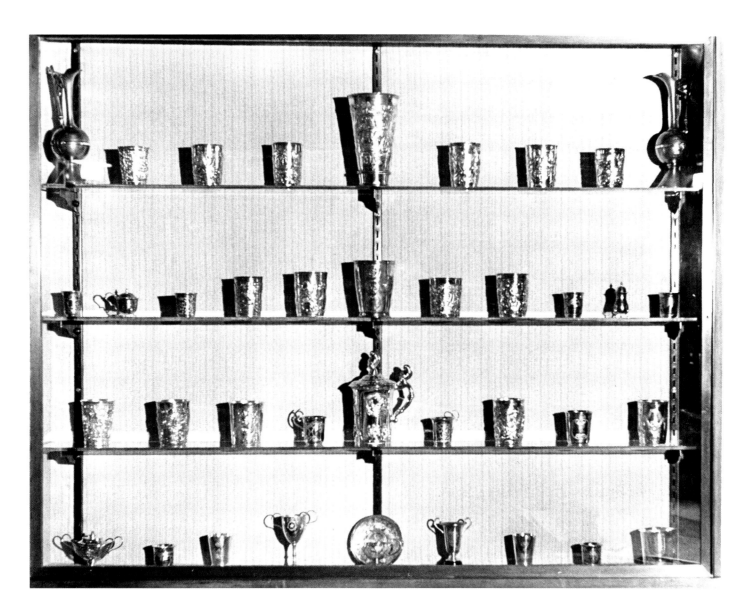

Fig. 6
Silver display case, Topridge, 1972.

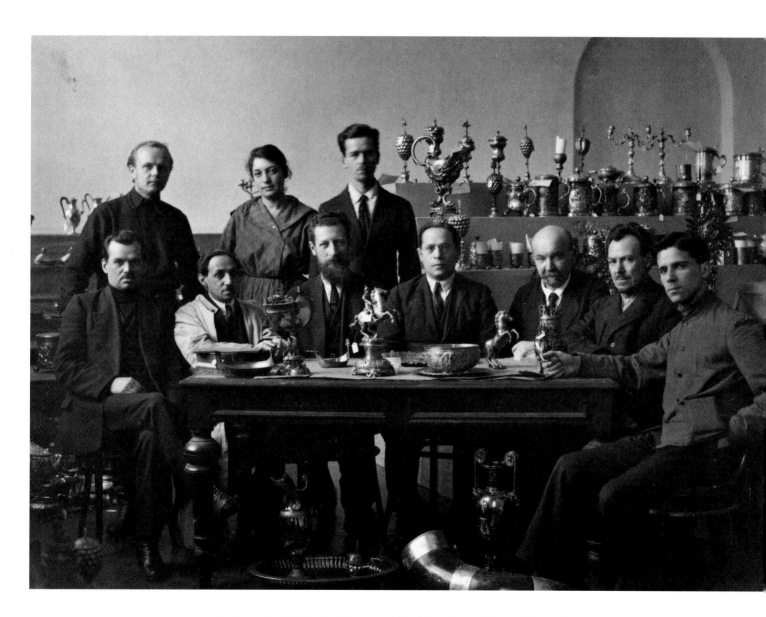

Fig. 7
The Classification Committee,
Gokhran, Moscow, ca. 1923.
Moisei Lazerson, chair of the
committee, is seated in center,
Professor Sergei Troinitskii,
director of the Hermitage, is seated
third from left. From the Max
Lazerson Collection, Hoover
Institution Archives, Stanford
University.

In the early 1920s the Currency Administration of the Ministry of Finance was in charge of sorting out what valuables went to museums, which were to be sold, and what was to be melted down for bullion (fig. 7). This was the first attack on the church and its holdings of silver plate, but another attack occurred in the early 1930s, and it is probably from this second round of confiscations that the Davies acquired most of their chalices. Objects after 1835 were considered of no artistic value and were generally destined for the melting pot. Of the approximately twenty-two chalices Post purchased only one dates later than 1835. Marvin Ross found it in New York and convinced her

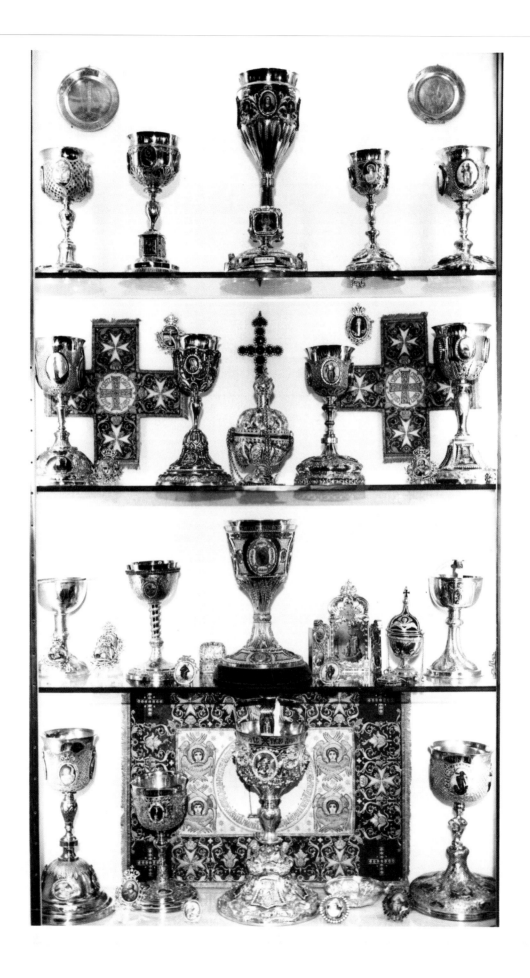

to buy it, resulting in an excellent example of rococo revival being added to the collection (fig. 118). At Hillwood Post exhibited her chalices all in one case, originally backed with altar cloths to give a very rich effect (fig. 8).[4]

She acquired most of the eleven presentation *kovshi* in the collection in two purchases. In 1956 she bought four (see, for example, fig. 32) from Prince Zourab Tchkotoua, a New York collector and race car driver, and then in 1960 she purchased five more from A La Vieille Russie in New York on the recommendation of Marvin Ross. In 1968 Leon Grinberg, a Paris dealer, offered her two seventeenth-century *kovshi* from the collection of Nils Uthemann, son of the famous Russian pre-Revolutionary collector F. F. Uthemann. Grinberg wanted double the price of the five she had purchased from A La Vieille Russie only eight years earlier. After Post refused Grinberg's offer, Ross gloated in a memo that the 1960 "purchase certainly was a good one."[5] Presented by Romanov tsars and tsarinas, these *kovshi* reflect Post's special interest in Romanov connections.[6]

Post was "a primary collector" of Russian art, that is, someone who bought art in the Soviet Union during the interwar period. But she was also a secondary one, buying from dealers and at auction later in life. Other collectors of Russian silver tended to be one or the other, and their reasons for collecting and the quality of their collections varied. Frances Bunker Rosso (1898–1976) gave a small Russian collection to Hillwood in the late 1960s in memory of her husband, Augusto Rosso (1885–1964), the Italian ambassador to the Soviet Union from 1936 to 1941. Post and the American-born Frances Rosso became friends during their time in Moscow and retained close ties after the war. Her collection reflects the type of art still available at the commission shops in the late 1930s (see figs. 12 and 29 for several examples of silver from her collection). Whereas Post continued to collect for the rest of her life, Rosso did not. It is quite possible that Rosso, a newly married bride, was collecting in Moscow for the adventure of exploring the commission shops and the pleasure of finding affordable treasures.

Lillian Thomas Pratt (1876–1947), whose superb collection of Fabergé is now at the Virginia Museum of Fine Arts, was one of the first of a group of American women to patronize the department store exhibitions organized by Armand Hammer in the United States. Hammer, selling Russian artifacts, often with imperial family provenances, on behalf of the Soviet government in the 1930s, successfully created an American market for what the Soviets considered the detritus of the *ancien régime*. Pratt, like Post, was also seduced by Romanov family lore. The Pratt collection includes both Fabergé silver and objects made by other silversmiths as well, like the bread and salt dish in figure 132. She willed her collection to the Virginia Museum in 1947.

Henry Walters (1848–1931), founder of the Walters Art Gallery (now Walters Art Museum), looked at Russian art in a very different way. At the beginning of the

twentieth century he was creating a museum with a universal approach to art and chose Russian objects that reflected his global interests. Accordingly his Russian purchases augmented his already existing interests in Limoges enamels, medieval ivories, and eighteenth-century gold boxes. Unlike Post, he purchased seventeenth-century enamels from the northern Russian town of Solvychegodsk and eighteenth-century enamels with appliqués from the northern trade center of Velikii Ustiug.[7] The Russian silver he bought included seventeenth-century drinking vessels, like an *endova* (see fig. 19), two *bratiny*, and several eighteenth-century tall standing cups with lids (see fig. 57), objects that didn't attract Post.

A generation older than Post, he did not seem to share Post's or Pratt's interests in the Romanovs. He actually bought pieces made by the renowned firm of Fabergé directly from Fabergé's shop in St. Petersburg before the Revolution.[8] Aside from these works, he appears to have purchased all his Russian art in Paris either directly from Aleksandr Polovtsov (Alexandre Polovtsoff, 1867–1944) or with his assistance between 1928 and 1930.[9] Polovtsov had served as a curator at the famed Shtiglits (Stieglitz) Museum of the Central Institute for Technical Drawing in St. Petersburg before the Revolution and had been instrumental in protecting the summer palace, Pavlovsk, in the upheavals that followed it.[10] He soon gave up and left Russia for Paris. With his background Polovtsov, as a member of the pre-Revolutionary intelligentsia and a connoisseur of the arts, was in a position to recommend excellent purchases to Walters, and many of the pieces acquired by Walters had belonged to famous pre-Revolutionary collections. In a 1973 letter Marvin Ross wrote to Richard H. Randall, Jr., the director of the Walters, that "Henry Walters was very fortunate in having Polovtsoff…select most of his Russian items. Many came from the original A La Vieille Russie on Faubourg St. Honoré in Paris, run by [Jacques] Zolotnitsky and his nephew Leon Grinberg."[11] How and from whom Polovtsov acquired objects is unclear. He may have been a finder rather than an actual dealer because it is unlikely that Polovtsov, as an upper-class émigré, could have returned to the Soviet Union on buying trips.

Ralph Sylvester Bartlett (1868–1960) of Boston was a dealer in Russian decorative art that he acquired on various trips to Russia after the Revolution. A lawyer by training, he began traveling to Europe on international business, going to Russia for the first time in 1911–12.[12] How many trips he made to Russia both before and after the Revolution is unknown, but by 1928 he had acquired enough Russian objects to open a Boston gallery, called Old Russia (fig. 9). Bartlett was familiar with Baron Armin Felkerzam's famous 1909 catalogue of the Russian silver in the Hermitage, and usually identified his pieces correctly. He closed his shop in 1939 when it was no longer legal to export art from the Soviet Union and then loaned objects from his collection to various museums. In 1958 he donated his collection to his alma mater, Dartmouth College.

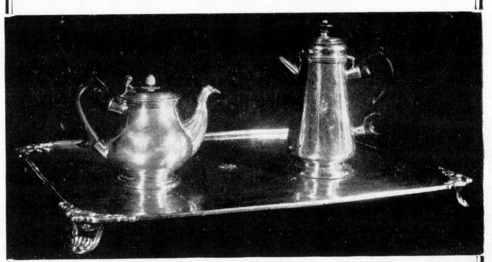

FROM THE IMPERIAL SERVICE OF THE WINTER PALACE

EIGHTEENTH-CENTURY Russian Imperial pieces of gold-on-silver, made in St. Petersburg by Johann Henrik Blom, of Swedish birth, who was admitted to membership in the St. Petersburg Society of Foreign Silversmiths in 1766. He is reputed to have been the foremost craftsman working for the Imperial Court during the reign of Catherine the Great.

The tray, $21\frac{1}{4}$ x 16 inches, supported by four feet and dated 1796, is engraved in the center with the Russian double-headed eagle with the Imperial Crown above, and it weighs 3,760 grams. '70' is its number, and it is recorded in Vol. II, on page 475, under item 338, of Baron Foelkersam's Inventory of the Treasures in the Imperial Palaces, which was published in St. Petersburg in 1907.

The coffee pot, engraved with the Russian double-headed eagle with the Imperial Crown above, weighs 803 grams, and is dated 1780. It is No. 1 of the Blom collection in the Winter Palace.

The tea pot, dated 1784, weighs 785 grams, and is No. 4 of the Blom collection.

Old Russia

16 ARLINGTON STREET, BOSTON, MASSACHUSETTS, U.S.A.

(OPPOSITE THE RITZ-CARLTON)

XLIII

Many pieces of silver Bartlett bought have Winter Palace provenances, including the coffee pot seen on the right in figure 10, made for Empress Anna in 1735 and now at Hillwood. In 1963 Dartmouth College sold some of the silver to A La Vieille Russie.[13] The fact that many of the finest silver pieces seen in Bartlett's advertisements in *Connoisseur* in the 1930s were not sold, like the coffee pot with Catherine's cipher (on the left in fig. 10) now at the Hood Museum, indicates either that Bartlett set very high prices, perhaps because he preferred owning them to selling them, or that there was little interest in America in the 1930s for Russian silver.[14]

Thomas Whittemore (1871–1950) was an exceptionally knowledgeable Byzantinist and archeologist, and well connected to a number of people interested in philanthropy and art in the Soviet Union. He traveled there several times in the 1920s to deliver aid to people displaced by World War I. He, himself, was probably not a collector, but in connection with his trips he acquired some rare *bratiny* and *charki* from the Troitse-Sergieva Monastery (see figs. 17 and 22). He presented them along with several small eighteenth-century silver beakers to the Museum of Fine Arts in Boston in 1953.

Fig. 10
Original Bartlett photo of two coffee pots: one made for Catherine on the left and Anna on the right.

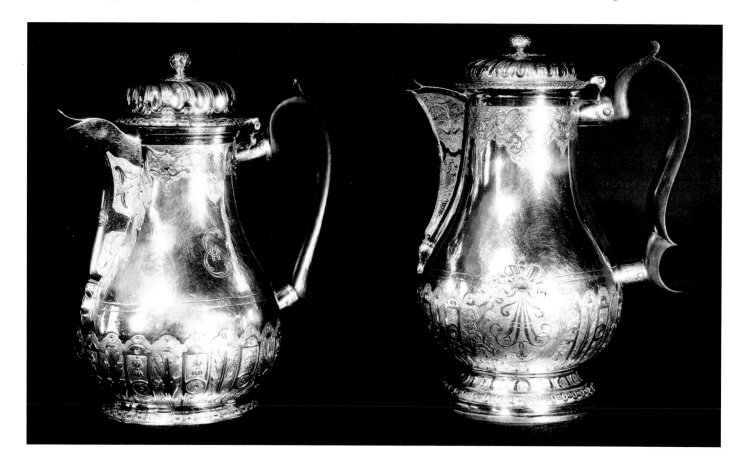

Whittemore is most well known in the Russian area for his efforts to negotiate the purchase of the bells from the Danilov Monastery in Moscow, on behalf of Charles R. Crane, who paid for them.[15] Crane gave the bells to Lowell House at Harvard where they hung until 2008, when they were returned to the monastery after the Russians had another set cast for Harvard. Whittemore's negotiations with the monastery in the late 1920s or early 1930s may well have led him to his acquisition of Russian silver. Whether these were gifts or purchases he no doubt saw, as Joseph Davies did, his efforts as saving Russia's religious treasures.

Except for the objects she donated to the Philadelphia Museum of Art, the collecting motives of Eugenia Clair Smith (1883–?1972) remain something of a mystery. She was an heir to the Arbuckle (Yuban) coffee company following the death of her husband, coffee magnate William E. Smith. Probably from Pittsburgh, she moved to Nevada where she became involved in state politics. She claimed to have found the tea set made for Grand Duke Nikolai Nikolaevich, son of Nicholas I, in Reno in the 1930s (see fig. 107).[16] She gave a champagne cooler and a flatware service to the museum at the same time.

Only one of the collections included in this book was retained by a family of émigrés, that of Nancy Leeds Wynkoop, granddaughter of Grand Duke Georgii Mikhailovich, now at the Middlebury College Museum of Art. The grand duke's wife, Maria Georgievna (Princess Marie of Greece and Denmark) left Russia for England with her two daughters (one of whom, Ksenia, was Nancy's mother) in the summer of 1914 for a cure. While in England, World War I broke out. Maria never returned to Russia, nor did she ever see her husband again. He was shot in the Peter Paul Fortress in 1919.

The objects in the collection, numbering about one hundred, include many family pieces made by Fabergé.[17] When in 1919 a British warship rescued the dowager empress, Maria Fedorovna, from the Crimea, she was able to take out of the country most of the grand duke's silver (see fig. 138). The empress lived her last weeks in Russia in Harax, the couple's Crimean estate, where the silver had been stored.

All these collectors were among the first wave of aficionados of Russian art in the United States. While not all had direct exposure to Soviet Russia, many of them did. After World War II the main source of art was closed off, and another generation began to develop an interest in Russian art, primarily in the work of Carl Fabergé—people like Jack and Bell Linsky and Lansdell K. Christie. He acquired most of the Linsky collection of Fabergé when the Metropolitan Museum of Art's director James Rorimer called it "turn of the century trinkets."[18] Not all considered Fabergé kitsch, and some of his works in silver remain the most exuberant examples of modernism. Those who did collect seemed undeterred by the Cold War and negative attitudes toward the Soviet Union, especially that great proponent of capitalism, Malcolm Forbes, whose collection of Fabergé did not go to a museum, but was sold to the Russian tycoon, Viktor Vekselberg in 2004. It included some important pieces of Russian silver.

There are, of course, random pieces of Russian silver in various museum collections throughout the United States. Some silver assembled by Jean Herbette (1878–1960), the French ambassador to the Soviet Union from 1924 to 1930, is now in the Frick Art Museum in Pittsburgh (for an example see fig. 71).[19] Helen Frick purchased for the museum six pieces from Herbette's collection as well as five other works at A La Vieille Russie in 1973 after his collection was sold at auction at Christie's in Geneva in 1971. Boston's Museum of Fine Arts' collection of Russian silver from Thomas Whittemore was enhanced by the gift from the estate of Mrs. John Gardner Coolidge – a tea set made for Catherine the Great (see fig. 64). It is tempting to think that Gardner bought this tea set from Old Russia, Bartlett's shop. Francis E. Fowler, Jr. gave his extensive collection of silver, especially English and Irish, to the Fowler Museum of Cultural History of the University of California, Los Angeles in 1983. Among the continental silver in the collection are a small number from Russia (for an example see fig. 117).[20] In the case of Fowler, he was obviously collecting Russian silver in the context of his overall silver collection.

Although Henry Walters was perhaps the most discerning of all the collectors in his appreciation of historical context, Post stands out for the sheer size (367 pieces) and overall quality of her collection. She had the advantage of a long collecting life and a sustained interest in Russian decorative art. Thus Hillwood is the only place in the West where the viewer can focus on Russia art as an entity in itself.

There is a remarkable amount of Russian silver in American museums. Because of the American interest in the Russian imperial family many of the objects have imperial connections. Rarely, however, are there the finest tablewares, such as tureens and centerpieces, a few of which are still preserved in Russia. There are exceptions, like the gold chalices at Hillwood, the tea set in Philadelphia, and the Fabergé *kovsh* in Richmond. It has been possible with this study to shine a light on many small treasures hidden away in the storerooms of museums.

Clearly many of the collectors came by their Russian collections in different ways. Marjorie Post, Frances Rosso, and Ambassador Herbette had the advantage of living in the Soviet Union at the time of the sales. Henry Walters discovered Russian art near the end of a long collecting career, and Ralph Bartlett, Thomas Whittemore, and others saw an opportunity while traveling to the Soviet Union to engage in business or to see the socialist experiment for themselves. For others, like Malcolm Forbes and Francis Fowler, their collections of Russian silver were only a small part of a larger collecting venture. By giving, with the exception of Forbes, their collections to museums, they have ensured that Americans can see Russian craftsmanship, and make comparisons with European and American silver.

NOTES

1. "Memorandum of Preliminary List of Russian Objects in the Embassy," May 9, 1939, 20. This list refers to items in the Brussels Embassy. Hillwood Archives.

2. Joseph E. Davies, *Mission to Moscow* (New York: Simon and Schuster, 1941), pp. 129–30. When Mrs. Post and Davies divorced in 1955 they split the Russian collection. According to Davies's will, the chalices in his possession went to the Washington National Cathedral upon his death in 1958. In 1980 the Cathedral sold the chalices in order to raise money to complete the tower. Bishop Michael J. Dudick purchased some of them, which are now in the Episcopal and Heritage Libraries and Museum in Passaic, New Jersey. See "The Byzantine Episcopal and Heritage Institute Museum and Libraries," *Eastern Catholic Life*, February 13, 1994, 6.

3. Scrapbook, Vol. I, Box 38 1937, Bentley Library, University of Wisconsin.

4. The altar cloths were removed from display for conservation reasons and are now exhibited on a rotation basis in the Liturgical Gallery at Hillwood.

5. Memo from Marvin Ross to Mrs. Post, March 22, 1968, Hillwood Archives, Papers of Marvin C. Ross.

6. Also in 1968 Ross suggested to Post that she consider buying the Eugene Lubovitch collection, which came on the market privately that year. Leon Grinberg of A La Vieille Russie considered it the best collection in Europe. Ross wrote to Post that if she "added this collection to Hillwood…[t]he Merriweather Post collection would then really be something to talk about." Her response to the possible cost of almost one million dollars was "under present condition I am not willing to spend much money." See letter of Marvin C. Ross, to Post, March 22, 1968, Hillwood Archives, Papers of Marvin C. Ross. For the catalogue of silver in the collection, see *Argenterie Russe ancienne de la Collection Eugène Lubovitch* (Paris: Imprimerie Maulde et Renou, 1932). For more on Lubovitch see "The Grzgor Sapiena Beaker," Christie's, London, November 28–29, 2007, lot 662, 301.

7. For examples of Walters's enamel acquisitions, see Anne Odom, *Russian Enamels*, 40–45 and 48–63.

8. Walters was taken to Fabergé's shop by Julia Cantacuzene, President Grant's granddaughter. Her grandson married Post's granddaughter. See William R. Johnston, *William and Henry Walters, The Reticent Collectors* (Baltimore: The Johns Hopkins University Press, 1999), 119–20.

9. William R. Johnston, *William and Henry Walters*, 218.

10. See Suzanne Massie, *Pavlovsk* (Boston: Little, Brown and Company, 1990), chs. 8 and 9 for his role at Pavlovsk.

11. Letter from Marvin C. Ross to Richard H. Randall, Jr., 1973, Hillwood Archives, Papers of Marvin C. Ross.

12. Joseph William Pepperell Frost, "Ralph Sylvester Bartlett," *New England Historical and Genealogical Register* (April 1961), 81–82.

13. Bartlett's donation to Dartmouth was part of a complicated agreement, in which he was to be paid a monthly stipend and his hospital, funeral, and burial arrangements were to be paid by the college. The college needed to sell some of the collection to pay for these expenses. See Bartlett files in the Registrar's office at the Hood Museum of Art. I wish to thank Deborah Haynes, registrar at the Hood Museum of Art at Dartmouth College, for providing me access to the Bartlett collection and to the papers stored there. Marvin Ross had a selection of original Bartlett photos, which must have been sent to him from Dartmouth. The college was uncertain about what it was willing to sell.

14. Some examples of Bartlett's advertisements can be found in *Connoisseur* 97, no. 418 (June 1936), 340; 98, no. 424 (December 1936), xviii; 100, no. 433 (September 1937), 155.

15. Charles R. Crane, from the famous Chicago plumbing family, helped to organize Russian art exhibitions in the United States in the 1920s and provided aid to Russians.

16. I wish to thank Donna Corbin, Curator of European Decorative Art at the Philadelphia Museum of Art for help finding out about Eugenia Clair Smith.

17. For more about this collection, see Anne Odom, *What Became of Peter's Dream: Court Culture in the Reign of Nicholas II* (Middlebury, VT, and Washington D.C.: Middlebury College Museum of Art and Hillwood Museum and Gardens, 2003).

18. For more on these collections, see Géza von Habsburg, *Fabergé in America* (San Francisco: Thames and Hudson, 1996), 191.

19. Perusal of the silver sold from Herbette's collection gives a good picture of what one foreigner was collecting in the 1920s. The objects for sale – one hundred and forty-one were silver – are not too different from the many *charki* and beakers Post bought in Moscow a decade later. *The Herbette Collection*, Christie's Geneva, May 25 and 26, 1971.

20. See Timothy B. Schroder, *The Francis E. Fowler, Jr. Collection of Silver* (Los Angeles: Fowler Museum of Cultural History, University of California, Los Angeles, 1991), 82–103 for examples.

TRANSITION TO WESTERN STYLES: SILVER BEFORE 1700

FASHIONING OBJECTS FROM silver and gold in Russian lands goes back to the earliest history of Kievan Rus'. Production was limited following the Mongol invasions of the thirteenth century and their subsequent domination of Muscovy, but gradually Moscow began centralizing its power, and by the sixteenth century the Moscow Kremlin workshops were active. Producing each category in its own separate chamber (*palata*), the workshops turned out not only ceremonial arms, but also icons, church vestments, gold and silver plate for the church as well as secular objects used at court banquets and diplomatic receptions. Unfortunately few silver objects, like those described in the reports of foreign emissaries cited earlier, remain from this period even in Russia. During the Time of Troubles, following the death of Boris Godunov in 1605 many works of art were stolen by Poles occupying Moscow or were melted down to raise money to fight the invaders. At the same time, silversmiths fled occupied areas and were scattered around the country. Only with the accession of Michael Romanov in 1613 did the country achieve sufficient stability for the Kremlin workshops to resume their activity and restore to the new dynasty the trappings of rule. The gold and silver chambers reached their height of production in the second half of the seventeenth century in the reign of Tsar Aleksei, Peter the Great's father. By then they became a virtual academy of art under the direction of the chief armorer, Bogdan Matveevich Khitrovo (active 1655–80). Even the Patriarch had silver- and goldsmiths attached to his court creating objects for the church.

As part of its centralization process the Russian tsars commandeered the best Russian masters from cities like Novgorod, Iaroslavl', Kostroma, and Nizhnii Novgorod and confiscated the most valuable objects in those towns for display in the Kremlin.

OPPOSITE:
Beaker
Moscow, late 17th century.
Detail of fig. 28.

Such policies not only strengthened the cultural power of Moscow, but left provincial centers bereft of their most talented craftsmen and cultural treasures.[1] The seventeenth-century tsars hired many foreign silversmiths to work for them because of a shortage of skilled artisans after the Time of Troubles. They signed contracts stipulating among other things a requirement to train Russian masters in their specialties. In turn, the latest techniques already well established in the West were being introduced, and Western influences infiltrated the design vocabulary of the artists and artisans—a process Peter and his successors greatly expanded in the eighteenth century. These innovations came at a cost though, because foreign workmasters were usually paid considerably more than native Russians.

Stylistically, the silverwares of the seventeenth century are increasingly rich and varied in ornament reflecting diverse influences. Artists copied new designs from gifts presented by foreign dignitaries and from imported textiles, especially those from Persia and Turkey, but also from Venice. It appears that Tsar Aleksei especially favored Turkish-Byzantine decoration like that found on the works known as *tsargradskiia rabota* (that is, more stylized and geometric work from Constantinople) as opposed to *friazheskiia* (the name given to objects with a more naturalistic Western influence).[2] As the Turkish-Byzantine ornament was interpreted by Kremlin silver- and goldsmiths, it became known as *Moskovskoe delo* (or Moscow work, fig. 11). At its finest, this decoration included enameling, and precious stones on gold.

In the last two decades of the century an increased number of printed books came to Russia through Ukraine. Following the annexation of Kiev in 1686, foreign craftsmen brought new designs, and Russian artisans began to copy Western symbols and emblems or Biblical scenes from engravings. Exposure to foreign travelers and their gifts and printed materials surely led to the boyars' desire to acquire and consume. This phenomenon became more pronounced in the last part of the seventeenth century and increased exponentially in the next century with increased travel.[3]

While the production of the Kremlin workshops was of the very finest quality and was reserved for the tsar, the church, and high-ranking boyars, most of the wealthier urban citizens patronized the "silver rows," (*serebrianye riady*) located in the *posad*, or merchant quarter, outside the Kremlin walls.[4] Certainly most seventeenth-century works found in American collections were made in the silver rows of Moscow or other provincial cities. In these bazaars numerous artisans made and sold their wares alongside merchants selling everything from clothes to grain to icons.[5] This was the only legal place to sell works made of precious metals. Silversmiths and silver merchants were organized within the rows and were required to produce and sell according to prescribed laws. At the head of the silver rows were two *starosty*, or aldermen, chosen by the merchants to ensure that the silver was not diluted with alloys below the lawful standard. Such silver rows also existed in the *posadi* of numerous other

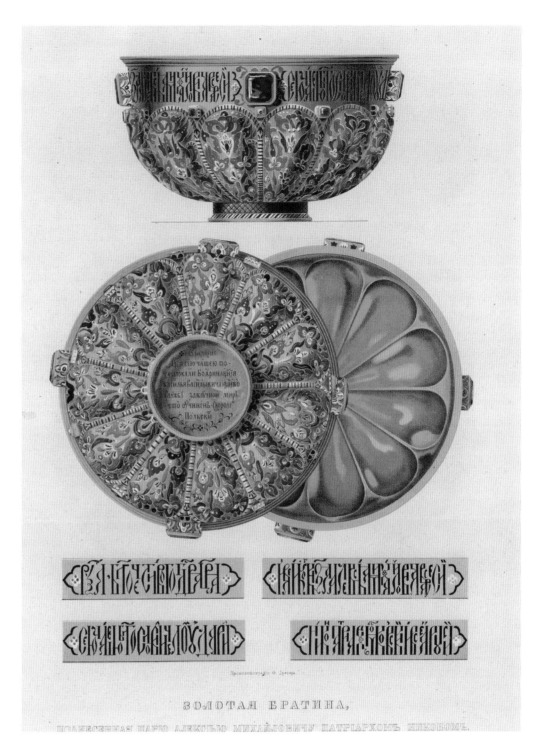

seventeenth-century Russian cities, especially along the Volga and northern trade routes—Iaroslavl', Kostroma, Nizhnii Novgorod, and Velikii Ustiug. At the end of the seventeenth century there were 250 silver merchants and around 300 silversmiths in the Moscow silver rows alone.[6] In the eighteenth century this number steadily declined, as the court moved to St. Petersburg following the creation of a new capital, and Peter transferred especially talented artisans to his new city.

In the seventeenth century, Russia was limited by few native sources of gold or silver and prospecting for these precious metals expanded as expeditions set out to explore and conquer Siberia. The large bulk of gold and silver came in the form of ingots from customs houses handling foreign trade. To create artistic wares, silversmiths melted

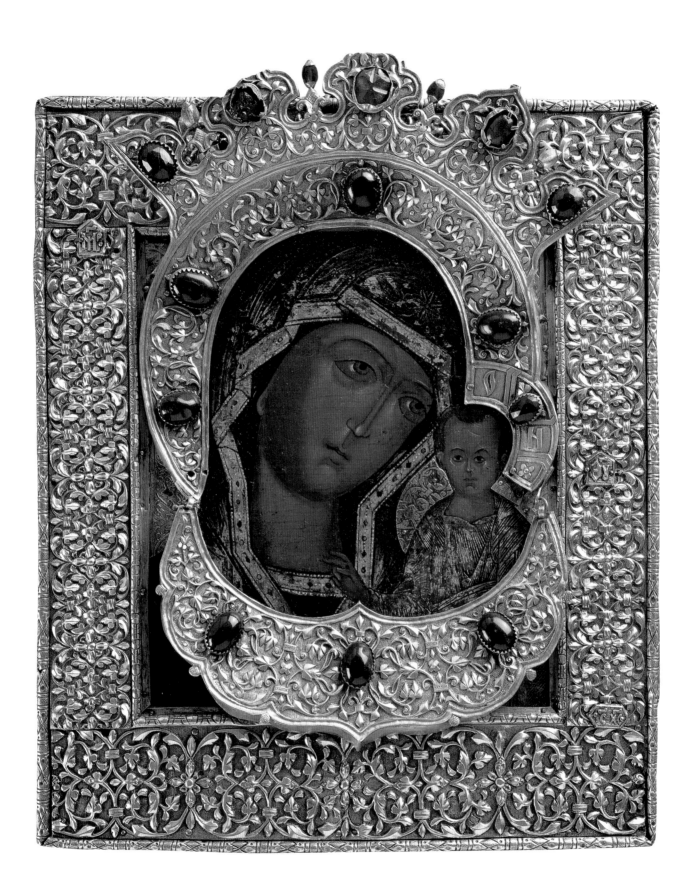

OPPOSITE: *Fig. 12*
Kazan Mother of God
Russia, 1600–50
Tempera on wood with gilding,
silver gilt, and paste gemstones
H. 13¼ in. (31.4 cm.),
W. 10⅝ in. (26.4 cm.)
54.7

down foreign coinage as well as old objects that had gone out of fashion. They also burned old vestments for the gold and silver threads woven into them.

In 1700 Peter established a Mining Department to find sources of gold and silver. A small silver mine was opened near Nerchinsk in 1704, but it was not until the Demidov family opened its silver mines in the Urals between 1725 and 1744 that silver was available in any quantity. In that last year rich veins were found in the Kolyvan mines in the Altai Mountains. Empress Elizabeth ordered the first year's supply (1,500 kg) to be used to make the huge silver sarcophagus for St. Aleksandr Nevskii, patron saint of St. Petersburg.[7] It was also during Elizabeth's reign that the first significant gold deposits were found in the Urals near Ekaterinburg. Further explorations in the second half of the eighteenth century resulted in Russia becoming one of the world's primary sources of precious metals.

Until the time of Peter religious objects dominated the production of Russian silversmiths, and fortunately there are enough objects in American collections to give a good idea of the range of seventeenth-century production. As Philippa Glanville notes, "gold and silver have been linked with rituals of religious practice since ancient times as their purity and value symbolize the divine."[8] Originating in Byzantium, Persia and the Ottoman Empire, the use of tightly controlled foliate ornament on a stippled ground of a gilded silver *oklad* or icon cover, like that on an icon of the *Kazan Mother of God*, was ubiquitous in this period. Icons were a fundamental part of the interior decoration of a well-to-do Russian home (fig. 12), and such leaf and vine decoration recalled grape vines, religious symbols of the blood of Christ. This *oklad* is made of stamped strips of gilded silver, known as *bas'ma*, to form the frame. The strips are not uniformly the same, but a symmetrical scrolled floral pattern dominates all parts. The *oklad* is adorned with a full "wardrobe" (*ubor* or *kuzn'*). This includes a halo (*venets*), a diadem (*korona*), and a collar (*tsata*). These three elements intended to honor the icon are additionally highlighted with large cabochon semi-precious stones and glass.[9]

Hillwood owns two chalices and a censer from the second half of the seventeenth century. One chalice (*potir*, fig. 13) can be dated by an inscription around the foot that reads in Cyrillic: "In the year 7174 [old style for 1666] on the 2nd of November the holy father Seth, Archbishop of Astrakhan, had this cup made for the Church of St. Nicholas." The chalice is decorated on the bowl with engraved images of the Deësis—Christ, flanked by John the Baptist, and the Mother of God—in circular, gilded medallions. On the other side of the bowl in a round medallion is the Cross of Golgotha. These images overlap the traditional inscription around the rim: "Drink from this everyone; this is my blood of the New Testament which was shed for you and many others in remission of sins." Repoussé lobed panels, sometimes called "spoons," and ending in trefoils are applied over a chased fish-scale design on the base

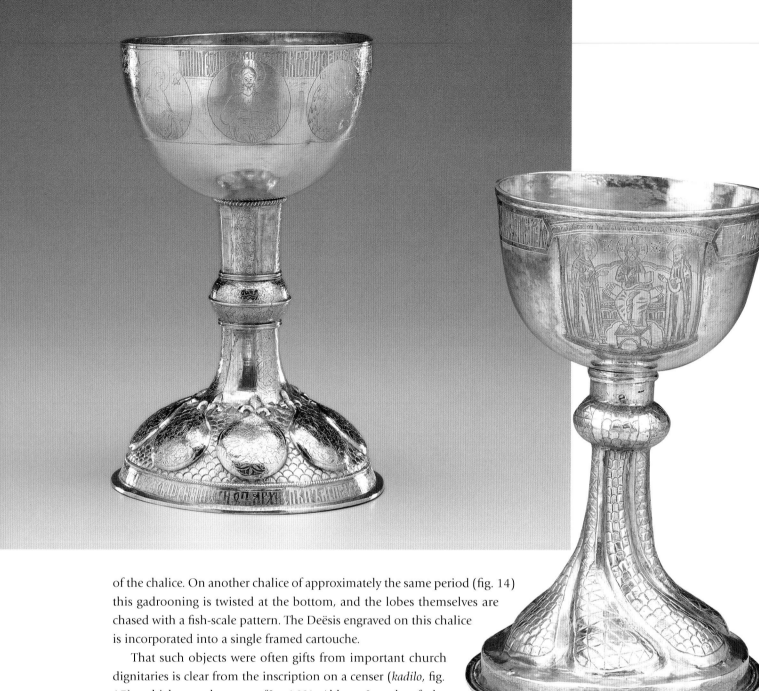

of the chalice. On another chalice of approximately the same period (fig. 14) this gadrooning is twisted at the bottom, and the lobes themselves are chased with a fish-scale pattern. The Deësis engraved on this chalice is incorporated into a single framed cartouche.

That such objects were often gifts from important church dignitaries is clear from the inscription on a censer (*kadilo*, fig. 15), which translates as: "In 1681 Abbott Joseph of the Monastery of the Savior in Staraia Russa gave this censer to the House of the Holy Life-giving Trinity and the Holy Mother of God in the Mogilev Monastery in remembrance of his soul and his parents." Whether made in Moscow, Novgorod, Iaroslavl' or Kostroma, such liturgical objects were being sent around Russia from all these cities to provincial monasteries from Mogilev, southwest of Smolensk, to Astrakhan, located on the lower Volga River.[10] This was a period when lavish gifts to monasteries and churches were extremely common, providing these institutions with enormous wealth and thus considerable power.[11]

The workmanship on each of these objects is extremely fine with delicate engraving on both chalices. Inscriptions, written in the elaborate Old Church Slavonic lettering, were organically integrated into the decorative design. This was a common feature of Byzantine and Russian liturgical objects prior to the reign of Peter the Great and is especially evident on the censer whereby the inscription appears at first glance to be an ornament on the plain lobes, which alternate with those with a repoussé foliate design.

ABOVE LEFT: *Fig. 13*
Chalice
Russia, 1666
Silver, parcel gilt
H. 8⅞ in. (22.5 cm.),
Dia. of cup 4⅞ in. (12.5 cm.),
Dia. of base 5½ in. (14 cm.)
12.82

ABOVE: *Fig. 14*
Chalice
Russia, 17th century
Silver, parcel gilt
H. 9 in. (22.9 cm.),
Dia. of cup 5¼ in. (13.3 cm.),
Dia. of base 5½ in. (14.1 cm.)
12.80

Fig. 15
Censer
Russia, ca. 1681
Silver, parcel gilt
H. 10½ in. (26.5 cm.)
12.2.1–2

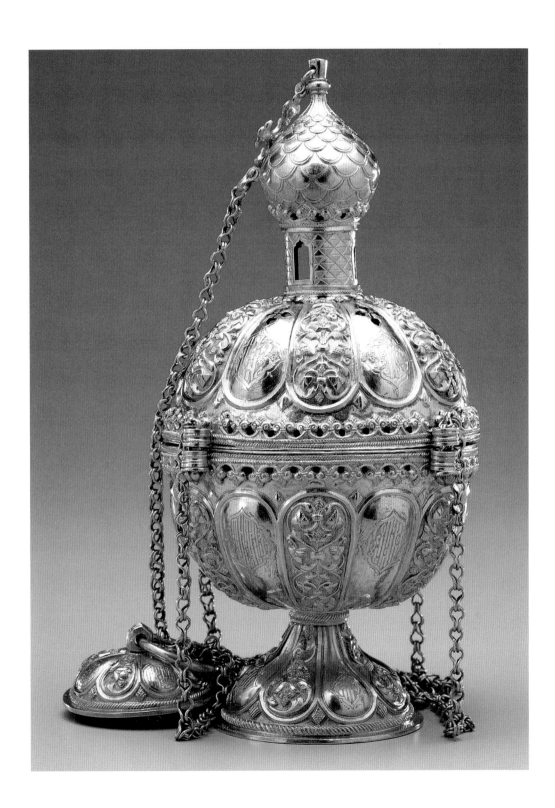

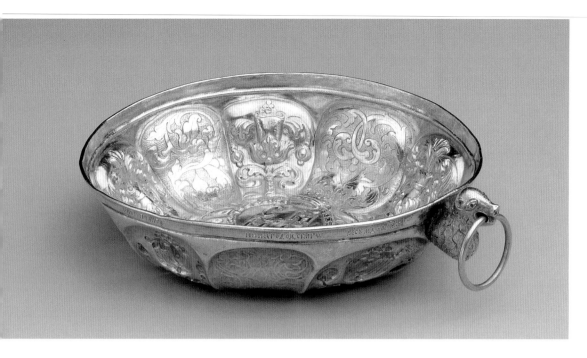

Fig. 16
Chara
Russia, ca. 1713
Silver gilt
Dia. 5¾ in. (14.6 cm.)
12.5

According to the inscription, an unusual ceremonial drinking cup (*chara*) was made for Sylvester, Metropolitan of Nizhnii Novgorod in 1713 (fig. 16). This cup was intended for the metropolitan's personal use in his *kelia*, or cell.[12] The lobed shapes forming the cup are alternately embossed with trefoil leaves on a stippled ground and a vase holding fruit or flowers. The handle of the cup is in the shape of a serpent's head, holding a ring in its mouth from which to suspend the cup.

In the seventeenth century there proved to be an increasing demand for secular objects made in silver, and drinking vessels in particular. Throughout history toasts have accompanied ceremonial and social occasions. In sixteenth- and seventeenth-century Russia, toasts were raised to the glory of God, the Mother of God, the health of the tsar and the princes, and the patriarch. Originally made of wood, drinking vessels, such as the *bratina* and *kovsh*, were used for toasts after the festive meal. The word *bratina* derives from the Russian word for brother, and they were used in monasteries by the monks (brothers) and gatherings at fraternities (*bratchiny*), or social drinking organizations, found most commonly in Russia in the sixteenth century.[13] Filled with honey and water, they were also placed on the fresh graves of the deceased. The *bratina*'s shape was bulbous, tapering to a narrower diameter at the lip and foot. With a lid, which some still retain, the *bratina* took on the shape of an old warrior or bogatyr's helmet or an onion dome. A group of five small *bratiny* at the Museum of Fine Arts in Boston all bear a gilded inscription in Slavonic script: "Bratina of the Troitse-Sergieva Monastery" around the lip (fig.17).[14] Otherwise they are completely plain, although of different sizes and weight. The latter is significant because the silver weight is noted on the bottom, giving each a monetary value (fig. 17).

Bratiny often bore the name of the owner, but the Hillwood example (fig. 18) is inscribed simply: "Bratina of an Honest Man, Drink from it to your Health." An engraved design of interlaced leaves and vines forming a wide band around the rim separates the two segments of the inscription, formed of tightly packed and vertically fashioned Old Church Slavonic lettering known as *viaz*. This same decoration flows down onto the bowl of the *bratina*, but is contained within a strapwork pattern.[15] Many *bratiny* were decorated with an all-over low-relief foliate ornament like that found on the icon *oklad* in figure 12.

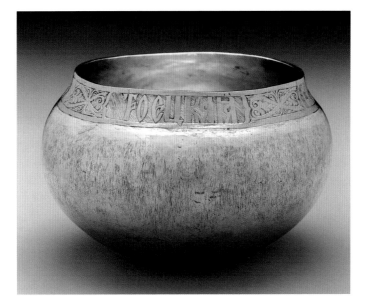

Fig. 17
Bratina
Russia, 17th century
Silver, parcel gilt
H. 2⅞ in. (7.3 cm.),
Dia. 3¾ in. (9.5 cm.)
Museum of Fine Arts, Boston.
Bequest of Thomas Whittemore.
53.1041

Mark of bratina, *see p. 216*

Fig. 18
Bratina
Russia, early 17th century
Silver gilt
H. 5½ in. (14 cm.),
Dia. 4⅞ in. (12 cm.)
Hillwood Museum purchase 1987
12.581

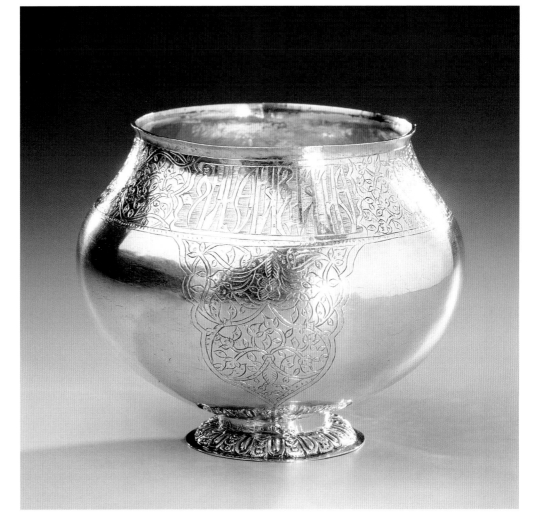

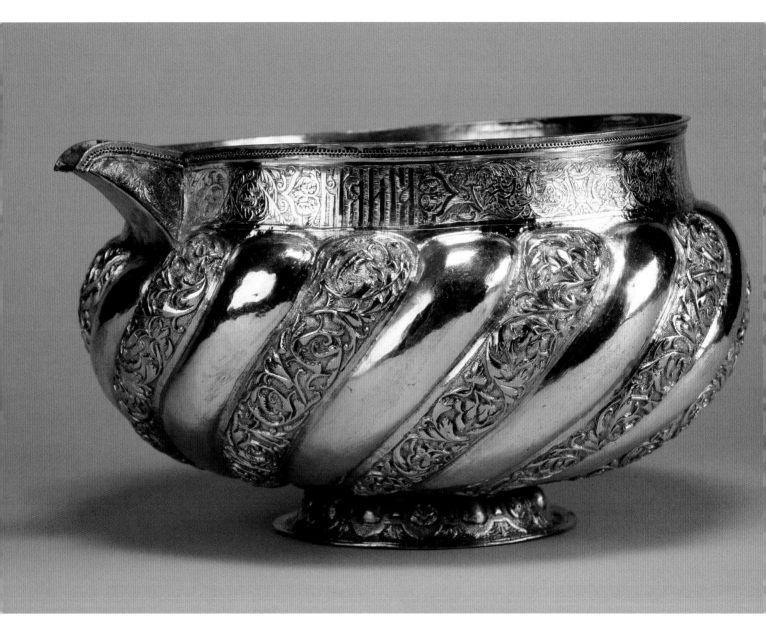

Fig. 19
Endova
Russia, 17th century
Silver, parcel gilt
H. 6 in. (15.1 cm.),
Dia. 10¼ in. (26 cm.)
The Walters Art Museum,
Baltimore. 57.794

The *endova* is a serving vessel, a fine example of which is owned by the Walters Art Museum in Baltimore (fig. 19). The *endova* is distinguished by a spout at one side for pouring drink into a smaller container. The silversmith designed this one with typical swirling gadrooning, in this case with alternating decorative and plain silver panels. A decorative inscription around the rim reads, "Bratina of Iakov Anikiev, son of Stroganov."[16] This *endova* obviously began life as a *bratina*. At some point in its history a cut was made in the rim and a spout with different ornament was soldered in place, thus changing the vessel from one for drinking to one for pouring.[17]

The shape of the *kovsh*, another drinking vessel, probably originated in Novgorod and is in the form of a Viking ship or a swimming bird. They were used for drinking or for ladling drink from a larger container. A *kovsh* on a foot is often called a *korchik* (fig. 20). The one shown here from the Walters Museum is made from a northern root wood with silver gilt mounts.[18] A lion and a unicorn appear in a medallion set onto the center of the bowl. On the top of the handle is a crouching lion with two birds on either side of the

Fig. 20
Kovsh *(Korchik)*
Russia, 17th century
Silver, parcel gilt, root wood
H. 4¼ in. (11 cm.)
The Walters Art Museum,
Baltimore. 57.795

Tree of Life where the handle turns down onto the bowl. This last image dates back to Kievan Rus', and is frequently found on enamels made in the twelfth century. According to the inscription the *kovsh* belonged to "Secretary Roman Arkhipov's wife Evdokia, daughter of Ivan."[19]

At the end of the seventeenth century, the *kovsh* was transformed from a drinking vessel into a gift for services rendered the state. Tsar Fedor III, son of Tsar Aleksei and older half-brother of Peter the Great, presented one such *kovsh* to the Ataman or Hetman of the Don Cossacks, Pozdei Stepanov, according to the inscription (fig. 21). It is the earliest of ten in the Hillwood collection. *Kovshi* were most frequently awarded to tax collectors or military retainers on the vulnerable borders of Russia. In the late seventeenth century there were political efforts to strengthen the southern border

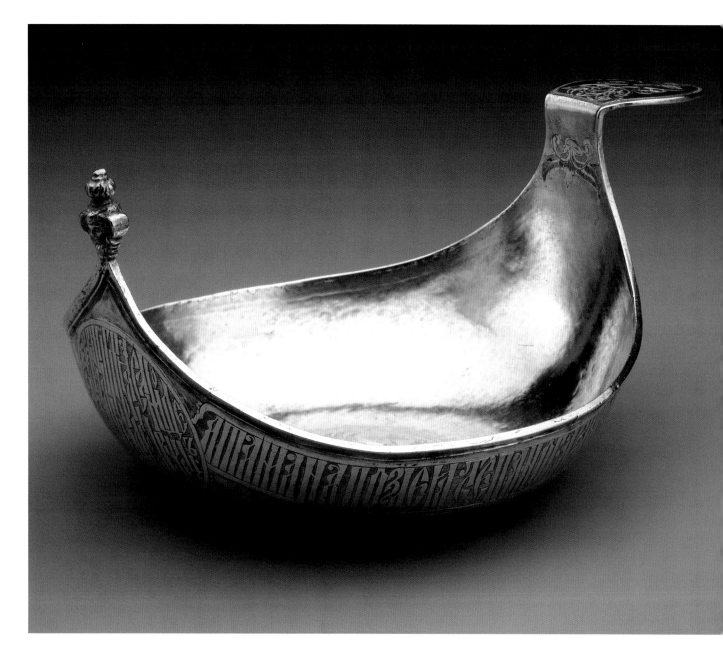

Fig. 21
Kovsh
Russia, ca. 1680
Silver, parcel gilt
L. 10 in. (25.4 cm.),
W. 7 in. (17.7 cm.)
12.57

resulting in the need to reward Cossack hetmen who served in this capacity.[20] Early *kovshi* like this one are hand-hammered out of a single sheet of silver. A cast knob at the tip features a cupid's face on either side. All of these presentation *kovshi* have inscriptions around the rim and usually an embossed or in this case an engraved double-headed eagle in the bottom.

The most common beverage served in *bratiny* and *kovshi* was mead, a honey drink flavored with raspberries, blackberries, cherries, or other fruits. These fruits also colored the mead. Red mead was served in a golden *kovsh*, white mead in a silver one.[21] Beer was also served, as was *braga*, an ale, and *kvass*, brewed from rye or black bread and malt, both mildly alcoholic drinks. All these beverages appear to have been known in Kievan Rus'.[22] Stronger drink was served in *charki*. Called wine tasters in English, these small, flat vessels, in the shape of a porringer, were intended for fortified (*krepkii*) wines (brandy or vodka), or aqua vitæ.[23]

There are three early *charki* at the Museum of Fine Arts in Boston, which like the *bratiny*, have as their only decoration the gilded inscription: "Charka of the Troitse-Sergieva Monastery" (fig. 22).[24] These *bratiny* and *charki* were most likely made in the monastery's workshops. According to Smith and Christian, the leading Western experts on Russian drinking culture, a meal in the sixteenth and seventeenth centuries started with bread and vodka. Jacques Mageret, who served in Russia's armies in the late sixteenth and early seventeenth centuries, described dining with the tsar, "Before the meat comes, aqua vitæ in large silver flasks is brought in and placed on the tables, with little cups for pouring and drinking. On these tables there is only bread and salt, vinegar, and pepper; no plates or napkins."[25] These *charki* seem to fit that purpose. The early eight-eenth century would see the introduction of *zakuski*, or cold hors d'oeuvres served with vodka, a course which became an un-dying feature of Russian dining.[26] Vodka appeared in Russia in the late fifteenth and early sixteenth centuries and was probably first drunk by foreign merchants.[27] Already at this time the *charka*

Fig. 22
Charka
Russia, 17th century
Silver, parcel gilt
Dia. 6⅛ in. (15.6 cm.)
Museum of Fine Arts, Boston.
Bequest of Thomas Whittemore.
RES.53.68

appears to have been used as a vodka measure of 143.5 ml., which was reduced to 123 ml. in the nineteenth century.[28]

Three other *charki* demonstrate different approaches to ornamentation in this transitional period between the seventeenth and eighteenth centuries. They also reveal the growing importance of print sources and the problem of how to transfer alien imagery onto traditional Russian shapes. One *charka* (fig. 23) has a handle decorated with a poorly defined image of Samson wrestling with the lion. This was a favorite subject in this period, symbolizing among other things courage, and probably related to Peter's struggle for power in the 1690s. Handles such as this one were cast separately and are rarely as finely made as the bowls to which they were attached. The bowl of the *charka* is fashioned in repoussé, in which the decoration has been hammered out to create the desired shapes. The *charka* has been partially enameled with animals, each identified, around the sides, including a lion and unicorn rampant, animals often viewed as protective beasts. These animals probably entered the Russian lexicon of symbols from Western heraldry. Sometimes *charki* like this included a cast bird or swan soldered so it stood upright on the bottom.[29]

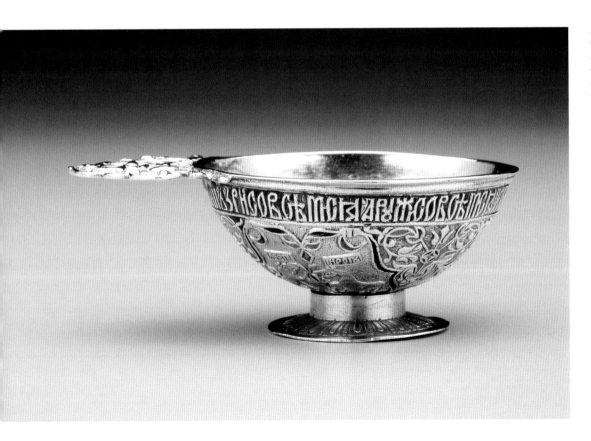

Fig. 23
Charka
Russia, late 17th century
Silver gilt, enamel
L. 3¾ in. (9.5 cm.),
Dia. of bowl 2¾ in. (7 cm.)
12.4

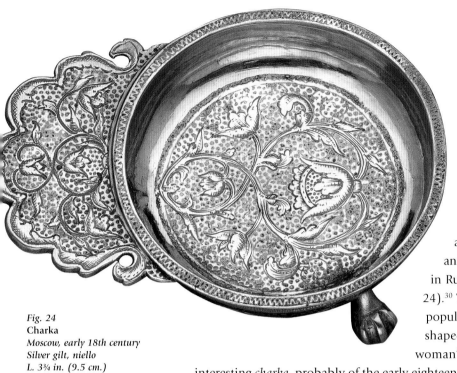

An engraved flower decoration on a ground of tightly spiraled leaf and vine ornament in niello on another *charka* reveals Turkish influence in Russian silverwork of this period (fig. 24).[30] This one—the style was particularly popular—is distinguished by its *kokoshnik*-shaped handle, that is, in the shape of a woman's headdress.[31] One particularly interesting *charka*, probably of the early eighteenth century, includes what appears to be a copy of a medal or a coin with a panoramic view of the city of Augsburg in the bottom (fig. 25) and the inscription URBS AUGSBURGAE.[32] While similar, though not

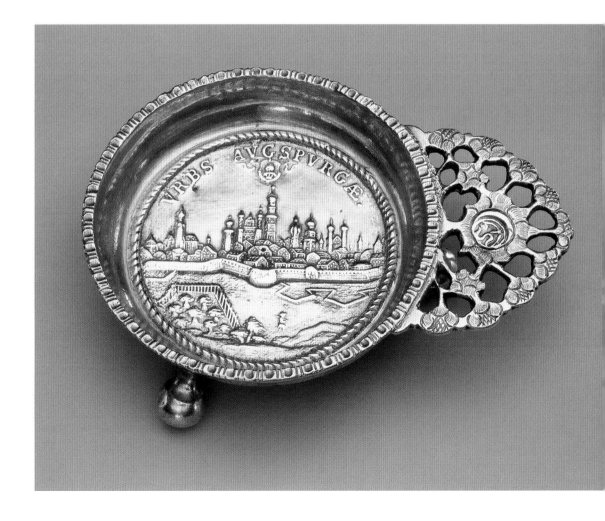

identical, views of Augsburg can be found on sixteenth- and seventeenth-century coins, none are the same and none include this inscription because Augsburg was a free city and designated "Augusta Vindelicorum."[33] It is possible that the image was copied from a print of Augsburg or that Russian artisans didn't know that URBS AUGSBURGAE was an inappropriate legend. This *charka*, one of two known, reveals the importance and widespread reputation of Augsburg as a silver center.

By the beginning of the eighteenth century the *bratina* and *kovsh* in their traditional forms had fallen out of use. Tall beakers began appearing in Russia at the end of the seventeenth century, inspired by those made in Germany. Increasingly Western imagery or decorative motifs are found on these cups. An eight-sided silver-gilt beaker dating from 1682–83, at the Hood Museum of Art at Dartmouth College, is decorated with the eight Sibyls (Cybeles), Grecian prophetesses who were thought to have foretold the birth of Christ (fig. 26). Each is identified with the Russian version of the geographic region from which she originated. For example, the inscription under one of the Sibyls, identified as "the third Sibyl Delfina" (from Delphi) proclaimed the "Virgin will be inspired by God, and God will take the image of man." Others have similar inscriptions. Each prophetic pronouncement appears below the figure, an organizing feature of the decoration. Each Sibyl is depicted in an engraved cartouche formed of delicate curls and crosshatching. Similar beakers can be found at the State Historical Museum in Moscow and at the State Hermitage.[34] The realistic flowers and birds and the allegorical figures all prefigure the enormous impact of baroque images in Russia in the first half of the eighteenth century.

In the last quarter of the seventeenth century there was a considerable increase in the number of wares decorated in niello, an alloy containing silver, copper, lead and sulfur. It is rubbed into an engraving on gold or silver to create a black-like background or to define the engraved design. Niello decoration goes back at least to the tenth century in ancient Kiev and was probably imported from Byzantium. By the twelfth century it can be found in northern cities. Although rarely used in the West after the Renaissance, silversmiths from Constantinople were working in the Kremlin Armory teaching niello techniques to Russian masters in the 1660s.[35] Only at the end of the seventeenth century do we see the dynamic combination of realistic fruits, flowers, and animals engraved and gilded on a niello ground, as a distinct Russian style. A plate (fig. 27), a beaker (fig. 28), a flask (fig. 29), and three cups on ball feet (fig. 30) all have such characteristics: fruits and flowers in bunches, linked with ribbons, some on thick, sturdy stems; on the plate a parrot sits in the foliage. Many of these fruits and flowers, like the pomegranates, carnations, poppies, and tulips, originated in the east, but probably came into Russian art via engravings from Holland or the Ukraine or on textiles imported for court use or received as gifts from Persia and Turkey.

OPPOSITE:
Fig. 26
Beaker depicting eight Sybils
Russia, 1682
Silver gilt
H. 9½ in. (24.1 cm.)
Hood Museum of Art, Dartmouth College, Hanover, New Hampshire.
Gift of Ralph Sylvester Bartlett, Class of 1889. 159.2.19461

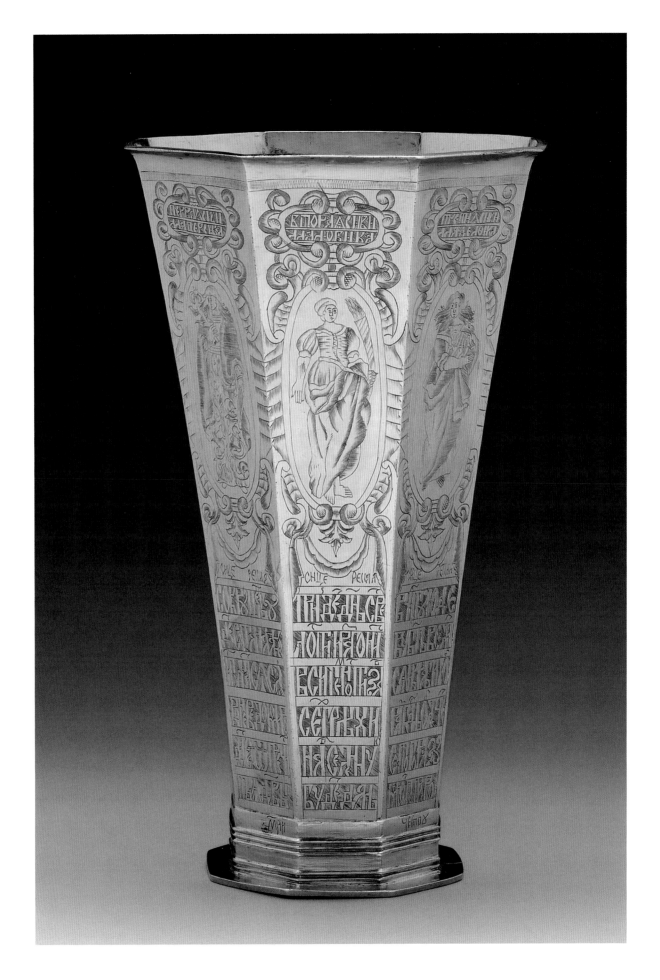

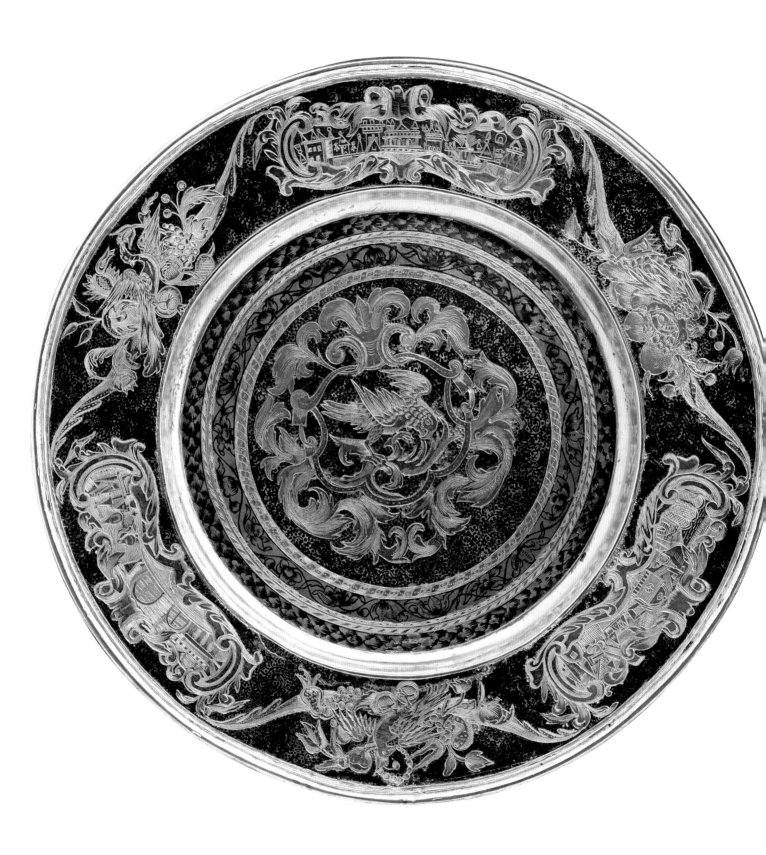

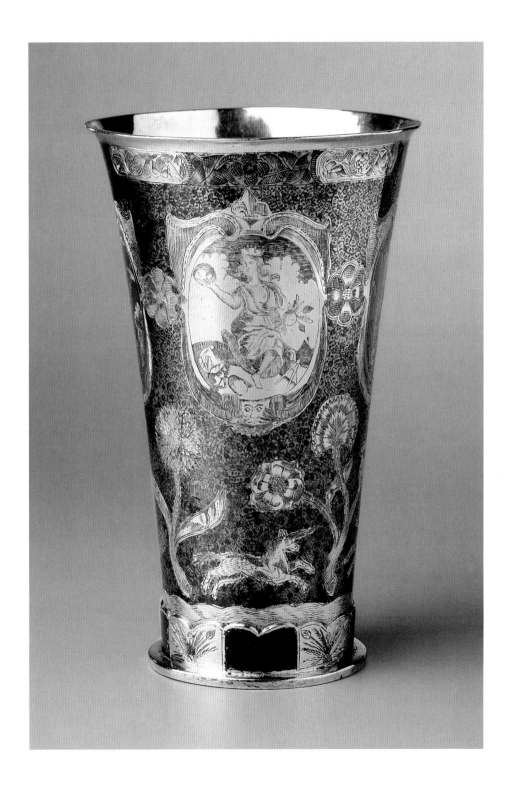

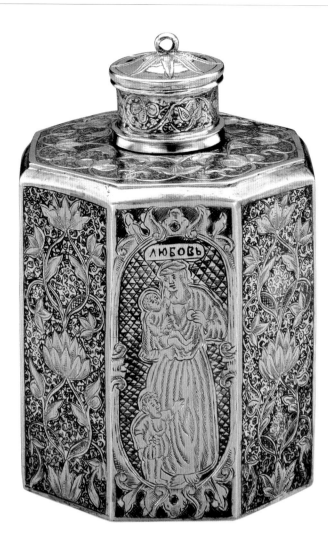

Fig. 29
Flask
Moscow, late 17th century.
Silver gilt, niello
H. 4¼ in. (10.8 cm.)
13.155.1–2

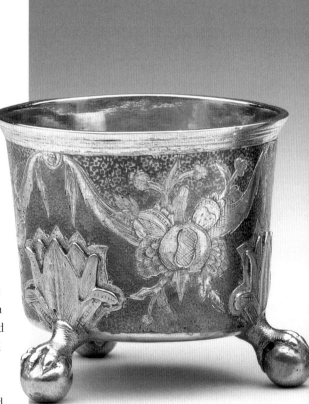

In addition to these familiar fruits, flowers, birds, and animals, there are baroque cartouches enclosing city views on the plate and female figures on the beaker, both taken from western engravings. The crosshatching used to define the women's drapery on the beaker reveals the influence of shading in western engraving. The four women may represent the four elements: earth, air, fire, and water. A unicorn and a stag run through a profusion of flowers—a tulip, carnation, and poppy—on one stem, or a bird perches beneath another tree-size flower. The background to these lively images is created by tiny spiraling leaf and vine ornament in niello. Appearing almost like black velvet from a distance, this design is clearly visible only with careful scrutiny (see p. 32). The effect of these gilded flora and fauna against the black background is striking. Trefoil leaves and chrysanthemums connected by vines decorate alternate panels of a flask (*chetvertina*) or perhaps a tea caddy. Figures representing Faith, Hope, Love, and Truth—each is identified—are engraved against a ground of tiny diamond shapes. The background niello ornament was typical of that found on Turkish weapons.

Fig. 30
Three cups on ball feet:
(left) Russia, 1777
Silver gilt, niello
H. 3⅛ in. (7.9 cm.)
13.11

(center) Russia, late 17th century
Silver gilt, niello
H. 2¾ in. (7 cm.)
13.13

(right) Russia, late 17th century
Silver gilt, niello
H. 3⅛ in. (7.9 cm.)
13.1

Just as Russia's distinctive style matured, incorporating all the influences in a coherent manner, Peter's Westernization policies shifted the focus so dramatically that anything that smacked of *Moskovskoe delo* was soon eliminated and replaced with tall standing cups and beakers based on models from the West, primarily from Augsburg, Nuremberg, Sweden and the Baltic states. Western imagery already in the second half of the seventeenth century preceded western forms, which did not start being copied in Russia until the next century.

This flowering of a composite Muscovite ornament in the last half of the seventeenth century formed the basis for the revival of the national style two hundred years later at the end of the nineteenth century. Shapes like the *bratina* and *kovsh* would be resurrected, and were often decorated with enamel by the leading silversmiths of the day. Even though much of the ornament had derived from Persian or Turkish origins, by the 1860s it was considered quintessentially Russian.

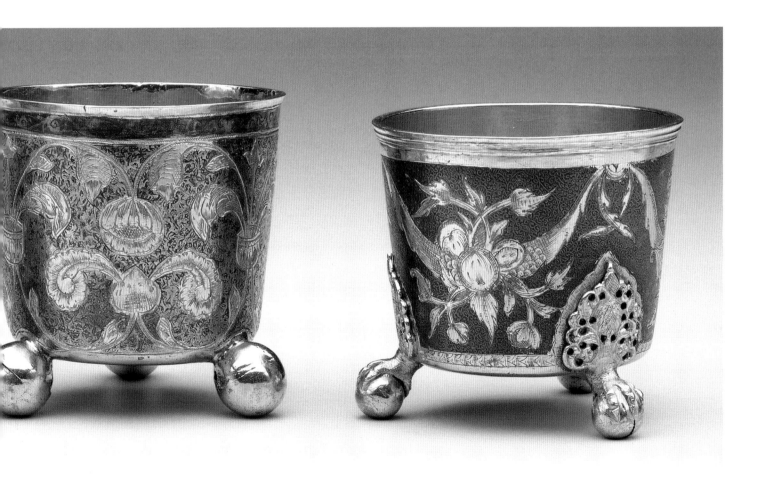

NOTES

1. I. A. Selezneva, *Zolotaia i serebrianaia palaty: Kremlevskie dvortsovye masterskie XVII veka* (Moscow: Drevlekhranilishche, 2001), 88, for Bogdan Khitrovo's search for silversmiths to come to Moscow for "eternal life."

2. V. Trutovskii, "Boiarin i oruzhenichii Bogdan Matveevich Khitrovo i Moskovskaia oruzheinaia palata," *Starye gody* (Jul.–Sept. 1909), 377.

3. For the role of trade and printed material in creating a desire to consume in England one hundred years earlier, see Linda Levy Peck, *Consuming Splendor: Society and Culture in Seventeenth-Century England* (Cambridge: Cambridge University Press, 2005).

4. The silversmiths in the silver rows and those in the Kremlin were known to each other and in fact they often worked together on a project, indicating that the quality was quite high in the silver rows as well. Postnikova-Loseva, "Prikladnoe iskusstvo XVI–XVII vv.," in *Istoriia russkogo iskustva* IV, ed. I. M. Grabar (Moscow: Akademiia Nauk, SSSR, 1959), 540.

5. These rows were located approximately where the present-day department store GUM is situated, and from GUM to the Moscow river.

6. I. D. Kostina, T. N. Muntian, and E. V. Shakurova, *Russkoe serebro, XVI–nachala XX veka* (St. Petersburg: Slaviia, 2004), 72. Also Alexander von Solodkoff, *Russian Gold and Silverwork* (New York: Rizzoli, 1981), 19–20.

7. Peter ordered Nevskii's remains to be transferred from Vladimir to St. Petersburg in 1723. Originally created for the Trinity Cathedral in the Aleksandr Nevskii Lavra in the 1740s, the sarcophagus, one of the truly monumental silver masterpieces, was transferred to the State Hermitage in 1922.

8. Philippa Glanville, ed., *Silver: History & Design* (New York: Harry N. Abrams, Inc., 1996), 16

9. For a discussion of the *oklad*, see Wendy R. Salmond, "The Art of the Oklad," in *The Post/Hillwood Studies* 3, no. 2 (Autumn 1996), 5–16. Also Wendy R. Salmond, *Tradition in Transition: Russian Icons in the Age of the Romanovs* (Washington, D.C.: Hillwood Museum & Gardens, 2004), 49 and Liubov Shitova, "Russkie okladnye ikony kontsa XVII–nachala XX veka," *Antikvariat: predmety iskusstva: kollektsionirovaniia*, 5, no. 17 (May 2004), 114–21.

10. See S. Ia. Kovarskaia, I. D. Kostina, and E. V. Shakurova, *Russkoe serebro XIV–nachala XX veka iz fondov gosudarstvennykh muzeev moskovskogo Kremlia* (Moscow: Sovetskaia Rossiia, 1984), no. 55 for a nearly identical censer.

11. James H. Billington, *The Icon and the Axe: An Interpretive History of Russian Culture* (New York: Vintage Books, 1970), 125.

12. According to a letter from Marina Postnikova-Loseva, former curator of silver at the State Historical Museum, to Marvin Ross. See correspondence in curatorial file 12.5.

13. R. E. F. Smith and David Christian, *Bread and Salt: A Social and Economic History of Food and Drink in Russia* (Cambridge: Cambridge University Press, 1984, 79. Heinrich von Staden describes *bratchiny* in *The Land and Government of Muscovy: A Sixteenth-Century Account*, trans. and ed. Thomas Esper (Stanford: Stanford University Press, 1967), 64–65. Because taverns were forbidden in villages during the reign of Ivan IV "good friends,… formed clubs and brewed beer and assembled with their wives on holidays. Such [a club] is called a *bratchina*." See also "Dekorativno-prikladnoe iskusstvo XV–XVII vekov," in O. M. Ioannisian, *Russkaia kul'tura XVI–XVIII vekov, ocherk – putovoditel'* (Leningrad: Iskusstvo, 1983), 45

14. See Larisa Spirina, "Kovshi, chashi, bratiny, charki…," in *Antikvariat*, 1–2, no. 44 (Jan.–Feb. 2007), 15 for other very similar *bratiny* from the same monastery.

15. *Bratiny* (and even *kovshi*) were also made in Hamburg for the Russian court and sometimes have Russian inscriptions. See M. N. Lopato, *Nemetskoe khudozhestvennoe serebro v Ermitazhe* (St. Petersburg: State Hermitage, 2002), 135 and 139 for examples.

16. For a very similar *endova*, dated 1644, from the Kremlin Armory Museum in Moscow, see *Czars: 400 Years of Imperial Grandeur* (Memphis: Wonders Memphis, 2002), 119. It is the only one in their collection, although historically they were supposed to be quite common.

17. This raises a problem. The only way to create an *endova*, would be such a cut, but its inscription designates it a *bratina*.

18. For a *kovsh* made of very similar wood with silver mounts, see *Zolotaia kladovaia Russkogo muzeia* (St. Petersburg: Palace Editions, 1998), no. 66.

19. I would like to thank Georgi Parpulov, formerly at the Walters Museum, for help with this inscription.

20. I. A. Selezneva, *Zolotaia i serebrianaia palaty*, 86.

21. Barry Shifman and Guy Walton, eds, *Gifts to the Tsars: Treasures from the Kremlin* (New York: Harry N. Abrams, Inc., 2001), 152.

22. As the bee population declined after the Mongol invasion, mead increasingly became an aristocratic drink; the common people drank beer or ale only on certain holidays. See Smith and Christian, *Bread and Salt*, 76.

23. Dr. Giles Fletcher, on an ambassadorial mission of 1588–89 from Queen Elizabeth I to Tsar Fedor Ivanovich, said aqua vitæ was what the Russians called "strong wine" or "Russian wine." Giles Fletcher, "Of the Russe Common Wealth," in Edward Bond, ed. *Russia at the Close of the Sixteenth Century* (New York: Burt Franklin, Publishers, 1969), 58. See also Carolyn Johnston Pouncy, ed. and trans., *Domstroi: Rules for Russian Households in the Time of Ivan the Terrible* (Ithaca, NY, and London: Cornell University Press, 1994), 157.

24. For a similar *charka* from the Percherskii Monastery in Kiev, see Christie's, London, June 9, 2009, lot 232. See also Iu. A. Olsuf'ev, *Opis' serebrianykh charok c ploskimi polkami i serebrianykh bratin v Troitse-Sergievoi Lavry* (Moscow (?): Komissii po khrane pamiatnikov iskusstva i stariny b. Troitse-Sergievoi Lavry, 1925) and Liubov' Shitova, "Serebrianye masterskie Troitse-Sergievoi Lavry," *Antikvariat* 9, no. 20 (Sept. 2004).

25. Jacques Mageret, *The Russian Empire and the Grand Duchy of Muscovy: a 17th Century French Account*, trans. and ed. Chester S. L. Dunning (Pittsburgh: University of Pittsburgh Press, 1983), 55.

26. Smith and Christian, *Bread and Salt*, 174.

27. William Pokhlebkin, *A History of Vodka*, trans. Renfrey Clarke (London and New York: Verso, 1992), 95–97.

28. K. Helenius, *Charka: The Silver Vodka Cup of the Romanov Era, 1613–1917* (Helsinki: Kustannus W. Hagelstam, 2006), 6.

29. See Alexander von Solodkoff, *Russian Gold and Silverwork* (New York: Rizzoli, 1981), fig. 2.

30. E. Korsh, "Russkoe serebrianoe delo XVII veka i ego ornamentatsiia," *Starye gody* (July–Sept. 1908), 421, and M. M. Postnikova-Loseva, N. G. Platonova, and B. L. Ul'ianova, *Russkoe chernevoe iskusstvo* (Moscow: Iskusstvo, 1972), 10.

31. There are at least six in the Kremlin Armory. See I. D. Kostina, *Proizvedeniia Moskovskikh serebrianikov pervoi poloviny XVIII veka* (Moscow, 2003), 107–11.

32. For an example in the Kremlin Armory, see ibid., 179.

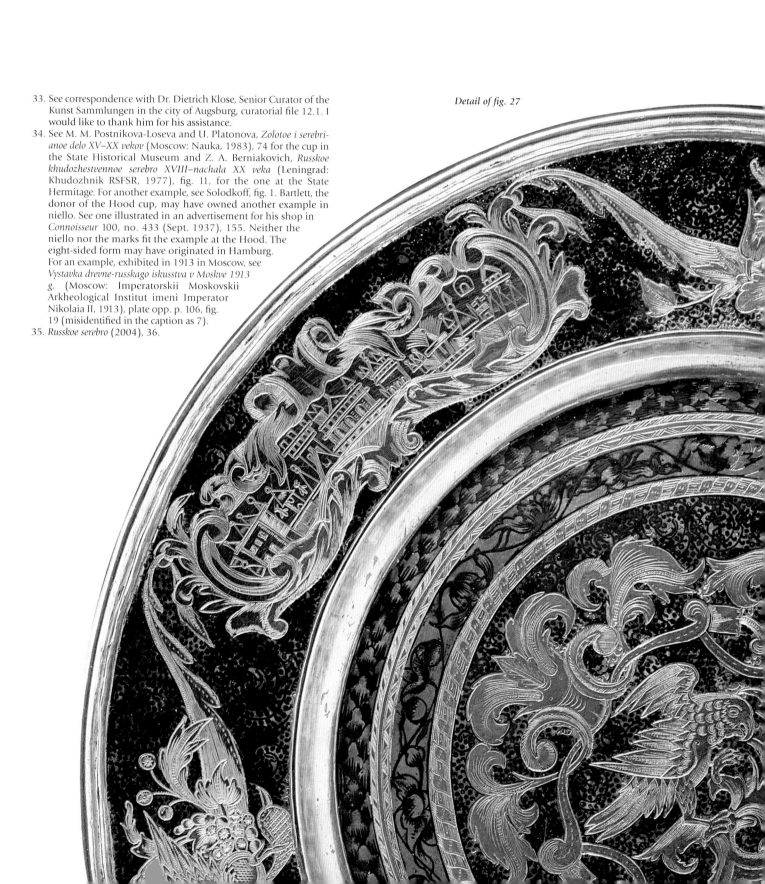

Detail of fig. 27

33. See correspondence with Dr. Dietrich Klose, Senior Curator of the Kunst Sammlungen in the city of Augsburg, curatorial file 12.1. I would like to thank him for his assistance.

34. See M. M. Postnikova-Loseva and U. Platonova, *Zolotoe i serebrianoe delo XV–XX vekov* (Moscow: Nauka, 1983), 74 for the cup in the State Historical Museum and Z. A. Berniakovich, *Russkoe khudozhestvennoe serebro XVIII–nachala XX veka* (Leningrad: Khudozhnik RSFSR, 1977), fig. 11, for the one at the State Hermitage. For another example, see Solodkoff, fig. 1. Bartlett, the donor of the Hood cup, may have owned another example in niello. See one illustrated in an advertisement for his shop in *Connoisseur* 100, no. 433 (Sept. 1937), 155. Neither the niello nor the marks fit the example at the Hood. The eight-sided form may have originated in Hamburg. For an example, exhibited in 1913 in Moscow, see *Vystavka drevne-russkago iskusstva v Moskve 1913 g.* (Moscow: Imperatorskii Moskovskii Arkheological Institut imeni Imperator Nikolaia II, 1913), plate opp. p. 106, fig. 19 (misidentified in the caption as 7).

35. *Russkoe serebro* (2004), 36.

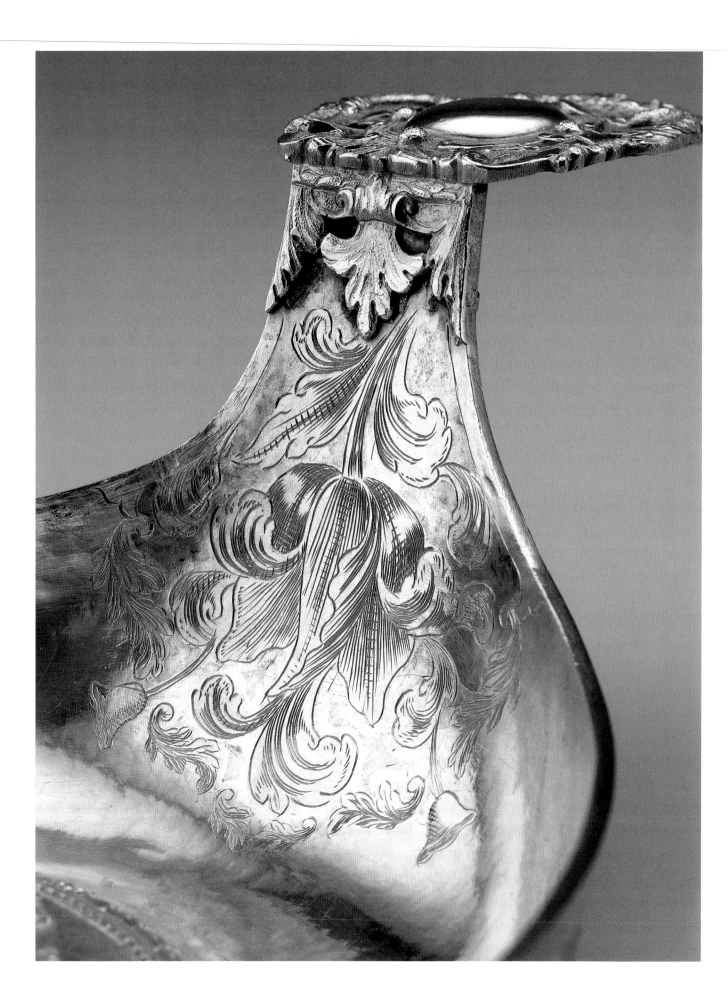

TRIUMPH OF THE BAROQUE:
PETER AND ELIZABETH

OPPOSITE:
Kovsh
Russia, 1700.
Detail of fig. 32.

PETER THE GREAT embarked on a celebrated two-year trip—the Grand Embassy—to Western Europe, spending extended periods in Holland and England in 1697 and 1698. He surely perceived for himself the dynamics of modernization in those countries and strived to emulate these successes at home. He founded his new city of St. Petersburg in 1703 on the Baltic Sea with its "window on Europe." While Peter wanted to learn about new technologies to strengthen his military, he also must have realized that to be taken seriously by Western nations, he would have to acquire all the baggage of modern eighteenth-century civilization: education, scientific inquiry, efficient government, the arts, theater, and literature. These are the assets needed for what Richard Wortman called "the theater of power," already cited, or what another author called "the theater of self-presentation."[1] These Western influences that were infiltrating Russia during the seventeenth century, as already discussed, now turned into a flood.

The path to modernization stalled the production of artistic silver in the early years of the eighteenth century, however, as Peter the Great concentrated on building a new city and fighting the Swedes. These activities, and earlier battles with the Turks, diverted the funds, which might otherwise have been available for luxuries. Peter instituted reforms in all aspects of Russian military, political, religious, and social life, and monetary reform was needed to finance these initiatives. The latter impacted silversmiths because the mint controlled silver for currency and for artistic wares.

When Peter closed the gold and silver workshops in the Kremlin in 1711 he sent some of the best masters to St. Petersburg, which formally became the new capital in 1712. This move reflects his effort to leave the Byzantine and Asiatic ways of Muscovite

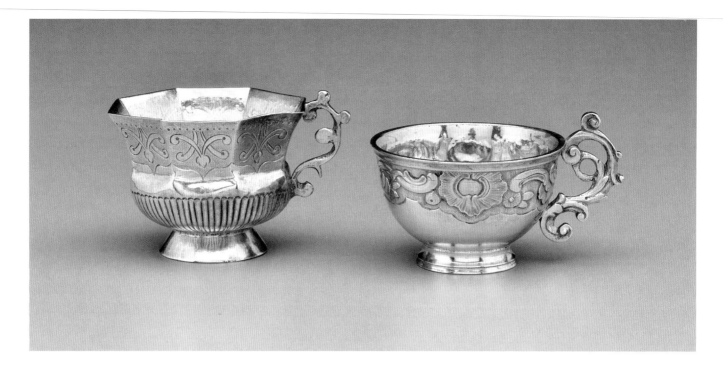

Russia far behind. V. K. Trutovskii, director of the Kremlin Armory at the beginning of the twentieth century, saw this act of Peter's as a disaster, carrying "with it to the grave the old traditions, originality, and uniqueness…the very spirit and sensitivity of the Russian artistic soul."[2] As part of his administrative reforms in 1721 and 1722, Peter divided the *posad* or urban middle-class population into two guilds (*gil'dy*). Silver and goldsmiths fell into the first, more desirable, guild together with bankers, doctors, wealthy merchants, ship captains, and icon painters. As J. Michael Hittle notes, citizens of the first guild could be described as "valued urban dwellers."[3] Each craft had to set up its own guild (*tsekh*) to manage its affairs. Already in 1714 foreign silversmiths working in the new capital organized a guild, which Peter confirmed in 1721, and in 1722 a Russian guild was formed both in Moscow and St. Petersburg. Similar guilds were also established in provincial centers.

Although based on West European models, the craft guilds in Russia had distinct differences: they were not compulsory; children could not inherit membership; nor did members necessarily receive any privileges in the market place. The guilds were more a governmental arm for tax collection than an organization designed to improve the quality of production.[4] Among the foreign masters in St. Petersburg there were more Germans than all other ethnic groups combined, and proceedings were conducted in German. Swedes formed the next largest group. Even after the institution of the guilds many masters refused to register and evaded marking their objects because of the taxes imposed. They were constantly tempted to produce wares in a metal alloy below the standard demanded by the assayer.[5]

There was no place for traditional national forms in Peter's Westernization program. Instead, new dining customs resulted in the need for tureens and wine bottle coolers. The new drinks, coffee and tea, demanded containers appropriate for serving them. Tankards and beakers from Germany, Scandinavia, and the Baltic countries appeared on the tables of Russia. At the same time the *bratina* and *endova* disappeared. The form of a *charka* changed from the flat porringer shape to that of a small demitasse cup with a handle (fig. 31). None of these changes came about abruptly, but evolved from the end of the seventeenth century through the first decade of the eighteenth century.

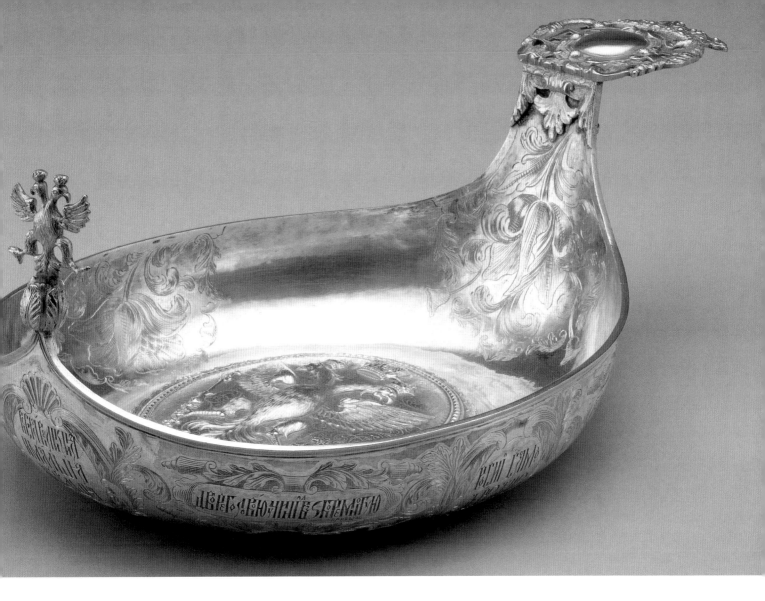

Fig. 32
Kovsh
Russia, 1700
Silver gilt
L. 14⅞ in. (37.9 cm.),
W. 8⅞ in. (22.5 cm.)
12.58

The *kovsh*, as we have seen, became a presentation award, and was no longer actually used for drinking in polite society. Wooden *kovshi* continued to be used for drinking by the peasantry, an early indication of the split of Russia into two societies, which no longer shared all the same customs. In the seventeenth century and before, the boyars may have used silver and the peasants wood, but both groups celebrated holidays and special occasions in much the same way. This is only one small example of the way in which the divide between the upper and lower classes began to be delineated.

Two *kovshi* from the reign of Peter, given as awards to tax collectors, reveal the monetary crisis Peter faced as he tried to raise money to finance his costly and long-term war with Sweden. Peter presented one to Ivan Mikliaev, the head of one of the merchant companies in charge of collecting taxes, for the profits he made in 1700, in this case from a licensed tavern (*Kruzhechnyi dvor*) in the Volga city of Kazan (fig. 32).[6] Such valuable awards made a great deal of sense when the revenue from liquor sales was about 11.4 percent of the budget income during the reign of Peter and increased by mid-century to 20 percent.[7] The inscription, as was typical, is spaced around the sides of the *kovsh* in cartouches bordered by especially delicate and fine engraving of leaf motifs, shells, and scrolls with large tulip blossoms along the inside (see p. 56). The applied handle is capped by a royal crown and has a plain cartouche in the center, possibly reserved for a never-applied monogram or a double-headed eagle as is found on Hillwood's other *kovsh* from the reign of Peter. With the cast double-headed eagle at the

tip of the *kovsh* and the sharp turn of the applied handle, the *kovsh* has acquired a more formal shape, which it retained for the rest of the century.

Little table silver remains from Peter's reign for the practical reasons noted above. However, Peter clearly understood the need for entertaining in the grand manner and was known to have commissioned silver and gold table services, toilet services, and other luxuries from German masters, especially from Augsburg. Unfortunately few of these have survived.[8] In 1711 he is known to have commissioned the Kremlin Armory to make a silver service for twenty-four persons, stipulating that it should be "plain and without decoration or gilding."[9] Peter's chief lieutenant, Aleksandr Menshikov, who had gone to Holland with him on the Great Embassy, assembled a remarkable collection of silver, much of it from Holland, but also three table services made in London, Hamburg, and Augsburg.[10] Just as the Grand Tour in Western Europe opened the eyes of the elites and increased demand for luxury articles, the Grand Embassy did the same for Peter and his followers.

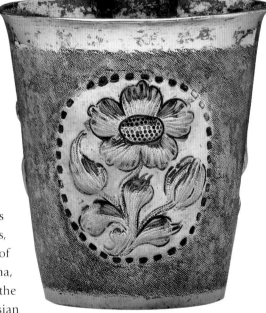

Fig. 33
Cup
Moscow, 1695
Silver, parcel gilt
H. 3¼ in. (8.4 cm.),
Dia. 3¼ in. (8.2 cm.)
Hood Museum of Art, Dartmouth
College, Hanover, New Hampshire.
Gift of Ralph Sylvester Bartlett,
Class of 1889. 159.2.22418

At the tables of the grandees during the first decades of the eighteenth century, small beakers must have been used for beer or mead, and were produced in large quantities, many with almost the same decoration (fig. 33). Unlike those of a slightly later period, which are decorated with overall scrolls, flowers, leaves, and eagles, these have a single gilded flower with its leaves set in an oval on three sides. The petals of the flower and leaves are smoothly polished and thus highlighted against a stippled ground.[11]

Peter's wife, Catherine I, became empress for two years following Peter's death in 1725. She continued his practices, and there was no change stylistically during the brief rule of Peter II and Ivan VI. When Peter's niece, Anna Ioannovna, came to the throne in a coup in 1730, we begin to see the enormous influence of German and Baltic styles on Russian silver. This no doubt reflected the tastes of Anna's favorite, Ernst Johann Biron from Courland (now Latvia); his banker Isaak Liebman was the supplier of the Augsburg services.[12]

A coffee pot (fig. 34) made for Empress Anna is one of the few remaining examples of Russian tableware from this early period, especially in America. It makes for an interesting comparison with the seventeenth-century wares already discussed and demonstrates the difference in form and ornament brought about by Westernization. In 1735 Anna commissioned the French/German (he is called both) silversmith,

OPPOSITE:
Fig. 34
Coffee pot
St. Petersburg, 1735
Nikolai Don or Dom (Nicholaus
Dohm, active 1714–48)
Silver gilt, wood
H. 9⅜ in. (24 cm.)
12.10

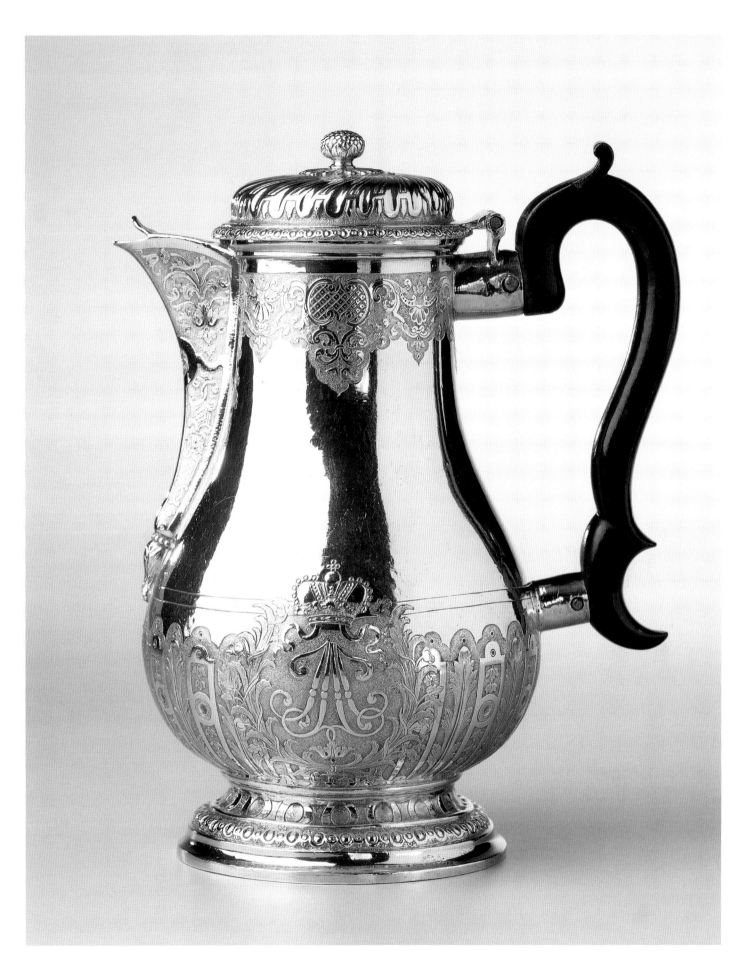

Fig. 35
Box for seal and grant of nobility
Moscow, 1746
Silver gilt, wax, fabric, cord,
parchment, leather, paper
Dia. of box 5¼ in. (13.3 cm.)
57.1

Nikolai Dom or Don (Nicolaus Dohm, active 1714–48), to make a dessert service, known as Dessert (*Nakhtishnyi*) Service I, from which no known pieces remain.[13] Nikolai Dom was one of the first recorded foreign silversmiths in St. Petersburg. He was among those who established the foreign guild in 1714, and when the guild was officially recognized by Peter in 1722, he was an assistant alderman.[14]

The Hillwood coffee pot, apparently from another service, shares both its pear-shaped form and ornament with European silver of the same period, referred to in Russia as "Regency."[15] The coffee pot's neck is enlivened with a polylobed band ornamented with shells, foliage, and a lattice medallion on a stippled ground. Some of these motifs are repeated on the spout. Chased acanthus leaves alternate with distinctive plain vertical bands on the lower section of the pot. On one side, at the lower bulge in a medallion framed in a chased wreath of leaves, appears the crowned monogram of Empress Anna. Similar decoration can be found on the gold service that two Augsburg goldsmiths, Johann Ludwig II Biller and Johann Jakob Wald, made for Anna between 1736 and 1740.[16] Little of his work has survived, making this coffee pot an exceptionally rare piece.[17]

Much more silver and of a much greater variety remains from the period of Elizabeth I. Although it is primarily secular, silversmiths certainly produced a great quantity of presentation objects and church plate. Numerous seal boxes accompanying grants of nobility conferred on deserving citizens are still extant. Peter had begun the policy of ennobling servitors in order to bring new blood into the nobility. One of three grants or patents of nobility at Hillwood, this one has its original brocade covers

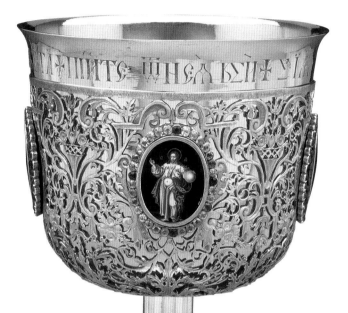

*Fig. 36
Chalice
Russia, 1740s
Silver, parcel gilt,
painted enamel,
paste stones
H. 11⅝ in. (29.5 cm.),
Dia. of cup 5½ in.
(14 cm.), Dia. of base
6⅞ in. (17.5 cm.)
12.89*

and cord attached to a gilded silver box containing the wax seal (fig. 35). It is decorated, as they all are, with the imperial coat-of-arms, the double-headed eagle holding the orb and scepter in its talons. St. George slaying the dragon is portrayed in a medallion on its breast, encircled by the Chain of St. Andrew, Russia's oldest and highest order. The imperial crown of Elizabeth tops the heads of the eagles. The empress presented this grant to "Captain Filat Anikiev, son of Kludenov, on 25 November 1751." From the date of the box, 1746, and that of the grant five years later, it is obvious that such boxes were made ahead of time and kept ready for the appropriate occasion.

Silversmiths continued to rely on the church as a major patron. Russian chalices of the mid-eighteenth century remain quite traditional in form (fig. 36). From the beginning of the century they were often decorated with a cast and hammered silver cage enclosing a gilded bowl and foot. The cage is decorated with baskets of flowers and baroque scrollwork and swags (see detail). In the Hillwood example of the 1740s, four enamel medallions depicting the Deësis and the Crucifixion are attached to the cage, and four medallions of the scenes from the Passion of Christ decorate the foot. Such enamels were made by specialists in painted enamels, who supplied them to the silversmiths.

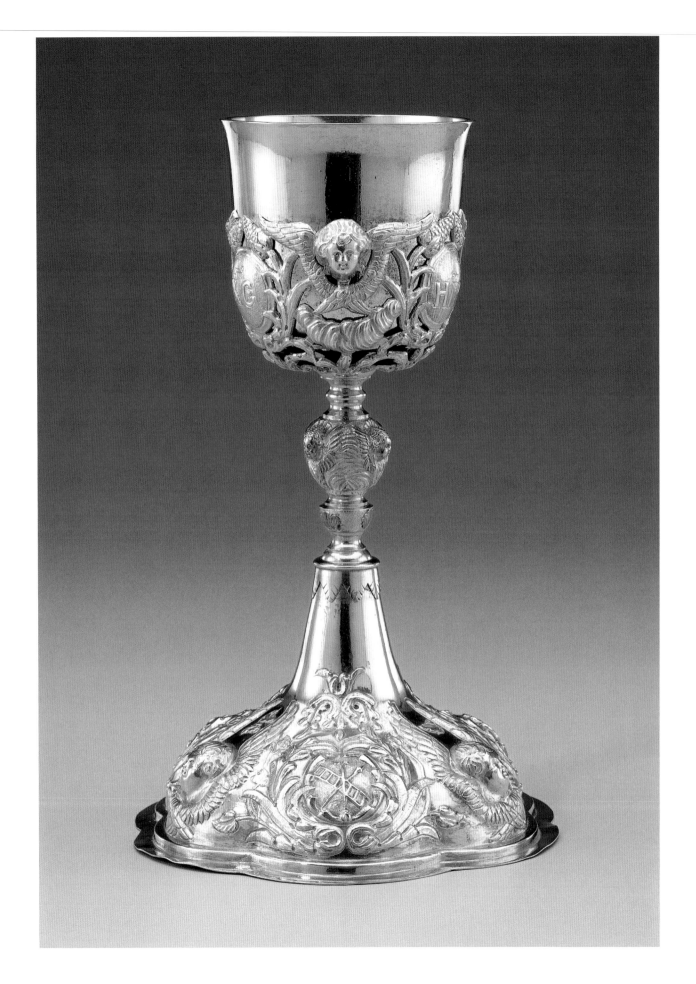

The basket supporting the gilded cup on another chalice (fig. 37) is also openwork, but of a more pictorial nature with three winged cherubim separated by branches and small medallions and the Cyrillic initials for Jesus Christ, the Conqueror. These cherubim are repeated on the knop and also on the wide base. Given other examples in Belarusian museums, it would appear that this chalice might have been made in the mid-eighteenth century in Poland, which became a part of Russia as a result of the first and second partitions of Poland in 1775 and 1793 respectively.[18]

What really marks the difference with the seventeenth century, however, is the huge preponderance of secular drinking vessels. Wine, beer, or *kvass* were always served with celebratory meals. Wine would have been consumed from the footed goblets, especially for toasts. The guests drank *kvass* or beer from small tumblers. All these vessels vary considerably in type and complexity of execution. A cup from the reign of Anna with portrait busts of Peter I, Peter II, and Anna is in the Metropolitan Museum of Art (fig. 38). It, like the chalice above, is also decorated with a baroque pierced cage of leaves. According to its inscription, the Moscow merchant Anton Posnikov ordered it made on August 3, 1737 and bestowed it on the Empress Anna. In a rare inscription on the base of the cup, it is noted that the peasant Vasilii Nikiforov of the village of Pokrovskoe made the cup. Both its lid and base are decorated with an openwork cage giving a sculptural quality to the decoration.

Another small standing cup with a lid (fig. 39) is similar in construction, although the ornamentation on both the lid and base are repoussé with chasing. The finial on the lid is a cast and chased double-headed eagle. It sits on a thin piece of silver that has been cut at the edges, forming strips and then curled like ribbons on a present. The same decoration reappears where the bowl of the cup meets the short stem. Three medallions, probably of Peter I, Peter II, and Catherine I, are set into the basket. The punched portraits are quite crudely delineated, making identification difficult.

Even as Peter created his new capital in St. Petersburg, Moscow, where tastes were more conservative and stylistic changes slower to take

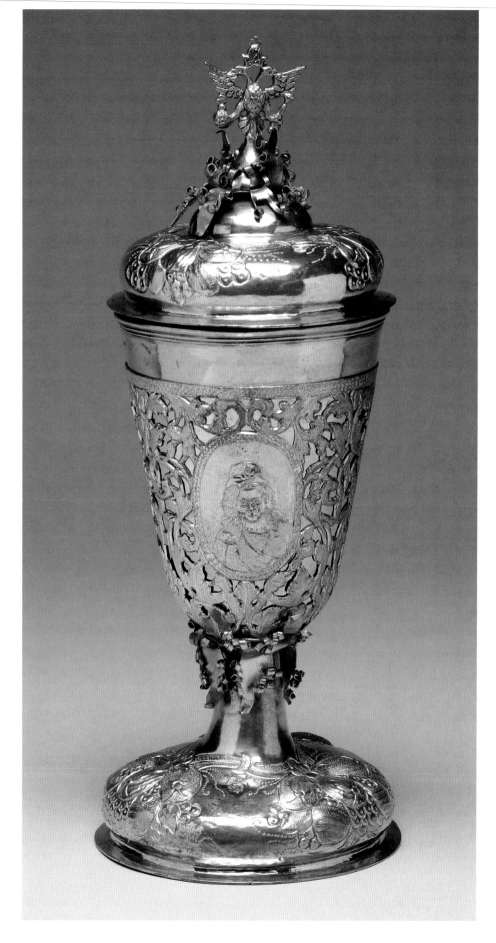

Fig. 39
Covered cup
Moscow, 1745
Silver, parcel gilt
H. with cover 8½ in. (21.5 cm.)
The Walters Art Museum,
Baltimore. 57.807

effect, remained the center of silver production right down to the time of the Russian Revolution in 1917. In the seventeenth and eighteenth centuries provincial centers tended to copy the fashion of Moscow, and so, if unmarked, their pieces are often difficult to distinguish stylistically. Fine tablewares in the eighteenth century, like the coffee pot by Dom, or dowry services made in the nineteenth century were mostly produced in St. Petersburg, often by foreign workmasters. The huge bulk of more commonplace beakers and tankards in the eighteenth century and tablewares and flatware for the gentry and merchants in the nineteenth century, however, were made in Moscow. A higher number of foreign workmasters lived in St. Petersburg than in Moscow, but the number of silversmiths overall was much higher in Moscow and their labor was less expensive.

Characteristic of Russian baroque silver is a surface saturated with a proliferation of realistic flowers, especially large tulip blossoms on the verge of decay, animals, and birds, entwined in or framed by a floral ornament, giving way to acanthus leaves by mid-century. In the late seventeenth century these images are quite flat, but as the eighteenth century progressed, they become more sculptural and three-dimensional. As the rococo began to dominate toward mid-century, stylized shells, scrolls, and the decorative use of punches in various patterns often form the overall pattern or separate pictorial medallions.

The beaker, both tall (*stopa*) and small (*stakan*) is the most ubiquitous form of Russian silver for most of the eighteenth century. There are numerous examples in the Hillwood collection and in America in general, to say nothing of the number in Russian collections. The sheer volume speaks to their widespread use in the first half of the eighteenth century, as all the nobility followed the lead of the court. They are most interesting for the variety of decoration, with different patterns being repeated many times. Symbols, emblems, and allegorical references recur again and again. Many of these derived specifically from a book entitled *Symbols and Emblems* (*Symbola et Emblemata*).

In 1705 Peter the Great ordered this handbook of devices to be published in Amsterdam with Russian translations of the emblems added to those in other languages. It included 840 engraved vignettes, originally compiled by Daniel de La Feuille (ca. 1640–1709). Peter's original intent was to provide symbolic designations to his new regiments and the ships in his new navy for use on their flags.[19] This handbook was widely disseminated in Russia, where artisans rendered the subjects quite freely, and sometimes left out critical details needed to accurately identify the moral message. This is not surprising given that most of the silversmiths were illiterate and quite likely would have not fully understood what they were copying. In the fall of 1721, after signing the Treaty of Nystatt recognizing Russia's victory over Sweden in the Great Northern War, the Senate declared Peter emperor of all the Russias for his

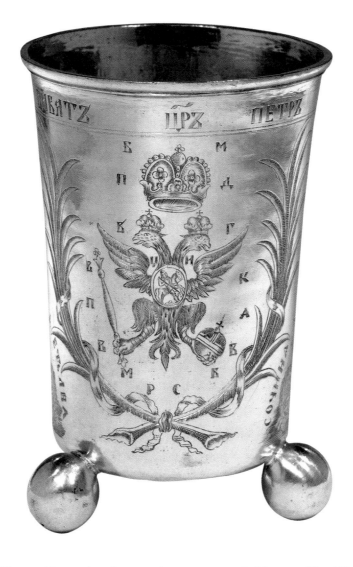

Fig. 40
Coronation cup, celebrating
Peter I as emperor
Moscow, 1721
Silver gilt
H. 6⅛ in. (15.7 cm.)
The Metropolitan Museum of Art.
Bequest of Vladimir M. Eitinggon,
in memory of his wife, Nadine
Eitinggon,1982. 1983.183.6

service to the state. Silversmiths produced coronation cups to mark this event (fig. 40). On the front side the double-headed eagle under three crowns is surrounded by the first letters of Peter's full title: "By the Grace of God, most enlightened and all-powerful Supreme Sovereign, Tsar and Grand Duke, Peter Alekseevich of All Great, Small, and White Russia, Autocrat," a designation Peter used already in the seventeenth century. On either side of the eagle, small vignettes depict Cupid riding the lion with reins in his hand ("I make a lamb of him"), a constant reference to Peter's defeat of Sweden.[20] On the back of the cup is an image of Samson splitting open the jaws of the lion. This image probably comes from another source, the illustrated Bible by the Dutch publisher and engraver Nicholaus Johannes Piscator (1586–1652). This so-called Piscator Bible was published in Russia in the 1670s.[21]

Another lion, holding the scepter, is very simple, although the lion has acquired a lavish mane (fig. 41). Here the symbolic message: "Who is to take it from me?" (fig. 42) was certainly appropriate for a ruler, like Elizabeth, who had come to the throne in a coup.[22] Ganymede, a mythological figure who was carried up to Olympus on the eagle of Zeus to be the cupbearer of the gods, is on the beaker on the right in figure 43. The message is: "He aims at higher things." The baldachin, or canopy, over this image of Ganymede seems to have been a particularly popular type and is found on numerous

Fig. 41
Beaker
Moscow, ca. 1752
Timofei Filippov Siluianov
(b. 1736, active 1752–1802)
Silver
H. 7³⁄₈ in. (18.8 cm.)
12.46

Fig. 42
Page from Symbola et
Emblemata *(Amsterdam, 1705).*
*The Library of Congress,
Washington, D.C.*

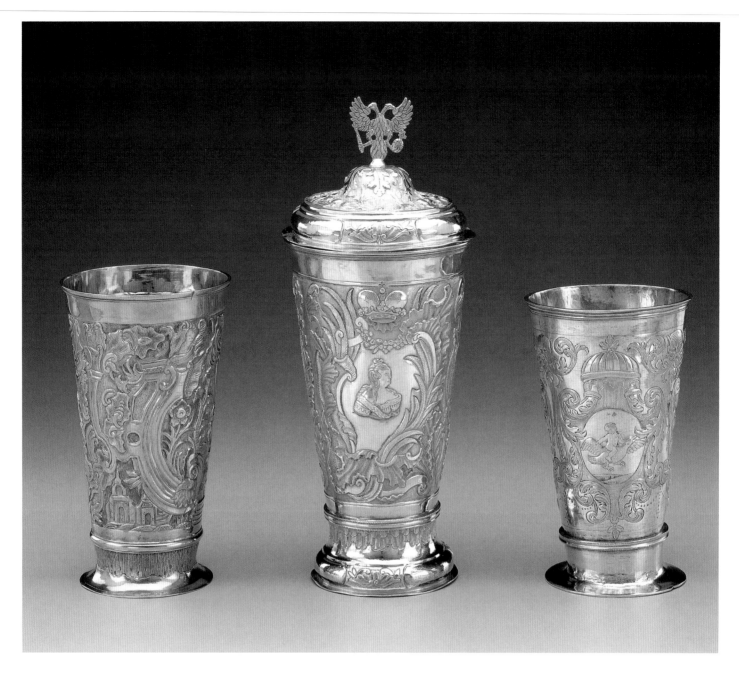

Fig. 43
Three beakers:
(left) Moscow, 1750s
Gavrila Grigor'ev Serebrennikov (b. 1718, active 1750s)
Silver, parcel gilt
H. 7½ in. (19.2 cm.), Dia. 4⅜ in. (11.2 cm.)
12.41

(center) Beaker with cover
Moscow, 1750
Silver
H. 12¼ in. (31.3 cm.), Dia. 4⅞ in. (12.5 cm.)
12.16.1–2

(right) Moscow, 1751
Andrei Kostrinskii (active 1739–76)
Silver
H. 7⅛ in. (18.1 cm.)
12.42

beakers. In figure 44, two small beakers are decorated with eagles with widespread wings. Eagles are featured in numerous devices in *Symbols and Emblems*, but it is difficult to pinpoint which one for certain these might represent. They are inscribed with morals like: "He keeps his enemies down," or "Without fear."[23] Birds sitting on a branch of a tree are also common, both on beakers and in *Symbols*. Their sayings are "My love lasts after death," or "I sing only to complain." Even in *Symbols* it is difficult to see the differences between the devices. The falcon on the beaker on the far right in figure 44, pecking at his claw, bears the message, "His noise is hurtful to him." These devices were also widely used on ivory boxes and pewter tableware.[24]

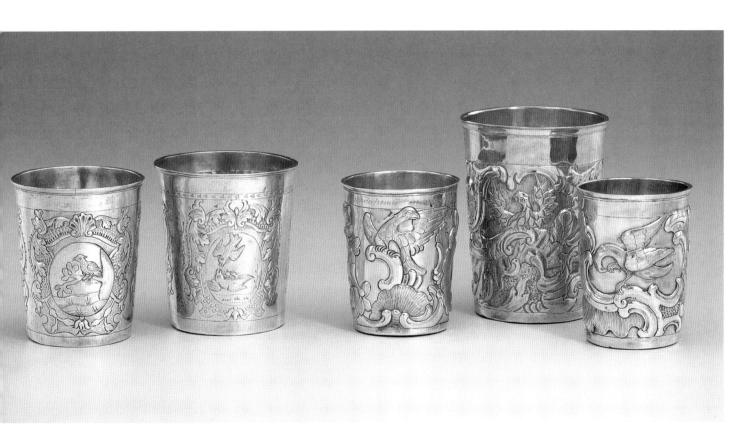

Fig. 44
Five small beakers, from left:

Moscow, 1745	*Moscow, late 1730s*	*Moscow, 1770s*	*Moscow, 1760*	*Moscow, 1774*
Mikhail Maksimov Kliushin	*Iakov Grigor'ev (?)*	*T S T, unidentified maker*	*Gavrila Gavrilov Zon*	*Andrei Dement'ev (?)*
(?) (active 1741–55)	*(active 1706–40)*	*(active 1770s)*	*(active 1743–62)*	*(active 1743–93)*
Silver	*Silver*	*Silver*	*Silver*	*Silver*
H. 3¼ in. (8.3 cm.)	*H. 3⅜ in. (8.6 cm.)*	*H. 3 in. (7.6 cm.)*	*H. 4⅛ in. (10.3 cm.)*	*H. 3⅛ in. (7.9 cm.)*
12.13	*12.33*	*12.40*	*12.26*	*12.34*

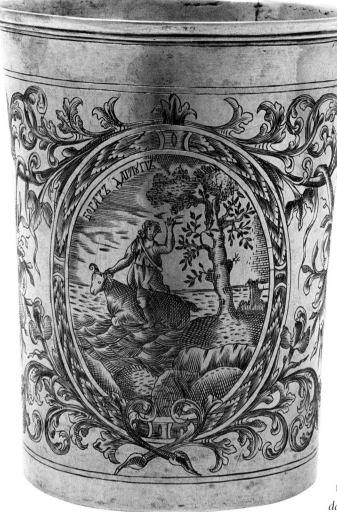

On a large beaker in the Metropolitan Museum (fig. 45), much more detailed images are featured. One is similar to the Rape of Europa, a woman riding the bull across the sea, but in this case she is riding a ram. On the medallion is the inscription *"Bogat da glup"* or "Rich but a fool," taken verbatim from *Symbols* (fig. 46). On the other side is a cupid fishing, while a bird overhead looks on with outstretched wings.

Fig. 45
*Cup with a woman riding a ram
Russia, first half of the 18th
century
T K for unidentified maker
Silver
H. 5¾ in. (14.6 cm.),
Dia. 4¾ in. (12.1 cm.)
The Metropolitan Museum of Art.
Bequest of Alphonso T. Clearwater,
1933. 33.120.71*

Fig. 46
Device from Symbola et
Emblemata *(Amsterdam, 1705).
The Library of Congress,
Washington, D.C.*

More rarely beakers display portraits of Roman emperors wearing laurel wreaths in oval medallions, sometimes quite crudely rendered (fig. 47). They are not identified on this example, but on a tankard in the Kremlin Armory Museum they turn out to be those known for their progressive rule.[25] These may reveal a growing awareness of early Western rulers and a desire to equate the power of Russia with that of Rome.

Floral arrangements of realistically embossed flowers, with their vines and leaves or acanthus leaves encircling them continued to decorate many beakers. Abstract ornament began to appear in the 1750s with stylized flowers and shell shapes, volutes and complicated scrolls, as on the left in figure 43 above and in figure 48. Restraint and flatness gave way to more sculptural ornament. These designs are quite elaborate examples of fine embossing and chasing used together to flood the surface with both pattern and movement. The silversmith who created the tankard employed a full vocabulary of ornament using various punches to create a fish-scale pattern, a rough, uneven stippling, and tiny circles in vertical lines (see detail on p. 74).

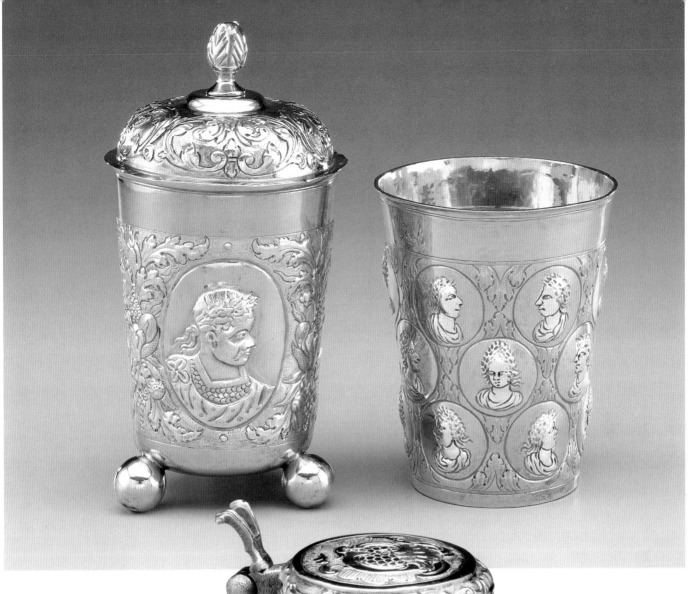

ABOVE: *Fig. 47*
Covered cup
Moscow, 1740s
Il'ia Ivanov Sliuniai (b. 1718,
active late 1730s and 1740s)
Silver, parcel gilt
H. 7⅜ in. (18.9 cm.),
W. 3½ in. (8.9 cm.)
12.8.1–2

Beaker
Moscow, 1738
Erofei Semenev (active 1736–74)
Silver, parcel gilt
H. 4⅞ in. (12.5 cm.),
W. 4 in. (10.2 cm.)
12.11

LEFT: *Fig. 48*
Tankard
Moscow, 1756
Pëtr Semenov (active 1739–77)
Silver, parcel gilt
H. 6½ in. (16.5 cm.)
12.20

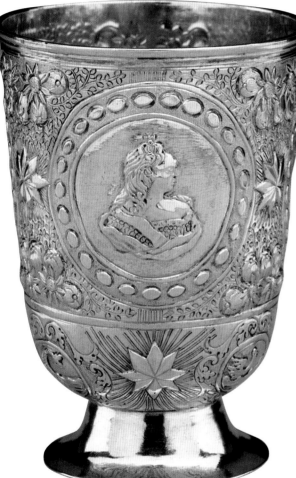

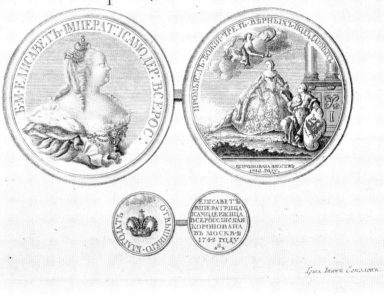

No. 34. Коронаціонные Медали и жалюны.

Many of these eighteenth-century beakers were presentation gifts from the empress to worthy citizens who had performed services for the state or gifts to diplomats and other foreign guests, whom the ruler wished to honor. There are numerous examples from Elizabeth's reign incorporating her portrait. The profile bust of Elizabeth on a tall beaker in the center of figure 43 and on figure 49 is taken from her image on the medal she ordered struck in 1742 for her coronation (fig. 50). Such portraits are also found on glass goblets of the period. Many beakers featuring Elizabeth's portrait, such as the one in figure 43, also include portraits of Peter and Catherine I, Elizabeth's father and mother, with whom she wished to link herself politically.

Military victories were occasions for celebration, and tributes to these victories often persisted long after the event. Two examples in the Hillwood collection are connected to the Russian defeat of Sweden in the second Russo-Swedish War of 1741–43. This war was already in progress when Elizabeth came to the throne. With her accession the Swedes believed, with the encouragement of their French allies, that Elizabeth would

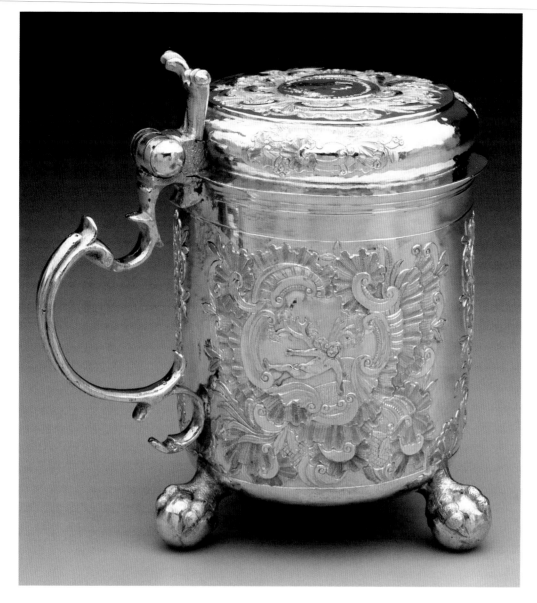

Fig. 51
Tankard
Moscow, 1751
Ia Ia for unidentified maker
Silver, parcel gilt
H. 6⅜ in. (16.9 cm.),
W. 6½ in. (16.5 cm.)
12.17

OPPOSITE:
Medal on tankard.
Detail of fig. 51.

make concessions in order to end the conflict. Both France and Sweden hoped to push back some of the territorial gains made by Peter the Great, and certainly intended to discourage any further advances. Elizabeth surprised the negotiators by not giving way. She was determined to hold onto those territories along the Baltic that her father had secured during the Great Northern War, which ended in 1721.

In 1743 she signed a treaty at Åbo, in present-day Finland, that was favorable to Russia, allowing her to retain all lands held before the conflict started.[26] To celebrate the occasion a commemorative medal was struck with a portrait bust of Elizabeth on one side and on the reverse an inscription part of which reads: "In commemoration of a long-lasting peace treaty with Sweden signed in Abo on 7 August 1743" (fig. 50). Although unsigned, the medal is believed to be by the Scotsman Benjamin Scott.[27] The medal has been inserted into the lid of a tankard (fig. 51) that was presumably a presentation gift in 1751, eight years after the event. In addition to the bust of Elizabeth, two other images chased in medallions framed by rococo curls and stylized shell shapes decorate the tankard. One is a profile portrait of Peter—a reference that Elizabeth was preserving her father's accomplishments. The other is of a young male reclining on the ground.

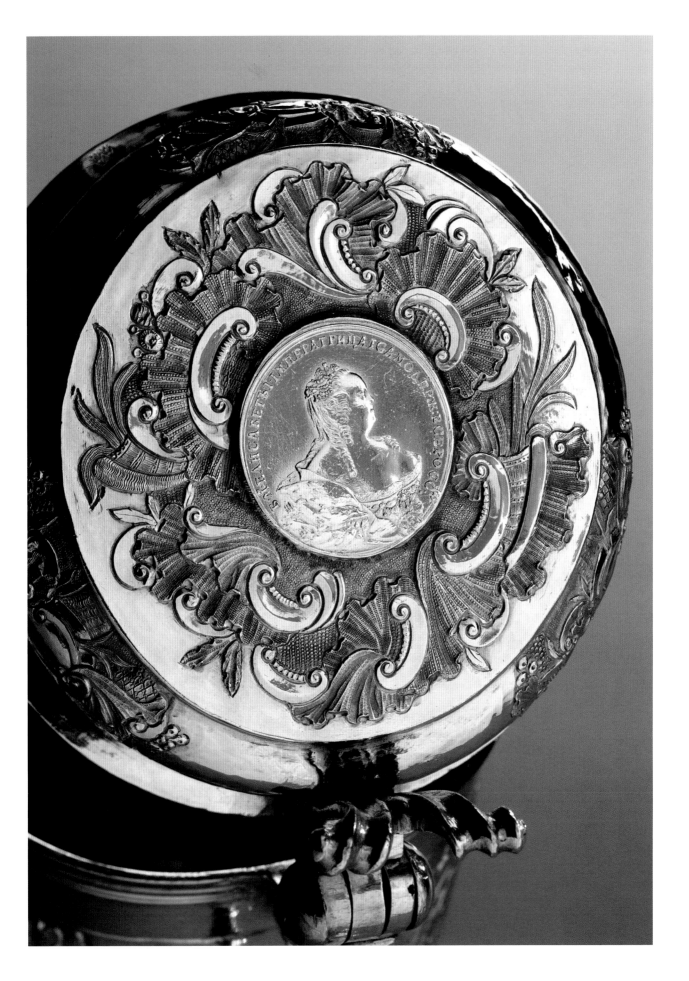

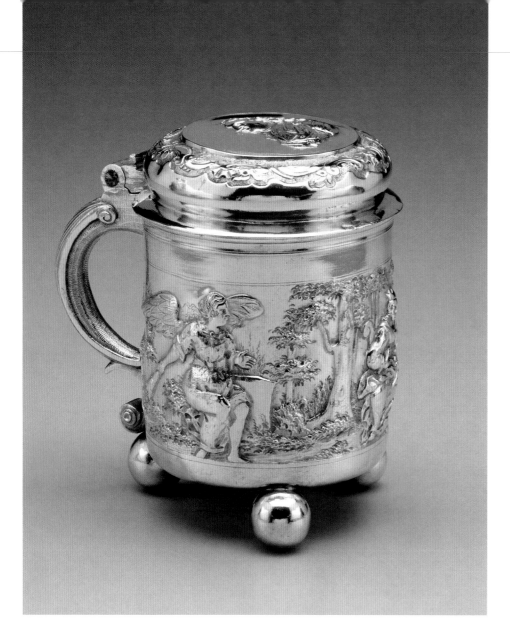

A tankard (fig. 52), dated 1748, also seems to be a reference to this event. On the lid of this tankard is the profile portrait of General-Admiral Count Fedor Matveevich Apraksin, copied from another medal struck in 1708 (fig. 53).[28] This medal commemorates Apraksin's defense of St. Petersburg in that year while Peter was tracking Swedish King Charles XII toward Poltava. The inscription under four sailing ships reads: "He who guards this does not sleep; better death than disloyalty." This was a sentiment with which Elizabeth surely must have sympathized. In addition to defending St. Petersburg Apraksin was involved with the taking of Åbo in 1713, which Russia held until the end of the Great Northern War in 1721.

This tankard, which is missing its thumb-piece for raising the lid, has additional images dedicated to this event. A winged angel holding a horn looks on from one side, and on the other is another woman holding up a laurel wreath and carrying a palm frond. Both symbolize victory and honor. Angels holding or trumpeting horns were often featured on triumphal arches built to welcome home victorious troops. At the center front sits a female ruler (fig. 54), holding an open book on her lap and a scepter in her hand. These are the same attributes identifying the personification of Doctrine in Cesare Ripa's *Iconologia*, another source of symbolic imagery in the eighteenth century.[29]

LEFT: *Fig. 52*
Tankard
Moscow, 1748
Vasilii Nikitin (?)
(active 1737–67)
Silver gilt
H. 5¼ in. (13.3 cm.)
12.15

TOP: *Fig. 53*
Detail of tankard lid with bust of General-Admiral Count Fedor Apraksin

ABOVE: *Fig. 54*
Detail of female ruler on front of tankard

Fig. 55
Tankard with medallions
Baltic region, first half of
the 18th century
IPD *in Latin letters for*
unidentified maker
Silver, parcel gilt
H. 8⅝ in. (21.9 cm.)
12.77

BELOW:
Tankard with medallions.
Detail of fig. 55.

One Hillwood tankard (fig. 55) is typical of those made in the Baltic centers and was likely made in Reval (now Tallinn) in the eighteenth century. Its solid form and ear-shaped handle conform to Scandinavia and Baltic models.[30] The decorative scheme of the medallions and inscriptions seems to be directed toward youth ascending to a monarchy justly ruled by a crowned monarch (see detail). There is reference to "adornments and majesty" with a crowned woman sitting robed and holding an oval medallion depicting stately buildings, revealing her as enlightened. The Latin letters EP, the cipher of Elizaveta Petrovna, appear on a wreath at the top of the scepter, held by a double-headed eagle on the lid. To her left is "youth

ascending", represented by a youthful figure holding flowers and a censer. He is positioned against a background with the sun rising. To the monarch's right is St. Michael as a conqueror of Satan, dressed in armor, holding a book in one hand and spearing a serpent with the other. He rests his foot on a skull and the inscription appears to mean "temptation averted."

Marina Lopato, curator of European silver at the State Hermitage, has suggested this might have been a gift from a group in the Baltics at the time of Paul's birth in 1754.[31] Elizabeth certainly welcomed Paul, Catherine's son, as a future heir. It appears that this may be an older tankard of Baltic origins to which the plaque on the top with the double-headed eagle and the scratched inscriptions were added to make it an appropriate presentation piece. It is even possible it was a christening gift, a custom that was common in the West. Russian tankards took their shapes from both the Baltic, like this one, and from Germany. Taller, thinner tankards with handles formed of several S and C curves were derived from those made in Augsburg.[32]

Another favorite presentation gift was the tall standing cup, known in the West as a welcome cup, usually balanced on a figure or a tree-trunk, a shape derived from seventeenth-century German sources. The bowls of these cups can be bell-shaped, round, or shaped like a bunch of grapes (sometimes called pineapple cups). Bell-shaped cups, such as these, originated in Nuremberg in the first half of the sixteenth century and spread from there throughout Germany, especially to Hamburg.[33] There are numerous examples in the State Hermitage, presented by German and Swedish merchants to their counterparts when doing business in Russia. That such cups and tankards were desired by museums and were also attractive as commodities in the 1920s, can be concluded, not only from the examples in the West, but also from the photograph (see fig. 7) of the Classification Commission making those tough decisions about the fate of the rows of such cups behind them, not all necessarily Russian.

The most exotic of such cups were those with a bowl carved from a coconut shell and mounted in silver (fig. 56). Already in the seventeenth century, the Russians, like the Europeans, were fascinated by such exotic natural objects from South Asia.[34] The top fourth of the coconut has been cut and mounted separately to form the lid with a cast double-headed eagle as the handle. The bottom has been carved with portraits of Peter, Catherine I, and Elizabeth. The inscription indicates that it was presented to the *sotnik* (in this case the head of a Cossack unit) Ivan Stepanovich Pustovoitov in December 1760. The plain mount supporting the cup sits on the head of the cast figure of a small boy, nude except for a long scarf wrapped over his shoulder and around his waist. He holds his arms out as if he were balancing the world on his head. Such cast figures were common and like other cast and attached pieces were often not of the quality of the rest of the object. The boy stands on the bell-shaped base, embossed with a busy rococo floral design.

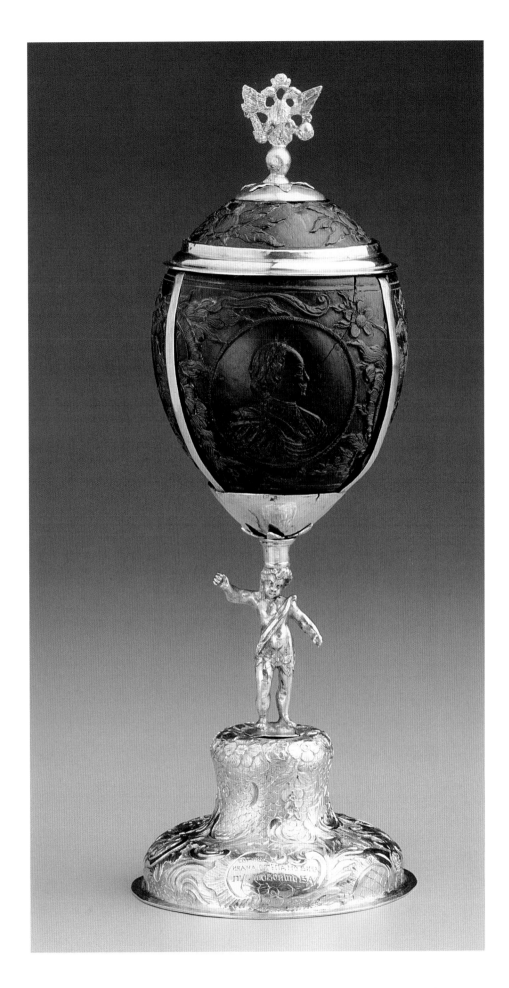

Fig. 56
Coconut cup with cover
Russia, ca. 1760
Silver, parcel gilt,
coconut
H. 9⅝ in. (25 cm.)
12.27.1–2

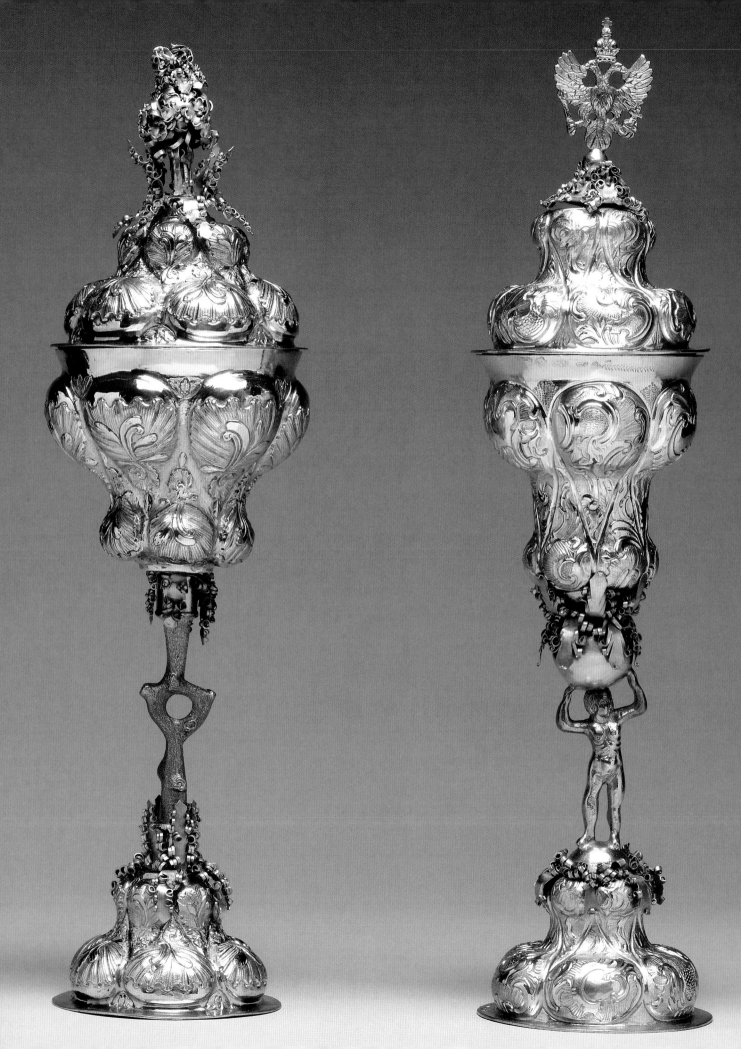

OPPOSITE:
Fig. 57
Pair of standing cups with covers
(left) Moscow, 1748
Silver, parcel gilt
H. 15⅜ in. (39.1 cm.)
The Walters Art Museum,
Baltimore. 57.808–809

(right) Moscow, 1745
Silver, parcel gilt
H. 15⅜ in. (39.1 cm.)
The Walters Art Museum,
Baltimore. 57.807

Two standing cups in the collection of the Walters Art Museum have very similar characteristics (fig. 57). In each case the bowl is decorated with larger, more rounded lobes near the lip, with their spoon-like shapes facing upward and alternating with smaller lobes facing down. On both, the lobes are decorated with rococo repoussé and chased shells and scrolls. The double-headed eagle handle sits on a mass of small silver shavings. One cup is supported by a tree-trunk, the other by a young Hercules-like figure holding a globe to which the cup is attached. The base and lid of each, incorporating similar lobes, are almost identical. One is dated 1748, the other 1760, so it is clear that these remained stylish for a fairly long time.[35] A small cup with a lid at Hillwood is shaped like the bowls of these two standing cups (fig. 58), but is set on three ball feet. It is dated 1764, and was likely intended as a salt cellar. Such rococo ornament clearly continued into the early years of Catherine's reign.[36]

Up to this point little has been said about the makers of most of these objects. In some cases initials have been matched up with names found in the documents; more often only their initials are known. Unfortunately the archives of the guilds were either destroyed or were sold, especially in 1864 and in 1871, as unnecessary paper.[37] For that reason, most of the silversmiths of the first half of the eighteenth century, especially, are identified by initials only. Much of the Moscow work, regardless of maker, is very similar in motifs, style, and craftsmanship, making distinction from one maker to another with the same initials difficult. Irina Kostina of the Kremlin Armory Museum has found in the documents more than one person with the same initials, for example "MK" usually identified only as Mikhail Kliushin (the maker of the cup on the left in fig. 44). Examining the quality of the repoussé or chasing, Kostina has tried to separate one "MK" from another.[38]

RIGHT: *Fig. 58*
Covered cup
Moscow, 1764
Timofei Filippov Siluianov
(b. 1736, active 1752–1802)
Silver, parcel gilt
H. 7½ in. (19.1 cm.)
Dia. 3¼ in. (8.4 cm.)
12.31.1–2

From the time Peter founded St. Petersburg in 1703 as his "window onto Europe" until the mid-nineteenth century Russia assiduously adopted Western styles. In this transitional period of the first half of the eighteenth century, we see the dominance of German and Baltic-style tankards, beakers, and standing cups in the production of Russian silversmiths as they tried to master a new vocabulary of shapes, ornament and imagery.

Detail of fig. 35

NOTES

1. Thomas DaCosta Kaufman, *Court, Cloister, and City. The Art and Culture of Central Europe 1450–1800* (Chicago: University of Chicago Press, 1995), 308.

2. V. Trutovskii, "Boiarin i oruzhenichii Bogdan Matveevich Khitrovo i Moskovskaia oruzheinaia palata," *Starye gody* (Jul.–Sept. 1909), 348.

3. J. Michael Hittle, *The Service City: State and Townsmen in Russia 1600–1800* (Cambridge, MA: Harvard University Press, 1979), 86.

4. Ibid., 87 and 127.

5. I. D. Kostina, *Proizvedeniia Moskovskikh serebrianikov pervoi poloviny XVIII veka* (Moscow, 2003), 10.

6. For the other Hillwood *kovsh* from Peter's reign, see Anne Odom and Liana Paredes Arend, *A Taste for Splendor: Russian Imperial and European Treasures from the Hillwood Museum* (Alexandria, VA: Art Services International, 1998), 96–97.

7. R. E. F. Smith and David Christian, *Bread and Salt: A Social and Economic History of Food and Drink in Russia* (Cambridge: Doctrine University Press, 1984), 202–203.

8. See M. N. Lopato, *Iuveliry starogo Peterburga* (St. Petersburg: Izdatel'stvo Gosudarstvennogo Ermitazha, 2006), 4.

9. Z. A. Berniakovich, *Russkoe khudozhestvennoe serebro XVIII–nachala XX veka* (Leningrad: Khudozhnik RSFSR, 1977), 8. Nothing from this service remains.

10. L. M. Vikhrova, "Niderlandskoe serebro vtoroi poloviny XVII–nachala XVIII vekov v Rossii," in *Soobshcheniia Rossiisko-niderlanskogo nauchnogo obshchestva*, vol. 1 (St. Petersburg: Evropeiskii Dom, 2003), 105–13 and Marina Lopato, "English Silver in St. Petersburg," *British Treasures from Russian Imperial Collections in the Hermitage*, ed. Brian Allen and Larissa Dukelskaya (New Haven: Yale University Press, 1996), 126.

11. For examples in the Kremlin Armory, see Kostina, nos. 118, 123, and 208.

12. Lopato, "English Silver," 128–29.

13. Baron A. Fel'kerzam, *Opisi serebra dvora Ego Imperatorskago Velichestva*, vol. 2 (St. Petersburg: P. Golike & A. Vil'borg, 1907), 306.

14. Baron A. Fel'kerzam, "Inostrannye mastera zolotogo i serebriannago dela," *Starye gody* 3 (Jul.–Sept. 1911), 99.

15. Berniakovich, 9.

16. See *Silber und Gold: Augsburger Goldschmiedkunst für die Höfe Europas* (Munich: Himer Verlag, 1994), 450–57.

17. In fact, little of his work remained in 1907 when Fel'kerzam compiled his inventory of silver belonging to the Russian court.

18. *Dekaratyuna – prykladnoe mastatstva Belarusi XII–XVIII stagoddziau* (Minsk: Belarus, 1984), nos. 65, 67, and 68.

19. See Elena El'kova, "'Posol zhelatel'nyi' ili 'Simvoly i Emblemata russkii oloviannoi posudy XVIII veka," in *Antikvariat* 11, no. 22 (Nov. 2004), 15.

20. For another cup with the same engraving, see ibid., 15.

21. Piscator's non-Latinized name was Klaus Jans Fischer. For an almost identical example, see Odom, *Russian Enamels*, 43.

22. This symbol was already used by Peter in his Summer Palace in St. Petersburg, symbolizing his delight in taking Narva back from Charles XII. See B. F. Borzin, *Rospisi petrovskogo vremeni* (Leningrad: Khudozhnik, 1986), 183–84.

23. One of the panels in Peter's Summer Palace has an almost identical eagle sitting on a cannon. See Borzin, 184–85.

24. See El'kova, 14–22.

25. Kostina, 342.

26. Evgeny V. Anisimov in *Empress Elizabeth: Her Reign and Her Russia 1741–1761* (Gulf Breeze, FL: Academic International Press, 1995), 85–90, explains these negotiations and how important they were to Elizabeth for carrying out her father's wishes.

27. E. S. Shchukina, *Dva veka russkii medalii: Medal'ernoe iskusstvo v Rossii 1700–1917 gg.* (Moscow: Terra, 2000), 52–53.

28. See *Medali i monety Petrovskogo vremeni* (Leningrad: Avrora, 1974), no. 37. The medalists were Solomon Gouin and Gottfried Haupt.

29. Cesare Ripa, *Baroque and Rococo Pictoral Imagery: The 1758–60 Hertel Edition of Ripa's 'Iconologia' with 200 Engraved Illustrations* (New York: Dover Publications, Inc., 1971). See no. 83 for Doctrine. Another tankard, made in Narva (in present-day Estonia) in 1675 is decorated with the winged figure. What is on the other two sides is not pictured nor mentioned. See Sotheby Parke Bernet, Los Angeles, February 4, 1974, lot 164. There is also in the Hillwood collection a small beaker (acc. no. 12.557) with the same three images.

30. See Christie's London, November 17, 2009, lots 30, 31, and 34. Carl Ehrnrooth, ed., *Silver Treasures from Livonia, Estonia* (Stockholm: Frenckellin Kirjapaino Oy, 1991), nos. 80, 81, and 88.

31. I would like to thank Marina Lopato for her very helpful thoughts.

32. For examples of German silver in the State Hermitage, see M. N. Lopato, *Nemetskoe khudozhestvennoe serebro* (St. Petersburg: Slaviia, 2002). For examples in the Kremlin Armory, see G. A. Markova, *Nemetskoe khudozhestvennoe serebro XVI–XVIII vekov v sobranii gosudarstvennoi oruzhennoi palaty* (Moscow: Iskusstvo, 1975). These collections provide a useful survey of what Russians would have seen.

33. Markova, no. 33.

34. For more on the use of coconut shells, see Irina Ukhanova, "Khudozhestvennye izdeliia iz kokosa russkikh masterov XVII–XIX vekov," *Antikvariat*, 9, no. 50 (Sept. 2007), 6–21.

35. In the Fowler collection there is an almost identical cup by the same maker in the same year as the one on the left. See Schroeder, 95.

36. There is an almost identical cup, dated 1748 by another master, in the collection of the Kremlin Armory, which has curled shavings of silver extending under the double-headed eagle. See S. Ia. Kovarskaia, I. D. Kostina, and E. V. Shakurova, *Russkoe serebro: XIV–nachala XX veka iz fondov Gosudarstvennykh muzeev Moskovskogo Kremlia* (Moscow: Sovetskaia Rossiia, 1984), plate 80.

37. Baron A. Fel'kerzam, "Nekotoryia svedeniia o S.-Peterburgskikh zolotykh i serebrianykh del masterakh za sto let (1714–1814)," *Starye gody* 1 (1907), 11.

38. Irina Kostina, "Tri kleima. Ch'i oni?" *Antikvariat*, 5, no. 27 (May 2005), 86–91.

ROCOCO TO NEOCLASSICISM: CATHERINE AND PAUL

"AT DINNER-TIME Apollo, the Four Seasons and the Twelve Months made their entry....In a short speech, Apollo invited the company to proceed to the banqueting hall....The hall was oval, and contained twelve alcoves, in each of which a table was set for ten. Each alcove represented a month of the year, and the room was decorated accordingly."[1] So wrote Catherine the Great to Voltaire about the reception and banquet she held in 1770 for Prince Henry of Prussia. She was determined to recreate the feasts of the gods on Mount Parnassus, home of Apollo and the muses, to surround her guests with a fantastic world of make-believe.

Catherine was not the first to attempt to bring to life this splendid world. Russian rulers, beginning with Peter, turned to silversmiths, foreign as well as Russian, for the lavish silver services, necessary as accessories to their "theater of self-presentation." The leading center for silver production at that time was Augsburg; later Paris and London gained prominence. Anna had ordered a large toilet service from Augsburg in the 1730s, which in design was almost identical to the dessert service made by Dom for Anna (see fig. 34). Anna and Elizabeth depended on agents for the purchase of foreign silver: Anna and her favorite Ernst Johann Biron on Isaac Liebmann, a silversmith and supplier of services particularly from Augsburg, and Elizabeth on the English merchants Simon Chaser and the brothers James and Charles Woolf.[2] Elizabeth commissioned what was soon known as the "Parisian Service" from François Tomas Germain in 1757, but did not live to see it delivered (see fig. 59). This service was regularly used during Catherine's reign. For example, on St. George's Day, November 26, 1784, the table was set "with the silver Parisian service...and both for the table and dessert porcelain plates with the insignia of the Order of St. George were used."[3] The Parisian Service also accompanied

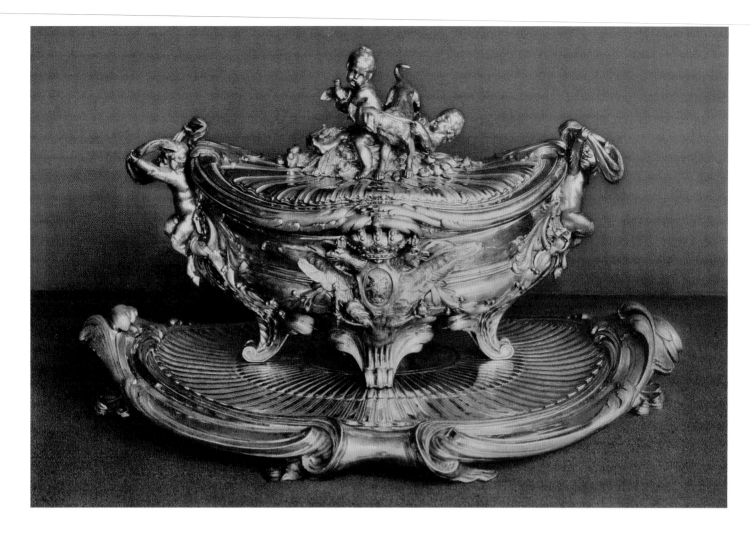

Catherine on her famous tour of the Crimea, where it was used on the Monday after Easter in Kiev and on her return to the Moscow Kremlin.[4]

Foreign purchases increased exponentially during the eighteenth century, peaking during the reign of Catherine, whose era stands out for many reasons: her political astuteness, imperial ambitions, collecting mania, her attention to building palaces and gardens, and her patronage of the arts. Her commissions were unprecedented. She ordered from all three Western centers as well as from Swedish, German, and Russian silversmiths working in St. Petersburg. These foreign services were of tremendous importance for imperial dining and personal use and played no small role in spreading European tastes to Russia. While earlier wares had been an expression of fashion and imperial dictate, new commissions in Catherine's reign were about prestige. Catherine especially was ever mindful of creating an impression of boundless resources, taste, and subtle messages to enhance her power.

Starting in 1775 when Catherine divided Russia administratively into eleven *gubernii*, or provinces and continuing into the 1780s she commissioned no fewer than nineteen silver services abroad. The *guberniia* services, as they are known, were intended to enable the governors-general (*namestniki*) of the provinces to entertain in a manner befitting the personal representative of the empress. Her known commissions include five from England, six from Augsburg, and eight from Paris. Russian silversmiths in St. Petersburg also provided parts of these foreign commissions.[5] The services commissioned from Augsburg, each for forty people, were the city's largest orders of the century. In 1797, after Catherine's son Paul I came to the throne, he ordered that all the *guberniia*

Fig. 59
Tureen from the Paris Service
From Baron A. E. Fel'kerzam,
Opisi serebra dvora Ego
Imperatorskogo Velichestva,
vol.1 (St. Petersburg, 1901).

services should be returned to the *pridvornaia kontora* or court office. Nicholas I ordered many parts of these services melted down in order to purchase a new service in London in 1844.

In 1770 Catherine ordered from Jacques-Nicolas Roettiers the Orlov Service, intended for twenty-four persons. This was one of two silver services she gave to Grigory Orlov, who helped place her on the throne, as part of her separation agreement with him in 1772.[6] One of the largest services known at the time, it consisted of a table service and tea and coffee services, totaling more than 3,000 items, counting course changes or *peremeny*.[7] A massive tureen, now at the Metropolitan Museum of Art, is a superb example of the fine quality of this service (fig. 60), and the enormous attention to detail she paid to all her commissions. The sculptor Étienne-Maurice Falconet advised her and may have prepared some drawings. Following Orlov's death in 1784 Catherine purchased the service back for the crown.

An entry in the official journal of the tsar's daily activities reveals several pieces of valuable information about the use of silver at court. It states that at a dinner at Peterhof in June, 1799 for 125 people, the table was set "with Japanese and arabesque [the Arabesque Service] porcelain with the gilded dishes and the Orlov Service as usual for the hot course."[8] Not only were silver services used together with porcelain, a practice that continued for the rest of the empire, but silver was used most importantly for the hot meat courses, even after full dinner services were made of porcelain—the Arabesque being the first full Russian porcelain dinner service.[9] Both the silver and the porcelain were also transported to Peterhof on the Gulf of Finland for this occasion. In fact, the *pridvornaia kontora* in St. Petersburg oversaw all table silver and brought the necessary services to the summer palaces when the court was in residence. For this reason there are few if any examples of table silver in the collections of these palaces today.[10]

Elizabeth and especially Catherine did not ignore local silversmiths, both Russian and foreign. Elizabeth commissioned the so-called "Gilded Service" (*Zolochenii Serviz*) in 1758, but it was not completed until 1784, well into Catherine's reign. This was used frequently, with additions made to it in the nineteenth century by Nichols and Plinke and the firm of Ivan Khlebnikov. Georg Eckardt (active 1758–63) was the chief silversmith for this service, but following his death in 1763 it was completed by Johann Feuerbach and Johann Blohm.[11] Parts of this service were repeatedly melted down. Little but flatware remained in 1907 when Baron Armin Fel'kerzam (1861–1917) compiled his inventory of all the silver of the imperial court. In the case of the Gilded Service, as in many others, when the court supplied the masters with the necessary silver the master would charge only for his labor. When the silversmith purchased the necessary gold, silver, and jewels, he charged for everything.[12]

In the first year of her reign Catherine commissioned twenty-one services to present as awards for those who had participated in the coup that put her on the

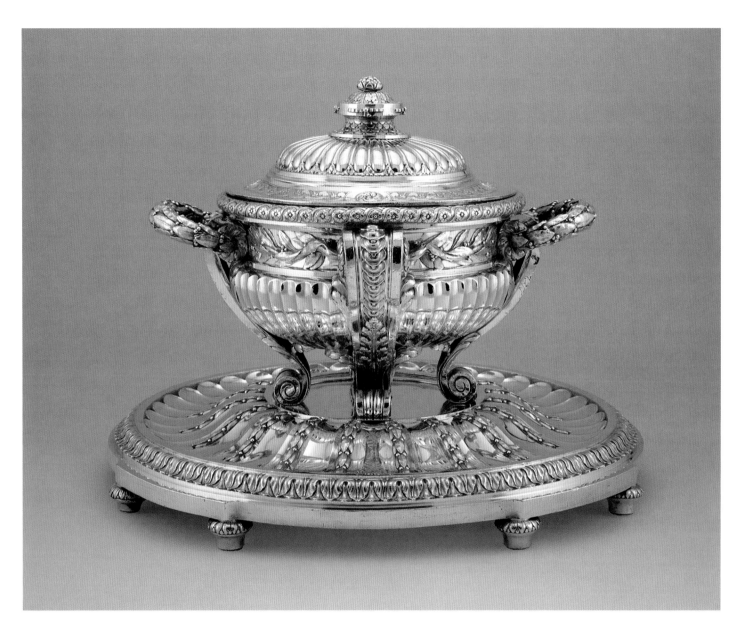

Fig. 60
Tureen from the Orlov Service
Paris, 1770–71
Jacques-Nicolas Roettiers
(active 1765–77)
Silver
Tureen: H. 10⅞ in. (27.9 cm.),
W. 11¾ in. (29.8 cm.)
Stand: H. 7⅞ in. (7.3 cm.),
Dia. 18⅜ in. (46.7 cm.)
The Metropolitan Museum of Art.
Rogers Fund 1933. 33.165.2 a–c

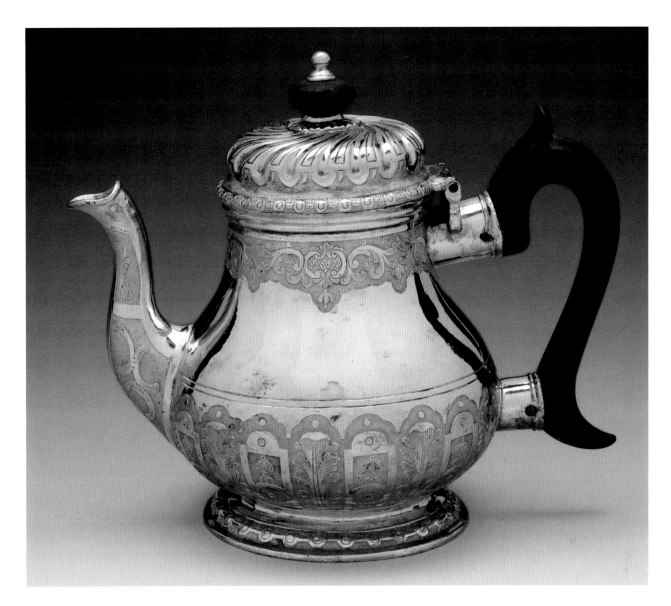

Fig. 61
Teapot
St. Petersburg, 1779
Johan Fredrik Köpping
(1718–1783)
Silver gilt, wood
H. 6½ in. (16.5 cm.)
Hood Museum of Art, Dartmouth
College, Hanover, New Hampshire.
Gift of Ralph Sylvester Bartlett,
Class of 1889. 159.2.22422

throne. She ultimately presented silver services to thirty-three of her major supporters on the third anniversary of the coup in 1765.[13] Marina Lopato, Curator of European silver at the State Hermitage, notes that thirteen of the initial services commissioned were made by a Swedish silversmith living in St. Petersburg, Johan Fredrik Köpping (1718–1783)[14]. Köpping became a master of the foreign guild in 1748, succeeding his father. He worked for the court from 1750 to 1782, and his workshop turned out a huge amount of gold and silverwork. He was also one of three silver stewards (*Silberdiener*), who were responsible for all the silver in storage in the Winter Palace. They made repairs and determined which pieces should be melted down when they were obsolete or beyond repair.

One of his first commissions, known as the Oranienbaum Service, was for the future Peter III. Elizabeth gave Aleksandr Menshikov's famous palace at Oranienbaum to Peter, where the service was used.[15] Köpping made an everyday service of more than 500 pieces, and he also produced additions and replacements for foreign-made services. Fel'kerzam states that it is difficult if not impossible to tell Köpping's replacements from the original French or Augsburg works, if they are unmarked.[16] Köpping's ability to copy many styles is evident in a teapot (fig. 61). This decoration is very similar to that of the teapot made for Anna (see fig. 34). An example of Köpping's simple

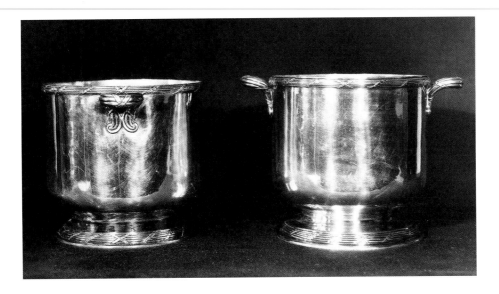

Neoclassical style can be seen in two wine coolers (fig. 62) from the First Service of St. Petersburg, made in 1771 and recorded in Fel'kerzam's inventory.[17] Their only decoration is the wrapped, reeded band around the rim and the foot and the scrolls attaching the handles to the body. These were brought out of the Soviet Union by Ralph Bartlett and were apparently sold by him; their present location is unknown. Pieces from this service were also made by Zacharias Deichman (1709–1776), a master from Olenets in northern Russia who had trained in Moscow.

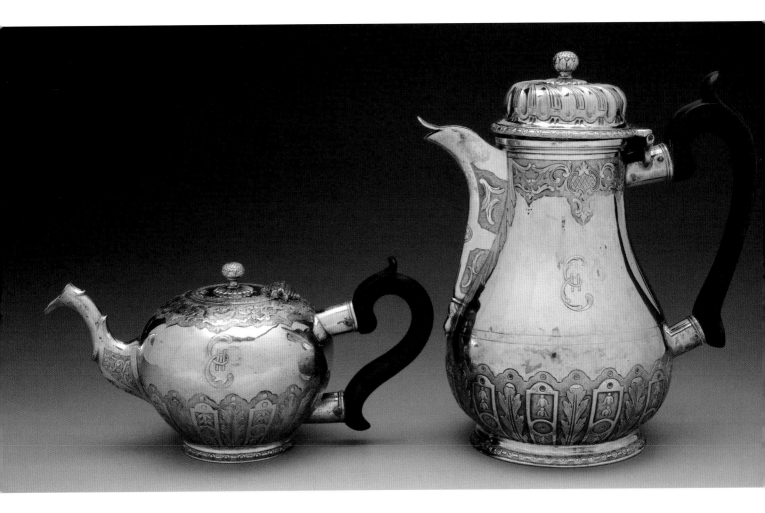

Johan Henrik Blohm (active 1766, d. 1805), who assisted the elder Köpping in many of his commissions toward the end of his life, became a master in 1766 and soon was one of the most overworked silversmiths in St. Petersburg. Ralph Bartlett brought several excellent examples of Blohm's work to the United States including a silver-gilt coffee pot and teapot (fig. 63).[18] The pieces bear the monogram of Catherine—the E II, for Ekaterina—but the decoration is otherwise almost identical to the earlier coffee pot Dom made for Empress Anna. A teapot and sugar bowl, now in the Museum of Fine Arts in Boston, both dated 1791, are part of another service Blohm made at this time (fig. 64).[19] The bulbous-shaped teapot has graceful fluting on the curved spout, but is otherwise plain, except for the double-headed eagle on the side. The sugar box is of a large, oval shape typical for the period of Catherine, and there are a number of them in American museum collections. The sudden preponderance of tea sets made in Catherine's reign reveals the firm place tea and coffee had attained as upper class drinks by the 1770s. A new meal, afternoon tea emerged.

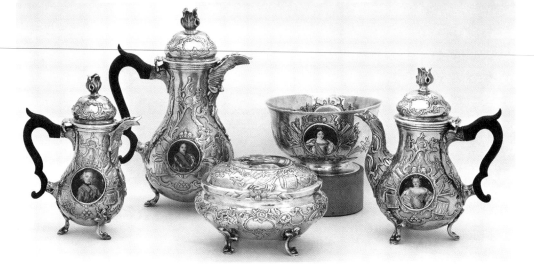

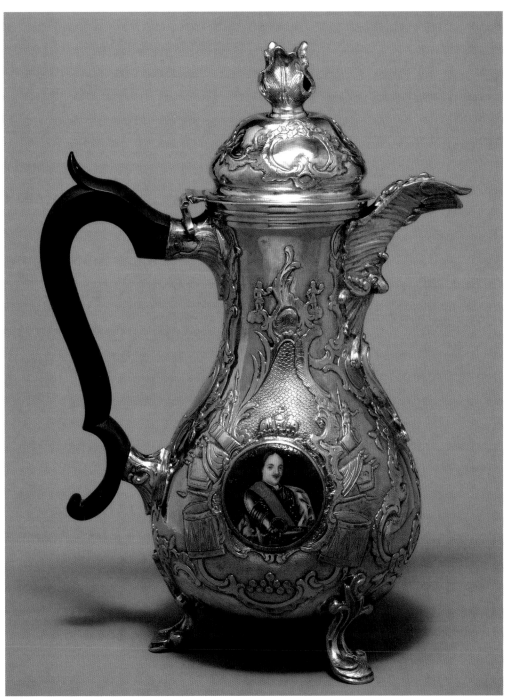

Fig. 65
Coffee and tea set with portraits
St. Petersburg, 1773
Johan Henrik Blohm
(active 1766, d. 1805)
Silver, parcel gilt, enamel, wood
Coffee pot: H. 10¼ in. (26.0 cm.)
Teapot: H. 8⅛ in. (20.6 cm.)
Cream jug: H. 7⅝ in. (19.4 cm.)
Waste bowl: H. 3⅜ in. (8.6 cm.),
Dia. 6 in. (15.2 cm.)
Sugar box: H. 4⅛ in. (10.5 cm.),
W. 6¼ in. (15.9 cm.)
The Metropolitan Museum of Art.
Rogers Fund, 1947. 47.51.1–5

Fig. 66
Coffee pot, part of fig. 65

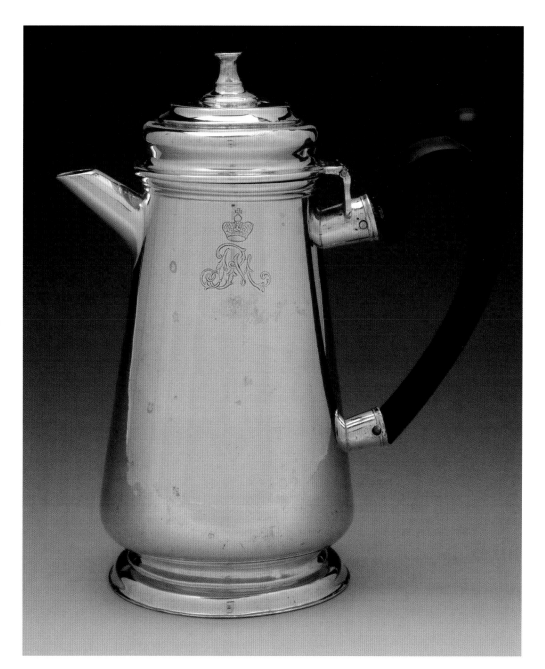

Blohm's productivity and versatility are immediately evident in several other examples. A very ornate rococo tea set is now at the Metropolitan Museum of Art (fig. 65). The service is dated 1773, exhibiting the persistence of the rococo style into Catherine's reign. Enameled portraits of all the Russian monarchs are applied to the sides of each piece and outlined in repoussé scrollwork. The coffee pot with a fanciful molded spout and military trophies features portraits of Peter I and Catherine II (fig. 66). The set is said to have been a gift to Count Pëtr Rumiantsev (1742–1796), who commanded the Russian forces fighting the Turks in the Trans-Danube campaigns between 1768 and 1774, for which he received the appellation "Zadunaiskii," meaning "of Trans-Danube fame." Blohm also made a small coffee pot, part of a service for Paul in 1794 (fig. 67). This coffee pot is completely plain in style, allowing light and reflections from candles and table decorations to play on the shiny polished silver surfaces. It is engraved with the crowned letters P and M for Paul and his wife Maria. This coffee pot was also part of the silver in the Winter Palace at the time of the Revolution.[20]

Fig. 68
Two salt cellars with covers
(left) Moscow, 1800
A V for unidentified maker
(active 1792–1800)
Silver, parcel gilt
H. 7 in. (17.8 cm.)
12.101.1–2

(right) Moscow, 1795–1805
Silver, parcel gilt
H. 12¾ in. (17.3 cm.),
W. 3⁹⁄₁₆ in. (9.1 cm.)
12.102.1–2

Fig. 69
Two beakers
(left) Moscow, 1782
S F for unidentified maker
(active 1773–94)
Silver
H. 3⅜ in. (8.6 cm.)
12.44

(right) Moscow, 1793
S S for either Stepan Savel'ev or
Savva Semenov
(active 1787–97)
Silver
H. 3½ in. (8.9 cm.)
12.45

Gifts of silver continued to be essential for ceremonial occasions. A presentation of bread and salt (*khleb-sol'*), the traditional ceremony of welcome in Russia was regularly performed when greeting the tsar on travels. For example, Catherine received an extraordinary number of bread and salt dishes on her 1787 trip to the Crimea as she was greeted in each town along the way. Local dignitaries presented a platter with a loaf of bread on an embroidered cloth with a cellar of salt on top. These were generally made of silver, and the salts were usually footed (fig. 68). Their austere decoration consists of Neoclassical swags of laurel leaves, acanthus leaves around the base and lid, or a banded pattern of rosettes. Cast double-headed eagles form the finials. Post purchased one of these salts from Hammer Galleries with the provenance that it came from the Winter Palace.[21] While many of the platters, especially from the eighteenth century, seem to have been melted down in the intervening years, more salts have survived. They, no doubt, could still have served a practical purpose for use on the table. Such stylized vases, swags, laurel wreaths, and fruits and flowers in bunches also populated the mundane beakers that in Elizabeth's reign featured curling leaves and scrolls (fig. 69).

Neoclassical motifs also dominate the decoration of a lidded racing cup made in the reign of Catherine (fig. 70). It is identical in its decoration and the inscription on the body to one in the Kremlin Armory.[22] It is known that eight such cups were made, all apparently by the eminent Moscow silversmith Aleksei Rat'kov (active 1777–1821). In 1795, the recipient was Pavel Alekseevich Chemodanov, the owner of a stud farm, whose horses regularly won races on a track built near the palace of Aleksei Orlov-Chesminskii (brother of Grigorii Orlov) in Moscow. Three medallions are attached to the sides, one with the cipher of Catherine above the double-headed eagle, acknowledging her patronage of the races. Another includes an inscription: "To encourage those who are eager to breed good horses." The third, an image of bees buzzing around a hive, is supported by a bird plucking at its breast for blood with which to feed its young. These are symbols of industry and self-sacrifice in the attempt to raise pure-bred horses. The cup took on a new life in the twentieth century in the United States when it was designated The Virginia Gold Cup until its retirement in 1953.[23] It is now in the National Museum of Racing in Saratoga Springs, New York.

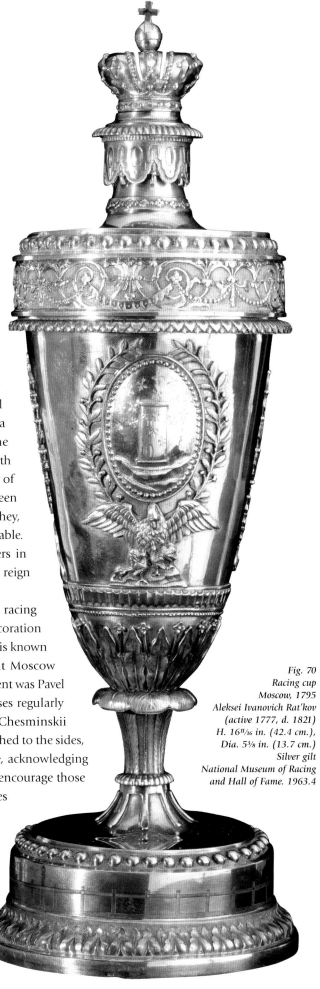

Fig. 70
Racing cup
Moscow, 1795
Aleksei Ivanovich Rat'kov
(active 1777, d. 1821)
H. 16¹¹/₁₆ in. (42.4 cm.),
Dia. 5⅜ in. (13.7 cm.)
Silver gilt
National Museum of Racing
and Hall of Fame. 1963.4

The persistence of the rococo into the reign of Catherine has already been noted. A teapot of the 1760s (fig. 71), now in the Frick Art & Historical Center in Pittsburgh, is decorated with rococo curves and stylized shell shapes, but the ornament does not saturate the surface as it does in the earlier Elizabethan beakers or even in some of the examples made by Blohm: rather it is rendered in a more offhand manner. A pear-shaped creamer (fig. 72), also at the Frick, but of a later date, still retains beautiful S curves in its silhouette and in elegantly turned lines at the spout and the bent end of the lid. Sculpted and cast roses form the knob and decoration where the feet are attached to the body. On the front is a chased image of a general officer in profile, framed by two swags of laurel leaves.

Baron Fel'kerzam notes the time lag between the changing styles in Western Europe and those in Russia as between ten and twenty years as a way to explain the continued commissioning of works with rococo design even into the 1790s.[24] There are two excellent examples of this phenomenon at Hillwood, a ewer and basin (fig. 73). The robust flowers, fruit, and leaves embossed and chased in high relief are more reminiscent of the late seventeenth century than of the Neoclassical style of Catherine, despite the Neoclassical shapes and beading around the edges. There are, however, numerous examples of this style.[25] As Kremlin curator Irina Kostina notes, conservative merchants and town folk "remained loyal" to these early styles, which more closely coincided with their idea of beauty.[26] These two pieces were made by different St. Petersburg silversmiths, Carl Bredenberg (active 1788–1821), a Finn, and Erik Hitelin (active 1783–1820), from Reval, present-day Tallinn. While ewers and bowls were important for ceremonial meeting and greeting as well as ceremonial washing before meals in the sixteenth and seventeenth centuries, it is unclear whether this custom was still practiced in the late eighteenth century or whether it was reserved for the toilette.

It is also possible to see the time lag for new styles in objects made in such provincial cities as Velikii Ustiug, Tobol'sk, and even in Moscow. The love of pictorial decoration drawn from printed sources and the sinuous shapes of the rococo retained their popularity there and are particularly evident in niello wares, which remained in production in all three cities. (Niello work was a rarity in St. Petersburg, where design was concentrated on the latest Western forms, ornament, and techniques.)

Despite the growth of St. Petersburg, Velikii Ustiug continued throughout the eighteenth century to support trade and a wide array of craftsmen. It was located on an enviable crossroads on both north–south and east–west trade routes. The city was well known for everyday brass objects—caskets, desk sets, and ink pots—decorated with enamel as well as enameled copper and silver wares with silver appliqués.[27] As early as 1630, there were twenty stalls selling silver in the *posad*. This number had dwindled to nine by the mid-eighteenth century. In 1744 masters from Velikii Ustiug were invited to Moscow to train specialists and revive the niello production in the capital city.[28]

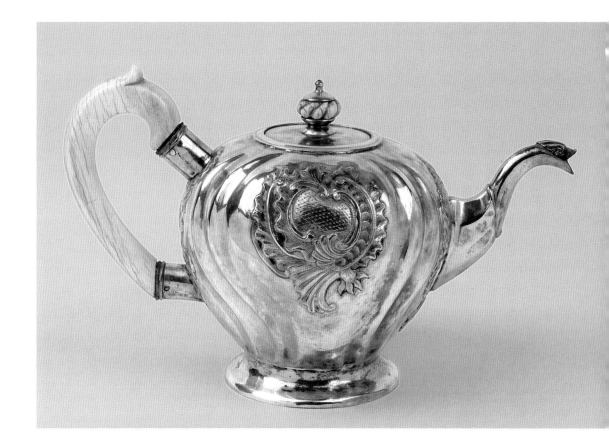

Fig. 71
Teapot
Tobol'sk, 1757–80
Silver, ivory
H. 5⅛ in. (13 cm.),
W. 8⅝ in. (21.9 cm.)
Frick Art & Historical Center,
Pittsburgh. 1973.7a, b

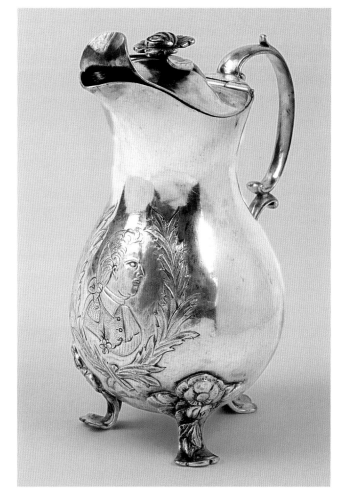

Fig. 72
Creamer
St. Petersburg, 1772–83
Silver
H. 5½ in. (14 cm.)
Frick Art & Historical Center,
Pittsburgh. 1973.14

OVERLEAF: *Fig. 73*
Ewer
St. Petersburg, 1794
Erik Hitelin (active 1783–1820)
Silver, parcel gilt
H. 11⅝ in (29.5 cm.),
W. 6½ in. (16.5 cm.)
12.48

Basin
St. Petersburg, ca. 1790
Carl Fredrik Bredenberg (active
1788–1821)
Silver, parcel gilt
W. 16⅛ in. (41 cm.),
D. 11¼ in. (28.5 cm.)
12.49

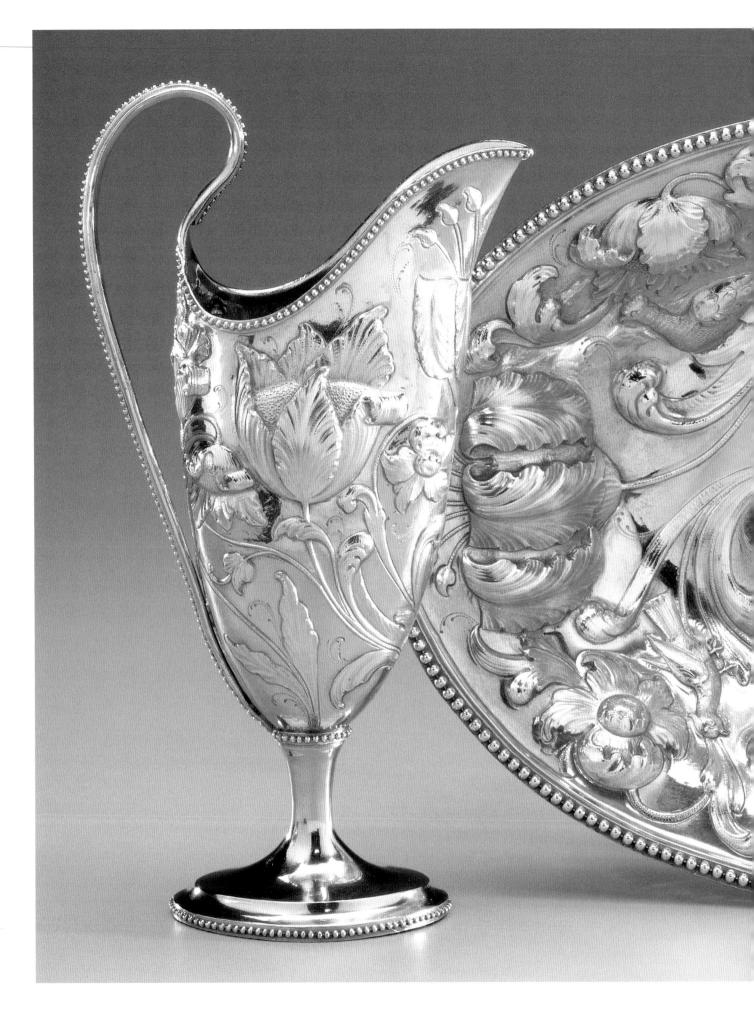

In fact of the two known "factories" (*fabrika*) in the eighteenth century, one founded by the merchants Afanasii and Stepan Popov was located in Velikii Ustiug.[29] The factory operated from 1761 to 1776, but suffered from several natural disasters until a fire in 1776 finally closed it completely. Although the decree establishing the factory in 1761 stated that its works must be stamped with the city and maker's mark, this was not always the case, and it appears that the factory didn't even have a stamp because the known marks are usually chiseled or engraved. After the fire at the factory in 1776 only the city mark is used. There are rarely maker's marks until the 1790s.[30]

Niello work of this period is distinguished by monograms, coats-of-arms, pastoral, mythological, and gallant scenes with figures portrayed doing their daily work in the fields or posed before classical monuments. A splendid snuffbox, one of two at Hillwood with the same image, illustrates a fantasy and perfectly exemplifies the international nature of Velikii Ustiug (fig. 74). The box has a silver cover decorated with niello that is formed in two parts and hinged in the center. On one part of the lid a sinking ship, a triton riding a hippocampo, and a sea nymph struggle in stormy waters surrounded by a serpent and a sea creature. The other half is decorated with sea trophies and shells. The curving shape, designed to fit the shell bottom, complements the image's rococo elements.

An unidentified silversmith chose *Naufrage* (Shipwreck), a print by Jacques de Lajoüe (1687–1761), as the source for this turbulent scene. The original print appeared in *Livre nouveau de douze morceaux de fantaisie utile à divers usages*, a volume of ornamental fantasies that enjoyed wide circulation throughout Europe after it was published in Paris in 1736 (fig. 75).[31] The rococo ornament, after all, had its roots in sea motifs, in shells and waves.

Decorative objects employing exotic shells were fashionable in mid-eighteenth century Europe. This polished green turban snail shell (*Turbo marmoratus*) came from China, where such shells were used as ceremonial wine cups. On the other, smaller, Hillwood box (fig. 76) a Chinese engraving on one end of the shell reads, "Your honor, wine in your cup." Snuffboxes were usually carried in the pocket, but here, three small squares on the shell's bottom have been left after the outer layer was polished to serve as feet, enabling the box to sit flat on a table. These boxes were clearly very popular. In addition to a box with the same scene at the Metropolitan Museum of Art, there is one with a gallant scene at the State Hermitage.[32]

Fig. 74
Snuffbox
Velikii Ustiug, 1750s–1760s
Silver gilt, niello, turban snail shell
H. 2¼ in. (5.7 cm.),
W. 2⅞ in. (7.3 cm.),
D. 4½ in. (11.5 cm.)
13.5

Fig. 75
Naufrage (Shipwreck)
Paris, 1736
Engraving by Pierre Aveline after
Jacques de Lajoüe
The Metropolitan Museum of Art,
The Elisha Whittelsey Collection.
The Elisha Whittelsey Fund, 1954.
54.513.5

Fig. 76
Snuffbox
Velikii Ustiug, 1750s–1760s
Silver gilt, niello, turban snail
shell
H. 1⅞ in. (4.8 cm.),
W. 2⅜ in. (6.2 cm.),
D. 3⅝ in. (9.2 cm.)
13.6

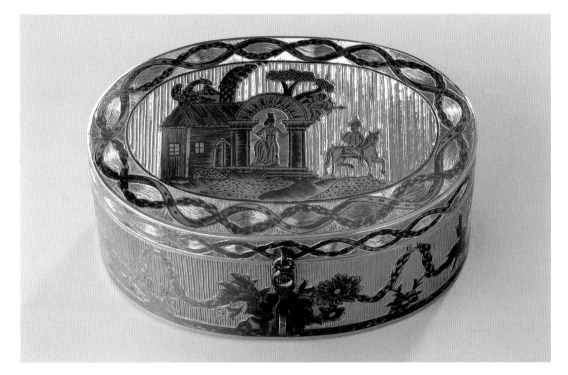

Fig. 77
Box with genre scene
St. Petersburg, 1775
Silver gilt, niello, iron
H. 1⅞ in. (4.8 cm.),
W. 4½ in. (11.4 cm.),
D. 3⅜ in. (8.6 cm.)
13.10

Like *Naufrage* on the snuffbox, most images were copied from western engravings and book illustrations, which were clearly available along this northern trade route or they may have derived from folk interpretations of those engravings, like the scene on another box (fig. 77). A woman in a Neoclassical doorway appears to be bidding farewell to a charming horseman as he rides away. The rendering of the horseman and especially his horse departing from the house is very close to such figures found in folk prints, known as *lubki*. On the roof of the house sits a cupid with his arrow at the ready and on the other end of the roof is an eagle.

In these two examples, it is possible to see that the application of niello in the second half of the eighteenth century changed dramatically from that of the previous century and was applied in the manner of an engraving. In the earlier silver wares the niello decoration consisted of swirls of vines and leaves that provided the ground for gilded and chased flowers, foliage, birds, and animals. By the mid-eighteenth century the niello work defines the engraved image, which is often raised above a gilded and stippled surface. The gilded ground is also engraved into decorative patterns such as vertical or horizontal lines, sunbursts, fish-scale designs, or mixtures of these. On the box mentioned above, large punches have been used to create vertical ribs. The ribs are counterbalanced by narrow horizontal lines behind the woman and curved striations between the interlaced ribbons around the border.

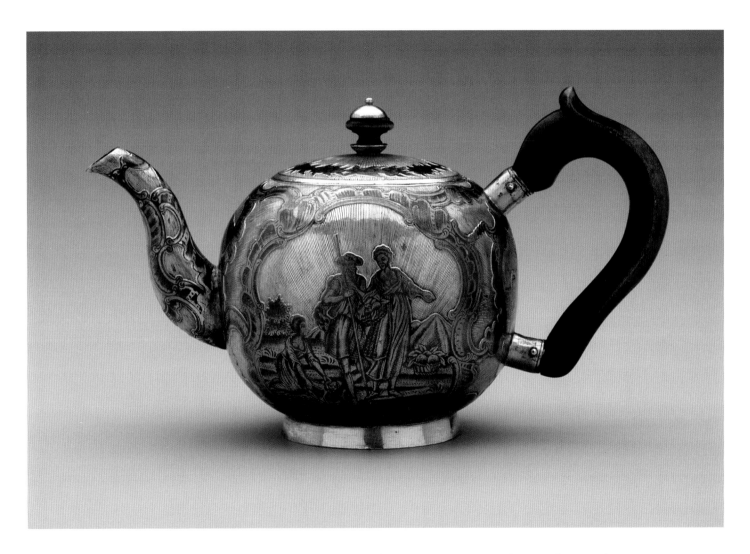

A teapot (fig. 78), like the snuffbox, also demonstrates the use of engraved sources for the decoration. A pastoral scene, depicting peasants dressed in Western clothes harvesting vegetables in a field with a village in the background, is found on each side of the pot. The sky is a gilded sunburst of incised lines, leaving the heads of the figures silhouetted against this bright ground. Each image is framed by curls and stylized shell shapes typical of the late rococo. Similar scrolls cover the spout, and a garland of fruit and flowers encircles the lid.[33] While the teapot is unmarked, as is often the case with pieces from Velikii Ustiug, it is possible it was made by the Popov Factory, which was producing the finest wares in Velikii Ustiug, or by Aleksei Moshnin (b. 1721), to whom several pieces, including a tray with a scene with a similar rendering of the mountains, have been attributed.[34]

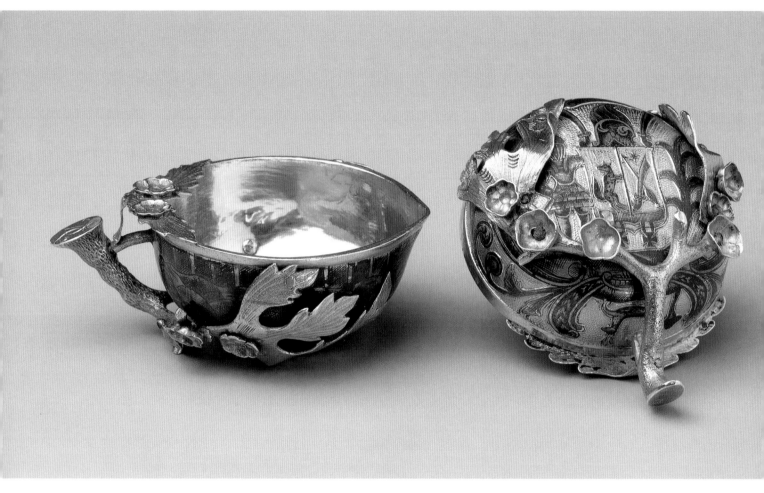

From Velikii Ustiug the art of niello also spread east to Tobol'sk. Denis Ivanovich Chicherin, its governor from 1763 to 1781, cultivated the arts and silver wares in particular. He complained to Catherine about an abundance of artisans, including thirteen silversmiths, resulting in idleness and disturbances and the need to resettle some in other Siberian towns.[35] Chicherin ordered a very large silver service decorated with niello for himself in the mid-1770s. Hillwood owns three *charki* from this service, two identified on the bottom by the Chicherin coat-of-arms with a sable, an important staple of the Siberian fur trade, on one side of a shield held by a knight, and a crossed sword and arrow on the other (fig. 79). On the front of each *charka* his initials appear in Latin letters under the nine-point crown of a count. Like the snuffbox made of a Chinese turban snail shell, these *charki* demonstrate the influence of Chinese porcelain shapes of a lotus seed pod, cut in half with *prunus*, or flowering plum branches supporting it.[36]

Fig. 79
Two charki
Tobol'sk, 1774–75
Silver gilt, niello
Each W. 3½ in. (8.9 cm.)
13.3.1, 13.3.2

Larger pieces of this service are scattered throughout numerous Russian and foreign collections. These include a tray, tea caddy, teapot, and several other items like these *charki*, that were part of a collection belonging to Grand Duke Aleksei Aleksandrovich, brother of Alexander III, at the end of the nineteenth century and now in the Hermitage.[37] Even their shapes retain rococo elements that were no doubt a result of the city's distance from Moscow. As a French officer is said to have heard Chicherin say, "God is in heaven, and the empress is very far away."[38]

Moscow silversmiths produced some remarkable niello ware in the 1790s and into the early nineteenth century. A small straight-sided cup makes use of decorative elements found more widely on trays, chalices, and other vessels in Russian museums (fig. 80).[39] Swags of drapery and leaves link Neoclassical urns and vases, rendered in niello on a ground, incised and gilded in a fish-scale pattern. They also link four medallions, each depicting a male personification of one of the Four Seasons.

Fig. 80
Beaker
Moscow, 1795
V A for unidentified maker
(active 1791–97)
Silver gilt, niello
H. 3⅜ in. (8.7 cm.),
Dia. 2⅜ in. (6.0 cm.)
13.15

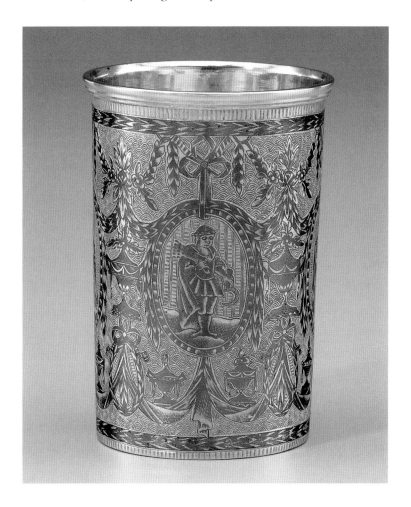

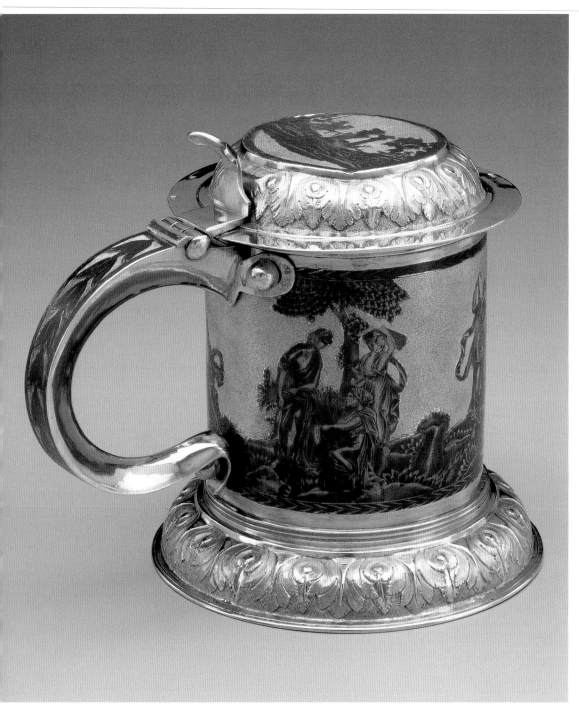

Fig. 81
Tankard
Moscow, 1802–04
I O for unidentified
maker (active 1802–16)
Silver gilt, niello
H. 8⅛ in. (20.6 cm.)
13.20

OPPOSITE:
Winter
Detail of fig. 81, from
an engraving by
Francesco Bartolozzi
(1756–before 1788)
after Angelica
Kauffman (1741–
1807).

A large niello tankard on a domed foot is decorated with multi-figured, but dark, scenes also of the Four Seasons (fig. 81). The four women by the fire, one of whom is holding a child, symbolize *Winter* (see detail) and the image is reversed from an original by Angelica Kauffman (1741–1807). The engraving for *Winter* was made by Francesco Bartolozzi (1756–before 1788), who produced this image as part of the highly sought-after series of *The Seasons*.[40] Kauffman created many images for use on decorative wares, porcelain, silver, furniture, as well as decorative room panels. With very few exceptions these images were all taken from printed sources that were extremely popular in England in the 1780s and 1790s. Combined with these sophisticated images is a rustic horseman on the lid, very similar to the one on the box in figure 77.

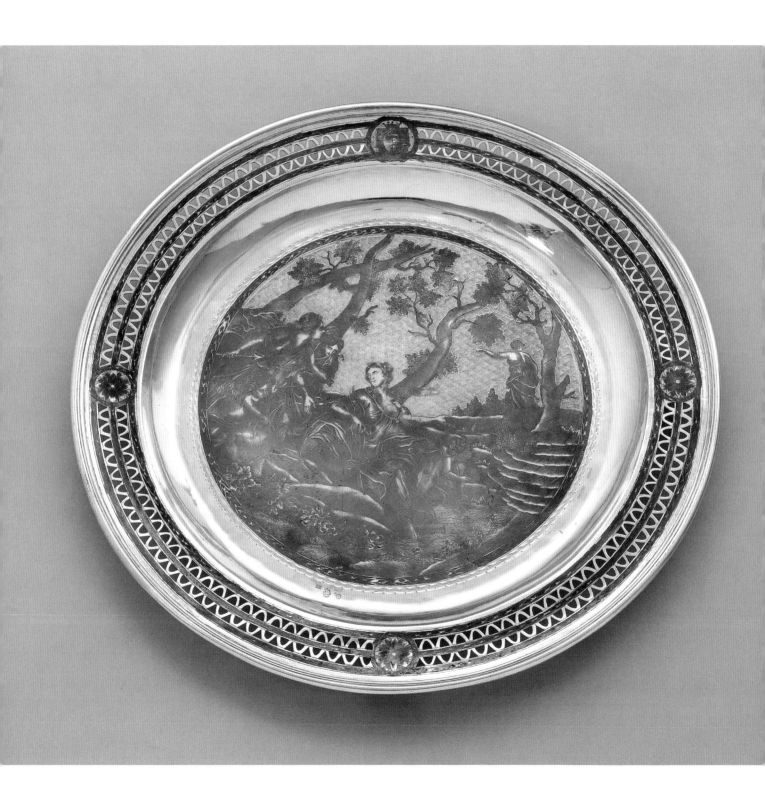

Diana, goddess of the hunt, resting with her nymphs and two cupids in a wooded landscape is featured on a large silver-gilt plate, decorated in niello (fig. 82). The busy, almost baroque, scene is filled with the lavishly draped dresses of the figures and luxuriant vegetation (for a detail see p. 86). The very dark niello contrasts with the Neoclassical openwork pattern that forms the rim. This design is broken by three rosettes and a coat-of-arms at the top. The maker, Semen Kuzov (active 1780–98), was a prominent niello master in Moscow.

The coat-of-arms on this service belongs to the Konovnitsyn family, which in 1798 received from Paul I the right to use it. According to Sergei Troinitskii, a curator at the Hermitage before the Revolution, the only Konovnitsyn family member who was wealthy enough to have ordered such a service was Count Pëtr Petrovich Konovnitsyn (1764–1822). He was promoted to major general in 1797 and named chief of the Kiev Grenadier Regiment. The next year the count retired to his estate of Kiiarov in the Gdovskii district, although he later became a hero in the Napoleonic Wars.[41] This service depicting mythological and gallant scenes was made for Pëtr Petrovich's marriage to Anna Ivanovna Rimskaia-Korsakova, which took place in 1798, the same year as his retirement and the confirmation of his coat-of-arms.[42] Consisting of approximately seventy pieces, the large service included four small oval dishes, two large oval dishes, four round platters (the Hillwood example appears to be one of four with the same scene), two large and seven small oval tureens, and forty-eight plates. Decades later, but prior to the Revolution, it was part of a large collection of various objects and paintings, both Russian and non-Russian, that belonged to Princess M. A. Shakhovskaia.

Liturgical silver did not lose its importance in this secular and enlightened era. While objects made for the church retained traditional forms and motifs, Neoclassical elements and western motifs were often in evidence. The construction of *oklads* also changed. By the late eighteenth century they were almost always of a single piece of metal with adornments, such as haloes and necklaces added. An icon of the *Mother of God "Promise of Those Who Suffer"* has both a very unusual subject and an *oklad* decorated in niello with classical vases, draped with swags of laurel leaves (fig. 83). A vine of leaves encircles the halo and shoulders of the Mother of God, with the vases forming a frame along the edges. All are rendered in dark niello against a gold stippled ground. A prayer inscribed around her halo invokes her as "the brightest dawn of the Heavenly King."

An *oklad* of the *Annunciation* made in 1781, this time embossed with columns of vases and urns stacked one on top of another, is much more rococo in the excessive lavishness of the ornament (fig. 84). Fruits and flowers flow out of the tops of the urns in florid splendor. While the Mother of God kneeling at her table under a baldachin faithfully reflects the painted icon underneath, the urns and vases are an addition to the metal *oklad*. In addition these elements are sculpturally defined creating considerable

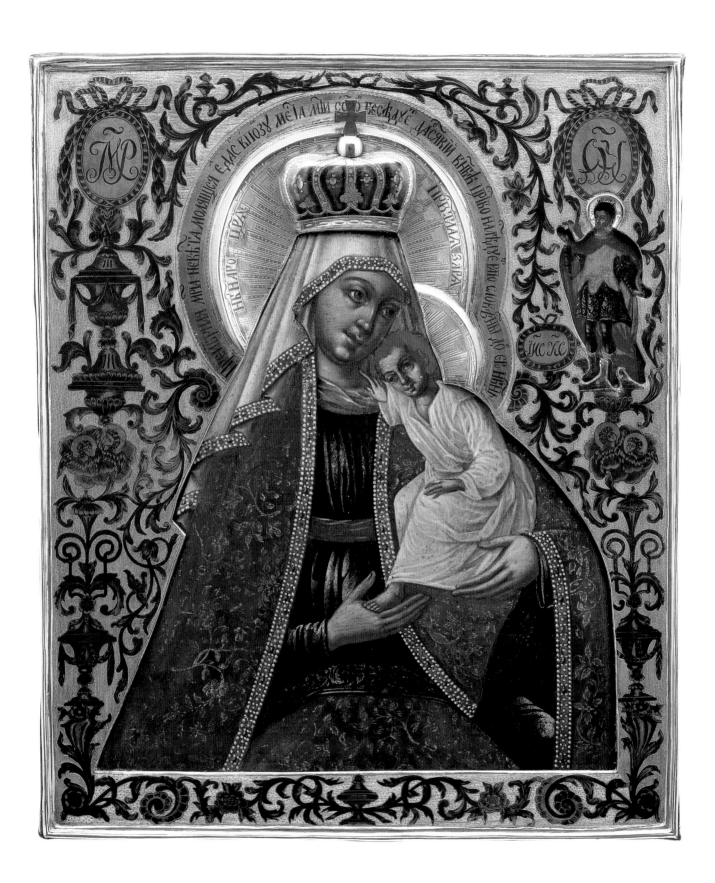

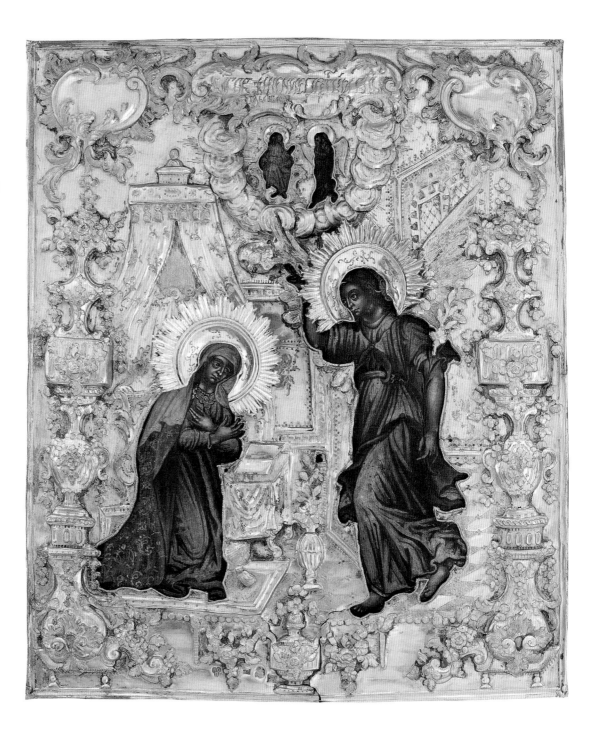

movement and busyness in the image. *Oklady* were often added later as an adornment to a beloved icon as an act of piety or thanks. This was the case with the *Annunciation oklad* because the painting under the cover is more subdued and was probably painted in the early eighteenth century. As icon specialist Wendy R. Salmond notes, the *oklad* served to protect the icon physically from touching, kissing, and the soot from candles. It also served spiritually as a border between this world and the one beyond.[43] By the nineteenth century both *oklad* and icon were often made at the same time.

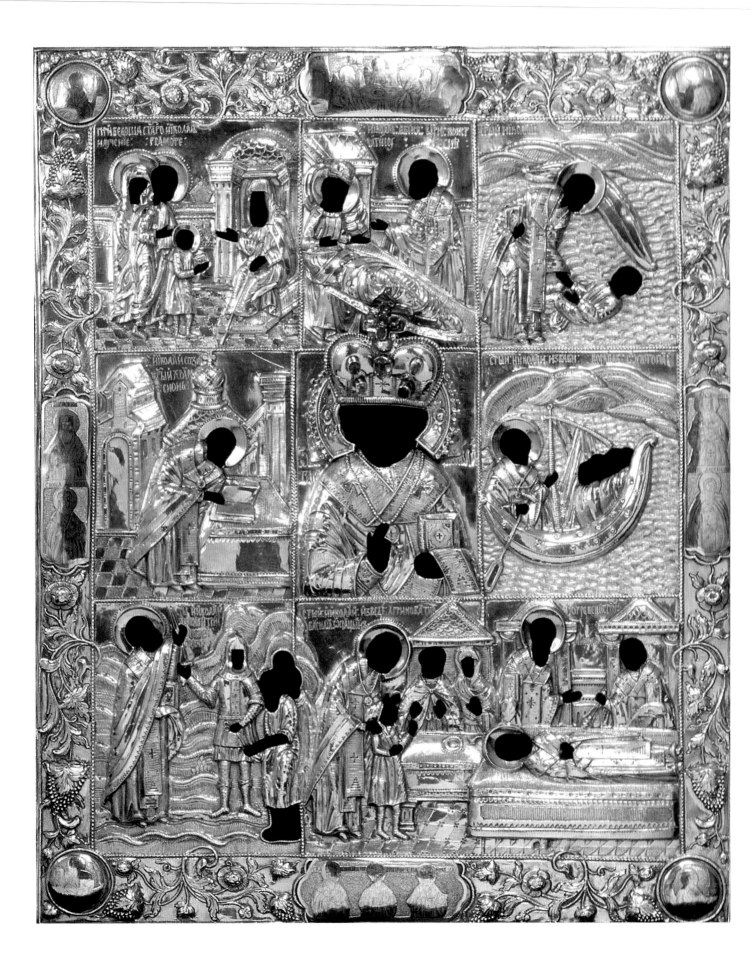

Another *oklad* and chalice reveal the tendency to continue traditional forms of decoration into the 1770s. The *oklad* (fig. 85), made in 1775, is a masterpiece of repoussé and chased design. (The original icon was separated from it probably in the 1920s or 1930s and replaced with a very poor twentieth-century oil painting on chipboard.) Dedicated to St. Nicholas the Miracle-worker, the usual twelve scenes from the life of this favorite Russian saint have been reduced to eight in a variant known as St. Nicholas of Velikoretsk. It is thought that the Muscovite state used this icon in bringing Christianity to the indigenous people around Viatka, northeast of Moscow in the sixteenth century. Salmond notes that the presence of two Moscow metropolitans on the niello plaques strengthens this theory.[44]

The chalice (fig. 86) has a silver fretwork cage around its gilded bowl like an earlier eighteenth-century example. But this cage has a very regular pattern of rosettes, compared to the graceful vines, leaves and vases of the chalice of the 1740s (see fig. 36). The very broad base of the chalice is embellished with silver rococo scrolls and leaves against a gilded ground. Small irregular niello medallions (*drobnitsii*) are attached to the bowl and the base. On the bowl, as was customary, they depict the Deësis and the Crucifixion, and on the base there are six scenes from the Passion of Christ.

OPPOSITE: *Fig. 85*
Oklad *of* St. Nicholas of Velikoretsk with Scenes from Life
Moscow, 1775
Fedor Studentsov (active 1775–80)
Silver gilt, niello, paste gemstones
H. 22⅝ in. (57.5 cm.),
W. 18¼ in. (46.3 cm.)
54.12

RIGHT: *Fig: 86*
Chalice
Moscow, 1774
Ivan Mikhailov (1705–after 1774)
Silver, parcel gilt, niello
H. 14⅜ in. (36.5 cm.),
Dia. of base 9¼ in. (23.5 cm.)
12.83

Two liturgical plates in the Hillwood collection and a portable sacraments box are examples of what must have been a staggering amount of silver made for the church. A liturgical plate (*tarel'*, not to be confused with a paten [*diskos*], which is footed) is used in the preparation of the bread for the communion service (fig. 87). The many knife marks testify to the use of these plates for cutting the bread to be placed in the wine. Engraved images on the plates refer to lines from the liturgy said during communion. A priest traveling to minister communion to the sick carried a small container around his neck, outfitted with a tiny chalice and a box for the bread (fig. 88). Engraved images of the Crucifixion flanked by the Mother of God and John the Baptist decorate the front of the cross-shaped box.

Fig. 87
Two liturgical plates
(left) Russia, 18th century
Silver, niello
Dia. 6⅛ in. (15 cm.)
12.72

(right) Moscow, 1779
A I Z *for unidentified maker*
(active 1779)
Silver, niello
Dia. 5½ in. (14 cm.)
12.71

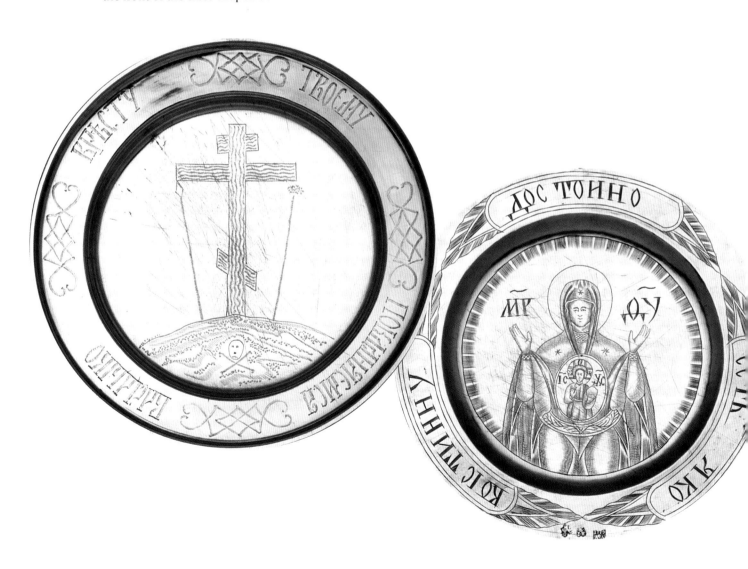

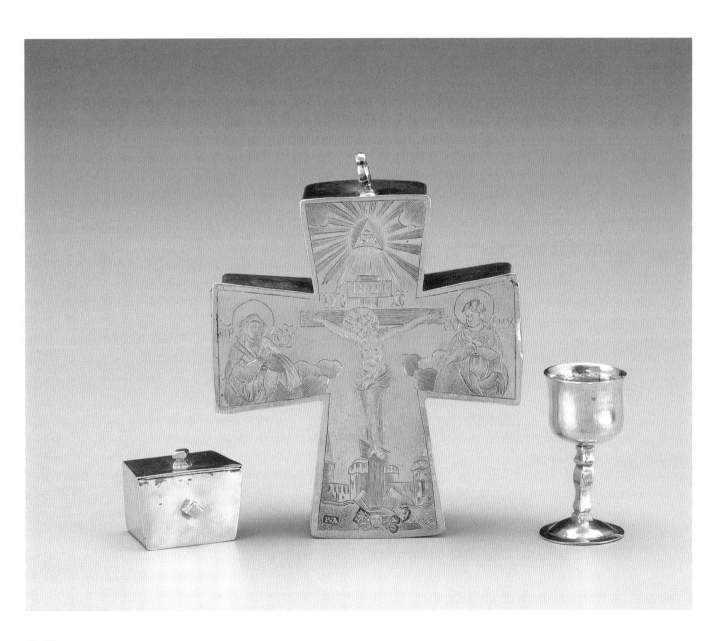

Fig. 88
Communion box
Moscow, 1793
R L for unidentified maker
Silver, parcel gilt
H. 4⅛ in. (11.7 cm.),
W. 3⅝ in. (9.2 cm.),
D. 1⅛ in. (2.9 cm.)
Gift of Mrs. John E. Wilhelmy Jr,
1993. 12.604.1–3

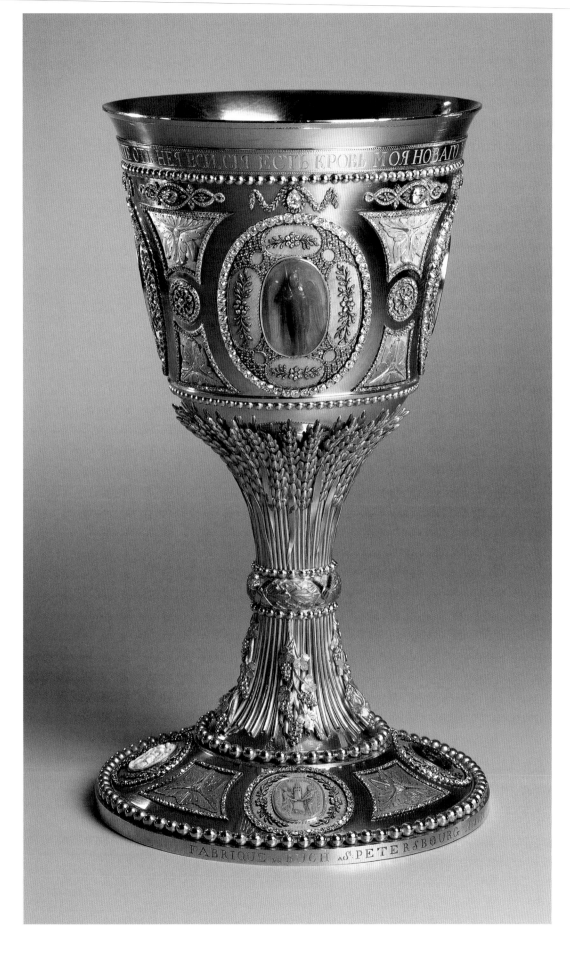

Fig. 89
Chalice
St. Petersburg, 1891
Iver Windfeldt Buch (1749–1811)
Gold, diamonds, chalcedony,
bloodstone, nephrite, carnelian,
cast glass
H. 13 in. (33 cm.),
Dia. of bowl 7 in. (18 cm.)
11.223

These everyday religious objects are in sharp contrast with one of the most extraordinary chalices ever commissioned. Catherine placed the order for this chalice and its accompanying set with Iver Windfeldt Buch (1749–1811), a silver- and goldsmith (fig. 89). The gold and diamonds for the chalice were provided by the State Treasury, and eight "antique stones" came from Catherine's extensive private collection.[45] The eight carved stones include some non-traditional subjects and are set both on the bowl and on the foot. Most noticeable in Buch's design of the chalice is an unconventional realism in the stalks of wheat and bunches of grapes on the stem. These Western symbols of the communion bread and wine were unknown in Russian liturgical art before this period. Catherine presented this liturgical set to the Aleksandr Nevskii Lavra in St. Petersburg on August 29, 1791, the eve of St. Aleksandr's feast day. The monastery was built on the site where Aleksandr Nevskii had defeated the Swedes in 1241, and the Trinity Cathedral, completed only a year before, had been consecrated on his feast day, August 30.[46]

Buch, like Köpping, Blohm, and Eckhardt, was one of the most important silver- and goldsmiths of Catherine's reign. Born in Norway, the son of a Danish goldsmith, he was later designated a Danish royal agent. After completing his apprenticeship in Sweden, he went to Russia where he became a master in the foreign guild in 1776. Buch produced an enormous amount of work for the Russian court. In 1797 alone he created the four torchères, candelabra, and console tables that originally adorned the reception room in Emperor Paul's pet project, the Mikhailovskii Castle. Today these objects can be found in the Small Throne Room in the Winter Palace.[47] Paul also commissioned Buch to produce silver veneered tsar's doors, chandeliers, and a balustrade, all designed by Vincenzo Brenna, for the chapel in his new Castle. Paul ordered some of the silver from the *guberniia* services to be melted down to supply Buch with enough silver.[48] Not a decade later, in 1810 Alexander I ordered the church silver to be melted down in order to fashion the plate for two field churches and a traveling toilet service.[49] Buch also received commissions to produce gold tea and coffee services for the dowries of Paul's daughters.[50] Sadly little remains from Buch's amazing production, although a church chandelier and icon lamps by Buch survive in the chapel at Pavlovsk in addition to those pieces in the State Hermitage.

Like the Buch chalice the design of a later gold chalice (fig. 90) also ignores the traditional iconography of the medallions of the Deësis and Crucifixion on the bowl of a chalice and scenes from the Passion on the foot. In 1824 the State Chancellor, Count Nikolai Rumiantsev (1754–1826), gave this chalice to the St. Petersburg Cathedral of Kazan' in memory of his mother.[51] The chalice is quite simple, although

Fig. 90
Chalice
Moscow, 1824
Gold, rubies, diamonds
H. 10½ in. (27 cm.)
11.38

very elegant. It has one medallion on the bowl, a red ruby cross enclosed by two rows, one of diamonds and the other of rubies, surmounted by a small crown in diamonds (for a detail see p. 123). A similar medallion is on the base. An overall repoussé and chased foliate scroll design on a stippled ground decorates the cup. A row of diamonds between two rows of rubies separates this ornament from the plain lip.

A censer in the collection also reveals the fashion for the Neoclassical style and western allusions (fig. 91). It is shaped like an urn on three ball feet with a cover in the shape of a stylized onion dome. The bottom half of this incense burner is plain, bordered by acanthus leaves and the initials P and M in Latin letters on blue enamel. Blue enamel bands separate four seraphim in openwork on the lid. A ball surmounted by an enameled cross completes the top. Inscribed in Cyrillic around the base is "Given by Plato [Platon] Metropolitan of Moscow, price of gold and work 1069 rubles," and around the stem is "year 1797."

Platon, the Metropolitan of Moscow, served as Paul's tutor and spiritual advisor before the emperor assumed the throne in 1796 following the death of his mother, Catherine the Great. Metropolitan Platon performed the coronation ceremony on April 5, 1797 in the Dormition Cathedral in the Moscow Kremlin. In turn Paul presented Platon with the Order of St. Andrew First-called following a parade and religious ceremony held on April 29.[52]

According to document sources the censer was a gift from Platon to the Chudov Monastery in the Moscow Kremlin, apparently on the occasion of his sixtieth birthday. He presented an identical censer to the Troitse-Sergieva Lavra marking the same occasion.[53] The initials in blue enamel are uncrowned for Metropolitan Platon. Among other churches and monasteries Stalin closed and then destroyed was the Chudov Monastery in 1929–30. Many of its contents were sold, although some rare objects remain in the Kremlin Armory.

I. P. Krag, a German silversmith working in Moscow, is rarely mentioned, but he seems to have received several important commissions at the time of Paul's coronation. Moscow merchants presented him with a Neoclassical salt cellar, made by Krag and now in the State Hermitage.[54] It was surely part of a bread and salt presentation gift.

Both the purchase of silver abroad and its production in Russia in the reign of Catherine was unparalleled. It has only been possible to give a hint of the variety, the vast quantity, and the quality here. While important presentation pieces continued to be made in the nineteenth century, a new lifestyle changed the focus of production from grand tureens and ice pails to domestic tea sets, commemorative cups and snuffboxes.

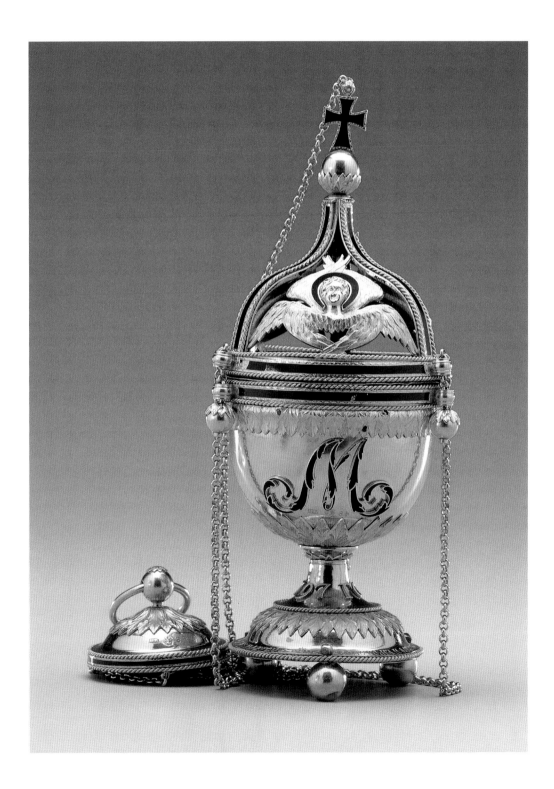

Fig. 91
Censer
Moscow, 1797
I. P. Krag
Silver, gilt, enamel
H. 8⅜ in. (18.5 cm.),
H. piece for holding chain 1½ in.
(4 cm.)
12.596

NOTES

1. A. Lentin, trans., *Voltaire and Catherine the Great: Selected Correspondence* (Cambridge, MA: Oriental Research Partners, 1974), 93.

2. Olga G. Kostjuk, "Introduction," *Gold of the Tsars* ([Stuttgart]: Arnoldsche, 1995), 17 and Marina Lopato, "English Silver in St. Petersburg," *British Treasures from Russian Imperial Collections in the Hermitage*, ed. Brian Allen and Larissa Dukelskaya (New Haven: Yale University Press, 1996) 128.

3. Ministerstvo imperatorskogo dvoram, *Kamerfur'erskii tseremonial'nyi zhurnal'* [hereafter *KTZ*] 1784 (St. Petersburg, 1853–1903), 564.

4. *KTZ* 1787, 29 and 622.

5. See Marina Lopato, "Catherine II's Collection of French Silver," 579–84 and Björn R. Kommer, "Remarks on Catherine II's Commissions for German Silver," 585–90, both in *Catherine the Great & Gustav III* (Stockholm: National Museum, 1999) for descriptions of French and German services made in Catherine's reign.

6. The other was an everyday service she purchased from the Danish envoy. See *Sobornik imperatorskago russkago istoricheskago obshchestva*, 13 (1876), 272 and Simon Sebag-Montefiore, *Prince of Princes: The Life of Potemkin* (New York: St. Martin's Press, 2001), 91.

7. Baron A. Fel'kerzam, *Opisi serebra dvora Ego Imperatorskago Velichestva*, vol. 2 (St. Petersburg: P. Golike & A. Vil'borg, 1907), part 2, 104–16.

8. *KTZ* 1799, 962.

9. For more about Russian dining, especially with porcelain, see Anne Odom, "The Politics of Porcelain," in *At the Tsar's Table: Russian Imperial Porcelain from the Raymond F. Piper Collection* (Milwaukee: Marquette University, 2001), 11–22.

10. A. M. Kuchumov, *Russkoe dekorativno-prikladnoe iskusstvo v sobranii Pavlovskogo dvortsa-muzeia* (Leningrad: Khudozhnik RSFSR, 1981), 290.

11. Fel'kerzam, *Opisi*, vol. 2, 28–33.

12. Ibid., 417, no. 59, and 413, no. 47.

13. See Lopato, "Catherine II's Collection of French Silver," 579; Sebag-Montefiore, 53 and 72.

14. Lopato, "Catherine II's Collection of French Silver," 579.

15. For a tureen from this service, see *Der Zarenschatz der Romanov: Meisterwerk aus der Ermitazh St. Petersburg* (Speyer: Verlag Gerd Hatje, 1994), 192.

16. Baron A. Fel'kerzam, "Inostrannye mastera zolotogo i serebriannago dela," *Starye gody* 3 (Jul.–Sept. 1911), 100. For a brief biography of Fel'kerzam, see Marina Lopato, "Baron Armin Yevgenyevich von Foelkersam, Curator of Silver and Jewellery," in *Hermitage*, no. 2 (Winter 2003–04), 21–22.

17. Fel'kerzam, *Opisi*, vol. 2, 239, no. 32.

18. Ibid., 413 and 418. Fel'kerzam calls these and numerous other coffee and tea sets in his list of works by Köpping and Blohm "gilded silver" (*zolochenye*), as distinct from the "Gilded Service." Presumably these were additions to several services because they vary considerably in style.

19. Ibid., 413 and 417.

20. Ibid., 412.

21. This is quite likely because the salt on the left is inscribed *IM AL P* in Cyrillic for Emperor Alexander Pavlovich.

22. I. D. Kostina, T. N. Muntian, E. V. Shakurova, *Russkoe serebro XVI-nachala XX-veka* (St. Petersburg: Slaviia, 2004), 122.

23. In 1953 Christopher M. Greer, Jr. earned permanent possession of the cup. To receive the cup an owner must win a race five times, not necessarily consecutively or with the same horse. His wife presented the cup to the museum in 1963.

24. Fel'kerzam, "Inostrannye mastera zolotogo i serebriannago dela," 108.

25. See *Secret Treasures of Russia* (New South Wales: Art Exhibitions Australia Limited, 1992), nos. 119 and 125 for two Moscow examples from the State Historical Museum in Moscow. Two bowls, one oval and one round, have floral and fruit motifs almost identical to the Hillwood objects. See *Moscow: Treasures and Traditions* (Washington, D.C.: Smithsonian Institution, 1990), nos. 46 and 47, for two other examples from Moscow.

26. I. D. Kostina, "Russian Jewelry Arts of the Eighteenth to the Twentieth Centuries," *Kremlin Gold: 1000 Years of Russian Gems and Jewels* (New York: Harry N. Abrams, Inc., 2000), 37.

27. See Anne Odom, *Russian Enamels From Kievan Rus to Fabergé* (London: Philip Wilson, 1996), 46–63 for more on enamels from Velikii Ustiug.

28. T. G. Gol'dberg, *Chernevoe serebro Velikogo Ustiuga* (Moscow: Gosudarstvennyi istoricheskii muzei, 1952), 8–9.

29. The merchant Vasilii Kunkin organized the first known factory (*fabrika*) in Moscow in 1751. Around seventy people worked in this establishment, which operated until Kunkin's death in 1761. It had a monopoly producing liturgical plate. See M. M. Postnikova-Loseva and U. Platonova, *Zolotoe i serebrianoe delo XV–XX vekov* (Moscow: Nauka, 1983), 124.

30. Gol'dberg, *Chernevoe serebro Velikogo Ustiuga*, 11, 13, and 14.

31. See Wolfram Koeppe, "Chinese Shells, French Prints, and Russian Goldsmithing: A Curious Group of Eighteenth-Century Russian Table Snuffboxes," *Metropolitan Museum of Art Journal* 32, 704–14. I am grateful to Wolfram Koeppe for alerting me to the purchase by the Metropolitan Museum of a box with the same image and for providing information on the shell, its inscription, and the print source.

32. Z. A. Berniakovich, *Russkoe khudozhestvennoe serebro XVIII–nachala XX veka* (Leningrad: Khudozhnik RSFSR, 1977), 14. For two other shell boxes—one with a scene and one with a design—see Sotheby's, London, July 17, 1996, lots 344 and 345.

33. A very similar teapot was in the collection of Ambassador Jean Herbette. See Christie's Geneva, May 25–26, 1971, lot 459.

34. M. M. Postnikov-Loseva, N. G. Platonova, and B. L. Ul'ianova, *Russkoe chernevoe iskusstvo* (Moscow: Iskusstvo, 1972), no. 73.

35. Ibid., 18.

36. For two examples, see Gunhild Avitabile and Stephan Graf von der Schulenburg, *Chinesisches Porzellan* (Frankfurt am Main, 1992), no. 342 and Christiaan J.A. Jörg, *Chinese Ceramics in the Collection of the Rijksmuseum Amsterdam: The Ming and Qing Dynasties* (London: Philip Wilson, 1997), p. 243. I wish to thank David Johnson for sharing these examples with me. For an example in silver and enamel from China, see *Treasures of Catherine the Great* (London: Hermitage Development Trust, 2000), 223. This cup is described as half a peach. Such cups were symbols of long life.

37. These objects came to the Hermitage from the Grand Duke's collections at the time of his death in 1908. See B. B. Piotrovskii, *Sokrovishcha Ermitazha* (Leningrad: Sovietskii khudozhnik, 1969), no. 99.

38. Quoted in *Russkoe chernevoe iskusstvo*, 19.

39. For a group of similar objects at the State Hermitage, see Berniakovich, no. 108. For an article on a tray at the State Historical Museum, see Iu. A. Kozlova, "Ob utochnenii datirovki chernevogo podnosa iz sobraniia gosudarstvennogo istoricheskogo muzeia," *Muzei* 4 (Moscow: Sovietskii khudozhnik, 1983), 71–73. Hillwood also owns a salt cellar (no. 13.30) in a similar style. See Katrina

V. H. Taylor, *Russian Art at Hillwood* (Washington, D. C.: Hillwood Museum, 1988), 46

40. See Wendy Wassyng Roworth, ed., *Angelica Kauffman: A Continental Artist in Georgian England* (London: Reaktion Books Ltd., 1992), 170 for the image and 169 for the comment that Bartolozzi made a whole series. I thank Yelena Harbick for finding this source.

41. Sergei Troinitskii, "Sobranie kniagini Shakhovskoi," *Starye gody* (June 1914), 6–7, ill. 8–9. For one of the tureens and a plate now in the State Hermitage, see Berniakovich, no. 96.

42. See *Ekaterina Velikaia. Russkaia kul'tura vtoroi poloviny XVIII veka* (St. Petersburg: AO "Slaviia-Interbuk," 1993), no. 143.

43. Wendy R. Salmond, *Russian Icons at Hillwood* (Washington, D.C.: Hillwood Museum & Gardens, 1998), 60.

44. Ibid., 45.

45. A. M. Terekhova, "Novye dannye o proizvedeniiakh peterburgskogo serebrianika Ivara Bukha," *Materialy i issledovaniia*, vol. 2 (Moscow; Sovetskii khudozhnik, 1976), 127. For more about the chalice and especially the stones, see Anne Odom and Liana Paredes Arend, *A Taste for Splendor: Russian Imperial and European Treasures from the Hillwood Museum* (Alexandria, VA: Art Services International, 1998), 212.

46. Nikolai Barsukov, ed. *Dnevnik A. V. Khrapovitskago* (St. Petersburg, 1874), 373, and KTZ 1791, 577.

47. Terekhova, "Novye dannye o proizvedeniiakh peterburgskogo serebrianika Ivara Bukha," 130.

48. James Christen Steward, ed., *The Collections of the Romanovs: European Art from the State Hermitage Museum, St. Petersburg* (London: Merrell, 2003), 168.

49. Kuchumov, *Russkoe dekorativno-prikladnoe iskusstvo*, 287.

50. RGIA, *fond* 468, *opis* 37, *dela* 478, 508, and 509. For a large silver vase made for Paul in 1799, see Fel'kerzam, "Inostrannye mastera zolotogo i serebriannago dela," no. 12.

51. Nikolai Rumiantsev was the son of Pëtr, to whom the tea and coffee set at the Metropolitan Museum (see fig. 65) was given. Alexander I appointed Nikolai Petrovich to the position of minister of foreign affairs in 1807 and state chancellor in 1809.

52. Robert S. Wortman, *Scenarios of Power: Myth and Ceremony in Russian Monarchy* (Princeton, NJ: Princeton University Press, 1995), 176 and 181.

53. See L. M. Vorontsova, *Sokrovishcha riznitsy Troitse-Sergievoi Lavry* (Moscow: Podkova, 2001), back cover. Archive ORDGE, *opis'* 14, *delo* 5, 1861g, *list* 54 *ob*. I thank Svetlana Kovarskaia at the Kremlin Armory and Liubova Shitova of the Troitse-Sergieva Lavra for this information.

54. N. V. Kaliazina, G. N. Komelova, N. D. Kostochkina, O. G. Kostiuk, and K. A. Orlova, *Russkaia emal' XII–nachala XX veka iz sobraniia Gosudarstvennogo Ermitazha* (Leningrad: Khudozhnik RSFSR, 1987), no. 99.

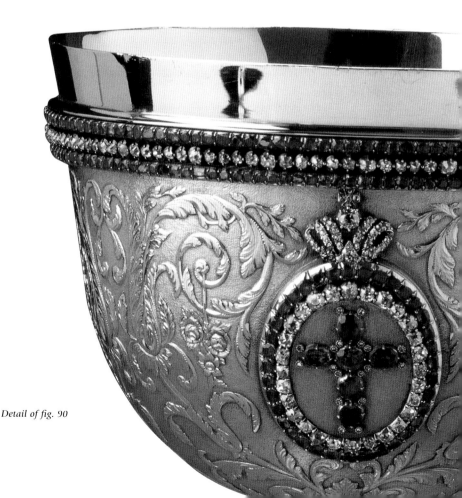

Detail of fig. 90

REVIVAL STYLES FROM EMPIRE TO NEOROCOCO: ALEXANDER I AND NICHOLAS I

A S NAPOLEON EXPANDED his rule across Europe, the fashionable Empire style created in Paris spread into Russia, where it was also known as the Aleksandrovskii style. The Napoleonic campaigns succeeded in uniting Europe in what was the last truly international decorative style until the twentieth century. The paradox of the Russian elite succumbing to the cultural tastes of France, now its enemy, is indicative of the enduring attraction of all that was foreign. The Empire style, recalling the militaristic Roman empire, was particularly beloved by the Russians who, in fact, considered the defeat of Napoleon in 1812 their finest hour. The style was also befitting an increasingly imperialistic nation. The mood of national confidence lasted until the Russian defeat in the Crimean War in 1855. Despite the later exploration of historicist styles, which soon fired artists' imagination, the Empire style was remarkably enduring and never completely lost its hold on the taste of the elite, especially for ceremonial affairs.

Military generals, battle scenes, soldiers and officers in regimental uniforms, and commemorative subjects all figure prominently in the decorative arts of the first third of the nineteenth century. Both Alexander I and his brother, Nicholas I, basked in the glory of the Russian army's victories over Napoleon. St. Petersburg was a military society; military personnel in uniform made up more than ten per cent of the population of the capital.[1] References to the Napoleonic campaigns can be found in numerous presentation objects and souvenir snuffboxes. The Napoleonic Wars were a powerful reference point for the generations growing up during these tumultuous decades.

Officers frequently made gifts to their regiments and to their commanders upon promotion or retirement. According to the inscription on one military presentation

cup in the Hillwood collection the officers of the Aleksandrinskii Hussars Regiment presented it to their commander, Major General Khristofor Romanovich Reitern (Christoph Adam von Reutern, 1782–1833), perhaps for his promotion in 1819 (fig. 92). He had led them from 1813 to 1820. The cup is inscribed August 14, 1813, a reference to the Battles of Goldberg and Katzbach near Dresden in eastern Germany. The Aleksandrinskii Regiment distinguished itself there with an honorable mention (*otlichie*), one of many battles fought in the Russian pursuit of Napoleon.[2] The names of the officers are all listed on a banderole that winds its way at an angle around the cup. The cup is marked *Meyer,* for the St. Petersburg firm of Carl Friedrich Meyer. Born in Narva, Meyer had been an apprentice to Iver Buch in St. Petersburg.[3]

The other military cup is made of gold and is a classic Empire example of the 1830s (fig. 93). The handle of the cup's lid is carved in minute detail to resemble a plumed helmet (derived from a Roman model) of the Imperial Chevalier Guards. The helmet sits on a band of laurel leaves and berries, an emblem of victory. A band of oak leaves and acorns, symbolizing power, surrounds this, and a row of acanthus leaves encircles the rim of the lid. Acanthus leaves also decorate the stem and foot. Details like the chasing of the matte plume stand out against the shiny burnished gold of the helmet creating striking visual contrasts.

An inscription on the front indicates that the officers of the Chevalier Guard Regiment presented the cup to General-Adjutant Count Stepan Apraksin (1792–1862) on June 25, 1833. Count Apraksin took part in the Napoleonic campaigns beginning in 1813. On December 13, 1825 he and his regiment played a major role in crushing the Decembrist revolt. This uprising was led by veterans of the Napoleonic Wars who were anxious to install a constitutional monarchy in Russia. Apraksin was rewarded for his services with the rank of major general. Elevated to the position of general adjutant in 1830, he also commanded the regiment in the campaign that suppressed the Polish revolt of 1831. On June 25, 1833, the date inscribed on this piece, Apraksin was given command of the Cuirassier Division.[4]

This cup is an especially grand example of the goldsmith's art. Its maker, Johann Christian Barbé (1780–1843), was born in Frankenthal in the Palatinate near Frankfurt am Main and came to Russia in the early nineteenth century. He became a master in 1804 and presumably worked with his younger brother Carl Helfried Barbé. The latter is identified as the maker of gold boxes, which are merely signed *Barbé*. It is possible that Barbé was a store with a workshop attached.[5]

Despite Russian success in the Napoleonic Wars, certain areas of the Russian empire remained restless. In 1820 Alexander I presented a *kovsh* to the troops of Major Andrei Andreevich Mizinov, posted in the Ural Mountains at a time when Tatar and Bashkir tribes were still causing trouble on the frontier (fig. 94). While the gift of a traditional object such as a *kovsh* continued into the nineteenth century, it was far less common

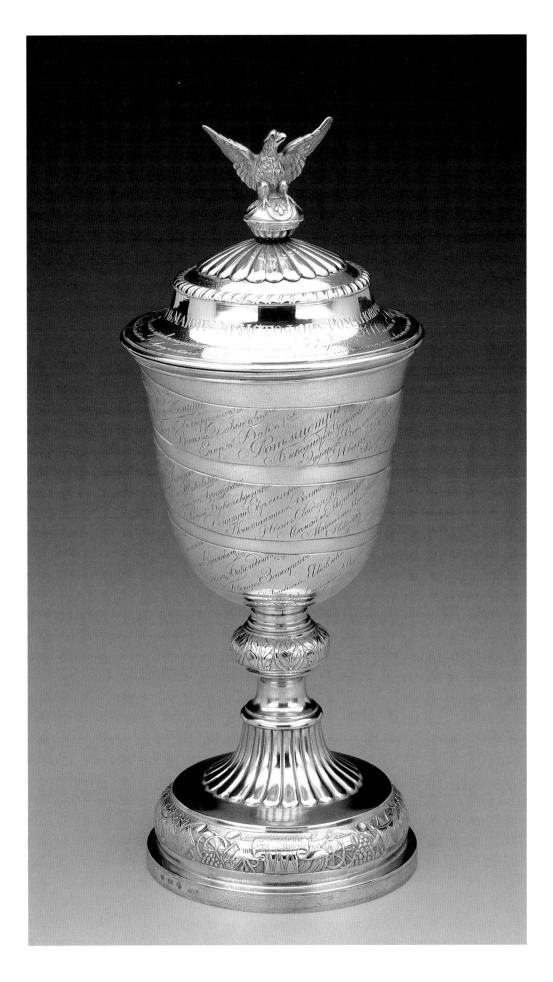

Fig. 92
Military presentation cup
with cover
St. Petersburg, ca. 1820
Firm of Carl Friedrich Meyer
Silver
H. 12½ in. (31.8 cm.)
12.107.1–2

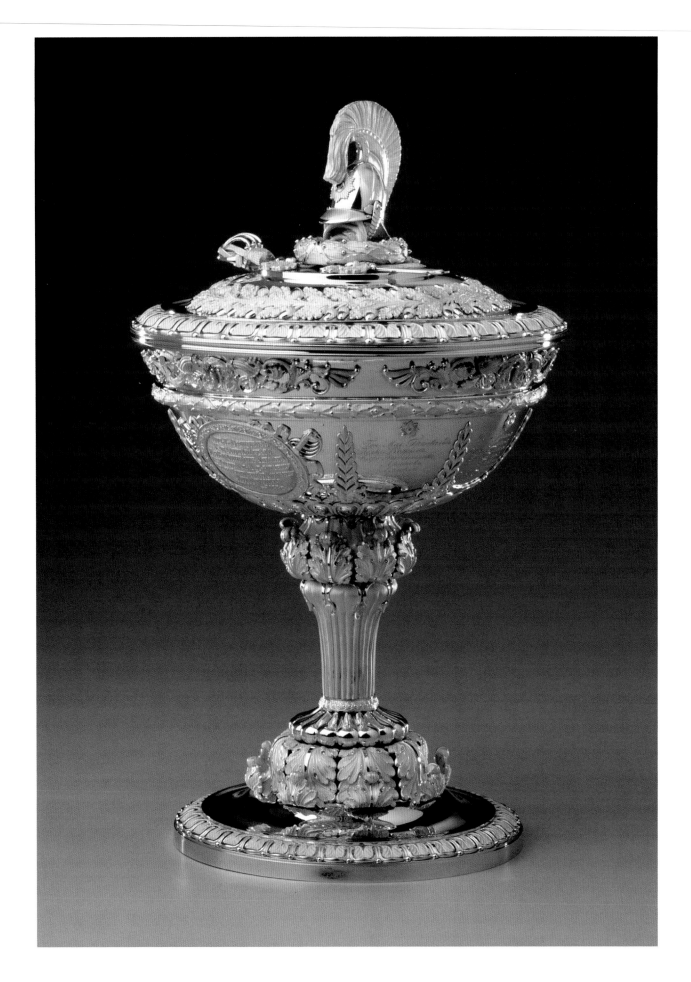

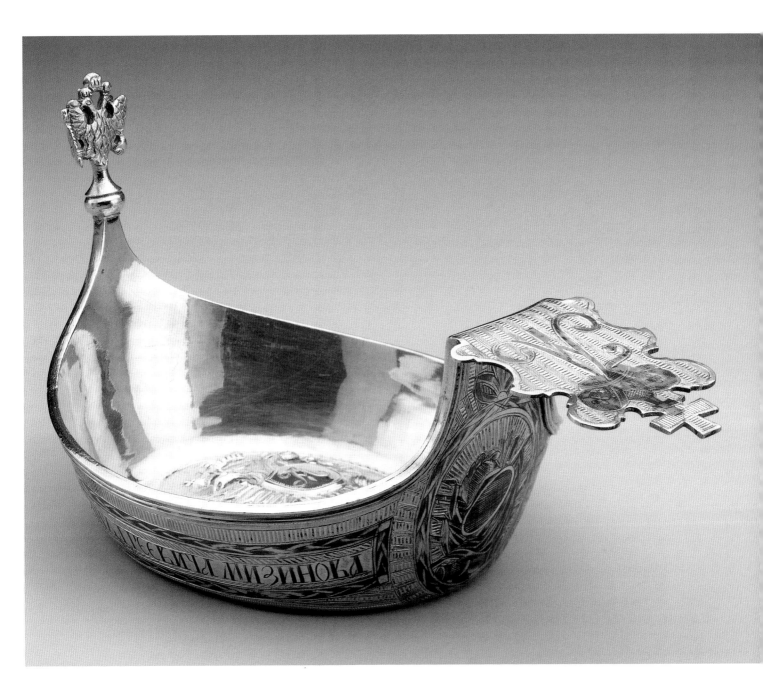

OPPOSITE: *Fig. 93*
Military presentation cup with
cover
St. Petersburg, 1834
Johann Christian Barbé
(1780–1843)
Gold
H. 13½ in. (34.3 cm.),
Dia. 7¾ in. (19.7 cm.)
11.42.1–3

ABOVE: *Fig. 94*
Kovsh
Moscow, 1820
Silver gilt, niello
L. 9¾ in. (24.8 cm.),
W. 5⅛ in (13 cm.)
12.66

than before. This one presents a much flatter and less curved silhouette than earlier examples of this form. It is distinguished by its decoration—both the inscription around the side and the cipher and crown of Alexander I on the attached handle underneath the imperial crown are rendered in niello. Military trophies are contained in medallions at either end of the vessel.

Gold snuffboxes, often decorated with enamel and gemstones, had been among the most popular imperial gifts to servitors, friends, and lovers in the eighteenth century. In the nineteenth-century they gave way to less costly small boxes made of silver and embellished with niello. Architectural views of favorite or newly constructed buildings and monuments, city and province maps, and military subjects were among the most common themes. These boxes, at least in the first half of the nineteenth century, projected a shared historical memory for both the grandees and the growing clientele of gentry and merchants who could afford such souvenirs. They frequently depicted images derived from prints or maps and thus reflected the explosion of such

nationally inspired popular engravings in the marketplace.[6] It is not surprising that the views on each of these boxes are rendered in niello. The black alloy remains in the engraved lines after the surface is polished, thus dramatizing the miniature engraving. By the late nineteenth century makers turned out such boxes in vast quantities of varying quality and interest.

Among a large collection of silver boxes at Hillwood a few representative ones relate to military events that became symbolic of heroism and bravery. During and after the Napoleonic campaigns a legend grew up around Lieutenant General Nikolai Raevskii (1771–1829), commander of the VII Corps for his defense of Saltanovka, a village near the city of Smolensk in 1812. According to the story, Raevskii, with his two sons, Aleksandr, age sixteen, and eleven-year-old Nikolai, personally led the Russian forces across a pontoon bridge to counterattack the French, with Aleksandr carrying the standard. The workmaster Ivan Kaltykov may have copied a popular engraving of the same scene published in 1813 by the Italian Salomon Cardelli (active in Russia 1796/7–?1814).[7] The scene is recreated on the bottom lid of this two-lidded box (fig. 95). The fortress walls on the upper lid are probably intended to be those of Smolensk. Raevskii is credited with stalling the French forces long enough for the armies of generals Pëtr Bagration and Mikhail Barclay de Tolly to join up in Smolensk. This event even makes an appearance in Lev Tolstoi's *War and Peace*.[8] Anecdotes and images of this sort served to reinforce national pride following Russia's defeat of Napoleon.

BELOW LEFT: *Fig. 95*
Box with **Feat of General Raevskii and his Sons**
Moscow, 182?
Ivan Kaltykov (active 1820–26)
After Salomon Cardelli (active in Russia 1796/7–1814?)
Silver, niello
H. ¾ in. (2.1 cm.),
W. 1⅝ in. (4.1 cm.),
D. 2½ in. (6.4 cm.)
13.31

BELOW: *Fig. 96*
Box with **Nicholas Crossing the Danube**
Moscow, 1830
Gavrila Ustinov (active 1806–52)
Silver, parcel gilt, niello
H. ¾ in. (2.1 cm.),
W. 3¼ in. (8.3 cm.),
D. 2 in. (5.1 cm.)
13.32

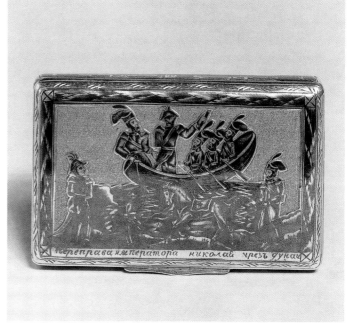

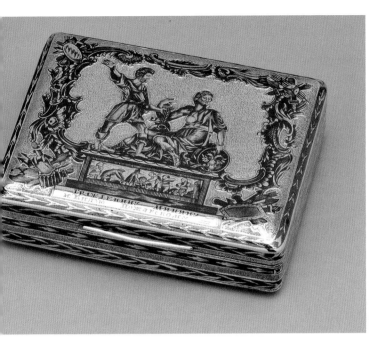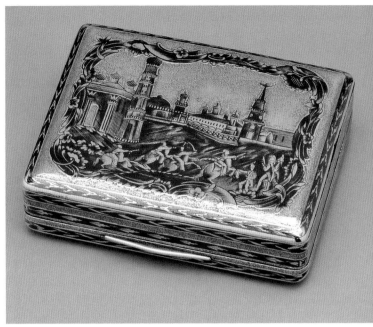

ABOVE: *Fig. 97*
Box with statue of Minin and
Pozharskii
Moscow, 1823
Silver gilt, niello
H. 1⅛ in (4.1 cm.),
W. 3⅝ in. (7.2 cm.),
D. 2⅞ in. (7 cm.)
13.29

ABOVE RIGHT: *Back of fig. 97,*
View of Kremlin

Another military event, which took place during fighting against the Turks in the Balkans in June 1828, became the subject of a popular print that also enjoyed wide distribution and was copied onto boxes in niello (fig. 96). Nicholas I, who had desperately wanted to play a role in the campaigns of 1812–14, was determined to lead his troops in the Balkans. Here he is seen crossing the Danube with Zaporozhets Cossacks in an open boat.[9] The box is inscribed "The Passage of Emperor Nicholas across the Danube". The official biographies of Nicholas I often featured this event.

By coincidence the year 1812 was the two hundredth anniversary of the efforts of Minin and Pozharskii to drive the Poles out of Moscow. Kozma Minin was a butcher from Nizhnii Novgorod, who funded the troops led by Prince Dmitri Pozharskii. The event was to be commemorated by a statue (fig. 97). In 1809 an engraving was widely circulated to raise money for the project. The sculptor, Ivan Martos (1752–1835) finally created the monument in 1818, and it was erected in Red Square. He adhered to the classical tradition of clothing his figures in ancient Roman dress. At the bottom of the statue is the inscription in Russian: "To Citizen Minin and Prince Pozharskii from a grateful Russia." A copy of the statue is rendered on this box of 1823 in much more detail than the images on the two previous boxes.

A view of the Ivanov Square in the Kremlin is depicted on the back with a view of the Ivan Bell Tower on the left and the Spasskii Gate on the right (fig. 97). There are soldiers on horseback fighting in the foreground. This scene could be read as Russian soldiers driving Polish invaders from the Kremlin in 1612, but it links Minin and Pozharskii, protectors of Russia, to those who forced Napoleon out of Moscow. In fact, the image on the back of the box appears to have as its source an engraving, *Fire of the Kremlin in 1812*, without the fire.[10] The sculpture and box symbolize the powerful national feelings ensured by Russia's defeat of a second invader two hundred years later.

The production of such patriotic souvenirs increased exponentially as the century wore on. Some of these boxes were finely crafted with details well defined, as is the case in the Minin and Pozharskii box. Others, like the one depicting Nicholas I on the Danube, can be small and quite crude. Such boxes marked what one author called the "bibelotization" or the "democratization of collecting" in the nineteenth century.[11]

Snuffboxes engraved with maps of cities and provinces and decorated with niello also became extremely popular at the beginning of the nineteenth century, although they were already known in the eighteenth. These seem to be related to another new phenomenon—the dissemination of engraved city and regional maps. One of the earliest known boxes of this kind is from the 1770s with street maps of the Siberian cities—Tobol'sk, Tomsk, and Tiumen'—among others on the lid and side. In 1796 the Velikii Ustiug master Ivan Ostrovskii (1759–1828) made another box with a map of St. Petersburg. He copied it from a plan of the city drawn up in 1786, then revised and published in 1791.[12]

In Hillwood's collection of boxes, two feature maps of the province of Vologda. The province included the old trading cities of Vologda, itself, and Velikii Ustiug. These particular maps probably appeared so frequently because both cities were still renowned for their niello masters. On one side of a round box (fig. 98) made in 1817 in Velikii Ustiug is the province in outline with the principal cities noted. In the lower right-hand corner is a *verst*, or mileage chart, much like that found on an old ESSO map, allowing the owner to determine the distance from one city to another. On the bottom of the box appear all the statistics of the province: its geographical location and its population, including the number of merchants and peasants of various kinds, as well as churches, monasteries, and factories. These boxes are among the last souvenirs of the north. It was perhaps the final gasp of a once powerful and vital area of the country forced into decline as its trade routes ceased to be in demand.

The production of silver boxes with niello expanded as the century wore on and as their popularity increased. With the advent of smoking what had once been a snuffbox or a matchbox quickly became a cigarette or a cigar box. Here too the decoration was often copied from engravings. Two cigarette boxes with a view of the cityscape of Moscow from across the river are good examples (fig. 99). The panoramic scene depicts the Kremlin wall and its towers surrounding the ancient citadel, with the Ivan Bell Tower as the tallest. The domes of St. Basil's in Red Square are at the right and in the center the Great Kremlin Palace and the Armory, newly completed in 1849 and 1851 respectively. The sharp, angular treatment of the bridge supports distinguishes this image, which was copied from a popular lithograph after a drawing by D. S. Indeitsev called "View of the Kremlin from the Stone Bridge," part of a series published by the firm of I. Kh. Datsiaro (Giuseppe Daziero, 1806–1865).[13] (For an American print derived from the Daziero one, see fig. 100.)

Fig. 98
Box with map of Vologda Province
Velikii Ustiug, 1817
Fedor Klimov Bushkovskii
(active 1795–1834)
Silver gilt, niello
Dia. 3⅜ in. (8.7 cm.)
13.23.1–2

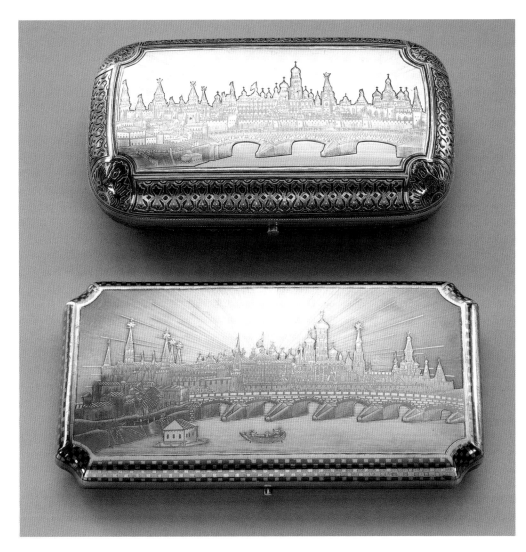

Fig. 99
Boxes with view of the Kremlin
(top) Moscow, 1883
Aleksandr Sergeevich Egorov
(active 1868–97)
Silver gilt, niello
H. 1 in. (2.5 cm.),
W. 4¾ in. (12.07 cm.),
D. 2¾ in (7 cm.)
13.76

(bottom) Moscow, 1856
Silver, niello
H. ¾ in. (1.9 cm.),
W. 5¼ in (13.3 cm.),
D. 3 in. (7.6 cm.)
13.102

BELOW: Fig. 100
"The Kremlin of Moscow"
Steel engraving
Selmar Hess, Publisher, New York,
1882.

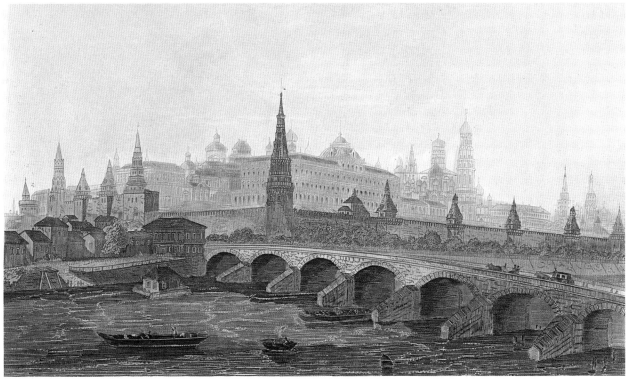

New industrial technologies distinguish a group of mugs, see figure 101 for one, and small beakers. They feature classical themes, such as the *Three Graces*, also known as *The Dance of the Graces*, twirling around the lower portion of the vessel. The figures on these cups are stamped out or die pressed in a mold and applied onto the body of the mug. Mills that could roll silver thin enough to press into a die were invented in the West at the end of the eighteenth century and spread to Russia. This process replaced the time-consuming labor of hand chasing and allowed multiples to be produced rapidly and inexpensively for wide distribution. In addition to the dancing graces, three plaques depicting other classical images are applied to the sides of the mug. The subjects include Minerva in a chariot drawn by a young man; two figures, one tying Cupid to a tree; and Venus riding on a shell drawn by dolphins. To complete the classical references are two heads with Roman helmets, one of which is the handle of the lid, the other is mounted on the handle.

Once the technique of stamping out applied ornament was perfected, it was reproduced in great numbers. Peter Andreas Möller (active 1794–1838) made three mugs and one beaker in the Hillwood collection decorated in this manner. They were all completed between 1828 and 1830. The image of the *Three Graces* is taken from an engraving by Gavriil Skorodumov (1754–1792), published in London in 1778 after an original by Angelica Kauffman.[14] Skorodumov had studied in London with Francesco Bartolozzi (also the engraver of Kauffman's *Winter*, mentioned earlier).

Another example of applied ornament can be found on a group of commemorative cups, which feature images of Nicholas I and Alexandra, and in the center a copy of a portrait medal of the young Tsarevich Alexander in uniform (fig. 102 right). The profile portraits of the imperial couple are in medallions imitating real medals, complete with identifying inscriptions. These commemorative cups celebrated a new ceremony Nicholas I introduced when the Tsarevich Alexander, the future Alexander II, achieved his majority on his sixteenth birthday in 1834, and may have been distributed to people in attendance. He took the oath on April 22, Easter Sunday, pledging allegiance to his father and the laws of Russia. He is wearing the uniform of a Cossack ataman, and the braid and decorations of his father's suite, which he wore that day.[15]

This cup also bears a later inscription: "From N. Ia. Strizkhov, the prize of first thoroughbred-trotter city horse, which ran on December 6, 1864 in Barnaul." Barnaul was an administrative center in the southern Urals, 800 miles southeast of Ekaterinburg on the frontier with Central Asia. Thus a commemorative mug of a religious imperial event was transformed into a racing cup.

The other mug (fig. 102 left) is one of two at Hillwood made to celebrate the marriage in 1841 of Alexander and his new bride Maria Aleksandrovna, daughter of Grand Duke Ludwig II of Hesse and the Rhine.[16] Profile portraits, also in the form of imitation medals, of Nicholas I and Alexandra Fedorovna are on either side of a double portrait of Alexander and Maria facing each other in the center opposite the handle. Both the Hillwood examples sport high curved handles. The applied medals are topped by the imperial crown and linked by the floral motifs which surround the medallions. The body sits on a repoussé foot with a foliate motif running over an uneven surface.

Because many of these souvenir and commemorative items have survived, we can form quite a detailed picture of this aspect of Russian silver production. However, it is table silver that would have been the bread and butter of any nineteenth-century silversmith, and the number of people wealthy enough to afford it for the table was constantly growing. As evidence of this, in the early nineteenth century there were more than one hundred gold and silver masters in St. Petersburg, who worked for the most part in the silver rows of the Gostinyi Dvor (the old market) on Nevskii Prospekt. By 1823 there were 200 and by 1848 there were 300.[17] Although the Russian and foreign guilds continued to exist as they had in the eighteenth century, they had lost their importance with the growth of capitalism. By the early twentieth century they had ceased to exist in many cities.[18] Imperial commissions still went to St. Petersburg silversmiths, but many of the most important commissions in this period went to Paris or London, especially after Alexander and Napoleon signed a peace treaty at Tilsit in 1807. Alexander, himself, ordered two important services from Paris. In 1808–09,

OPPOSITE AND ABOVE: *Fig. 102 Two mugs with applied portraits (left) Moscow, 1841*
N G *for unidentified maker*
Silver
H. 5⅞ in. (14.9 cm.), Dia. 4¾ in. (12.1 cm.)
12.108.1–2

(right) Moscow, 1834
N G *for unidentified maker*
Silver gilt
H. 5⅞ in. (14.9 cm.), Dia. 4¹¹⁄₁₆ in. (11.9 cm.)
12.109.1–2

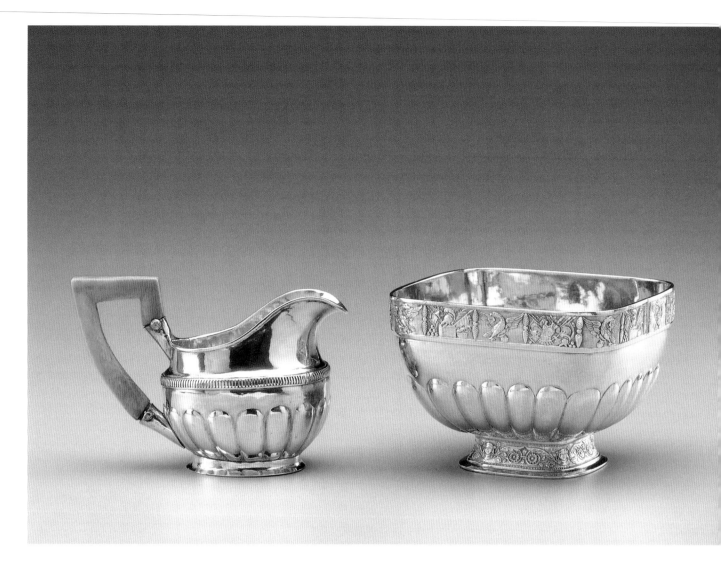

Mikhail Pavlovich, Alexander I's youngest brother, bought more than a thousand silver pieces, including a table service with his monogram from the French silversmith Martin-Guillaume Biennais (1764–1843), an example of the persistent preference for foreign, especially French, production and style.[19]

There is no question that a huge amount of domestic table silver was produced to meet the new tastes and social trends of the nineteenth century. Ceremonial banquets celebrating diplomatic visits and weddings certainly continued, but a preference arose, even among members of the imperial family, for intimate walks or rides in parks, gathering for tea and conversation (tea sets, both porcelain and silver abounded), and for a more casual social intercourse. This was true among the nobility, the landed gentry and the urban merchants, bureaucrats, and intellectuals. They often looked to English country estate culture and its comforts as the new model for life in Russia. A cream pitcher, a sugar bowl, and a cake basket (fig. 103 and fig. 104) symbolize not only the new attitude toward life but also the styles that became fashionable. Whole tea and coffee services began to be produced in the Biedermeier style, a version of the Neoclassical style prevalent in German and Austrian furnishings for the bourgeoisie between the Congress of Vienna in 1815 and the revolutions of 1848. Gadrooning around the body of the vessel became ubiquitous across Europe. Decorative bands often graced the rim or foot of these pieces. These bands, like the applied ornament on the commemorative cups described above, could also be stamped out in large numbers.

Fig. 103
Cream pitcher
St. Petersburg, 1833
Elias Modig (1795–1834)
Silver, ivory
H. 2½ in. (6.4 cm.)
12.571

Sugar bowl
Moscow, 1827
Matvei Grechushnikov (active 1818–46)
Silver
H. 2¾ in. (7 cm.),
W. 3⅝ in. (9.2 cm.)
12.570

OPPOSITE: *Fig. 104*
Cake basket
St. Petersburg, 1820–26
Firm of Carl Friedrich Meyer
Silver, parcel gilt
H. 4¼ in. (12.1 cm.) (without handle);
H. 8 in. (20.3 cm.) (with handle),
W. 7½ in. (19.1 cm.),
D. 5⅝ in. (14.3 cm.)
12.590

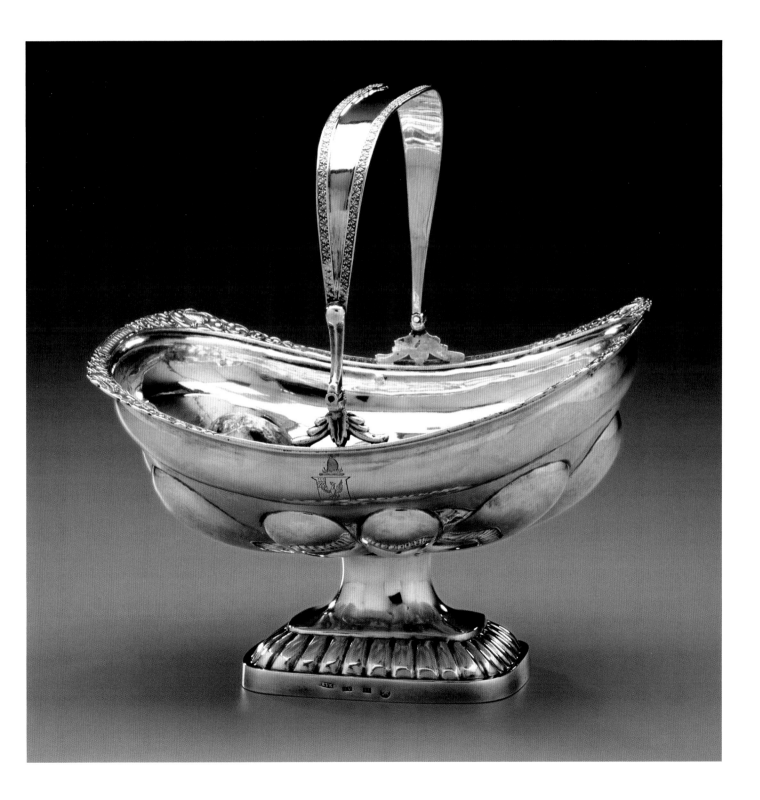

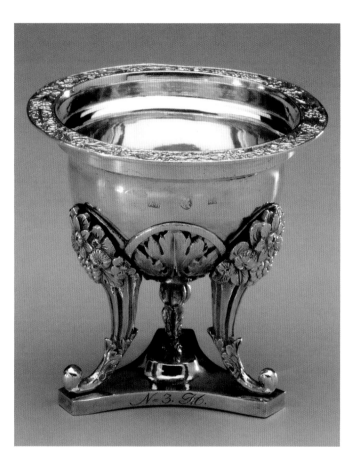

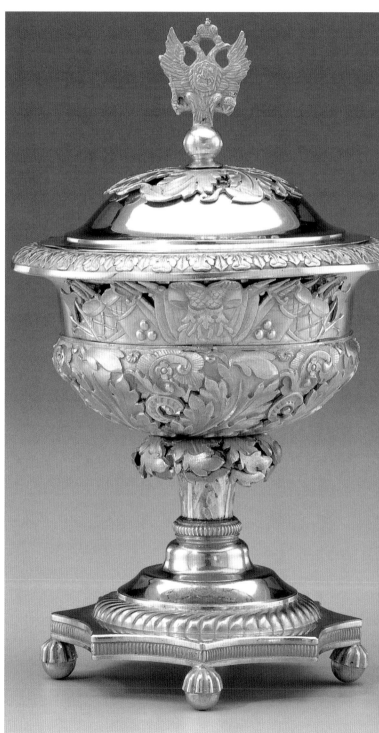

Fig. 105
Salt cellar
St. Petersburg, ca. 1826
Silver gilt
H. 3½ in. (8.9 cm.)
12.103

Fig. 106
Salt cellar with cover
Moscow, 1839
G L for unidentified maker
Silver gilt
H. 6¾ in. (17.1 cm.)
12.106.1–2

The reign of Nicholas I was a time for experimenting with various historicist styles, some based on serious research into past ornament, others more superficial.[20] Two salt cellars show the Empire style in its court form. They represent the continued popularity of this taste, at the highest levels. One (fig. 105) in the shape of a small urn is inscribed with the cipher of Nicholas I and may have been one of many made for his coronation in 1826.[21] The other (fig. 106) was probably intended as the salt for a bread and salt ceremony. Decorated with applied military trophies around the top of the bowl, it was likely presented by a military unit or was offered on some military occasion.

In the first departure from the Empire style, Nicholas I built the "Cottage" in the Aleksandria Park at Peterhof in 1828. Designed in the Gothic style, it inspired a flurry of rooms, furniture, porcelain, and other wares for a nobility keeping up with the latest fashion. By the 1840s, after a brief romance with Gothic ornament, the sinuous lines of the neo-rococo began to replace it and the gilded and glittery monumentality of late Russian Empire style. The neo-rococo, often called by Russians the second rococo, is widely seen in the dowry services of Nicholas's children.

Nicholas lavishly supplied his children with palaces and silver and porcelain services at the time of their marriages. His mother, Maria Fedorovna, had established the precedent of sending her daughters out into the world with the best of Russia's luxury production—furniture, silver, porcelain, glass, and linens. His grandmother, Catherine II had provided her oldest granddaughters with silver services made by Buch. Their younger sisters, Anna and Ekaterina, had services made by Paul Magnus Tenner, Otto Samuel Keibel, and Gustav A. Bernstrem (Bärnstrom). Their dowries included not only table wares, but also church silver for their chapels. Most of the services for Nicholas's children were made in the 1840s and 1850s, and are in the style of the second rococo with elaborate decoration beyond the imaginings of the eighteenth century.

A splendid tea service (fig. 107) made for Nikolai Nikolaevich (1831–1891), the third son of Nicholas I, is now at the Philadelphia Museum of Art. The pieces bear his coat-of-arms under the imperial eagle. The bulbous form and lobed indentations of the hot water kettle (see p. 142) recall the sinuous lines of the mid-eighteenth century. Floral ornament is applied around the top of the pot and along the spout. Most interesting, perhaps, are the twisted branches and small morning glories that form the stand of the kettle, evoking the Romantics' fascination with nature. Twisted twigs also wind around the handle.

Carl Johan Tegelsten (1798–1852), who came to St. Petersburg from Finland in 1817 as an apprentice, made the set. He became a master in 1833. This commission must have been one of his last as several pieces are dated 1852, the year of his death, although his widow and his son continued the workshop until 1855. He produced many of the dowry services for Nicholas's children. The service Tegelsten made for the

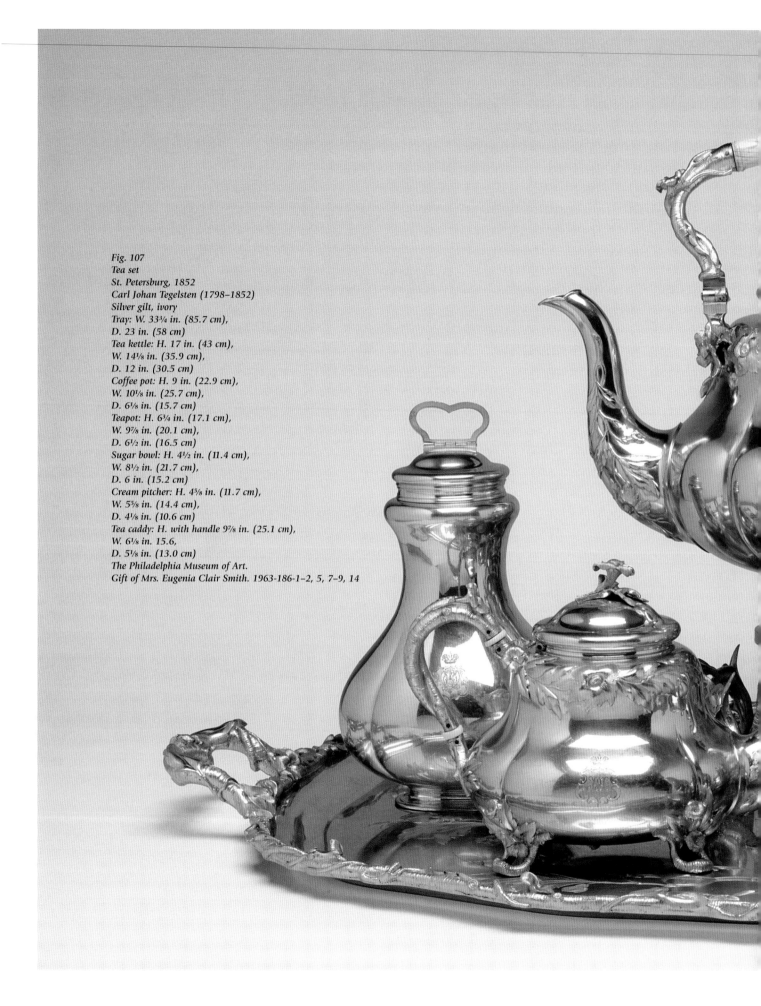

Fig. 107
Tea set
St. Petersburg, 1852
Carl Johan Tegelsten (1798–1852)
Silver gilt, ivory
Tray: W. 33¾ in. (85.7 cm),
D. 23 in. (58 cm)
Tea kettle: H. 17 in. (43 cm),
W. 14⅛ in. (35.9 cm),
D. 12 in. (30.5 cm)
Coffee pot: H. 9 in. (22.9 cm),
W. 10⅛ in. (25.7 cm),
D. 6⅛ in. (15.7 cm)
Teapot: H. 6¾ in. (17.1 cm),
W. 9⅞ in. (20.1 cm),
D. 6½ in. (16.5 cm)
Sugar bowl: H. 4½ in. (11.4 cm),
W. 8½ in. (21.7 cm),
D. 6 in. (15.2 cm)
Cream pitcher: H. 4⅝ in. (11.7 cm),
W. 5⅝ in. (14.4 cm),
D. 4⅛ in. (10.6 cm)
Tea caddy: H. with handle 9⅞ in. (25.1 cm),
W. 6⅛ in. 15.6,
D. 5⅛ in. (13.0 cm)
The Philadelphia Museum of Art.
Gift of Mrs. Eugenia Clair Smith. 1963-186-1–2, 5, 7–9, 14

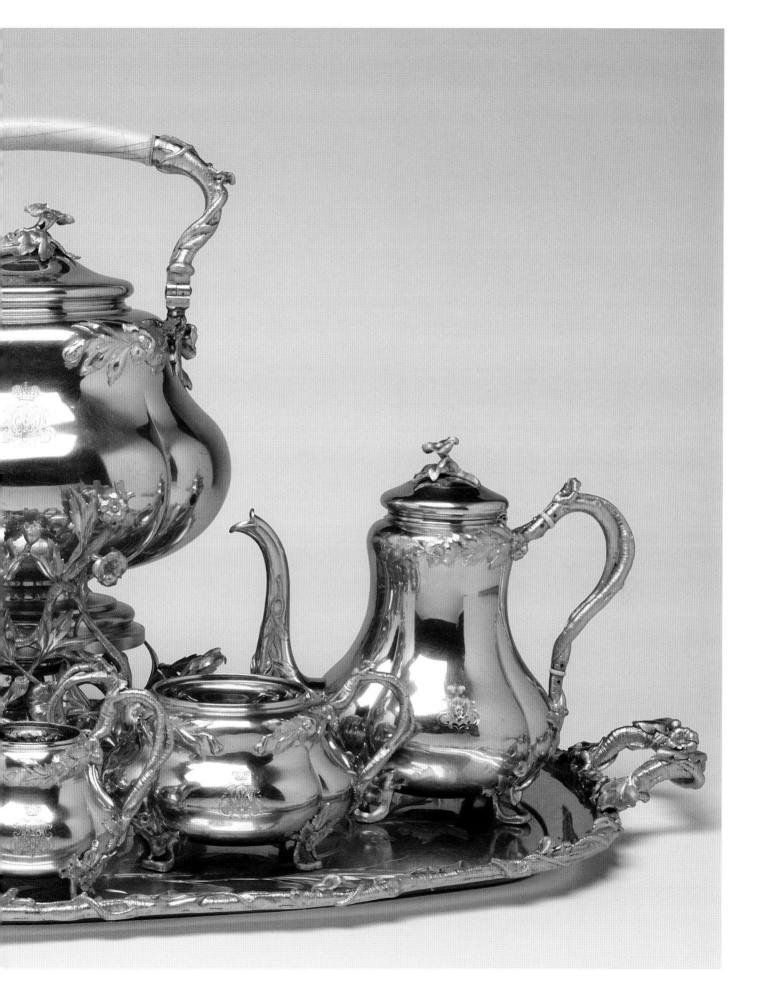

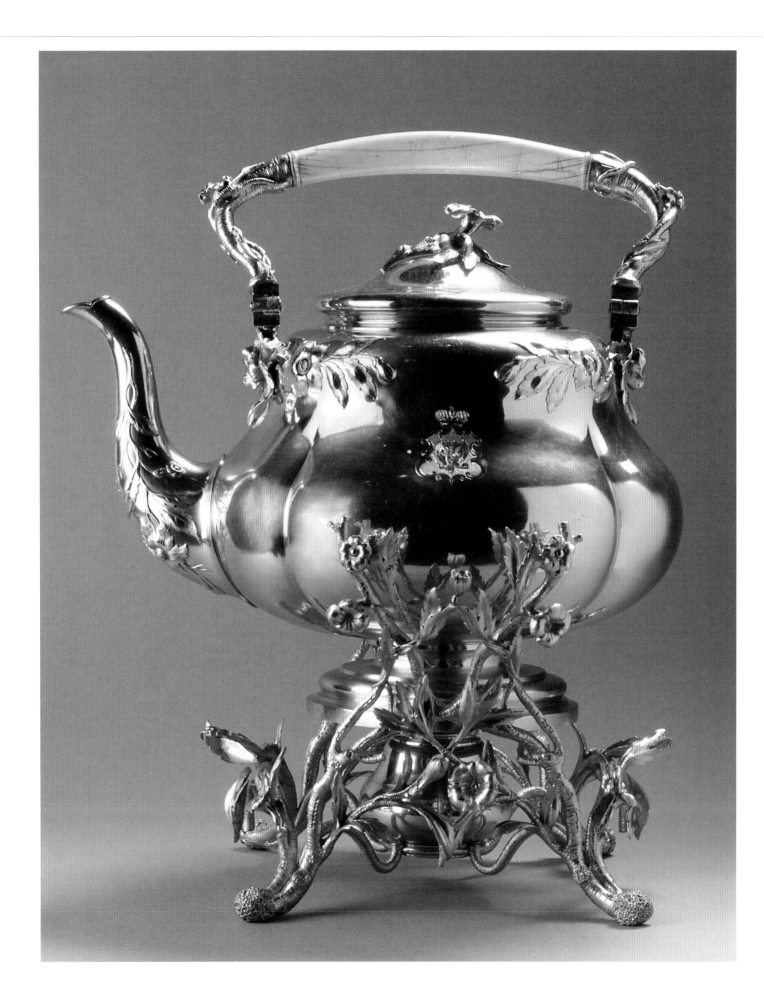

OPPOSITE: *Hot-water pot,*
part of fig. 107

Fig. 108
Part of a dressing table set
Paris, ca. 1851
Firm of Aucoc
Silver gilt, glass
Jewel box: W. 8¼ in. (21 cm.),
D. 6 in. (12.2 cm.)
Large round boxes: H. 7⅛ in.
(18.1 cm.), Dia. 4¾ in.
(12.1 cm.)
12.188.3, 10–15

oldest daughter, Ol'ga, was to be in the "latest truly beautiful and fine English fashion."[22] Much of the dowry service made for Aleksandra Nikolaevna's wedding in 1843 is now at Schloss Fasanerie in Germany, much of it made by Tegelsten, but some also by Johan Fredrik Falck (1799–1845). The service was also to be the exact same size as that of her older sister Ol'ga, whose dowry had been started, even though she was not yet engaged. The serving pieces made by Tegelsten for Aleksandra are similar in style to this tea set made for her brother Nikolai.[23] According to tradition each dowry was to include one gold and one silver toilet set. Part of the silver toilet set made by the firm of Aucoc in Paris for Nicholas's niece, Ekaterina Mikhailovna, for her wedding in 1851 to the Duke of Mecklenburg-Strelitz is now at Hillwood (fig. 108).[24]

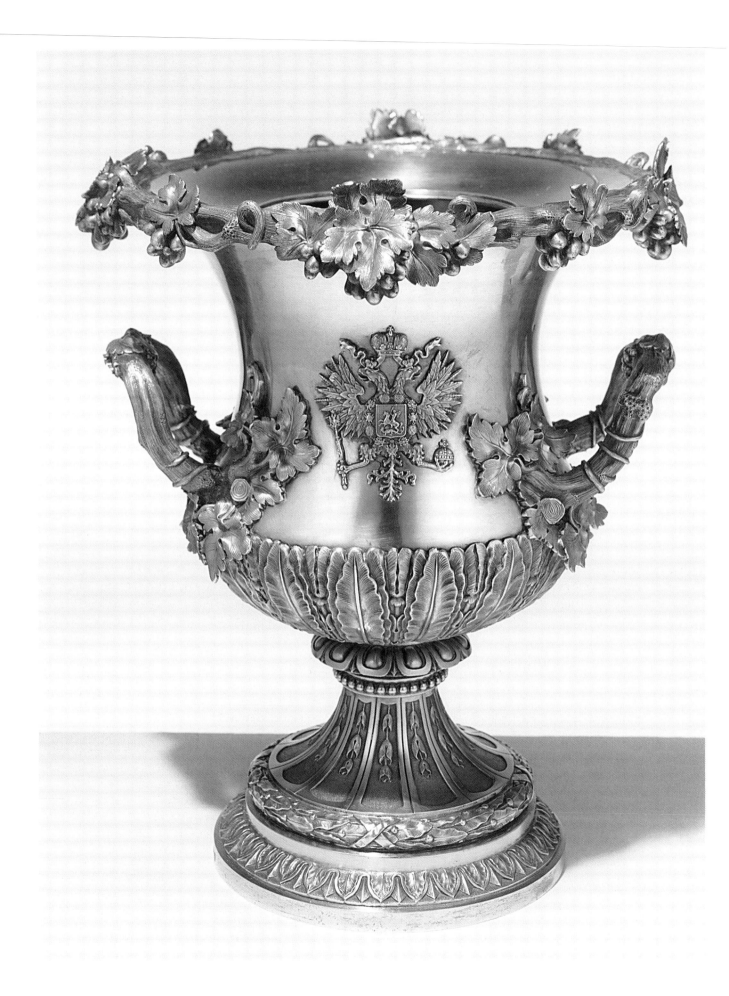

Tegelsten also created a wine cooler at the Philadelphia Museum of Art (fig. 109). Its design is defined by cast handles in the shape of tree-trunks, attached to the body by leaves, and more cast leaves and vines are applied around the top. The imperial double-headed eagle has been attached to both sides. This part of the decoration is very similar to that on a cooler the silversmith made for the marriage of Count Aleksandr Bobrinskii to Sofiia Shuvalova in 1850.[25] In this example, however, acanthus leaves decorate the bowl of the vase and a variety of Neoclassical ornament embellishes the foot. Tegelsten, who also owned a bronze factory, did not have his own store. He sold many of his wares and received commissions through the English Store (*Angliiskii Magazin*). The premier establishment in St. Petersburg in the 1830s and 1840s, it provided English luxury goods to a Russian clientele. Tegelsten made practically all the dowry services commissioned through the English Store, which according to the court chamberlain Dolgoruky, "enjoyed universal trust."[26]

Owned by the English merchants Konstantin Nichols and Wilhelm Plinke (variously spelled Nicholls and Plincke), the English Shop was founded by Messrs Hoy and Bellis in 1789 to trade in silks, ribbons, and other finery. Nichols and Plinke purchased the store in 1804, and by the 1830s they had become the leading suppliers of silver tableware, bronzes, wines, shawls, and other luxury fabrics. The name of the shop was changed to Nichols and Plinke in 1854 in the midst of the Crimean War, when Russia was fighting the English.[27]

Nicholas I did not neglect his own table. John S. Maxwell, when on a tour to Russia was present for Nicholas's name day banquet in the 1840s. He noted the "banquet hall, of immense extent…set with tables loaded with vessels of silver and gold."[28] In 1844 Nicholas made a brief state visit to England, where he took the opportunity to visit London silversmiths and commissioned a silver service for fifty people, known as the London Service, from R. and S. Garrard. Upon his return to Russia he turned to Nichols and Plinke, the firm of Sazikov, and others for additions to this service. By mid-century, however, the court's ceremonial dining was no longer the taste-maker it had been. That role was usurped by the bourgeoisie, which was learning about the latest styles from illustrated weeklies and the popular international exhibitions.

After the Napoleonic Wars European nations began to hold manufacturing exhibitions, gradually expanding markets, increasing consumer clientele, and setting the fashions for many manufactories, including silver- and goldsmiths. The first such national exhibition in Russia was held in St. Petersburg in 1829, and they continued to be organized regularly thereafter. Few of the well-known silversmiths of the time participated at the beginning. In 1839, Ignatii Sazikov and Aleksandr Kordes exhibited, but first prize was won by a silversmith not from Moscow nor St. Petersburg, but from Vologda: Sakerdon Skriptsyn (active 1837–44). After the exhibition, Nicholas I purchased his prize-winning entry, a niello tea service with scenes of Vologda and St.

Petersburg.[29] Only in the 1849 St. Petersburg exhibition were Sazikov and Jean-Baptiste Valliant awarded gold medals. Kordes is best known today for the many orders and badges his firm produced.

The powerful international exhibitions beginning in 1851 would contribute to the growth of large silver firms prepared to make use of modern technical equipment for expanded production. Small workshops continued to operate, as attested to by the vast number of little-known masters or those known only by their initials. The large firms, however, are the ones best known to us today. While the Empire style became a unifying style during a period of war across Europe, the international expositions ironically did not bring unity, but rather the opposite, the rise of national styles as nations competed for attention.

NOTES

1. Georgii Vilinbakhov, "Sankt-Peterburg—'Voennaia stolitsa'," Natal'ia Zolotova, *Parizh-Sankt Peterburg, Kogda Rossiia govorila po-frantsuzski* (Moscow: Interros, 2003), 20.
2. This battle is listed by date and regiments present along with all others on the walls of the Church of Our Savior in Moscow. See *Khram Khrista Spasitelia* (Moscow: Moskovskii rabochii, 1986), 212–13.
3. "Alfavitnyi ukazatel'," *Starye gody* 1 (1907), 38. Meyer died in 1806, but his widow continued his business.
4. Despite the inscription, the presentation of the cup appears to have actually taken place a year later on the anniversary of Apraksin's departure from the Chevalier Guards. The cup itself is dated 1834. S. Panchulidze, ed., in *Sbornik biografii kavalergardov*, vol. 4 (St. Petersburg: Expeditsiia zagotovleniia gosudarstvennykh bumag, 1908), 2, gives the date of its presentation as June 24, 1834.
5. See Anne Odom and Liana Paredes Arend, *A Taste for Splendor: Russian Imperial and European Treasures from the Hillwood Museum* (Alexandria, VA: Art Services International, 1998), no. 108.
6. See Peter Gay, "Affordable Masterpieces," *The Pleasure Wars: The Bourgeois Experience. Victoria to Freud*, vol. 5 (New York: W. W. Norton, 1998), 53–65 for this phenomenon in Western Europe.
7. For an almost identical box in the State Hermitage also by the workmaster Kaltykov, see Z. Berniakovich, "Ob odnoi serebrianoi tabakerke," in *Soobshchenia gosudarstvennogo Ermitazha* 35 (1972), 36–37. For a description of the engraving, see D. A. Rovinskii, *Podrobnii slovar' Russkii graviroval'nikh portretov*, vol. 3 (St. Petersburg: Tipografiia imperialskoi akademii nauk, 1888), 1850.
8. Nikolai Rostov in *War and Peace* would take issue with this legend, knowing that in the heat of battle no one could possibly have known exactly what happened. Leo Tolstoy, *War and Peace*, trans. Richard Pevear and Larissa Volokhovski (New York: Alfred A. Knopf, 2007), 646–47 (Book III, Part. 1, chapter 12). Raevskii later said, "But my sons were not there at the time. My youngest child was gathering berries in a wood (he was then a mere child, and a bullet made a hole in his britches); that was all, the entire anecdote was made up in St. Petersburg." Quoted in T. J. Binyon, *Pushkin: A Biography* (New York: Alfred A. Knopf, 2003), 104.
9. For more information about the publicity factor of this event and the images associated with it, see R. S. Wortman, *Scenarios of Power: Myth and Ceremony in Russian Monarchy*, vol. 1 (Princeton, NJ: Princeton University Press, 1995), 312–13.
10. For the engraving and more information about a cigar box with the same image in the collection of the Kremlin Armory, see S. Ia. Kovarskaia, "Izobrazhenie pamiatnikov arkhitektury na serebri-anykh izdeliiakh XIX veka iz sobraniia muzeev Kremlia," in *Dekorativno-prikladnogo iskusstvo: Materialy i issledovaniia IX* (Moscow: Gosudarstvennyi istoriko-kul'turnyi muzei-zapovednik "Moskovskii Kreml'," 1993), 76–79.
11. See Rémy G. Saisselim, *The Bourgeois Bibelot* (New Brunswick, NJ: Rutgers University Press, 1984), xiii and 73, Wortman, *Scenarios of Power*, vol. 1, 279, and Thomas Richards, *The Commodity Culture of Victorian England: Advertising and Spectacle, 1851–1914* (Stanford, CA: Stanford University Press, 1990), 60.
12. Galina Kriuk, "Gorod na kryshke tabakerki," *Antikvariat*, 6, no. 8 (June 2003), 15–17. I. D. Kostina, T. N. Muntian, and E. V. Shakurova, *Russkoe serebro XVI-nachala XX-veka* (St. Petersburg: Slaviia, 2004), 109. For a box with the map of eastern Siberia, see Alexander von Solodkoff, *Russian Gold and Silverwork* (New York: Rozzoli, 1981), no. 116 and no. 120 for a map of the province of Archangel.

13. For the same image on a cigar box in the Kremlin Armory, see Kovarskaia, "Izobrazhenie pamiatnikov arkhitektury", 76 and 80.
14. E. A. Mishina, *Gavrila Skorodumov: risunok, graviura, miniature, zhivopis'* (St. Petersburg: ARS, 2003), nos. 37 and 38.
15. See Wortman, *Scenarios of Power*, vol. 1, 355–57.
16. An unidentified Moscow maker, N.G made both the Hillwood mugs. For an identical cup at the State Hermitage by the same maker, see Kostina, *Russkoe serebro* (2004), 144.
17. Larissa Zavadskaia, "Gold and Silver in St. Petersburg 1830–1850," in Géza von Habsburg, *Fabergé: Imperial Craftsman and his World* (London: Booth-Clibborn Editions, 2000), 48.
18. M. M. Postnikova-Loseva and U. Platonova, *Zolotoe i serebrianoe delo XV–XX vekov* (Moscow: Nauka, 1983), 141.
19. For examples from this service by Biennais, see Christie's, London, November 29–30, 2006, lot 742 and for later pieces by Jean-Charles Cahier, see lot 741. The two silversmiths seem to have cooperated on this commission.
20. For a discussion of historicism in Russia, see Marina Lopato, "Istorizm kak khudozhestvennoe iavlenie," in *Istorizm v Rossii: Stil' i epokha v dekorativnom iskusstve 1820-e – 1890 gody* (St. Petersburg: A.O. "Slaviia," 1996), 9–17 and Tatiana Petrova, "Istorizm v Rossii," ibid., 24–29.
21. The assayer, Aleksandr Il'ich Iashinkov, whose mark is stamped on it, ceased to be active after 1826, the year of Nicholas's coronation.
22. M. N. Lopato, *Iuveliry starogo Peterburga* (St. Petersburg: Izdatel'stvo Gosudarstvennogo Ermitazha, 2006), 128. For sauce boats from the dowry service for Ol'ga Nikolaevna, made in 1840, see Sotheby's London, May 19, 2005, lot 206. Ol'ga married Carl I King of Württemberg in 1846.
23. *Die Mitgift einer Zarentochter* (Eurasburg: Edition Minerva, 1997), nos. 36 and 39. For a toilet service and a traveling tea set by him see also nos. 31–33. Grand Duchess Aleksandra died in childbirth within a year after her marriage, her dowry unused. Nicholas I allowed her husband Prince Friedrich Wilhelm of Hesse-Kassel to keep the dowry. It remains almost completely intact at Schloss Fasanerie, near Fulda in Germany. For a toilet service probably originally made for Ekaterina Mikhailovna, Nicholas I's niece, that was never delivered, but remained in storage in the State Hermitage, see *Russkoe serebro* (2004), p. 154. No monogram was ever engraved on the pieces.
24. There are nineteen pieces from this set at Hillwood. The rest are in the State Hermitage. See *The Fabulous Epoch of Fabergé* (St. Petersburg: Nord Publishers, 1992), 83.
25. The Bobrinskii wine cooler, now at the Hermitage, has his coat-of-arms on each side. See Kostina, *Russkoe serebro* (2004), 153.
26. L.A. Zavadskaia, "Angliiskii magazin v Peterburge i serebrianye velikokniazheskie servizy 1830–1840-godov," I. K. Bott, *Rossiia-Angliia: Stranitsy dialoga: kratkoe soderzhanie dokladov. V Tsarskosel'skoi nauchnoi konferentsii* (Tsarskoe Selo: GMZ Tsarskoe Selo, 1999), 143. See also Zavadskaia, "Gold and Silver in St. Petersburg 1830-1850," 50 and Lopato, *Iuveliry starogo Peterburga*, 128.
27. The shop later passed on to Robert Colqgoun. When he died in 1878, his heirs operated it until 1880 when it was liquidated.
28. *The Czar, His Court and People: including a Tour in Norway and Sweden* (New York: Baker and Scribner, 1849), 153.
29. For plates, possibly from this service, with scenes of Switzerland on them and now at the Hermitage, see Kostina, *Russkoe serebro* (2004), 143 and Sotheby's New York, December 14, 1981.

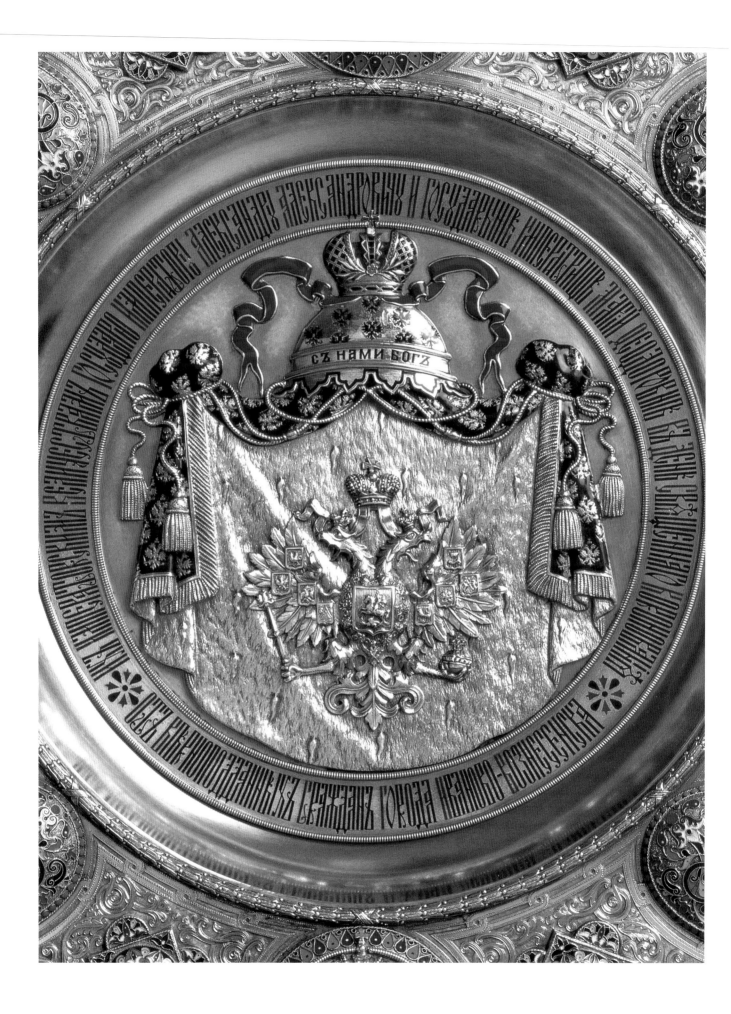

THE RUSSIAN STYLE TO FABERGÉ

FOLLOWING THE DEFEAT of Napoleon and the Congress of Vienna in 1815, royal residences throughout Europe began to lose their significance as centers of a nation's cultural life. By the 1840s, a secularized Gothic style and the neo-rococo better suited the apartments and homes of the expanding middle class throughout Europe, including Russia. Even the Russian imperial family was more inclined to live in a bourgeois setting at home. Historicism—the practice of using multiple historical styles for the decoration of contemporary objects—was really the bourgeoisization of the interior as the family increasingly became the center of social activity. Although not a patron of the arts, when Alexander II succeeded his father in 1855, the Russo-Byzantine style that Nicholas I had set in motion came to dominate his reign.

The Russian Revival had its basis in the historicist movement that began in Russia in the 1830s. In pursuit of a period of historical greatness Russia found its equivalent of medieval knights in its own *bogatyri* (the heroic warriors of Kievan Rus') and design elements from its Byzantine heritage in addition to its artistic development in the sixteenth and seventeenth centuries. In the 1820s Aleksei Olenin (1763–1843), president of the Academy of Arts, launched a study of native Russian ornament of the eleventh and twelfth centuries. In 1830, he sent a young graduate of the Academy of Fine Arts, Fedor Solntsev (1801–1892), to Moscow and other cities to catalogue Russian antiquities, which led to the beginnings of the Byzantine/Russian Revival. In 1836 Solntsev worked in the Moscow Kremlin and his studies there resulted in the monumental six-volume work, *Drevnosti rossiiskago gosudarstva* (*Antiquities of the Russian State*), published between 1849 and 1853.[1] This work launched a new, distinctively

Russian, vocabulary of ornament, impacting all media—silver, bronze, porcelain, glass, furniture, interiors, book design, and graphics of all kinds.[2] Vladimir Stasov, the great proponent of the Russian style in art and music, observed that Solntsev's great work "included, it is possible to say, a whole museum of old-Russian folk, artistic, and creative sources."[3] In 1837, Solntsev himself reworked the Russian style in his designs for the Kremlin Porcelain Service, commissioned for the new Great Kremlin Palace. This was the first use of the style in the decorative arts.

Unlike the dowry services for Nicholas's daughters, the porcelain service commissioned for the 1848 marriage of Konstantin Nikolaevich to Aleksandra, daughter of Joseph, Duke of Saxe-Altenburg was in this new style. In addition Solntsev was asked to draw up the designs for a massive gilded coffee and tea set, comprising a large tray, a samovar, a Turkish coffee pot, teapots, a cake dish and other pieces.[4] There were no traditional Russian forms used in the silver service, but its decoration is a mix of neo-rococo gadrooning and scrolls together with interlace handles in the Russo-Byzantine style.

The tea service was made by the firm of Sazikov. Pavel Sazikov (d. 1830), who had probably been a Moscow tradesman since the late eighteenth century, founded his firm in 1810 in Moscow. In 1837, he was succeeded by his son Ignatii (1796–1868), who in 1842 opened a branch in St. Petersburg. In 1847 he was one of several proprietors with showrooms in the so-called Russian Shop in the Engelhardt House on the Nevskii Prospekt. His firm became one of the best known in Russia,[5] and was one of the first to employ mechanical equipment, which he had seen when traveling to Western Europe. By the late 1840s, he had machines for rolling, guilloché, and polishing. He had also started to divide his workers by task so they could work more efficiently and faster. In 1844 Sazikov received the Imperial Warrant, that is, he became a purveyor to the court, and a year later he established a school at his factory for training young students, one of the first such institutions in the country.

Sazikov's firm was so well known by the time he made the tea service for Grand Duke Konstantin that Sazikov himself was credited with having conceived of the idea of using the Russian style for the grand duke's service.[6] In 1849 a correspondent for *Severnaia pchela (The Northern Bee)* described his work:

> The St. Petersburg public was full of admiration for Mr. Sazikov's candelabras, equal in quality to those produced in London, and his toilet accessories in the new Russian style, based on ancient designs and forms of jewelry in the Kremlin's Palace of Facets. Mr. Sazikov has resurrected and firmly established in Russia the art of Benvenuto Cellini.[7]

When Sazikov's relationship with Solntsev began is unclear. They may have become acquainted when both were in Moscow in 1836. Sazikov had been

commissioned to gild the silver *oklady* on the iconostasis of the Upper Savior Church at the very time when Solntsev was involved with the restoration of the Terem Palace.[8] It is clear, however, that he must have had access to Solntsev's drawings before the appearance of *Drevnosti*. In fact, it was noted in *The Northern Bee* that his drawings were regularly requested by the English Store (Nichols and Plinke) and by other silversmiths as well.

The great international forums where nations would display everything from mining riches and agricultural equipment to the latest styles in porcelain, silver, and bronzes, began with the Great Exhibition of the Works of All Nations (usually known as the Crystal Palace Exhibition) in London in 1851. In many ways these fairs replaced the ceremonies surrounding royal weddings, coronations, and diplomatic receptions in the seventeenth and eighteenth centuries as opportunities to show off the latest style. Now, however, the audience was not limited to royalty and the aristocracy, but included everyone, a large group of critics among them. As historian Peter Gay points out, the bourgeoisie had replaced royalty, aristocrats and the church as the new patrons of the arts. They were the primary attendees at the fairs.[9] In addition the fairs also unleashed a renewed discussion on the nature of the decorative arts and ornament as well as a drive to create schools designed to bring artistic taste to the exploding production of industrial wares. It was a mark of Sazikov's prestige in St. Petersburg surely fueled by commissions from the imperial family that he was among those selected to send work to the exposition.

In London Sazikov exhibited twenty-nine objects, most in the Russian style.[10] Eleven of them are illustrated in the official catalogue (fig. 111).[11] They included *bratiny*, and an *endova*, and many were decorated with the Russo-Byzantine interlace ornament first revived by Solntsev from illustrated manuscripts, among them a tall lidded cup now at Hillwood (fig. 110). Interlace patterns encircle the cup around polished spheres that shine like gemstones. One reviewer wrote:

> The Russian contributions to the Crystal Palace evince a large amount of costly splendour combined with quaint and characteristic design, showing much fancy in the Art-manufacturers who have been engaged in their fabrication…. There is a very free and fanciful taste prevalent in these articles, which gives them a strong individuality of character.[12]

In St. Petersburg acclaim followed Sazikov's London success. The *Russkii khudozhestvennyi listok* (*Broadsheet of Russian Art*) noted that "until now, all silver works made in Russia imitated foreign models; in the works of Mr. Sazikov, the ideas, drawings, models and their execution arise from the intellect and labor of the Russian."[13] At this time most Russian silversmiths still hand-chased their wares. Visitors to London found this surprising because Western European silversmiths were already casting most of their work.

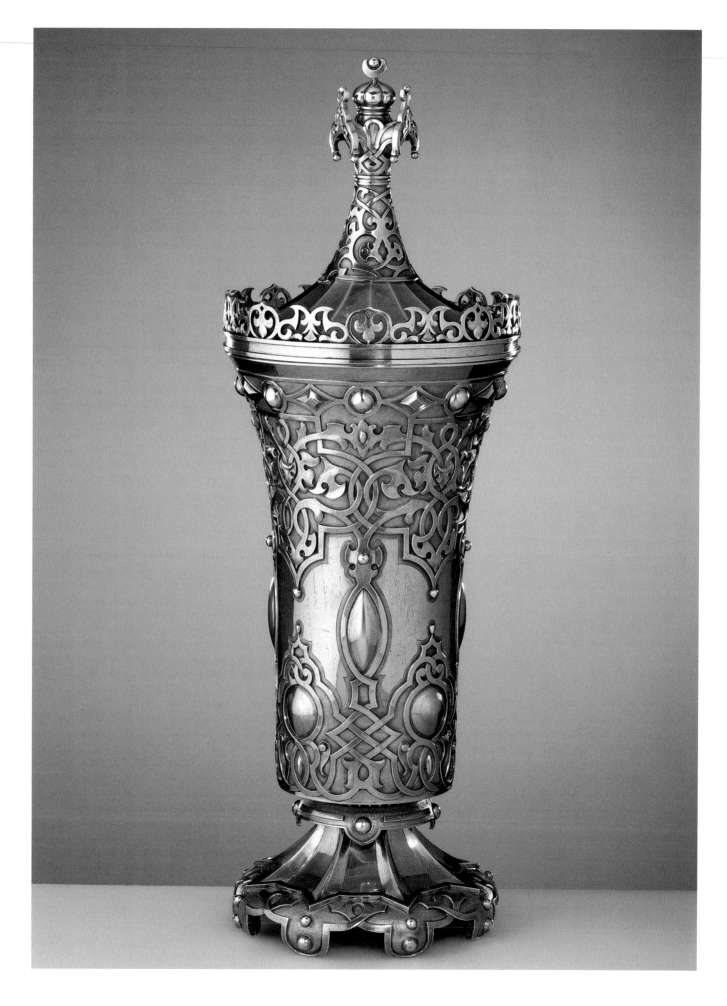

206. ORNAMENTAL GOLD AND SILVER ARTICLES, J. SAZIKOFF, RUSSIA.

194. A SILVER ORNAMENT THE PINE TREE, M. IGNACE SAZIKOFF, RUSSIA.

OPPOSITE: *Fig. 110*
Tall covered cup
St. Petersburg, 1851
Firm of Sazikov
Silver gilt
H. 18¼ in. (46.4 cm.),
W. 6⅜ in. (16.2 cm.)
Museum Purchase, 2000.
12.625.1–2

ABOVE: *Fig. 111*
Four objects exhibited by Ignatii
Sazikov at the Great Exhibition of
the Works of All Nations in
London, 1851, illustrated in the
Official Descriptive and
Illustrated Catalogue, *vol. 3,*
Foreign States (London, 1851).

ABOVE RIGHT: *Fig. 112*
Sculpture of Dmitrii Donskoi
Resting under a Tree, *exhibited*
by Ignatii Sazikov at the Great
Exhibition of the Works of All
Nations in London, 1851,
illustrated in the Official
Descriptive and Illustrated
Catalogue, *vol. 3, Foreign States*
(London, 1851).

In London Sazikov also received the highest praise for a vase, a free-standing sculptural group, two meters in height (fig. 112).[14] For his prize-winning entry the sculptor, Ivan Vitali, fashioned the models for the wounded figure of Dmitrii Donskoi resting under a fir tree with his warriors after the Battle of Kulikovo (1380), and Pëtr Klodt modeled the horse.[15] They consulted Solntsev to ensure the accuracy of the details, especially of the helmet and armor worn by Donskoi. In fact, however, the helmet and armor on the fourteenth-century heroic figure Donskoi was of a type used in the sixteenth or seventeenth century.

Sazikov may have been inspired to produce this sculptural figure by the centerpiece for the London Service, commissioned by Nicholas I from R. and S. Garrard. In 1844 Nicholas traveled to London to meet Queen Victoria. While there, he shopped for a new table service for fifty (some sources say forty) persons. It included seven sculptural groups, one of which was an English medieval knight with his huntsman. In 1852 Nicholas commissioned Sazikov to create another heroic figure as an addition to the centerpiece.[16] Sazikov was the first in Russia to produce large sculptural groups of Russia's medieval heroes, using some of Russia's best-known sculptors to create his models.

In both the Garrard sculpture and in Sazikov's addition, the silver is chased and tooled to bring out the pattern of the fabric of their clothing and the blankets thrown over the horses. These carefully defined details lend the figures and the accoutrements of harness, clothes, and landscape a naturalistic quality in keeping with the realism of the period. This foreshadows the trompe l'oeil damask napkins folded over woven baskets (fig. 124) that received such attention when Sazikov exhibited them at the Centennial Exhibition in Philadelphia in 1876.

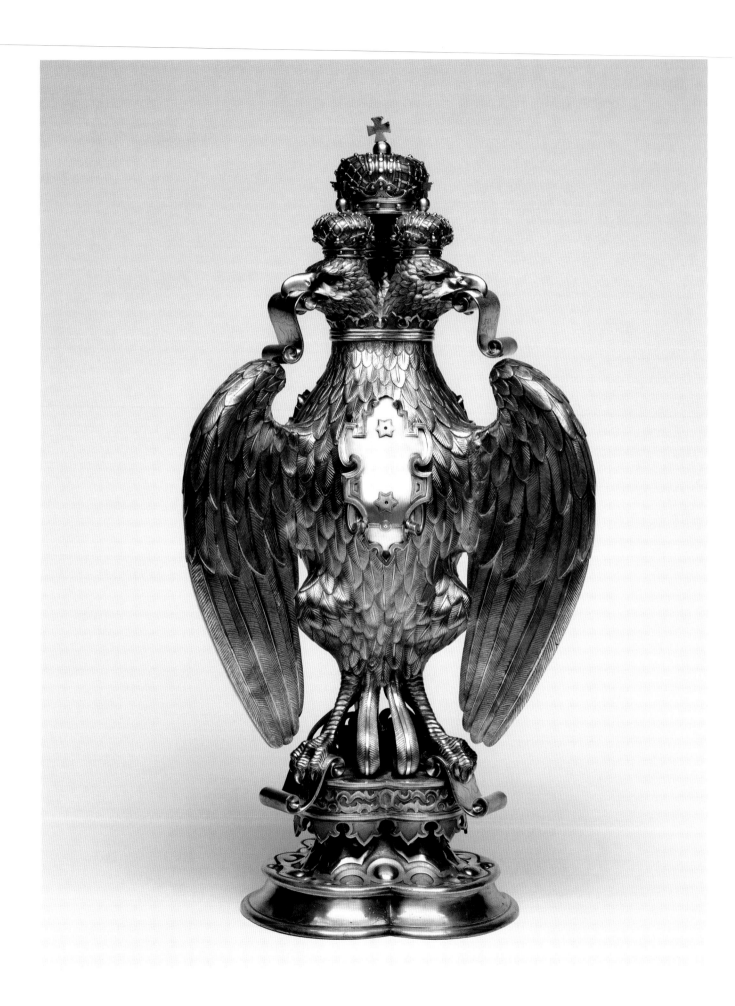

OPPOSITE: *Fig. 113*
Wine cooler in the shape of a
triple-headed eagle
St. Petersburg, 1851
Firm of Sazikov
Silver gilt
H. 20½ in. (26.7 cm.),
W. 10 in. (25.4 cm.)
The Philadelphia Museum of Art.
Gift of Eugenia Claire Smith.
1965-87-1a,b

RIGHT: *Fig. 114*
Heraldic eagle, made by Jörg Ruel
of Nuremberg, early seventeenth
century, and exhibited at the 1904
exhibition in St. Petersburg.
Illustration from Adrian V.
Prakhov, Albom istoricheskoi
vystavki predmetov iskusstva,
ustroennoi v S-Peterburge
(St. Petersburg, 1908).

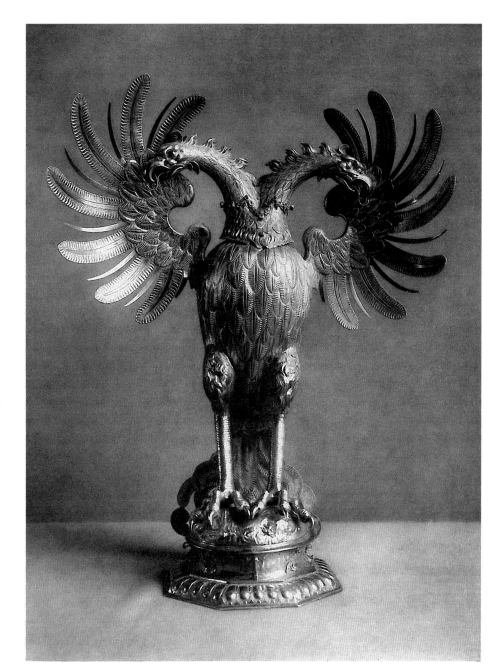

In the Philadelphia Museum of Art there is a splendid three-headed sculpted eagle, made by Sazikov in 1851 (fig. 113). Each head bears the imperial crown with another on top of all three. Their feathers are very finely chased. The eagles are holding in their beaks scrolls engraved with maps of Africa, Europe, and in their talons, maps of Asia and Russia. This sculpture is identical to one sold at Sotheby Parke-Bernet in New York in 1980.[17] The latter can be identified as a gilded yachting trophy by its inscription on three cartouches in Russian, "Yacht Georgian, F. K. Bird, 1st June 1851," and on the base "Imperial Prize for Sea Race between the Boats of the Imperial St. Petersburg Yacht Club." The applied cartouches on the Philadelphia eagle are blank, but it could also have been a trophy. The concept of these large eagles may have been inspired by a couple of heraldic eagles made in Nuremberg and Augsburg in the late seventeenth and early eighteenth centuries (fig. 114). Such eagles were popular as presentation gifts to the Russian court.[18]

M. SASIKOFF, of St. Petersburg and of Moscow,

sign and ornamentation. Some idea of their merit may be conveyed by the selection engraved

Goldsmith to the Imperial Court, exhibits a large

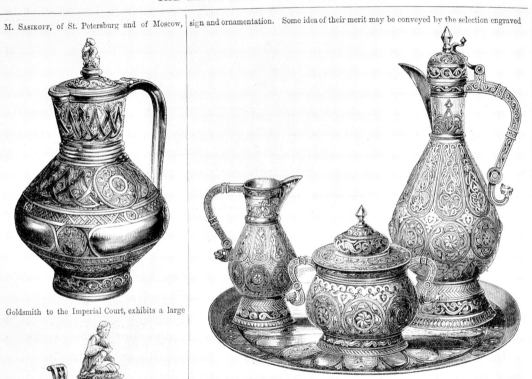

on this page; for adequate description we have no space. M. Sasikoff was awarded a gold

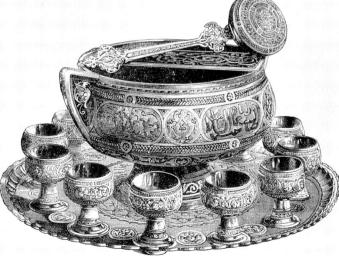

collection of very beautiful works, admirable in de-

medal, and has also been *décoré*. He is represented in Paris by M. GAILHARD, Rue Vivienne.

OPPOSITE: *Fig. 115*
*Group of objects exhibited by the
firm of Sazikov at the Universal
Exhibition in Paris in 1867.
Engraving from the* Illustrated
Catalogue of the Universal
Exhibition, *published with the*
Art Journal *(London, 1867).*

BELOW: *Fig. 116*
Traveling set
Moscow, 1860
Firm of Sazikov
Silver gilt, niello, steel
Salt chair: H. 3 in. (7.6 cm.),
Cup: H. 3½ in. (8.9 cm.),
Napkin ring: H. 1¾ in. (4.6 cm.),
Knife: L. 9⅛ in. (23.8 cm.),
Fork: L. 9 in. (22.9 cm.),
Soup spoon: L. 7⅞ in. (18.1 cm.),
Tea spoon: L. 5 in. (12.7 cm.)
12.113.1–7

To the Paris exhibition of 1867 Sazikov sent a large group of objects decorated with finely worked eastern interlace for which he was awarded a gold medal (fig. 115). The Turkish forms of a jug and a ewer distanced these works somewhat from Russian examples, but they highlight the persistent eastern influence in this period. A punch bowl and ladle with cups on a tray became a staple, not only for Sazikov, but also for Ovchinnikov and Khlebnikov throughout the rest of the century, as presentation gifts from the tsars to visiting dignitaries.[19]

A small set, consisting of a knife, fork, soup spoon, teaspoon, napkin ring and salt cellar, decorated with seventeenth-century leaf and vine ornament in niello is typical of the many kinds of gift items that all silver firms produced (fig. 116). As part of the ornament many such objects included peasant proverbs, like that on the salt chair: "Without bread, without salt, half a meal." This set by Sazikov dated 1860 has been called a traveling set or a bachelor's set. Nor was Sazikov by any means limited to the Russian style. He produced many objects in the popular rococo style such as a massive

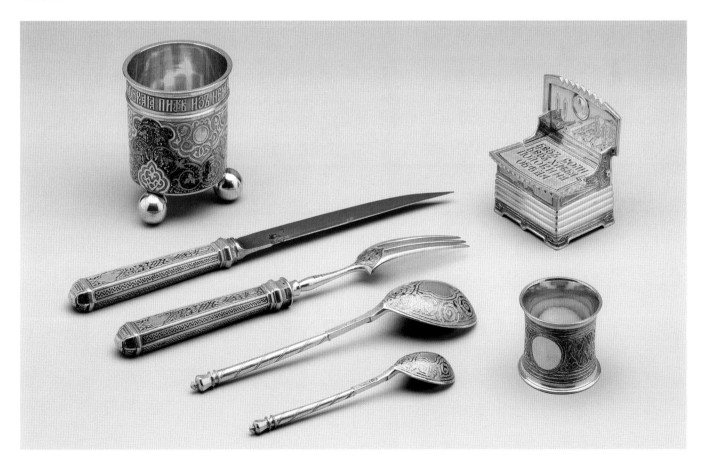

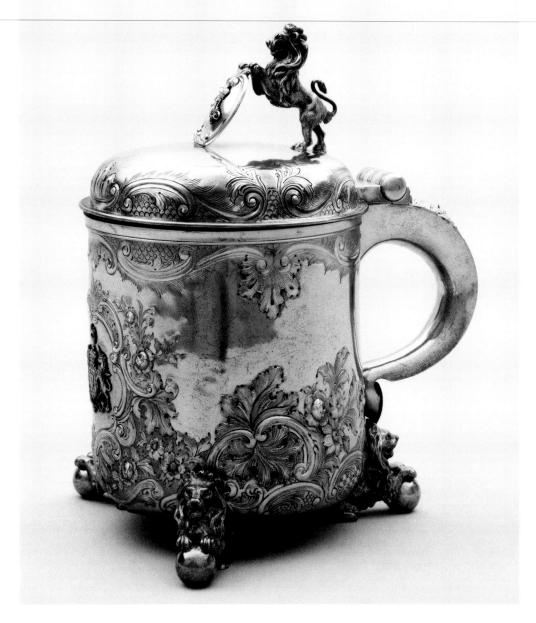

Fig. 117
Presentation tankard
St. Petersburg, ca. 1874
Firm of Sazikov
Silver
H. 13 in. (33.5 cm.)
Fowler Museum at the University
of California, Los Angeles.
x87.995

OPPOSITE: *Fig. 118*
Chalice
Moscow, ca. 1871
P A *for unidentified maker*
Silver gilt, paste gemstones
H. 16½ in. (41.9 cm.),
Dia. of bowl 6¾ in. (17.1 cm.)
12.388

tankard now in the Fowler Museum of Cultural History at the University of California in Los Angeles (fig. 117). Curls enclosing diaper patterns and leaves ornament the edge of the lid and the upper rim of the tankard. They swell in profusion around the bottom and enclose the coat-of-arms of His Royal Highness Prince Alfred, Duke of Edinburgh. A rampant lion holds a shield with his cipher. According to the inscription, Alexander II presented this tankard to his future son-in-law in 1874, on his visit to St. Petersburg, probably on the occasion of his marriage to Alexander's only daughter Grand Duchess Maria Aleksandrovna, which took place that year. Unlike many of the objects that were sold abroad in the 1920s and 1930s, this tankard is a good example of a work of art that came west as part of normal diplomatic or commercial relations between countries and was then later dispersed.

The neo-rococo style still could be found as late as the 1870s, especially in objects made for the church. The church was generally more conservative in its tastes than the prevailing fashion, so styles changed more slowly. A good example is a chalice of about 1871 with its very elaborate repoussé cage attached to the body (fig. 118). On the bowl are four oval medallions framed by paste stones imitating diamonds. Each contains in high relief the sculpted head and shoulders of Christ, the Mother of God, John the

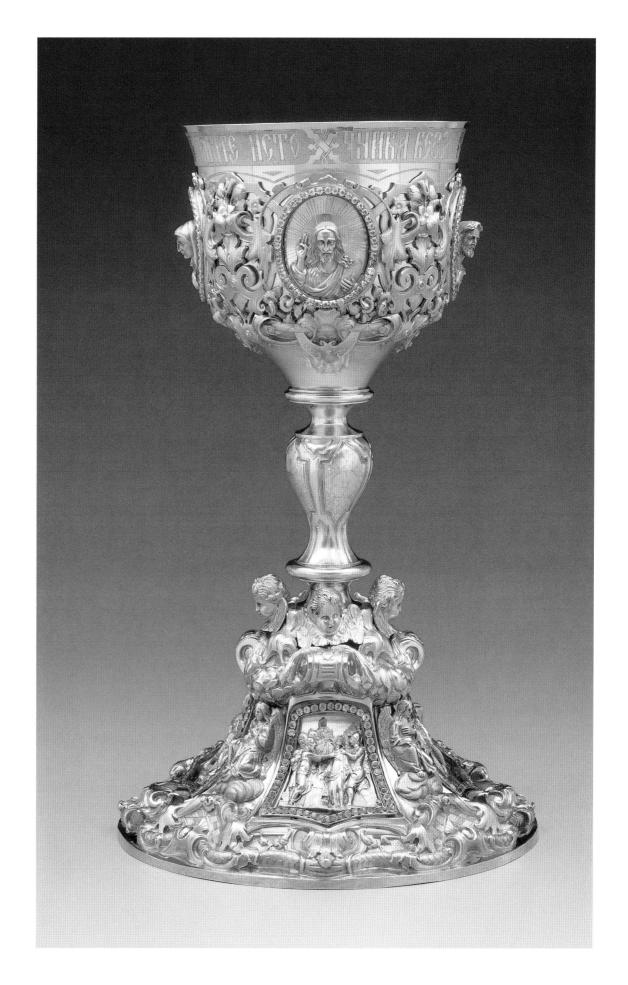

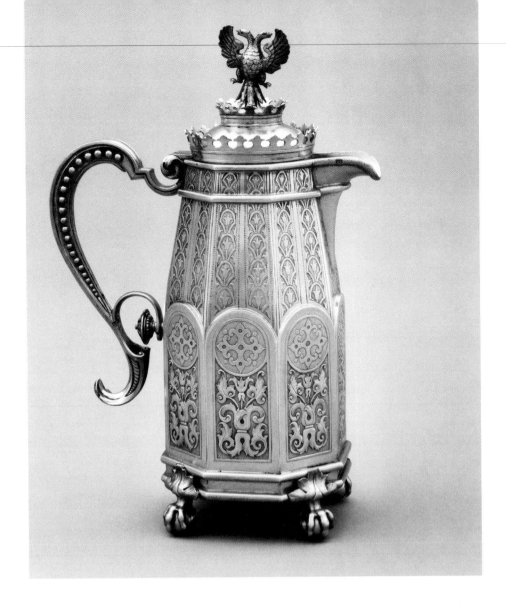

Fig. 119
Flagon
Moscow, 1862
Firm of Ivan Semenovich Gubkin
Silver gilt, niello
H. 10¾ in. (27.5 cm.)
Fowler Museum at the University
of California, Los Angeles. x87.991

OPPOSITE: *Fig. 120*
Teapot
St. Petersburg, 1857
Johann Myllys (Iogan Millis,
1814–1880)
Silver, parcel gilt, ivory
H. 7¾ in. (19.5 cm.),
W. 9⅜ in. (24 cm.)
12.113

Baptist, and on the back Christ with the Crown of Thorns. Below the knop are the heads of four cherubim in high relief, with scenes from the Passion in four panels below. The edge of the foot is decorated with baroque motifs and braided Russian birch. This type of overwhelming decoration was considered in the worst taste by the beginning of the twentieth century, and as a result many such pieces were melted down in the 1920s.

One of Sazikov's main competitors in the mid-nineteenth century was the merchant and factory owner Ivan Gubkin of Moscow. He founded his factory in 1841 and following his death the firm was continued by his sons until at least 1867. His works reveal the influence of the Russian style that Sazikov was so successfully marketing. A flagon shows the early imaginative use of a stylized geometric ornament with strapwork and trefoil decoration derived from the seventeenth century (fig. 119). A rather fanciful double-headed eagle forms the handle of the lid. Gubkin's pieces are always solid and well made.

As in the case of the Konstantin Service mentioned above, Russian ornament on objects in the second half of the nineteenth century sometimes combined neo-rococo elements and seventeenth-century Russian leaf and vine design. A teapot demonstrates the eclectic mixing of these motifs (fig. 120). It also exhibits the widespread use of varied stippling, punchwork, and hatching on the silver surfaces surrounding the entwined patterns of polished gilt, recalling the tankards of the mid-eighteenth century.

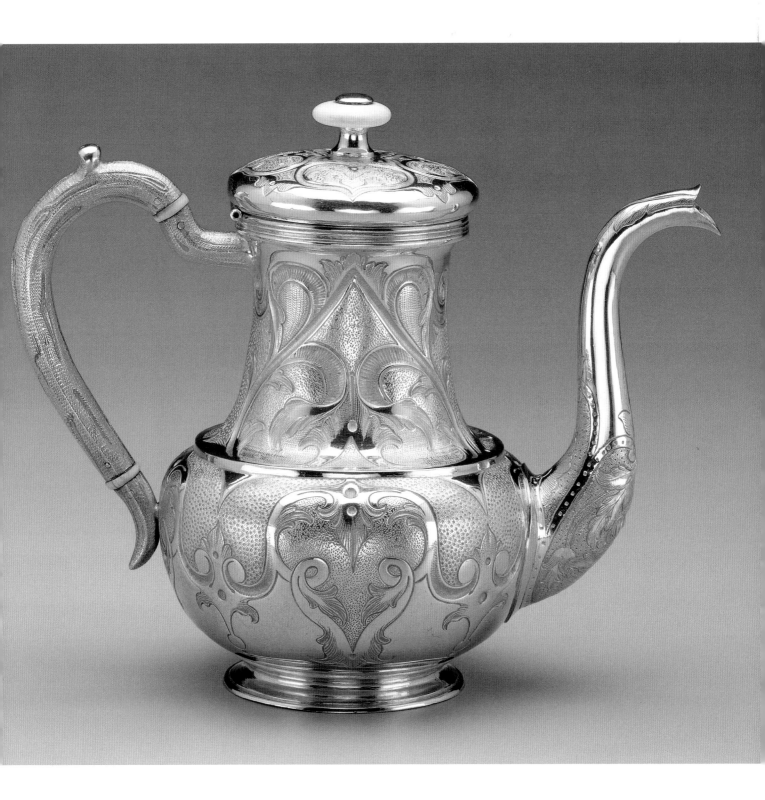

Another tankard (fig. 121) with decorated lozenges of polished gilded silver features a dancing peasant figure as the handle for the lid.[20] Such cast figures, these usually in bronze, were frequently found embellishing paperweights and other utilitarian objects. An inscription reveals the tankard to be a "token of gratitude from V. A. Travnikov" celebrating a twenty-fifth anniversary (1854–79).

In the 1870s and 1880s, studies of Russian ornament began to appear. They covered Slavic decoration from early manuscripts in both Russia and the southern Balkans, but also folk motifs, usually identified by region. These became another incredibly rich source for all craftsmen in addition to Solntsev's valuable work.[21] Thus Russians soon acquired their own grammar of ornament, in the spirit of those compiled by A. W. N. Pugin and Owen Jones in England and Auguste Racinet in France.

As the Russian style spread, silversmiths incorporated many peasant motifs into their interpretations. Once Alexander II had freed the serfs in 1861 enormous attention was focused on their lives, their music, and their arts and crafts. Especially popular were objects decorated to simulate wood, fabric, woven birch bark used to make the bast shoes worn by the peasants, or the angular designs copied from embroidered folk textiles. The bread and salt ceremony gained in popularity in the second half of the nineteenth century and inspired numerous salt cellars in the form of salt chairs (fig. 122) and miniature bread and salt forms (fig. 123). A silver chair is cast and chased around the bottom to look like the grain in wood, while the back is ornamented with

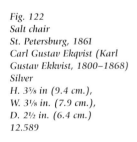

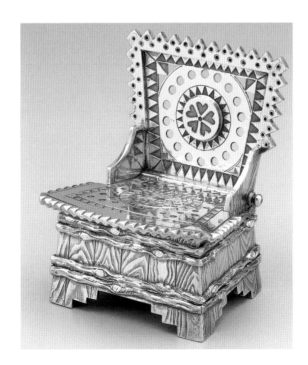

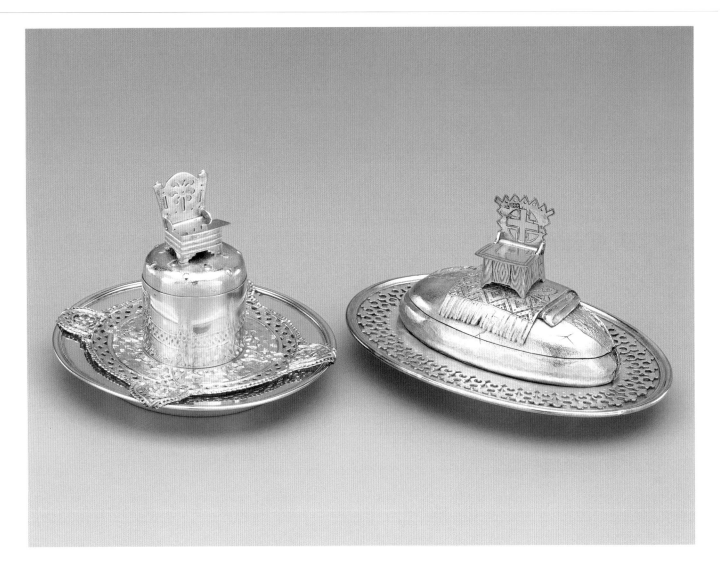

various geometric cut-work patterns. The two salt cellars in the shape of a miniature bread and salt platter include not only a salt chair, but also a trompe l'oeil "linen" napkin. These objects were considered amusements rather than having any utilitarian value.

Perhaps the most popular of such conceits was a bread basket of woven silver with a "linen" napkin draped over it (fig. 124). The napkin would be finely engraved to imitate damask. This detailing proved irresistible to the visitors at the 1876 Centennial Exhibition in Philadelphia and was soon copied by American silversmiths.[22] Martin P. Kennard, one of the judges at the 1876 exhibition, noted of Sazikov's offerings that they were

> an exhibition of much novelty and fascination. Commended for chased silver tea ware, tankards, and vases wrought in repoussé, various ornamental pieces, niello work, combinations of brilliant colored enamel and gilt work, and representations of silk and other fabrics in gold and silver designs of genuine artistic character.[23]

There were, however, a few critics. Art commentator George Ward Nichols complained about these amusements: "For an instant the eye is deceived, and then turns away, vexed that so much labor and good material should be wasted in the mere imitation of an object which suggests no thought of beauty."[24] Despite their frivolity this trompe l'oeil work demonstrated all the technical talents of the engravers and finishers of silverwares.

Fig. 123
Salt cellars in form of miniature
bread and salt presentations
(left) Moscow, 1882
Aleksandr Iosifovich Ful'd (active
1862–1917)
Silver gilt
Dia. 4⅛ in. (10.5 cm.)
12.173

(right) Moscow, 1886
G L *for unidentified maker*
Silver, parcel gilt
W. 5 in. (13 cm.)
12.174

OPPOSITE: *Fig. 124*
Bread basket with "linen" napkin
Moscow, 1886
G L *for unidentified maker*
Silver
H. 2½ in. (6.4 cm.),
W. 14¼ in. (36.2 cm.),
D. 10¼ in. (26 cm.)
Purchase of Hillwood Museum
Collectors Circle, 2009. 2009.2

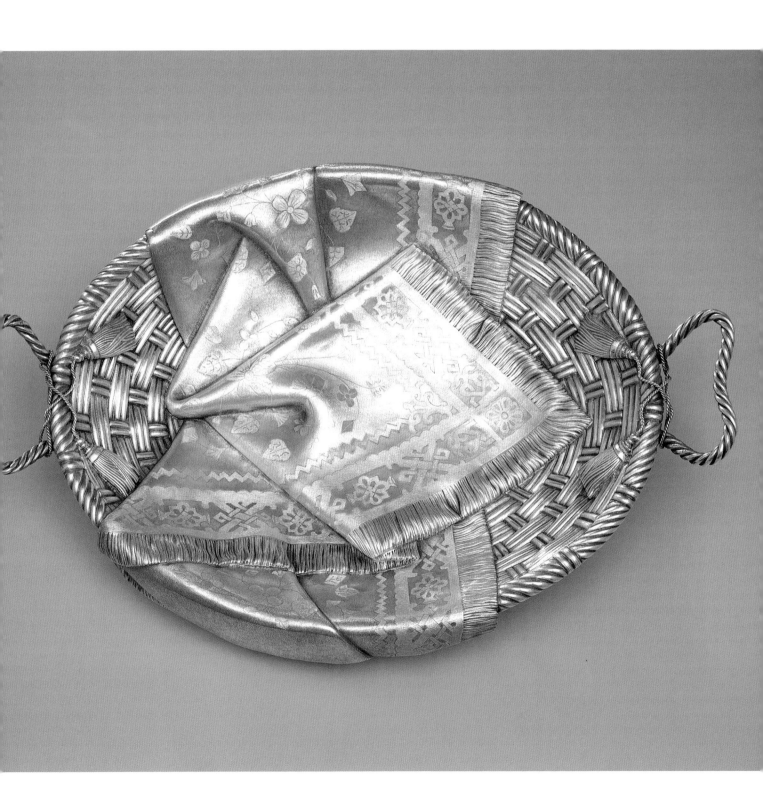

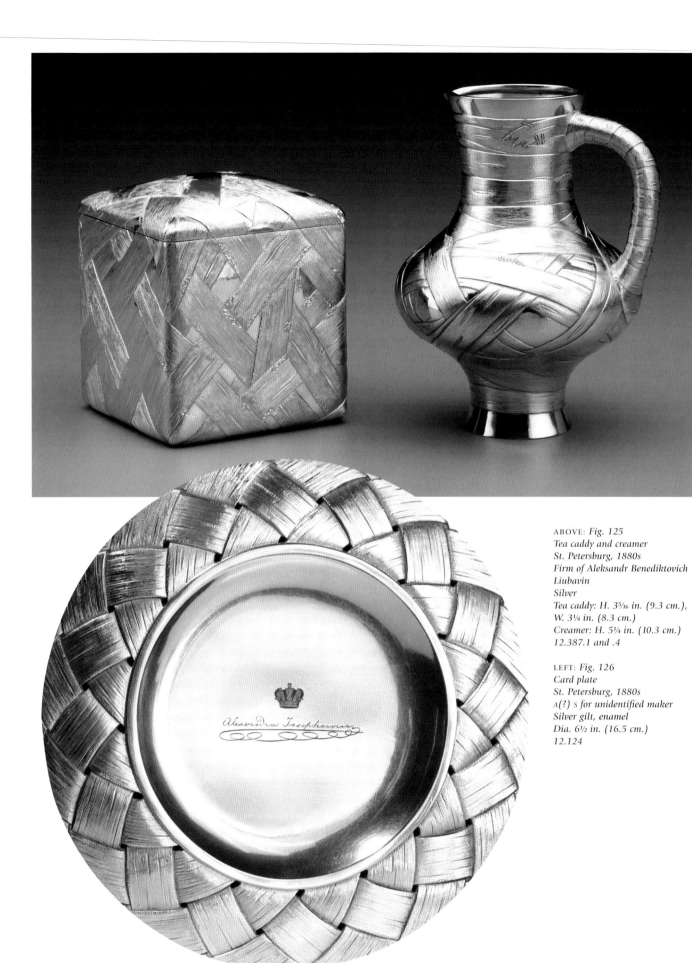

ABOVE: *Fig. 125*
Tea caddy and creamer
St. Petersburg, 1880s
Firm of Aleksandr Benediktovich
Liubavin
Silver
Tea caddy: H. 3⁵⁄₁₆ in. (9.3 cm.),
W. 3¼ in. (8.3 cm.)
Creamer: H. 5¼ in. (10.3 cm.)
12.387.1 and .4

LEFT: *Fig. 126*
Card plate
St. Petersburg, 1880s
A(?) S *for unidentified maker*
Silver gilt, enamel
Dia. 6½ in. (16.5 cm.)
12.124

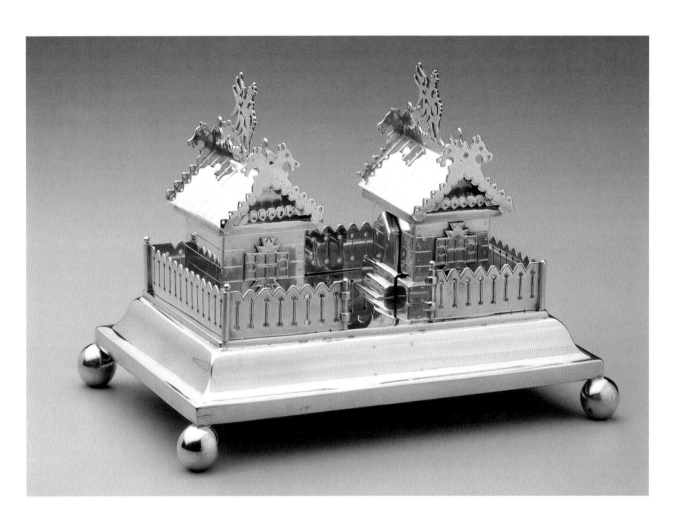

Fig. 127
Inkstand in form of two izby
St. Petersburg, 1880s
P E D *for unidentified maker*
(active 1879–1908)
Silver
W. 7¼ in. (18.4 cm.),
D. 4¾ in. (12.2 cm.)
12.121.1–5

Hillwood has several examples of a molded silver surface simulating woven birch bark, including a tea caddy and cream pitcher from a tea set by the well-known factory of Aleksandr Liubavin in St. Petersburg (fig. 125).[25] The firm Liubavin founded in 1853 operated until 1917. The broad strips simulated in silver here appear to be loosely woven. A tighter weave ornaments the rim of a card plate inscribed with the name of Aleksandra Iosofovna, wife of Grand Duke Konstantin Nikolaevich, brother of Alexander III (fig. 126). It was possibly a wedding gift at the time of their marriage in 1884.[26] The signature is surmounted with the Romanov crown in red enamel. In both cases the pattern of the bark strips is tooled into the silver.

Hillwood owns an inkstand, one of many desk sets and smoking accoutrements that were made in the shape of peasant huts or *izby* (fig. 127). The ridge beam and the barge boards along the roof line are jagged to imitate the carved and painted fretwork on peasant houses. An elaborate rooster forms the handle on each roof to access an

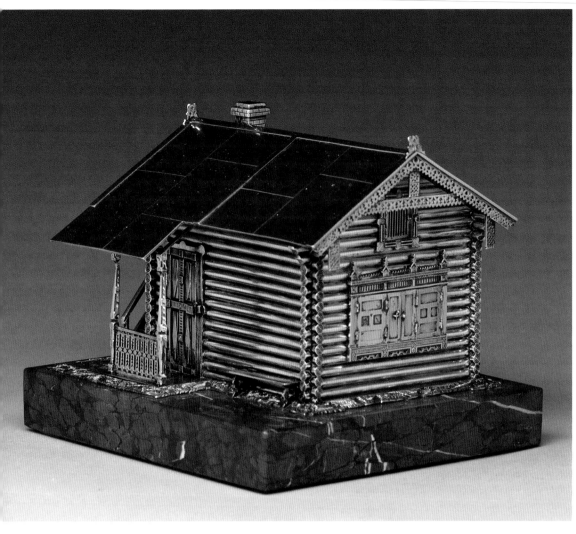

Fig. 128
Miniature izba
St. Petersburg, 1867
Firm of Sazikov
Silver gilt, jasper
H. 5¼ in (13.5 cm.),
W. 6¼ in. (16.04 cm.),
D. 5¼ in (13.5 cm.)
Collection of Middlebury College
Museum of Art, Middlebury,
Vermont. Gift of Nancy and
Edward Wynkoop. 2009.053

BELOW: *Interior of izba.*
Detail of fig. 128.

inkwell and sand pot. At Middlebury College Museum of Art is a magnificent *izba* on a jasper base, made by Sazikov considerably earlier (fig. 128). Actually this structure is more like the house of a merchant or a prosperous peasant of the kind found along the rivers of the Russian north. The roof comes off, and inside it is possible to see the stove, benches for sitting and sleeping, a table, and even an icon corner with identifiable icons. Along the walls there are tools (see detail). While wildly popular at first, these playful objects soon came to be viewed as kitsch, especially by the Russian cultural intelligentsia.

A quite different phenomenon of the second half of the nineteenth century was the growth of numerous large firms producing silverwares for the table, including tea sets in huge numbers decorated with niello scenes of Moscow or lavishly ornamented with enamel.[27] In addition to the firm of Sazikov, they include those founded by Pavel Ovchinnikov, Ivan

Khlebnikov, Iakov Mishukov, Vasilii Semenov, Anton Kuzmichev, and Orest Kurliukov, although Ovchinnikov and Khlebnikov dominated the production. In all 500 firms were producing silver wares in Moscow. All the aforementioned firms were located in Moscow where more silversmiths lived and where their labor costs were cheaper. Due to their size these firms were able to afford the latest technical equipment. They were also able to attract the leading designers, sculptors, and architects to provide new models and ideas. Representatives of the firms regularly traveled to the international expositions to stay current with the latest creative ideas and techniques and often brought examples back to Russia for study. Almost all of the objects produced by these firms were in the Russian style. Due to their lively colors and design, the enamels of all the Moscow silversmiths are favored by collectors over plain silver and as a result many more of them have survived. In fact, it is almost impossible to speak of these firms without including a few pieces with enamel decoration because their output of such enamel wares was so enormous.

After Sazikov the most famous of these was the firm that Pavel Ovchinnikov, a former serf, founded in 1853.[28] Like Sazikov, Ovchinnikov experimented with many traditional Russian techniques for applying enamel and niello. He too founded a school and received the imperial warrant in 1865. In 1873 he opened a store in St. Petersburg, which also included a small workshop. He received outstanding recognition in Philadelphia in 1876. Martin P. Kennard devoted several lines to him in his report:

> Richly chased silver work and decorated silver utensils of novel character and excellence. Chiseled and engraved work that is highly meritorious, fine enameling on silver in Byzantine character and silver gilt goods in Russian style, a resemblance of damask napkins in white silver with colored enameled borders, resting upon gold and silver baskets; very ingenious conceits. The productions of this exhibition are worthy of distinguished mention.[29]

The trompe l'oeil damask napkins were one of the Russian contributions to American design. Later in the 1890s Harper Brothers' author, Theodore Child, would comment on Russian ornament as "always a sort of tapestry or embroidery in very low relief.[30] The Gorham Manufacturing Company began copying such trompe l'oeil work soon after the Philadelphia exhibition.[31] Both Ovchinnikov and Gorham, inspired by the Japanese and probably each other, created silverwares with applied birds, dragonflies, and flowers out of polychrome metals. Sometimes the appliqués were polished and attached to a hammered surface to create contrast. Alternatively Ovchinnikov covered the surface with a thin coat of red enamel lacquer in imitation of Japanese lacquers and then affixed these appliqués.[32] At the All-Russian Exhibition of 1882 Ovchinnikov received praise in the official report for displaying "objects still more varied and of even higher quality than previously."[33]

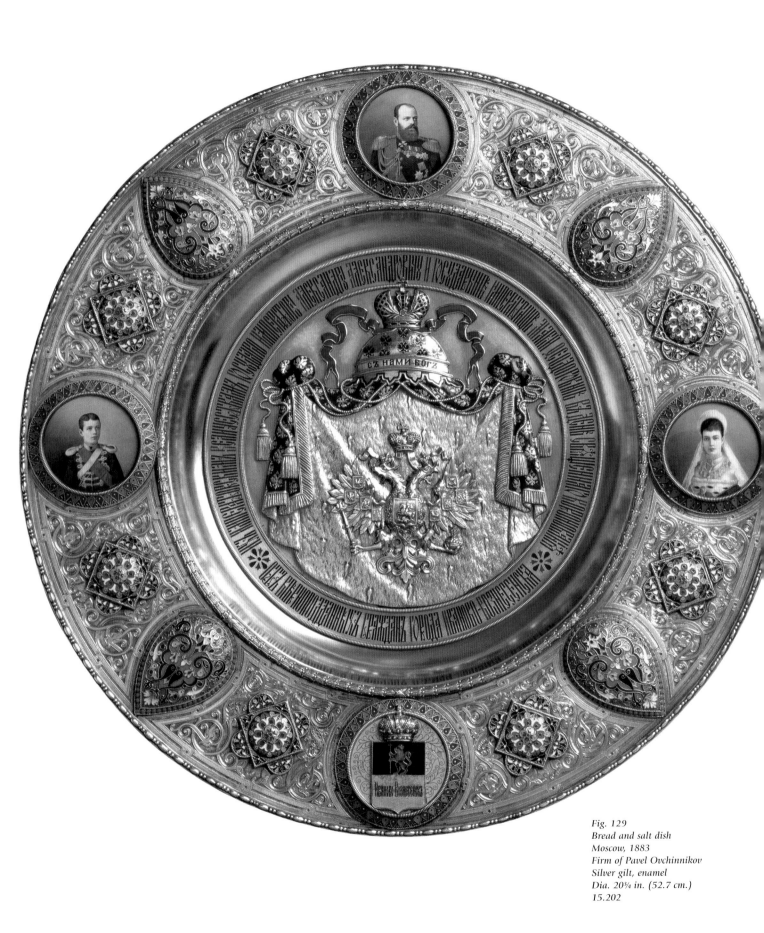

Fig. 129
Bread and salt dish
Moscow, 1883
Firm of Pavel Ovchinnikov
Silver gilt, enamel
Dia. 20¾ in. (52.7 cm.)
15.202

A lavish example of Ovchinnikov's rendering of natural elements can be seen on a bread and salt dish, one of literally dozens that he produced for presentation to the emperor and other members of the imperial family (fig. 129). Fine chasing delineates the feathers of the double-headed eagle against the fur of the ermine mantel in the center of the plate (for a detail see p. 148). The outside of the mantel is decorated with silver eagles on red champlevé enamel velvet. Portraits containing enameled miniatures of Alexander III, Maria Fedorovna, and a young Nicholas as tsarevich are attached to the rim. In between are various medallions decorated with the filigree enamel typical of Moscow work. These are all attached to the rim, which is covered with an elaborate raised interlace pattern of scrolls and curls. The citizens of the town of Ivanovo-Vosnesensk, a textile center north-east of Moscow, whose coat-of-arms appears in the bottom medallion, presented this dish with the traditional bread and salt to Alexander III on the occasion of his coronation in 1883. Such bread and salt ceremonies took place in the Great Kremlin Palace (fig. 130) or in the Winter Palace, where platters from previous ceremonies were mounted in wall cases.

Fig. 131
Teapot
Moscow, 1875
Firm of Pavel Ovchinnikov
Silver, enamel
H. 4½ in. (10.8 cm.)
12.386

OPPOSITE: *Fig. 132*
Bread and salt dish
St. Petersburg, 1888
Firm of Khlebnikov
Silver, parcel gilt, enamel
Dia. 21 in. (53.3 cm.)
Virginia Museum of Fine Arts,
Richmond. Bequest of Lillian
Thomas Pratt. 47.20.380

A relatively early example of Ovchinnikov's work is a teapot with a pink rose painted in champlevé enamel with buds and leaves at the side (fig. 131). Dated 1875, it is a simple example of the kind of everyday object that proliferated in the second half of the century. Ovchinnikov produced champlevé enamel of this type more frequently in the 1870s than later. After his death in 1888, the firm was continued by his sons, the oldest of whom, Mikhail, was active in organizing design competitions in Moscow. The mark of the firm remained the same until it was dissolved in 1917, although "M. Ovchinnikov" occasionally appears on pieces.

Ivan Khlebnikov (1819–1881) opened his Moscow firm in 1869 or 1870, and he received the imperial warrant in 1875.[34] After his death Khlebnikov too was succeeded by his sons. They acquired the shops and factories of the Sazikov firm after the last of the founder's grandsons died in 1887. Some of his workers went to work for Khlebnikov, some for Fabergé. In 1888 Khlebnikov's workshops and stores were amalgamated to form Tovarishchestvo I. P. Khlebnikov, that is, I. P. Khlebnikov and Company, keeping Ivan's name. As Ovchinnikov's principal competitor, Khlebnikov had by the beginning of the twentieth century become more creative and whimsical.

The large quantity of small collectible objects that Ovchinnikov and Khlebnikov produced make it is easy to forget some of the enormous commissions these two firms received. In 1882 Ovchinnikov restored the iconostasis in the Dormition Cathedral in the Kremlin prior to the coronation of Alexander III,[35] and he made a grand liturgical set in *champlevé* enamel, designed by the architect, Lev Dahl (Dal), for the consecration of the Cathedral of Christ the Savior in Moscow at the same time.[36] In 1895 the court commissioned Khlebnikov to make a gilt-bronze framework for the iconostasis of the Annunciation Cathedral in the Moscow Kremlin, and he also produced an extraordinary number of bread and salt dishes for ceremonial occasions.[37] In 1881, for example, Alexander III and his wife, Maria Fedorovna, made a stop at Kherson as part of a trip around the Caucasus and the Black Sea communities. Citizens of Kherson's local *zemstvo* presented a bread and salt dish, now in the Virginia Museum of Fine Art, to the imperial couple, whose initials appear at the top of the plate (fig. 132 and detail on p. 181). The *zemstva* were local governments set up after Alexander II freed the serfs in order to provide schools, hospitals, and other institutions to serve the community. The depiction of a school, a hospital, and a bridge engraved on plaques and set into the rim of the plate was a highly appropriate choice for this dish.

Both Khlebnikov and Ovchinnikov turned out dozens of tea, coffee, and vodka sets decorated in niello, usually with leaf and vine motifs inspired by seventeenth-century examples. The firms also retailed sets, made by contract silversmiths, such as this vodka set, made by Fedor Iartsov, in boxes in their own name (fig. 133). The inside of the wooden box it came in is stamped *Khlebnikov*. These sets included scenes of the major monuments of Moscow—St. Basil's Cathedral, scenes of the Kremlin walls or towers, and the gates into Moscow, which were torn down by Stalin in the 1930s.

OPPOSITE: *Fig. 133*
Vodka set
Moscow, 1880s
Firm of Khlebnikov
Fedor Kirillovich Iartsov
(active 1881–96), maker
Silver gilt, niello
Tray: Dia. 10 in. (25.5 cm.)
Decanter: H. 9 in. (22.8 cm.)
Cups: H. 2⅛ in. (5.5 cm.)
13.75.1–9

BELOW: *Scene of great Kremlin Palace. Detail of fig. 133.*

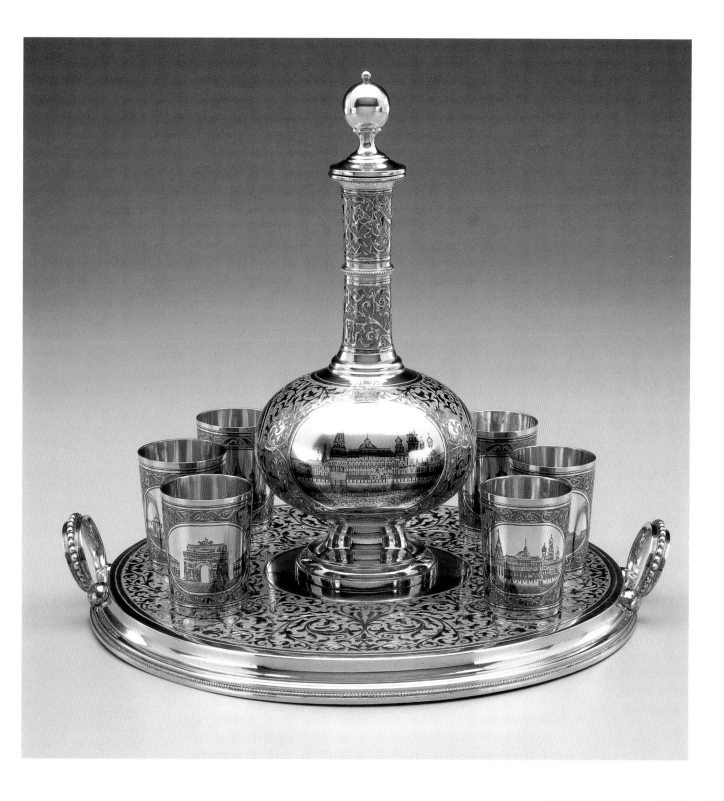

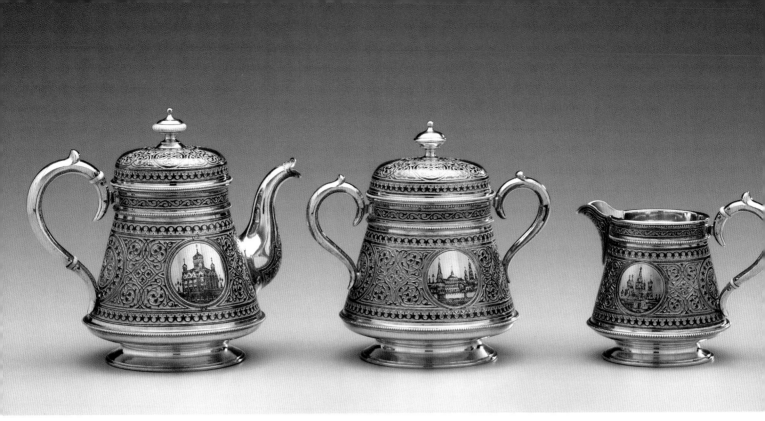

Another Moscow firm, that of Vasilii Semenov, was especially prolific in the production of niello wares. In 1865 he took over his father's firm, founded in 1852. Hillwood has several examples of his work including part of a tea set decorated with a traditional interlace leaf and vine pattern and scenes of Moscow (fig. 134). Following his death in 1896, his workshop was taken over by his daughter Mariia, who produced beautifully crafted enamels. She continued to own the firm until 1917. The ownership of a firm reverting to a wife or daughter was not unusual in Russia, and the tradition goes back to the eighteenth century.

The firm of Kuzmichev was known for its enamel wares, which were sold through Tiffany & Company in New York City. Tiffany opened a Russian department in its Herald Square store around 1885 and began importing porcelain, made by the St. Petersburg firm of the Brothers Kornilov, bronzes, silver, and enameled wares. In 1883 Henry W. Hiller (1838–1926), who had been a commercial agent and U.S. consul in Siberia in the administration of Abraham Lincoln, joined the Tiffany firm.[38] Hiller supplied the firm with its Russian silver and enamels. Tiffany carried the work of a number of Russian silversmiths, but only the marks of Anton Kuzmichev and more rarely Gustav Klingert are found on pieces marked *Made for Tiffany*.

The Moscow firm of Iakov Mishukov was particularly well known for its production of icon *oklady* (fig. 135). Mishukov founded his small workshop in 1880 and following his death in 1900 the business was continued by his widow, Pavla Aleksandrovna and their sons. The three saints, Gurii, Samon, and Aviv, wear vestments fashioned of silvered filigree wires, a most interesting decorative technique. The Russians often used filigree wires (*skan'*) to create works of art, small boxes in particular. Here they are twisted and shaped in various ways to delineate the floral patterns and ribs on the saints' robes. The frame of the *oklad* is in repoussé, and enameled plaques are fastened at the corners as was commonly the case.

As an interest in Russia's history became more widespread in the late nineteenth century, both institutions and private citizens began to assemble significant collections of sixteenth- and seventeenth-century Russian silver. The State Historical Museum in

Fig. 134
Part of a tea set
Moscow, 1889
Firm of Vasilii Semenov
Silver gilt, niello
Teapot: H. 6⅛ in (15 cm.)
Sugar bowl: 6⅛ in. (15 cm.)
Creamer: 4¼ in. (10.8 cm.)
13.81.1–5

OPPOSITE: *Fig. 135*
Icon of St. Gurii, St. Samon, and St. Aviv
Moscow, icon about 1850, oklad 1880–99
Firm of Iakov Mishukov
(active 1880–1917)
Tempera on wood, silver gilt, enamel
H. 12½ in. (31.9 cm.),
W. 10⅝ in. (10.7 cm.)
54.33

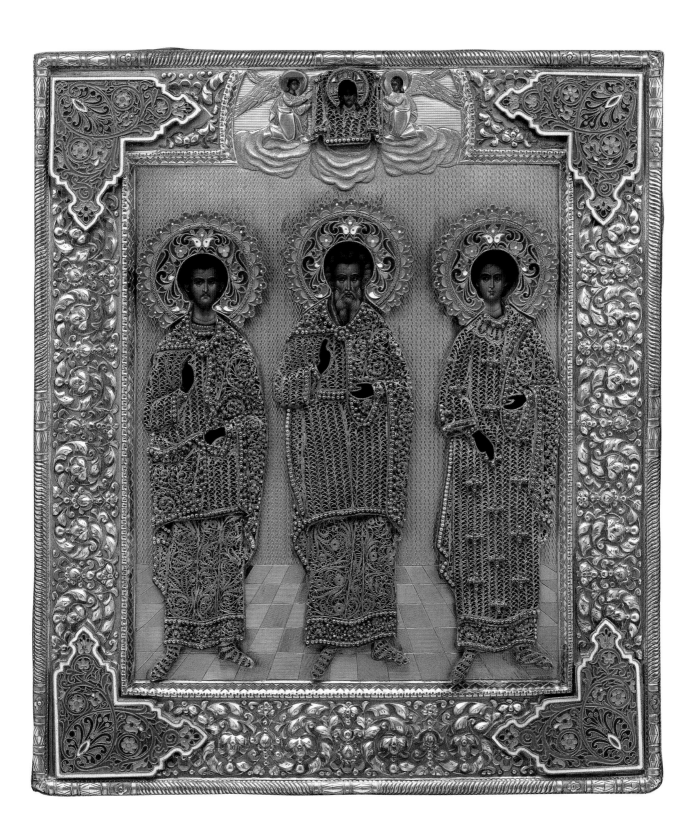

Moscow pioneered the collecting of what today we would call material culture, artifacts from the earliest settlements on the Russian lands up to the present. Pëtr Shchukin (1853–1912), brother of the more famous collector of Impressionist and Post-Impressionist art, Ivan Shchukin, assembled a considerable collection of early Russian artifacts, including silver, all now in the State Historical Museum in Moscow.[39] Shchukin focused on objects used by the middle classes of Russian society—the poorer nobility, the gentry, and merchants. Originally he exhibited his collection in his own museum not far from the Belorusskii train station (fig. 136).

In addition to Shchukin's collection there was also a small study museum at the Stroganov Central School for Technical Drawing (fig. 137). It was extremely important in this period of revival that students have actual seventeenth-century objects to study, so that in addition to their training in Russian design and decoration, they could also experiment with old techniques. Most graduates in the metal arts went on to work for Moscow jewelers. Mishukov's son, for example, studied here before joining his father's firm in 1903. In St. Petersburg the Shtiglits Central School for Technical Drawing played the same role. It is estimated that eighty percent of Fabergé's workers had graduated from the Shtiglits School. Both institutions initiated many drawing competitions and provided silversmiths to all the major firms.

Fig. 136
Shchukin Museum.
Photograph from
Khudozhestvennyi
sokrovishcha Rossii, *no. 6*
(1902).

Fig. 137
*Stroganov Museum.
Photograph from* Iskusstvo i
khudozhestvennaia
promyshlennost', *no. 4
(January, 1899).*

At the Hermitage, important silver and porcelain, mostly European, had been collected since mid-century and beginning in 1883 Alexander III ordered that the most important of these collections, including for the first time Russian works of art, be displayed in the Winter Palace. It was only in 1910 that this display of silver and porcelain was moved to the Hermitage for public exhibition.[40]

Russian collecting activities were recognized at two important exhibitions: "The Treasures in Moscow" in 1901 and an historical exhibition in St. Petersburg in 1904.[41] Members of the imperial family, the aristocracy, and wealthy collectors all contributed to both exhibitions. They were the first to display decorative arts, and part of the rationale for the exhibitions was for students to be able to see important Russian and European works of art. Thus grew an active internal market for Russian decorative art, including of course silver.

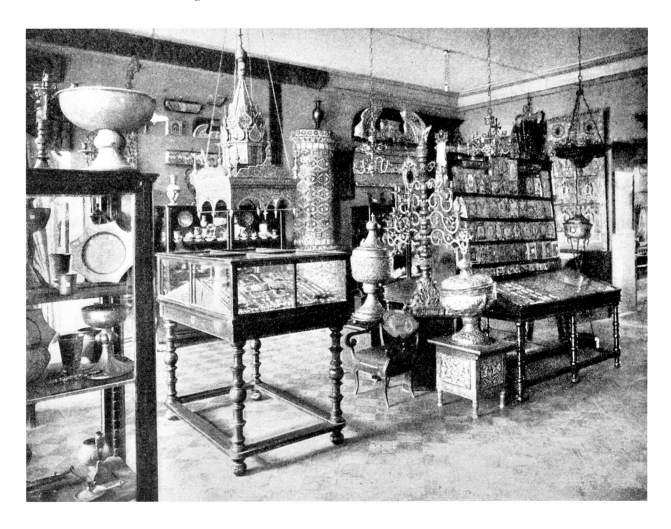

NOTES

1. F. G. Solntsev, *Drevnosti rossiiskago gosudarstva* (Moscow: V Tipografii A. Semena, 1849–53). For a study of Solntsev and his impact on Russian art of the second half of the nineteenth century, see Cynthia Whitaker, ed., *Visualizing Russia: Fedor Solntsev and Crafting a National Past* (Leiden: Brill, 2010) and Anne Odom's chapter in this volume, "Solntsev's Legacy in Russian Decorative Art," devoted specifically to the influence of Solntsev in this period.

2. Evgeniia I. Kirichenko has written most extensively on the Russian style. See *Russkii stil': Poiski vyrazheniia natsional'noi samobytnosti. Narodnost' i natsional'nost', traditsii drevnerusskogo i narodnogo iskusstva v russkom iskusstve XVIII–nachala XX veka* (Moscow: Galart, 1997) and in English *Russian Design and the Fine Arts 1750–1917* (New York: Harry N. Abrams, Inc., 1991).

3. V. M. Lobanov, ed., *V. V. Stasov: Stat'i i zametki, ne voshedshie v sobraniia sochinenii*, vol. 2 (Moscow: Iskusstvo, 1954), 186.

4. See Sotheby's New York, April 21, 2005, lot 18.

5. For more information on the Sazikov firm, see Vyacheslav Mukhin, "The Petersburg Branch of the Sazikov Firm and Russian Silverware of the 19th and Early 20th Centuries," in *The Fabulous Epoch of Fabergé: St. Petersburg-Paris-Moscow*, ed. Vyacheslav Mukhin (Moscow: Nord, 1992), 43–51 and Larissa Zavadskaia in "Gold and Silver in St. Petersburg 1830–1850," in Géza von Habsburg, *Fabergé: Imperial Craftsman and his World* (London: Booth-Clibborn Editions, 2000).

6. Sazikov was credited in the *Politseiskii vedomosti* (*Police Gazette*), and Solntsev refuted his claim in *Severnaia pchela* (*The Northern Bee*). See N. A. Belozerskaia, "Fedor Grigor'evich Solntsev, professor, arkheologicheski zhivopisi," *Russkaia starina* 54 (April, May, June, 1887), 732.

7. Quoted by Zavadskaia in "Gold and Silver in St. Petersburg 1830–1850," 51.

8. M. Pavlovich, "K voprosu o restavratsii dvortsovukh tserkvei Moskovskogo Kremlia v 1812–1850-kh gg.," S. L. Malafeeva, *Tsarskie i imperatorskie dvortsy. Staraia Moskva* (Moscow: Izdatel'stvo ob"edineniia "Mosgoarkhiv," 1997), 55–61.

9. See Peter Gay, *Modernism: The Lure of Heresy: From Baudelaire to Becket and Beyond* (New York and London: W. W. Norton and Company, 2008), 19–20.

10. See *Katalog rossiiskim proizvedeniiam otpravlennym na londonskuiu vystavku 1851 god* (St. Petersburg: V tipografii Departamenta vneshei torgovli, 1851), 77 for a list of the objects Sazikov sent.

11. *Official Descriptive and Illustrated Catalogue: Great Exhibition of the Works of Industry of All Nations, 1851*, vol. 3, *Foreign States* (London: Spicer Brothers, 1851), between 1382–84, no. 209 and between 1384–85, nos. 190, 194, 197, and 206.

12. *The Crystal Palace Exhibition Illustrated Catalogue, London 1851: An Unabridged Republication of the Art Journal Special Issue* (New York: Dover Publications, 1970), 266–67.

13. Quoted in Mukhin, "The Petersburg Branch," 46.

14. At the time the object was called a vase, although today it has occasionally been called a candelabrum. See I. D. Kostina, T. N. Muntian, and E. V. Shakurova, *Russkoe serebro XVI–nachala XX veka veka* (St. Petersburg: Slaviia, 2004), 161.

15. Mukhin, "The Petersburg Branch," 44.

16. Marina Lopato, *Iuveliry starogo Peterburga* (St. Petersburg: Izdatel'stvo gosudarstvennogo Ermitazha, 2006), 132–33. The knight itself was made by Sazikov. Later under Alexander II the English Shop master Samuel Arndt crafted the base, see Kostina, *Russkoe serebro*, 157. Stylistically the base is not suitable for the naturalistic style of the horse and knight. For the knight in the London centerpiece, see James Christian Steward, ed., *The Collections of the Romanovs: European Art from the State Hermitage Museum, St. Petersburg* (London: Merrell, 2003), 176.

17. Sotheby Parke-Bernet, New York, February 29–March 1, 1980, lot 129.

18. For a Polish eagle presented to Tsar Aleksei in 1671, see Reinhold Baumstark and Helmut Selig, eds., *Silber und Gold: Augsburger Goldschmiedkunst für die Höfe Europas* (Munich: Hirmer Verlag, 1994), cat. 36. For another in the Kremlin, made in Nuremberg by Christoph Jörg Ruel Jamnitser, see G. A. Markova, *Nemetskoe khudozhestvennoe serebro XVI–XVIII vekov v sobranii gosudarstvennoi oruzheinoi palaty* (Moscow: Iskusstvo, 1975), cat. 16.

19. For an example by Ovchinnikov, see Kirichenko, *Russkii stil'*, 172.

20. For the same dancing figure on another tankard by Khlebnikov at the State Historical Museum, see Kostina, *Russkoe serebro*, 164.

21. See Viktor Butovskii, *Histoire de l'ornement russe du Xe au XVIe siècle d'après les manuscrits* (Paris: Vve A. Morel cie, 1870–73) and V. V. Stasov, *Russkii narodnyi ornament* (St. Petersburg: Tip. T-va Obshchestvennaia polzy, 1872), among others.

22. Charles L. Venable, *Silver in America, 1840–1940: A Century of Splendor* (New York: Harry N. Abrams, 1994), 168. For a group of objects exhibited by Sazikov in Philadelphia, including one of these baskets with a napkin over it and comments about the novelty and beauty of them, see George T. Ferris, *Gems of the Centennial Exhibition* (New York: D. Appleton & Company, Publishers, 1877), 38–39.

23. Francis A. Walker, ed., *United States Centennial Commission, International Exhibition 1876 Reports and Awards, Group XI* (Philadelphia: J. B. Lippincott & Co., 1877), 27.

24. George Ward Nichols, *Art Education Applied to Industry* (New York: Harper & Brothers, Publishers, 1877), 175.

25. For a similar teapot exhibited by Sazikov at Philadelphia, see *Gems of the Centennial Exhibition*, 38.

26. The plate was said to be from the collection of Queen Olga of Greece, Konstantin's older sister. See Hillwood file 12.124.

27. For a review of firms producing wares in the Russian style, see G. G. Smorodinova, "Iuveliry serebrianogo veka," *Russkii stil': Sobranie gosudarstvennogo istoricheskogo muzeia: Katalog* (Moscow: Gosudarstvennyi Istoricheskii muzei, 1998), 158–201. Also V. Skurlov and G. Smorodinova include data on court silversmiths in *Faberzhe i russkie pridvornye iuveliry* (Moscow: Terra, 1992). For enamels produced by these firms, see Anne Odom, *Russian Enamels: From Kievan Rus to Fabergé* (London: Philip Wilson Publishers, 1996), 107–73.

28. For more on Ovchinnikov, see Galina Smorodinova, "Pavel Ovchinnikov and Russian Gold- and Silversmithery," in *The Fabulous Epoch of Fabergé*, 57–60 and K. A. Orlova, "Izdeliia firmy P. A. Ovchinnikova v sobranii Ermitazha," in *Dekorativno-prikladnoe iskusstvo Rossii i zapadnoi Evropa* (Leningrad: Gosudarstvennyi ermitazha, 1986), 86–90.

29. Francis A. Walker, ed., *United States Centennial Commission*, 27.

30. Theodore Child, "The Kremlin and Russian Art," *The Tsar and His People: Or, Social Life in Russia* (New York: Harper & Brothers, 1891), 335.

31. See Venable, *Silver in America*, 165 and 170 for examples.

32. See ibid., 169, 179, and 184 for both American and Russian examples.

33. V. P. Bezobrazov, ed., *Otchet o vserossiiskoi khudozhestvenno-promyshlennoi vystavke 1882 god v Moskve*, vol. 4 (St. Petersburg, 1884), 301.

34. For more information on Khlebnikov, see S. Ia. Kovarskaia, *Proizvedeniia Moskovskoi iuvelirnoi firmy Khlebnikova: Katalog* (Moscow: Gos. istoriko-kul'turnyi muzei-zapovednik "Moskovskii Kreml'," 2001).

Detail of fig. 132

35. For information on this restoration, see Svetlana Kovarskaia, "…Ne meniat' staryi oklad," *Mir muzei* 2 (174) (Mar.–Apr. 2000), 40–44.

36. *Vsemirnaia illiustratsiia*, 30 (1883), 428–29. He exhibited this set in the All-Russian Arts and Industry Exhibition in Moscow in 1882.

37. Svetlana Kovarskaia, "I. P. Khlebnikov," *Mir Muzei* 5 (170) (July–Aug. 1999), 22–23.

38. For a brief biography, see Henry Hiller's obituary in the *New York Times*, January 21, 1926. See also Norman E. Saul, *Concord and Conflict: The United States and Russia, 1867–1914* (Lawrence, KS: University Press of Kansas, 1996), 280.

39. *Liubiteliam russkii stariny: Velikii metsenat Rossii Pëtr Ivanovich Shchukin* (Moscow: Khudozhnik i Kniga, 2005), 38–41 and 60–61 for some of his silver.

40. V. A. Suslov, ed., *Ermitazh. Istoriia i sovremennost'* (Moscow: Iskusstvo, 1990), 155–57 and 253–55 and Sergei Gonchar, "Alexander III's Reforms in the Decorative Arts," *Maria Fedorovna, Empress of Russia* (Copenhagen: Christiansborg Palace, 1997), 278.

41. For the catalogues, see D. Nikiforov, *Sokrovishcha v Moskve* (Moscow, 1901) and Adrian V. Prakhov, *Albom istoricheskoi vystavki predmetov iskusstva, ustroennoi v 1904 godu v S-Peterburgie* (St. Petersburg: T-vo P. Golike i A. Vilborg, 1907).

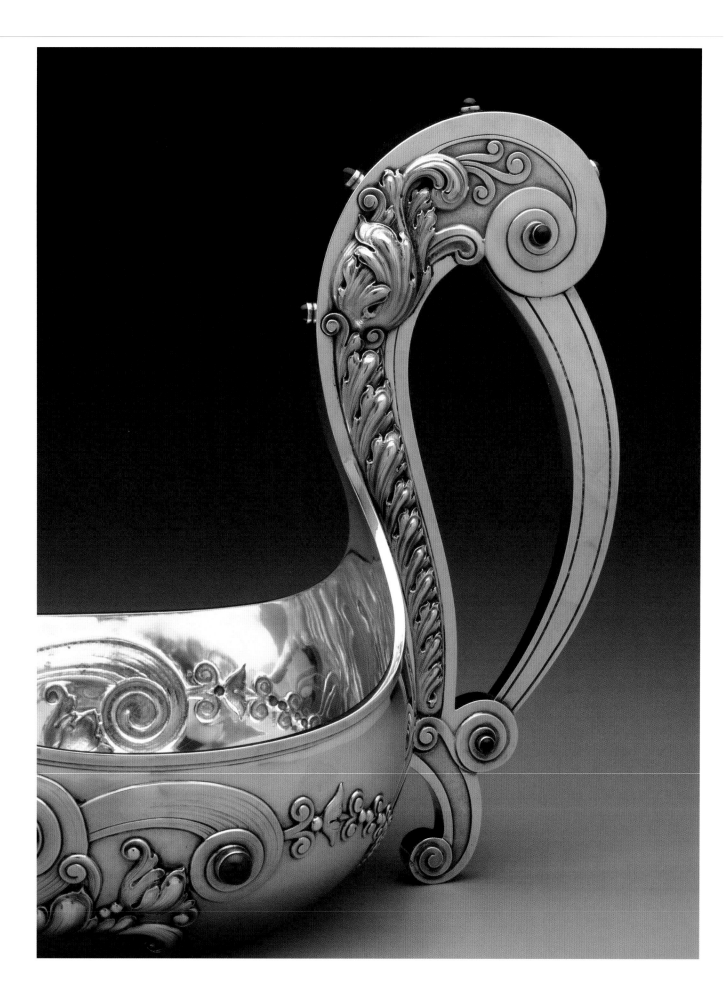

FABERGÉ TO MODERNISM

D ESPITE THE POPULARITY of the Russian revival of the 1870s and 1880s, traditional western styles never completely lost their hold and in fact, both the rococo and Neoclassical styles enjoyed a considerable revival in the 1890s and early twentieth century respectively. Their patrons were primarily members of the court, many of whom remained thoroughly western in their tastes. The rococo revival of the 1890s seems to have been inspired in part by intensified relations with France between 1891 and 1893, with naval visits to both Kronstadt and Toulon celebrating the Franco-Russian defense treaty in 1893, finally ratified in 1894.[1]

France had been enjoying its own rococo revival during the Second Empire (1852–70) and then into the Third Republic, beginning in 1870, when cultural arbiters institutionalized the unity of the Louis XV style as modern and the best of French tradition. As Debora L. Silverman points out, "the official affirmation of the rococo as a French *patrimoine* received powerful impetus from the Franco-Russian alliance. The ceremonial aspects of the alliance were multiple and elaborate and pressed the decorative arts into important service to the state."[2] The Russians presented objects enameled in the Russian style as state gifts in return. Just as diplomatic gifts of the seventeenth century acted as a means of molding style, so too these French gifts had their own impact on Russian design. A French exhibition in Moscow in 1890 prompted a new look at rococo ornament. Diplomatic exchanges continued with the visits of Nicholas and Alexandra to Paris in 1896 after their coronation and of President Félix Faure to Russia in 1897.

The St. Petersburg firms of Fabergé and the Brothers Grachëv both produced objects in the Russian style, but these firms were much better known for their work in the

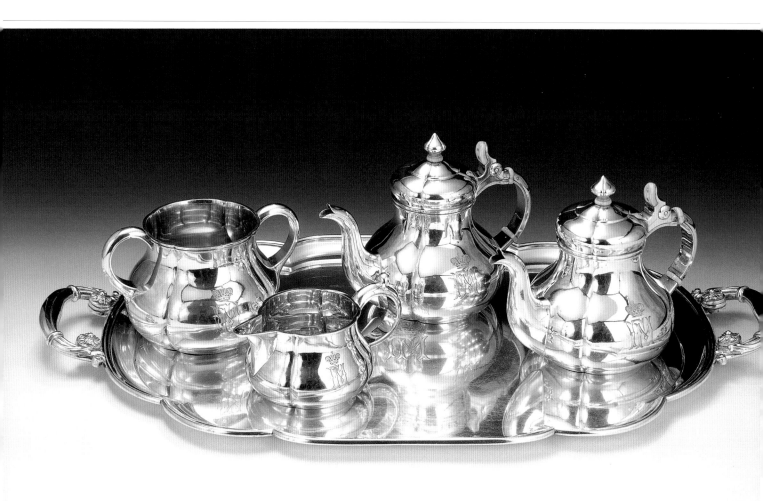

rococo and later in the Neoclassical style. The Grachëv firm was not nearly as prominent as Fabergé, or his Moscow competitors, but was certainly sought out by the imperial family for commissions. For example, in 1894 Grand Duke Georgii Mikhailovich ordered a tea and coffee set, now at the Middlebury College Museum of Art (fig. 138). Soft curves delineate the bulbous body of the teapot, hot-water pot, creamer and sugar, and the edges of the tray. The only other decoration is his cipher GM in Cyrillic, topped by the imperial crown. The grand duke ordered a flatware service from Grachëv at the same time, now also at Middlebury.[3]

Gavriil Grachëv founded his St. Petersburg firm in 1866. Following his death in 1873, his sons Mikhail and Simeon continued the factory's work until 1917. From 1896 the sons had the imperial warrant. Grachëv's production is always defined by fine craftsmanship and often, in the case of his Russian-style enamels, designs and colors quite distinctive from Moscow work. Like Fabergé the firm of Grachëv also provided silver lids and mounts for colorless cut glass wares made at the Imperial Glassworks and other factories (fig. 139). The glass would be produced at the factory and then sent to a silversmith for mounting and sale. The lid of this finely cut glass bowl is embellished with shell-shaped acanthus leaves around the lower edge, beading at the top edge, and a stylized pattern above the leaves. These borders are reminiscent of those on table silver at the beginning of the nineteenth century. Given the large amount of silver-mounted glassware by Fabergé and Grachëv still extant, their production must have been huge.[4]

Fig. 138
Tea set
St. Petersburg, 1894
Firm of the Brothers Grachëv
Silver, gilding, ivory
Tray: H. 1½ in. (3.8 cm.),
W. 25⅞ in. (65.7 cm.),
D. 15⅛ in. (38.4 cm.)
Teapot: H. 6¼ in. (17.2 cm.),
W. 8½ in. (21.6 cm.),
D. 6⅜ in. (16.2 cm.)
Hot-water pot: H. 6⅝ in.
(16.8 cm.), W. 8¾ in. (22.2 cm.),
D. 5⅜ in. (13.8 cm.)
Creamer: H. 3⅜ in. (8.6 cm.),
W. 6½ in. (16.5 cm.),
D. 4½ in. (11.5 cm.)
Sugar: H. 4⅜ in. (11.3 cm.),
W. 7½ in. (19.1 cm.),
D. 5⅝ in. (14.3 cm.)
Collection of Middlebury College
Museum of Art, Middlebury,
Vermont. Gift of Nancy and Edward
Wynkoop. 2001.020.1–4, 6

Fig. 139
Cut glass bowl with silver lid
St. Petersburg, 1899–1908
Firm of the Brothers Grachëv
Unknown glassworks
Silver, lead glass
H. 12 in. (30.5 cm.),
Dia. 6⅝ in. (17 cm.)
23.199.1–2

There is an enormous literature on the work of Peter Carl Fabergé (1846–1920), son of Gustav Fabergé (1814–1893), founder of what became Russia's most famous jewelry, silver, and goldworks.[5] No other Russian firm achieved the international recognition enjoyed by Fabergé. Of Huguenot descent, Gustav founded the business in 1841. When he retired to Dresden in 1860, he dispatched young Carl to train with various western jewelers and businessmen. It is unclear when Carl returned to the St. Petersburg shop, overseen by an assistant in the interval, but he assumed leadership of the workshops in 1872 when he was twenty-six.[6] His European education was expanded even further by studying the collections of Renaissance and eighteenth-century French and English goldwork in the Hermitage.

The firm is less famous for its silver production than for its enamels and jewelry, but it certainly produced the usual bread and butter items of all jewelers—tablewares— most of which no longer exists. For example, Fabergé produced the table silver for the dowries of both of Nicholas II's sisters, Kseniia and Olga.[7] Two silversmiths in St. Petersburg—Julius Rappoport (1851–1917) and Antti (Anders) Nevaleinen (1858–1933)—oversaw the most important silver commissions. An example of Rappoport's work is a vase mounted with coins and medals representing all of Russia's rulers from Peter I to Alexander III (fig. 140). The metal surface in between the coins and medals is filled with long stalks of morning glories; their flowers opening at the top. Baroque sprays of leaves fan out at the sides. At the top of the cup is an embossed double-headed eagle, a sign that the cup was surely an imperial presentation gift, probably between 1890 and 1899.

Rappoport also produced the silver mounts for two clocks at Hillwood. One of these shows the versatility of the firm in working in quite different styles (fig. 141). The clock is constructed of Bowenite panels mounted in silver in the shape of a small commode with two figures holding the timepiece on top. The clock case is fashioned in the rococo style inspired by an eighteenth-century English clock attributed to James Cox (active 1757–91) and now in the Walters Art Museum. The English clock was said to have belonged to Empress Alexandra and much admired by her mother-in-law, Maria Fedorovna. Fabergé made one like it that Nicholas and Alexandra are said to have given to Maria, whose monogram appears on the back.

Fabergé never copied his models exactly. The hardstone panels of the original Cox clock were formed from a bright orange, striated agate, while those of the Fabergé clock are of pale green bowenite. Rappoport replaced the very thin and finely chased gold mounts of the English clock with a sturdy cage of silver that was at one time coated with green gilding. The graceful S-curves of the mounts, the handles on the two drawers, and the swirling drapery on the two putti along with the shell design just below the clock face reveal the rococo revival of the 1890s at its best. Both clocks originally had an additional finishing ornament. A bird perched on the top of the spire with a baroque

Fig. 140
Tall vase with coins
St. Petersburg, before 1899
Firm of Fabergé
Julius Rappoport (1851–1917),
workmaster
Silver
H. 12⅞ in. (32.7 cm.)
12.184

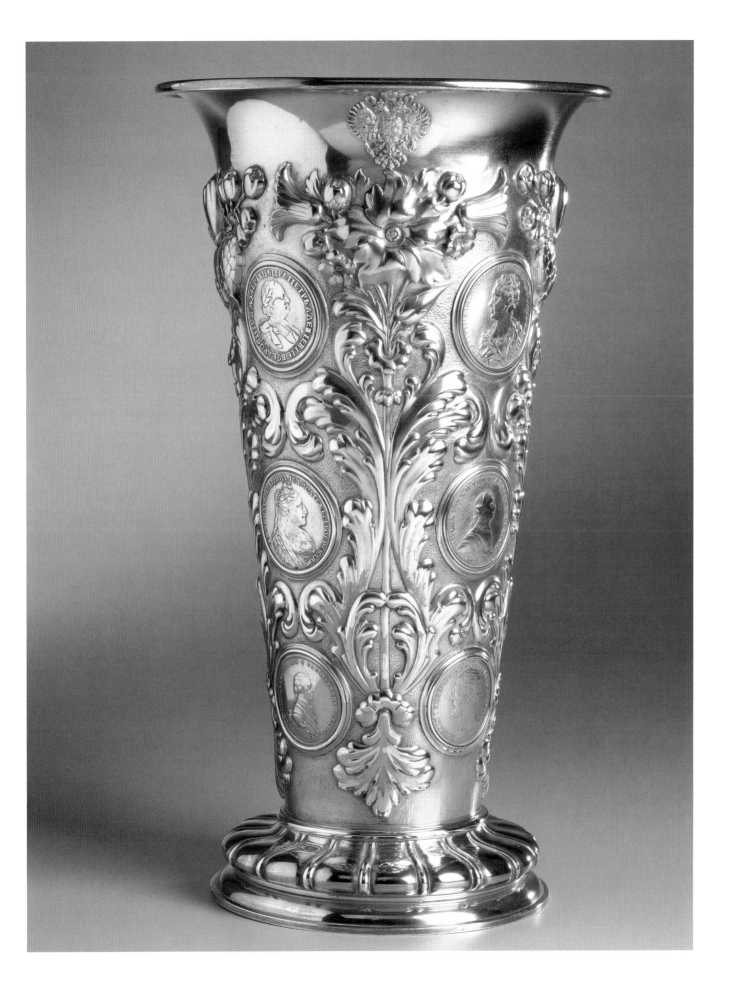

Fig. 141
Clock
St. Petersburg, 1894–96
Firm of Fabergé
Julius Rappoport (1851–1917),
workmaster
Works: H. Moser and Cie
Silver gilt, bowenite, watercolor
on ivory
H. 11¼ in. (28.6 cm.),
W. 4 in. (10.2 cm.)
12.155

OPPOSITE: *Fig. 142*
Regimental clock
Moscow, ca. 1896
Firm of Fabergé
Julius Rappoport (1851–1917),
workmaster
Silver gilt, enamel, marble,
chalcedony
H. 26½ in. (67.3 cm.),
W. of base 24¼ in. (62.2 cm.)
12.153

pearl dangling from its beak completed the Hillwood clock, as we know from an historical photograph of a 1902 exhibition of Fabergé objects from the imperial family at the Baron von Dervis mansion in St. Petersburg. This type of bird appears on several Cox creations and originally may have graced the top of the Walters clock as well.

Rappoport's silver mounts for a regimental clock, which the officers of the Imperial Horse Guards presented to their commander, Grand Duke Pavel Aleksandrovich, an uncle of Nicholas II, reveal the lack of control Fabergé's designers had over the components of a commissioned object (fig. 142). As François Birnbaum, Fabergé's chief designer after the death of his brother Agathon in 1895, remarked, the imperial guards "practically always wanted the main features of the regiment to be represented in the composition." He noted that "this was extremely difficult for the artist and was often to the detriment of the work as a whole."[8] The clock features the drums (as inkwells) and the cuirass, helmet, banners and flag of the regiment as sculptural decoration at the foot of the pedestal housing the clock itself. A cast double-headed eagle holding a laurel wreath in one talon and a torch in the other tops the clock itself. The decorative borders around the top and base of the blue-enameled pedestal are Neoclassical motifs of acanthus leaves similar to those found on the Grachëv lid (fig. 139).

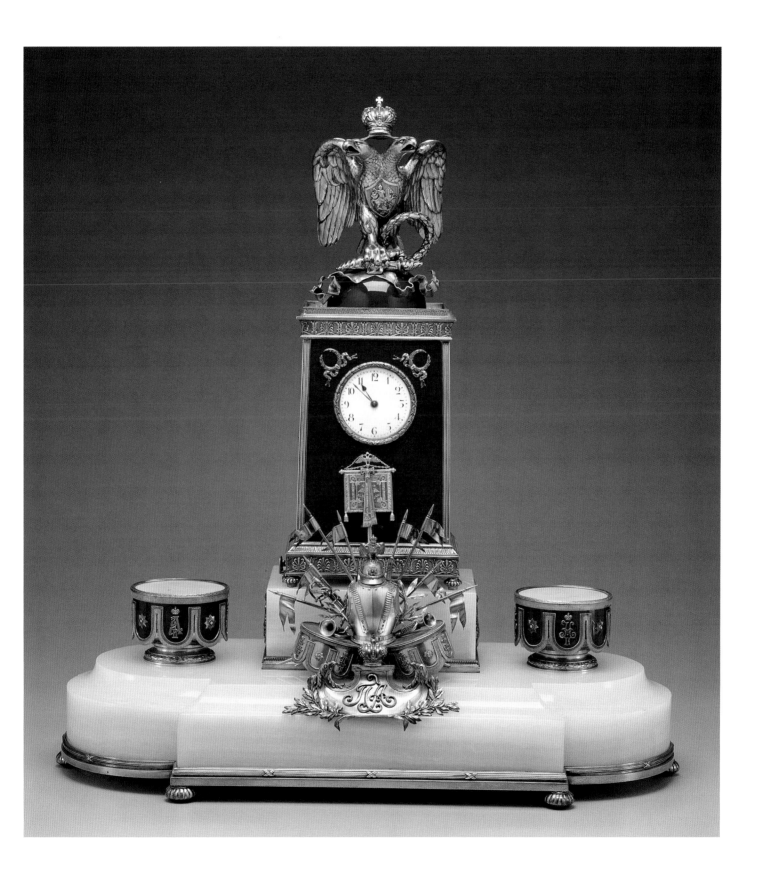

Three miniature silver helmets are examples of other military commissions sometimes made by Fabergé, but by many other firms as well (figs. 143 and 144). The smaller ones are regimental vodka cups, exact replicas of the headgear of the Life Guards, Pavlovskii Regiment. Because the cup could not be placed on the table with any liquid in it, it had to be consumed in the Russian fashion *do dnia* or "to the bottom." One of them is inscribed with the name of the owner, Akimovich, and is dated 1911, the year he joined the regiment.[9] The other cup, somewhat larger, has been called in some catalogues a *charka* or a vodka cup, but the Hillwood example has fabric in the interior, so it could not be used for drinking. It is a copy of the helmet of the Imperial Horse Guards.[10] This might be viewed as the military equivalent of trompe l'oeil silver pieces that imitate peasant artifacts.

Fabergé's realistic silver sculptures of animals are an intriguing phenomenon. He is, of course, famous for his animals in various semi-precious stones. Whereas he would sometimes create green elephants of nephrite or red horses of rhodonite, his silver rabbit with ruby eyes whose head tilts back on a hinge to form a pitcher is not as fanciful as his hardstone animals (fig. 145). Made in Fabergé's Moscow workshop, the rabbit exemplifies the attention to detail that the owner of the firm demanded. The rabbit has been cast, but his fur has been naturalistically chased, soft around the nose and in the ears, and left coarser along the back. The rabbit, like monkeys in the form of table lighters, a sturgeon open down the back to serve as a caviar dish, and other such creatures are both larger than the hardstone animals and functional.[11] These were perhaps inspired by silver toys, shaped as animals, including a bear and an elephant, owned by Tsar Aleksei's children or by sculptures in the shape of stags and boars used as drinking vessels in Germany in the seventeenth century.[12]

In order to facilitate expanded production, Fabergé opened a store and a workshop in Moscow in 1887. Alan Bowe, originally from South Africa and most recently an employee of the Bolin firm in Moscow, became its manager.[13] This operation provided Fabergé with an outlet in Moscow, but also the advantage of tapping into the large supply of silversmiths and the lower costs of producing silver in Moscow. As Fabergé's sales catalogues produced in 1893, 1899, and 1902 (for which copies are still extant) illustrate, the Moscow workshops were the main supplier of flatware, table silver, and simple jewelry for the firm. The 1893 catalogue included four different patterns of flatware.

Some of the most important imperial commissions were fulfilled by Rappoport or Antti Nevaleinen in St. Petersburg, but most of the silver production was turned out in Moscow. Hillwood owns a pair of candlesticks (fig. 146) that are said to have belonged to Grand Duke Aleksei Aleksandrovich, an uncle of Nicholas II. He made a celebrated visit to the United States in 1870–71, and was later Grand Admiral of the Russian navy. The design with laurel leaves entwining a fluted stem was a favorite conceit of the firm. All the favorite Neoclassical motifs are repeated—scrolls, acanthus leaves, beading and laurel bands.[14]

Hillwood also owns a grand tea set and samovar made by the First Silver Artel, which often supplied work to Fabergé for retail, which explains the appearance of the marks of both firms on the pieces (figs. 147 and 148).[15] The First Silver Artel came into being upon the retirement of Julius Rappoport in 1909. He left his workshop to his craftsmen, and they formed the artel.[16] Alexander Wäkevä, another of Fabergé's silversmiths, made the large tray. Designed in the Empire style, the vessels are all supported by square columns on lions' paws with winged lions' heads at the top. On the cover are the imperial crown and the monogram of Grand Duchess Aleksandra Iosifovna, the widow of Grand Duke Konstantin Nikolaevich, brother of Alexander II. As the inscription on the lid confirms, this was a twenty-fifth wedding anniversary gift from the grand duchess and three of her children to her son Grand Duke Konstantin and his wife Elizaveta Mavrikievna. The Roman numeral "twenty-five" decorates the handle of the samovar's spigot.

Fig. 147
Tea set
St. Petersburg/Moscow, ca. 1909
Tray: Firm of Fabergé
Alexander Wäkeva (1833–1910),
workmaster
Coffee pot, teapot, creamer, sugar:
First Silver Artel, maker
Silver, parcel gilt
Tray: W. 27⅛ in. (68.7 cm.),
D. 18¼ in. (46.4 cm.)
Coffee pot: H. 12 in. (30.5 cm.)
Teapot: H. 7 in. (17.8 cm.),
W. 8 in. (20.8 cm.)
Sugar: H. 6½ in. (16.5 cm.),
W. 7 in. (17.8 cm.)
Creamer: H. 5½ in. (14.0 cm.),
W. 4 in. (10.2 cm.)
12.379.1, 4, 6–8

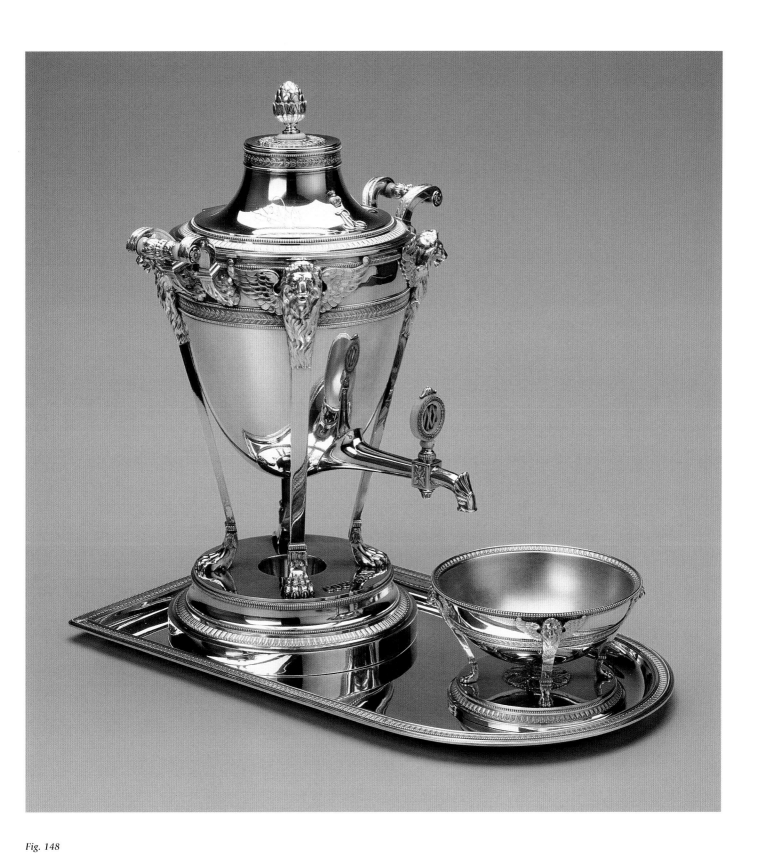

Fig. 148
Samovar
St. Petersburg/Moscow, ca. 1909
Firm of Fabergé
First Silver Artel
Silver, parcel gilt
Samovar: H. 16 in. (40.6 cm.)
Tray: L. 16½ in. (41.9 cm.)
Slop bowl: H. 5½ in (14.0 cm.), W. 5⅝ in. (14.3 cm.)
12.379.2–3, 5

Fig. 149
Table and tea set
St. Petersburg/Moscow,
1899–1908
Firm of Fabergé
Julius Rappoport (1851–1917), workmaster
Silver, ivory, Karelian birch wood
Table: H. 28¼ in. (71.8 cm.)
Kettle: H. 13½ in. (34.2 cm.)
Fine Arts Museums of San Francisco. Gift of Victoria
Melita, Grand Duchess Kirill, through Alma de Bretteville
Spreckels. 1945.366.1, 1945.355–65

Fig. 150
Tea set
Moscow, 1908–17
Firm of Fabergé
Silver
Tray: W. 16⅝ in. (42.2 cm.),
D. 11½ in. (29.2 cm.)
Coffee pot: H. 9½ in. (24.1 cm.)
Creamer: H. 5¼ in. (13.3 cm.)
Sugar: H. 5 in. (12.7 cm.)
12.566.1–5

A tea service and tea table now in the California Palace of the Legion of Honor (now one of the Fine Arts Museums of San Francisco) is another fine example of Fabergé's interpretation of the Neoclassical style (fig. 149). Made in the workshop of Julius Rappoport, it is comprised of ten pieces, employing swans and snakes in the decoration of handles and supports and as appliqués to the sides of the table. A silver gallery encloses the top of the Empire-style Karelian birchwood table. Grand Duchess Victoria Melita, wife of Grand Duke Kirill Vladimirovich, presented the table and tea set to Alma Spreckels of San Francisco in 1922 for generously transporting medical supplies to Romania during World War I, where the grand duchess's sister, Marie, was queen.[17] Both of these splendid tea sets and the table remind us of the popularity of the Empire style in St. Petersburg, which the World of Art group publicized through articles in its journal of the same name. A third Fabergé tea set, much simpler in its decoration, was purchased by Post in Moscow in 1937 as a wedding gift for Frances and Augusto Rosso, at that time the Italian ambassador to Moscow (fig. 150). It came to Hillwood with the Rosso collection.

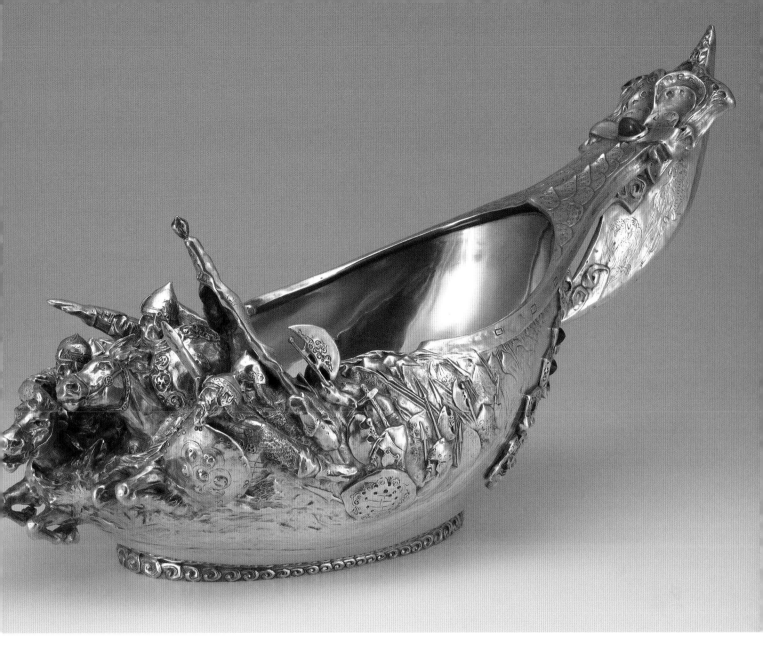

There is no question that Fabergé's Moscow workshops were also the source of most silverwares in the neo-Russian style. Many of the artists and artisans working in this new style, both for Fabergé and for other firms, trained at the Stroganov School in Moscow, one of the places where the neo-Russian style was being developed.[18] The neo-Russian style was an adaptation of the earlier Old-Russian style with the addition of motifs and forms, stemming largely from the Viennese Secession movement and German *Jugendstil*. It was a conscious attempt to create a modern style in the first decade of the twentieth century. Most neo-Russian wares were produced after 1896 and especially in the twentieth century. A frame employing bold stylized flowers and rosettes and a stylized double-headed eagle is a good example of this new interpretation of older elements (fig. 151). The patterns are often bold and there is frequent use of semi-precious stones. The carved curls around the feet of the frame became a common motif in Fabergé's neo-Russian style.

The Moscow workshops of Fabergé produced a number of large *kovshi* in the *stil' modern*. They often featured *bogatyri* in helmets and chain mail. Such *bogatyri* can be seen wildly galloping their horses off the front of a vessel at the Virginia Museum of Fine Arts (fig. 152). Curls set with semi-precious stones and amethysts line the back side

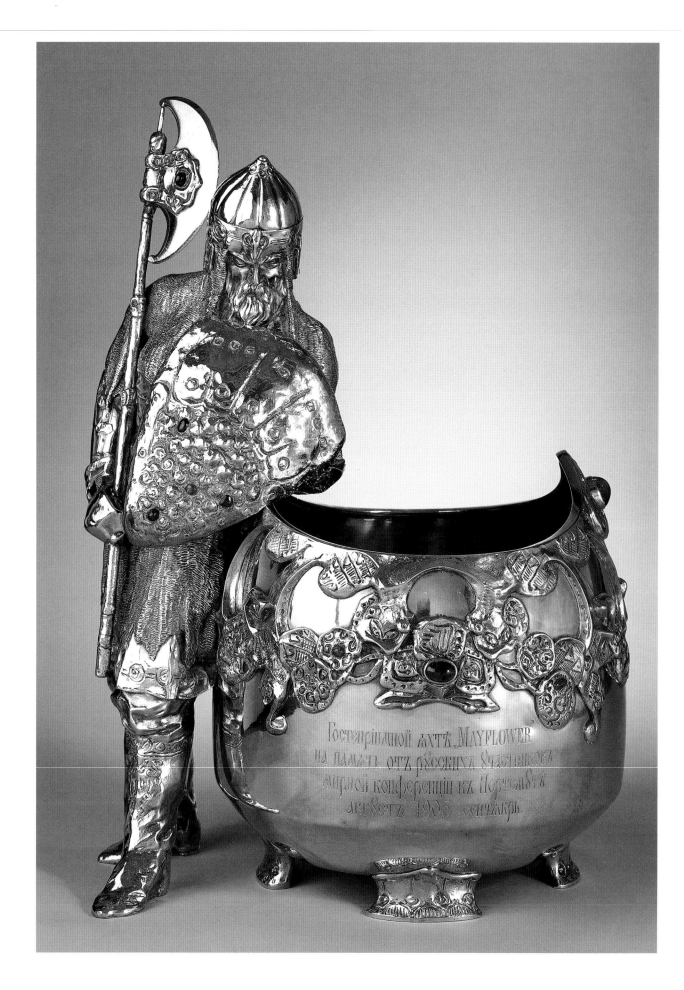

U.S.S. Mayflower *bowl*
Moscow, ca. 1905
Firm of Fabergé
Silver, emeralds, amethysts,
sapphires
H. 19¼ in. (48.9 cm.)
United States Naval Academy
Museum. 29.13

Fig. 154
U.S.S. Beale *bowl with ladle*
Moscow, ca. 1912
Firm of Fabergé
Silver, amethysts
Bowl: H. 12½ in. (31.8 cm.),
W. 22 in. (55.9 cm.),
D. 13⅓ in. (33.9 cm.)
Ladle: W. 13¼ in. (33.7 cm.)
U.S. Naval Academy Museum.
39.44

of the *kovsh* toward the handle. Another example of this type is the so-called "Mayflower Cup," a very large bowl-shaped *kovsh* with a standing *bogatyr'* wearing chain mail, a helmet and holding a shield and axe attached to its side as the handle (fig. 153).[19] There are elaborate details of stylized scrolls set with semi-precious stones, applied around the bowl. Russian delegates to the peace process following the Russo-Japanese War in 1905 presented the bowl to the wardroom mess of the Yacht *Mayflower*, where the Russian and Japanese delegates met to negotiate the Treaty of Portsmouth with the assistance of President Theodore Roosevelt.

The United States Naval Academy Museum also houses a large silver bowl on four ball feet with cast handles in the shape of the double-headed eagle with amethysts on their breasts (fig. 154). Mary Bakhmeteff, wife of the last Russian ambassador to the United States before the Revolution, presented this bowl to the wardroom mess of the destroyer U.S.S. *Beale*, probably at its commissioning in 1912. She was the daughter of Edward Fitzgerald Beale, in whose memory the ship and the bowl are dedicated.

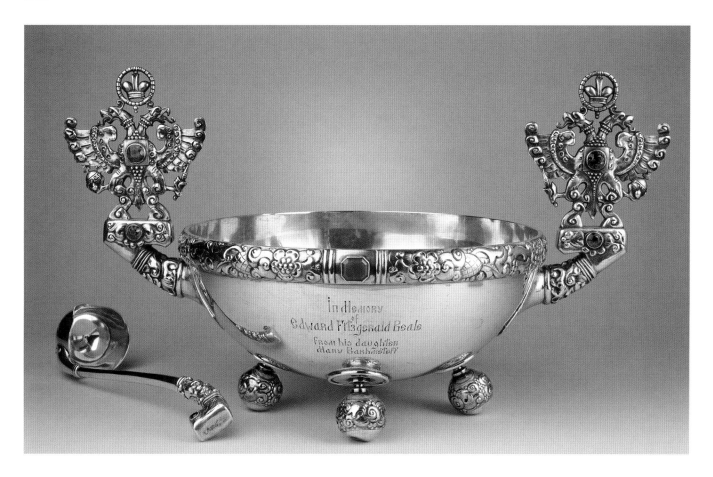

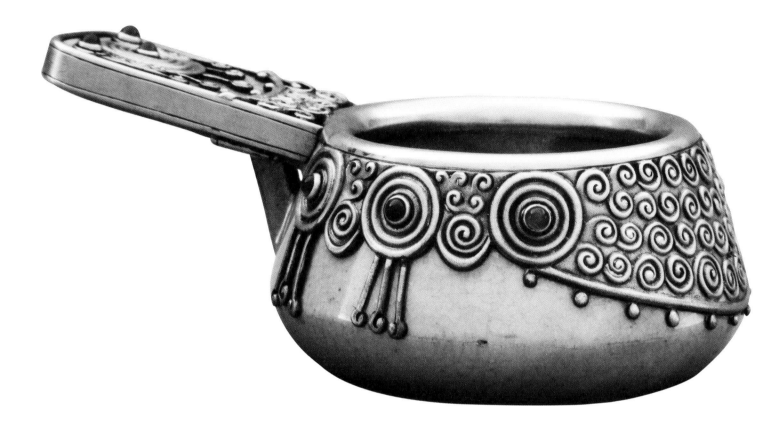

Less grand, but very much in the neo-Russian taste, are glazed stoneware *kovshi* with silver mounts and often set with cabochon stones made at Fabergé's Moscow workshops (fig. 155). This example has the familiar Fabergé curls in silver, dotted with occasional cabochon stones on the sides and handle. Usually the pottery is unmarked, so it is unclear where the stoneware was made, but occasionally pieces appear with the impressed mark of the Imperial Stroganov School for Technical Drawing.[20] Some ceramic wares may also have been made at the ceramic workshops at Abramtsevo, the arts and crafts colony north of Moscow.

Sea or ship motifs were often used to decorate *kovshi*, whose form was thought to be based on a swimming bird or a Viking ship. A *kovsh* and its ladle at Hillwood both have waves along their sides ending in semi-precious stones (fig. 156). Rather than the Secessionist curls found on the Fabergé *kovshi*, this one has acanthus leaves under the waves and along the handles. The S-curves of the handle and the prow of the vessel are pronounced Art Nouveau forms. Fabergé, if the most imaginative and daring of the silversmiths when it came to neo-Russian styles, was not the only one producing them. This example is by another Moscow silversmith, Ivan Tarabrov (active 1893–1913).

Fig. 155
Kovsh
Moscow, 1899–1908
Firm of Fabergé
Silver, glazed stoneware, enamel, semi-precious stones
W. 5 in. (13 cm.)
Fowler Museum at the University of California, Los Angeles.
x87.993

OPPOSITE: *Fig. 156*
Kovsh with ladle
Moscow, 1899–1908
Ivan Philippovich Tarabrov (active 1893–1913)
Silver, with precious stones, including carnelian, agate, and tiger's eye
Kovsh: H. 11½ in (29.21 cm.), W. 8¾ in. (22.2 cm.)
Ladle: H. 3⅛ in. (8.1 cm.), W. 8 in. (20.3 cm.)
12.391, 12.392

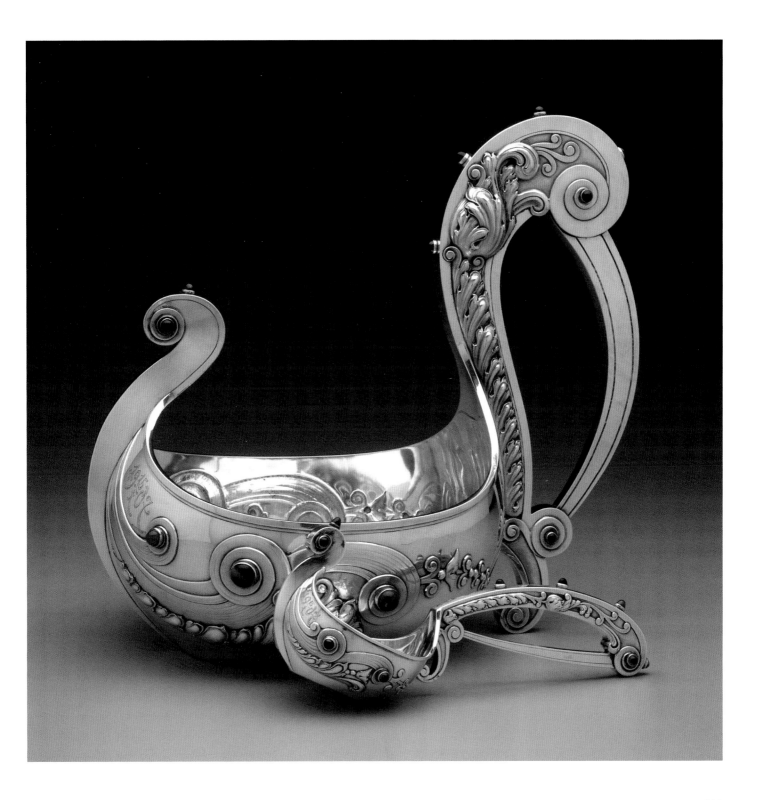

A monogram and an inscription dated 1907 indicate that the *kovsh* must have been a gift celebrating some special occasion. Lavish gift-giving had not disappeared: employees honored a retiring manager, years of service were recognized, birthdays and anniversaries were celebrated, and diplomatic gifts continued.

The firm of Olovianishnikov and Sons was Fabergé's chief competitor in the production of religious objects for church and personal use. The firm was an old one, founded in Iaroslavl' in 1766 to manufacture bells. It also produced liturgical textiles and church fixtures, such as brass chandeliers and candlesticks in the nineteenth century. The turn of the twentieth century witnessed the firm's transformation as its activities expanded and a younger generation took charge. In 1901 Viktor Ivanovich Olovianishnikov (1874–1932) assumed the directorship of the Moscow branch (bells were still made in Iaroslavl') and reorganized the firm into Olovianishnikov and Sons. It became the premier workshop for the supply of liturgical plate in the neo-Russian style.

The firm's chief designer, Sergei Vashkov (1879–1914), was a leading artist in the revival of the liturgical arts in the early twentieth century.[21] He began his association with the Olovianishnikov firm in 1901 after finishing an extensive course of study at the Stroganov Institute. He is a good example of the creative impact the school exerted on contemporary designers. His work included liturgical sets, *lampady*, crosses, and other furnishings needed to supply the large number of *stil' modern* churches being built in the new century, very few of which remain. The religious revival that swept Russia during the reign of Nicholas II resulted in many important commissions, including those from the imperial family.

Most of Vashkov's designs are in the seventeenth-century style, which was favored by Nicholas II's court. One typical example of Vashkov's interpretation of this style is a panagia, customarily worn by a bishop around his neck, and now at Middlebury College (fig. 157). An icon of the *Vladimir Mother of God* painted on mother-of-pearl is surrounded by river pearls. It is mounted in a gilded silver frame, delicately incised with scrolls and an inscription. It is enlivened with semi-precious stones and has three chains dangling from the bottom and attached to gemstones.

Vashkov very successfully experimented with early Christian styles. Chains are a feature of a chalice that was one of Vashkov's last commissions (fig. 159). They hang from the bottom of a cloisonné-enameled silver gilt band decorated with white doves. This mount supports a glass bowl, which replaces the sardonyx or onyx that was more commonly used in Byzantine chalices. This chalice is part of a set inspired by the early churches of the catacombs and epitomized for Vashkov the early Christian era when works of art "did not glitter with luxury, did not astound with the precious materials of their decoration, but fascinated with the richness of their ideological content and riveted attention to their strict simplicity."[22] Although most of his earlier chalices are

Fig. 157
Panagia
Moscow, 1908–17
Firm of Olovianishnikov and Sons
Sergei Vashkov (1879–1914), designer
Silver gilt, aquamarines, peridots, amethysts, sapphires, mother-of-pearl
H. 4 in. (10.2 cm.), W. 2⅝ in. (6.7 cm.)
Collection of Middlebury College Museum of Art, Middlebury, Vermont. Gift of Nancy and Edward Wynkoop. 2009.051

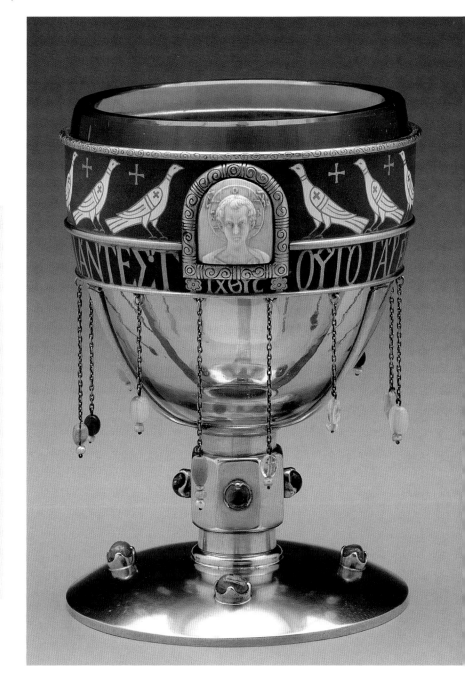

in a stylized version of the seventeenth century, Vashkov had designed one other chalice in the Byzantine style for the church at Novaia Chartoria, in south-western Ukraine, with chains hanging from the metal support of the white topaz bowl (fig. 158). The original prototypes for these Byzantine-style chalices are surely the ones in the treasury of the basilica of San Marco in Venice.[23]

This liturgical set of which the Hillwood chalice is a part was commissioned for a cave chapel dedicated to Saints Konstantin and Elena beneath the church at the Court Hospital in Tsarskoe Selo, consecrated in October, 1914 in the presence of Empress Alexandra and her daughters.[24] This may well have been the last commission of Vashkov's life for he died in November of that year. In an introduction to a volume illustrating ten years of his work for the Olovianishnikov firm, Vashkov wrote that he did not "consider it necessary to copy slavishly the ancient forms of art," but rather he strived "to revive only the previous religious-moral ideals."[25]

In the work of Fabergé's Moscow workshops and the designs of Sergei Vashkov, one begins to sense the confidence that Russian artists felt in the new century. No longer chained to historicist styles, they were creatively melding all the influences that had been streaming into Russia in the last ten centuries. Certainly in the luxury arts Russians were now able to compete with Western European craftsmen on more equal terms. The Russian Revolution of 1917 was a tragedy for many reasons, but it was especially so for the luxury arts and their design. This production, unlike that for porcelain, stopped cold. There were few silverwares produced in the Soviet Union until after 1990. Yes, some souvenir spoons and other small objects were turned out, especially in Velikii Ustiug, as the tourist market began to expand after Stalin's death in 1953, but it was very limited.

There is no question that the late Victorian and Edwardian eras saw an extremely high production of silverwares not only in Russia, but in Europe and especially in America. It signaled the middle class coming to power. Silver production declined rapidly everywhere in the twentieth century, especially after the Great Depression and World War II, as working women no longer wanted to clean their silver. But for Russia after the Revolution, silver just disappeared, swallowed by the Bolshevik regime's huge hunger for precious metals as foreign exchange. We only have an inkling of what Fabergé would have produced in the Art Deco style.

Russian designers since the 1990s have tended to start where Russia left off in 1914. Perhaps inevitably they have had to go through that first phase of recreating the Fabergé taste before they have been able to move on to new innovative ideas. In their new designs they have been mostly influenced by the modernist Scandinavian and Finnish design of the turn of the late twentieth century. This is most evident in their jewelry, and since the mid-1990s they have been fortunate to have once again a wealthy Russian class willing to pay for luxury wares.[26] While it is most unlikely that Russia would return to its pre-Revolutionary production, it could see a major revitalization of this sector of its economy.

NOTES

1. This was the beginning of a series of agreements between Great Britain, France, and Russia that became the Triple Entente. The Triple Alliance between Germany, Austria, and Italy was initially created in 1882.

2. Debora L. Silverman, *Art Nouveau in Fin-de-Siècle France: Politics, Psychology, and Style* (Berkeley: University of California Press, 1989), 159.

3. Georgii's silver had been kept at Harax, his estate in the Crimea, where Empress Maria Fedorovna stayed in the last weeks before she left Russia. The family was fortunate that she was able to take the silver with her when she was evacuated in 1919. Anne Odom, *What Became of Peter's Dream: Court Culture in the Reign of Nicholas II* (Middlebury, VT: Middlebury College Museum of Art, 2003), 10.

4. For examples in Fabergé trade catalogues, see *K. Faberzhe: pridvornyi iuvelir* (Moscow, 1899), ed. Valentin Skurlov and Tatiana Fabergé, facsimile edition (2009), 38, 40, and 54. See also *Russkoe serebro* (2004), 213, 216–19 for two pitchers, a caviar dish with a naturalistic silver crab holding the dish, and two glass vases for fruit, 204–05.

5. Several leading examples include: Kenneth Snowman, *The Art of Carl Fabergé*, rev. ed. (London: Faber and Faber, 1962); Marvin C. Ross, *The Art of Karl Fabergé and his Contemporaries* (Norman, OK: The University of Oklahoma Press, 1965); Géza von Habsburg and Marina Lopato, *Fabergé: Imperial Jeweler* (Washington, D.C.: The Fabergé Arts Foundation, 1993); Géza von Habsburg, *Fabergé in America* (London: Thames and Hudson, 1994); and Géza von Habsburg, *Fabergé: Imperial Craftsman and his World* (London: Booth-Clibborn, 2000).

6. In Tatiana Fabergé, Lynette G. Proler, and Valentin Skurlov, *The Fabergé Imperial Easter Eggs* (London: Christie's, 1977), 21, the authors state that Fabergé returned to St. Petersburg in 1872. Géza von Habsburg, however, in *Fabergé: Imperial Craftsman and his World*, notes that he returned in 1864. Habsburg's date chart notes, for example, that he was registered as a member of the merchants' guild in 1867.

7. François Birnbaum, "Birnbaum Memoirs," in von Habsburg and Lopato, *Fabergé: Imperial Jeweler*, 453. Marina Lopato, "New Insights into Fabergé from Russian Documents," ibid., 61.

8. Birnbaum, "Birnbaum Memoirs," ibid., 454.

9. I would like to thank Marvin Lyons for this information.

10. For a *charka* in the shape of a Life Guard hussar's helmet and a *bratina* simulating a shako, see Marina Lopato, *Iuveliry starogo Peterburga* (St. Petersburg: Izdatel'stvo gosudarstvennogo Ermitazha, 2006), 134 and 135.

11. For a monkey, see von Habsburg, *Fabergé in America*, 221, for the sturgeon, see ibid., 275, for an automated rhinoceros, ibid., 250, and for a pitcher in the shape of a dachshund, ibid., 64. For a whole group of monkeys, see von Habsburg, *Fabergé: Imperial Craftsman*, 110–11.

12. I. E. Zabelin, *Domashnii byt russkikh tsarei XVI i XVII stoletiakh*, vol. 1 (Moscow: Kniga, 1990), 216–17 and Alexander von Solodkoff, "Fabergé Silver Animals," von Habsburg, *Fabergé: Imperial Craftsman*, 102-108.

13. For a more complete biography, see *The Russian Sale*, Bonham's London, November 24, 2008. For more on the Moscow workshops, see Anne Odom, "Fabergé: The Moscow Workshops," in von Habsburg and Lopato, *Fabergé: Imperial Jeweler*, 104–15.

14. A pair of candelabra, each piece designed to hold two candles, includes the same features. See von Habsburg, *Fabergé in America*, 101.

15. About thirty artels, or cooperatives, were established, mostly after 1907 by workers often dissatisfied with the conditions in some of the larger factories and seeking to improve their circumstances. Many of them produced very fine quality work.

16. Birbaum, von Habsburg and Lopato, *Fabergé: Imperial Jeweler*, 448.

17. Victoria Melita and her sister Marie were granddaughters of Alexander II. Their mother Grand Duchess Maria married the Duke of Edinburgh. Victoria was first married to Ernst Ludwig, Grand Duke of Hesse-Darmstadt and brother of Empress Alexandra. They divorced in 1901, and she married Grand Duke Kirill in 1905.

18. See Wendy R. Salmond, "Design Education and the Quest for National Identity in Late Imperial Russia: The Case of the Stroganov School," *Studies in the Decorative Arts* 1, no. 2 (Spring 1994), 2–24.

19. The rendering of the sculptural details is very similar to that found on another large *kovsh* of this period, formerly in the Malcolm Forbes collection. See von Habsburg and Lopato, *Fabergé: Imperial Jeweler*, 347. For the designs of two *kovshi*, see 415 and 416.

20. See *Russian Art*, vol. 3, Sotheby's, New York, April 16, 2008, lot 403 for a similar example, but with the ceramic body marked. For a ceramic duck with Fabergé mounts, see von Habsburg, *Fabergé: Imperial Craftsman*, 146.

21. For more on Vashkov, see Anne Odom, "Sergei Vashkov," *Pinakoteke* 22–23 (2006), 211–16.

22. Sergei Vashkov, *Religioznoye iskusstvo: sbornik rabot tserkov-grazhdanskoi utvari ispolnennoi tovarishchestvom P. I. Olovianishnikova* (Moscow: T-vo P. I. Olovianishnikova S-ia, 1911), unpaginated. Most of this set seems to have survived. For other examples now in the Russian Museum, see *Zolotaia kladovaia Russkogo muzeia: k 100-letiu muzeia 1898–1998* (St. Petersburg: Palace Editions, 1998), ills. 202 and 203, and also in *Svetil'nik* 10 (1914), figs. 15–25.

23. *The Treasury of San Marco Venice* (Milan: Olivetti, 1984), 163 and 166. Several of these retain gold loops to hold chains which are still visible.

24. In fact, many members of the imperial family, especially the Empress and her sister Grand Duchess Elizaveta Aleksandrovna, were patrons of Vashkov and his style. They were the sisters of Grand Duke Ernst of Hesse-Darmstadt, the patron of *Jugendstil*, which developed at Matildenhöhe.

25. Vashkov, *Religioznoe iskusstvo*, introduction, unpaginated.

26. For Finnish jewelry of the period, see Tuula Poutasuo, ed., *Finnish Silver* (Helsinki: Kirjayntymä, 1989), 97–105. For Russian contemporary jewelry, see *Iuvelirnoe iskusstvo Rossii* (Moscow: Interbukbiznes, 2002), 226–29, 252–53, and 274–75. For a splendid silver wine carafe in the shape of a jester and two goblets designed by the St. Petersburg artist, Mikhail Shemiakin, see MacDougall's *Russian XIX and XX Century, Post War, and Contemporary Art Auction*, London, June 11, 2009, lot 568.

CHAPTER 8

THE REVOLUTION AND THE
FATE OF RUSSIAN SILVER

Most silversmiths, except the very large companies, had most likely ceased production before October 1917 because they were unable to procure precious metals and stones. Some turned to the production of small arms and medical instruments. Many workers were called to the front. We know much more about the fate of Fabergé's St. Petersburg workers than any others because so many of them returned to their native Finland. Many of these silversmiths, however, were at the end of their careers. Julius Rappoport died in 1917; Henrik Wigström, Fabergé's chief workmaster, in 1923; Aleksandr Tillander, a contemporary of Carl Fabergé, in 1918. His shop closed officially in 1917, but his son established the Tillander shop, which still exists today, the next year in Helsinki. Mikhail Ovchinnikov, who had headed his father's firm, died in 1915.[1] We unfortunately know very little about the last days of most of the firms, especially in Moscow—not even when and how they closed. Some surely closed during the war; others may have been nationalized, as was the firm of Fabergé in 1918, and their precious materials and inventory confiscated. Carl Fabergé emigrated in 1918 and died in Switzerland in 1920. His sons, Alexander and Evgenii, set up a workshop in Paris. Agathon was imprisoned and then released in 1922 to assist with the inventory of the crown jewels. He later escaped to Finland.

Following the Russian Revolution in 1917 and the civil war that succeeded it as the Bolsheviks consolidated their power, the government was strapped for funds to rebuild its infrastructure, buy railroad cars, engines, tractors, and feed its population.[2] Beginning in the winter of 1918, the Bolsheviks issued a steady wave of decrees regarding either registration or nationalization of private property, beginning with church property in January. In the same month, all bank holdings

OPPOSITE:
Bread basket with "linen" napkin, Moscow, 1886. Detail of fig. 124.

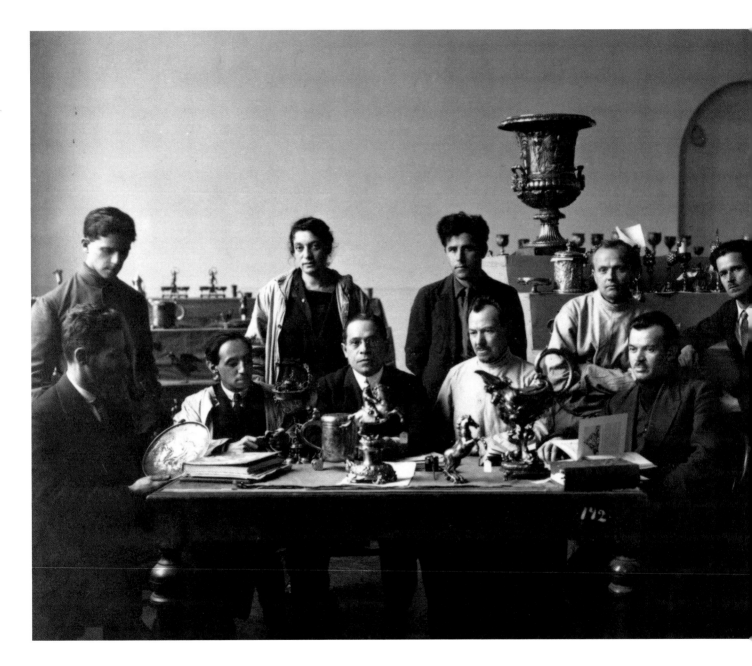

Fig. 160
Classification Committee,
Gokhran, Moscow, ca. 1924.
From the Max Lazerson Collection,
Hoover Institution Archives,
Stanford University.

were also nationalized. This move netted cash, jewels, jewelry and some silver because many had deposited their silver in bank vaults during what they thought would be a temporary disturbance in Russia. In October 1918 authorities required the registration of all privately held valuables and those in unoccupied homes, estates, and palaces were confiscated.

As the financial situation became more desperate during the Civil War of 1918–21, the authorities created Gokhran, or the State Depository of Valuables. Its main headquarters were in Moscow, although there were offices in other cities. From this point forward all precious metals—gold, silver, platinum—and precious stones were sent to Gokhran for evaluating and sorting (fig. 160). Beginning in July 1920, Lenin issued another directive limiting the amount of precious metals or stones an individual could own.

Lenin's attack on the church and its valuables in 1918 had resulted in huge resistance on the part of the faithful. The Bolsheviks backed down at the time. Then in the summer of 1921 famine struck the vast agricultural population of the Volga region. The Patriarch sent out calls to the churches and their congregations to donate unneeded church silver to assist the starving. But Lenin was not about to allow the church to take the lead in feeding the hungry. On February 23, 1922, the government issued an edict, "On the Confiscation of Property without Museum Significance Located in Churches and Monasteries" to obtain gold and silver objects to be melted down for the needed bullion to buy grain. As believers and soldiers faced off in towns near Moscow, Lenin sent a letter to Viacheslav Molotov, a secretary of the Central Committee:

> It is precisely now and only now, when in the starving regions people are eating human flesh and hundreds if not thousands of corpses are littering the roads, that we can (and therefore must) carry out the confiscation of the church valuables with the most savage and merciless energy, not stopping [short of] crushing any resistance…. We must…carry out the confiscation of church valuables in the most decisive and rapid manner, so as to secure for ourselves a fund of several hundred million gold rubles…. Without this fund, no government work, no economic construction in particular…is conceivable.[3]

This drive to melt down silver was not about feeding the peasants. The silver bullion was not used to buy grain, but rather to purchase transportation and industrial equipment and to fund communist movements abroad. The American Relief Administration (ARA) under Herbert Hoover fed the starving peasants.

In the spring of 1922 confiscations of church valuables proceeded relentlessly; they would continue for the next eighteen months. In April 1922, raids were carried out on the wealthy churches in the Zamoskvorech'e region of Moscow directly across the river from the Kremlin. Officials confiscated the treasures held in the Kazan' Cathedral and the Aleksandr Nevskii Lavra, two of St. Petersburg's richest religious institutions in the

late spring of 1922. The Kazan' Cathedral's iconostasis, made of trophy silver that the Cossack general Matvei Platov had captured from the retreating French army in 1812, went into the melting pot. The silver sarcophagus for the tomb of St. Aleksandr Nevskii, designed in the time of Elizabeth, barely escaped the same fate. Many of the church valuables saved from the melting pot were exhibited in the first-ever exhibition of liturgical wares in the Hermitage in 1923.[4]

Experts from Glavmuzei, the Committee for Museum Affairs, oversaw the operations and ensured that works of historical and artistic value were spared. According to instructions issued by Natalia Trotskaia, head of Glavmuzei, experts of Narkompros, the People's Commissariat of Enlightenment, were to sort the confiscated goods into three categories: anything made before 1725 should be considered of museum or historical importance and set aside for Narkompros to handle; examples of liturgical art from between 1725 and 1835, "reflecting the Louis XV and XVI styles," were considered likely to suit the taste of potential European buyers and so were designated items of export quality; everything made after 1835 should go to Gokhran for melting.

Confiscated flatware and table wares, vases, bowls, and any other silver objects suffered the same fate. Sir Martin Conway, a Member of Parliament, who traveled to the Soviet Union in 1925, must have visited Gokhran. He describes being led into a room where he saw "26,000 pieces of silver plate…. There was, for instance, a great heap, as though shot out of sacks upon the floor, of those little silver cups from which Russians were wont to drink vodka,…but as public property they were valueless;… The same is true of countless teapots, and coffee-pots and other objects of domestic utility."[5] What to do with this monumental amount of silver, much of which was from the eighteenth century? Conway's conclusion was to "either send most of it to the melting pot or sell it off into private ownership once more."

Moisei Lazerson, who oversaw these operations for Gokhran beginning in 1923, admitted that various eighteenth-century pieces had been melted down, but, he said, "considering the existing circumstances, it was impossible to save all the specimens from being melted down simply because they belonged to the eighteenth century."[6] By July 1923, more than 20,000 parcels of precious metals, including half a million kilos of silver, had been assembled. Lazerson noted, however, that half the silver objects collected were Russian:

> They could only be sold with great difficulty. Formerly there existed a wide market
> for Russian silver of the seventeenth and eighteenth centuries as well as that of the
> beginning of the nineteenth century, a market which once used to absorb good
> specimens at high prices…. The home market, however, had as good as disappeared
> under Soviet conditions, while the foreign market had no knowledge of, showed no
> interest in Russian silver.[7]

There was high demand abroad, of course, for European silver like the Orlov Service (see fig. 60). Conway noted the dilemma:

> Any country that decides to put an end to private property puts an end to all but the more monumental categories of art. Museum collections must mainly be recruited from objects made for private enjoyment.... The wholesale Russian confiscation proved to me how little the public gains by this vast multiplication of individual losses.[8]

In June 1922, the government turned to museums as a source, demanding that "items of high material value [gold and silver]" be released. For example, 82 pieces of gold and 342 of silver were transferred from the Chamberlain's stores (*Gofmarshal'skaia chast'*) of the Winter Palace to Gokhran at this time.[9] Between 1917 and 1923, the amount of silver sent to Gokhran from museums included: about 5,417 pounds of silver from the Troitse Sergieva Lavra, 3,033 from the Solovetskii Monastery, 4,189 from the State Historical Museum, and from the Armory, 1,444 of gold and silver.[10] In addition to huge amounts of table silver, large monumental sculptures, like the inkstand celebrating Alexander II's freeing of the serfs that Ovchinnikov sent to the 1867 exhibition in Paris (fig. 161), were desirable because of the huge amount of silver they contained. As we know from the illustrated magazines of the second half of the nineteenth century, Ovchinnikov and Khlebnikov made many of these.

There was a new drive on museum silver beginning in 1928 with Stalin's announcement of the First Five Year Plan. Between October 1, 1928 and October 1, 1929 items of silver and gold confiscated from Leningrad museums were valued at 1,131,146 rubles with slightly over a million of that amount coming from the Hermitage (by this time united with the Winter Palace).[11] Many silver objects in the Bartlett collection, the tea set in Boston, and the Anna coffee pot in Hillwood's collection bear Winter Palace inventory numbers. These were catalogued in Fel'kerzam's famous 1909 catalogue of the silver in the Hermitage and were surely confiscated in these years. Authorities claimed they were only getting rid of duplicates, but Russia lost heavily.

Documentation for the losses of the Kremlin Armory and the State Historical Museum in Moscow has not yet been published, with the exception of information about the crown jewels and the Fabergé imperial Easter eggs. French silver from the Kremlin Armory was seized for sale on the international market. We know from the court journal that "old silver" from the Kremlin storage was used for coronation banquets and other important events in the Faceted Hall before the Revolution.[12] It must have been this silver, much of it apparently French and from the *guberniia* services ordered by Catherine, which was then de-accessioned from the Armory.[13] In 1928 and again in 1930, according to eyewitness accounts, a total of 400,000 rubles worth of silver was removed from the State Historical Museum.[14]

This very beautiful work, in silver, is the production of PAUL OVTCHINNIKOFF, an eminent goldsmith of Moscow. It is constructed as an INKSTAND, but is designed to commemorate that great boon to Russia which gave FREEDOM TO THE SERFS. A freed serf is "crossing himself" as he scatters seed over his *own* land. The figures and *bassi-relievi* touchingly illustrate the most glorious incident in the history of Russia: the upper *bas-relief* in front illustrates the people taught by the Bible; on the opposite

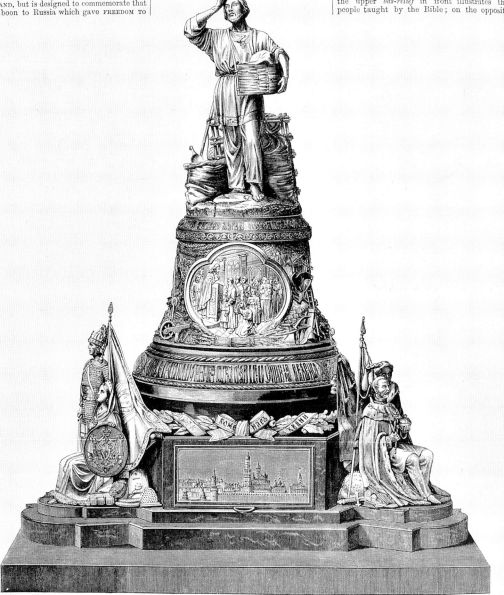

side is another *bas-relief*, which aptly records | the "Reading of the Manifesto of Freedom" | on the memorable 19th of February, 1861.

OPPOSITE: *Fig. 161*
Inkstand to commemorate
Alexander II's Freedom to the
Serfs, *made by the Firm of*
Ovchinnikov and exhibited at the
1867 universal exhibition in Paris
from the Illustrated Catalogue of
the Universal Exhibition,
published with the Art Journal
(London, 1867).

Given the limited trade and diplomatic contacts between Russians and Americans before the late nineteenth century, how did Americans come to build collections of Russian fine and applied art, and in this case collections of silver? There were two international exhibitions in the United States: the Centennial Exposition in Philadelphia in 1876 and the Columbian Exposition in Chicago in 1893. Philadelphia was the first opportunity for Americans to see Russian production of any kind, and the silver and enamels were enthusiastically received. But these two exhibitions, although they introduced Russian wares in the United States, did not provide the impact that constant European exhibitions did to familiarize collectors with the designs and quality of Russian decorative art. Even in Europe, however, this did not result in a large market for Russian works of art, as Lazerson noted.

Following the success of Russian silversmiths at the Centennial Exposition, Tiffany & Co. opened a Russian section in its Herald Square store in about 1885. This department lasted well into the twentieth century. Silverware formed a major part of goods sold by Tiffany to American matrons looking for the perfect gift. According to their small sale catalogue, however, most were decorated with enamel. That a large amount of Russian silver objects like the trompe l'oeil basket with the napkin over it (see fig. 124) have circulated on the American market should not come as a surprise. This was what was sold at the international fairs, or through Tiffany and other department stores in both Europe and America. It was not necessarily part of the export trade of the 1920s and 1930s.

To what degree, if any, these early sales influenced Americans to start collecting antique Russian silver when it became available on the market in the late 1920s and early 1930s is difficult to say, but a market was created, however slowly. Some of the collectors, as we have seen, actually spent time in the Soviet Union—Ralph Bartlett, Thomas Whittemore, and Marjorie Post. Others were attracted to collecting Russian art by the tragic stories of the Russian imperial family and displaced grand dukes and grand duchesses. Lillian Pratt and Post were among these. Post had the advantage of both knowing some members of the extended imperial family once they came to America, but also of having spent time in the Soviet Union, even if it was at the very end of the sales.

In 1925 the Soviet trade organization, Narkomtorg, established Antikvariat to dispose of valuables that were less than museum quality.[15] It was through this organization that foreign dealers began to buy antiques to sell in Berlin, Paris, and London, and later in New York. The Antikvariat leadership saw Americans as ripe for the picking; they saw the sales as an opportunity to feed the "pathological interest" and the "specific form of vanity" of American buyers, who were anxious to imitate the robber-baron collectors of the pre-war period. The Soviet authorities believed the newly wealthy did not have the taste of their predecessors and would therefore welcome the chance to buy the detritus of the Romanovs.[16]

Armand Hammer was to play a significant role in making this connection. He had spent the 1920s in the Soviet Union starting several concessions, the last of which was a pencil factory in Moscow. Hammer claimed in his memoir *Quest of the Romanov Treasure* (1932) that he had been given permission to export his vast collection of Russian art out of the country in exchange for the pencil factory. In fact, Anastas Mikoian, the commissar of trade, approached Hammer in 1928 to act as a middleman selling Russian art abroad on consignment. Hammer's "collection" included the artifacts still in state storerooms and imperial memorabilia from the many residences of the Romanov family.

Hammer, working with his brother Viktor, performed this role brilliantly. Beginning in 1932 he started selling the "treasures of the Romanovs" in department stores across the United States, particularly in the Midwest and along the East Coast. In 1933 Hammer signed a three-year contract with Lord & Taylor. The year before the Hammers had been joined by the Hungarian soccer player, Alexander Schaffer, who had previously been a buyer for Jacques Zolotnitsky, the owner of A La Vieille Russie in Paris. In 1934 Schaffer and his wife Ray opened their own shop, which in 1941 would take the A La Vieille Russie name. Following the department store sales, the Hammers opened Hammer Galleries. Ralph Bartlett, as we have seen, had a shop, Old Russia, in the 1930s in Boston.

Thus Hammer, Schaffer, and Bartlett helped shape the nucleus of the major Russian collections in the United States. In Europe, especially in Paris, émigré dealers and émigrés in general played a significant part in educating their fellow Europeans on the beauty and value of Russian art. To this end, they organized three exhibitions: in Brussels in 1928, at Sèvres in 1929, and in London in 1935. They, together with new American collectors, ensured that much of what was considered of little value by the Soviet authorities in the 1920s was saved.

As we have seen in this history, silver often doesn't survive because it can so easily be melted down for reasons of fashion, economic or military need, or even, as the case in the 1920s, for ideological reasons. At least what was sold has been saved. In museums, it is our responsibility to research and study such objects for their artistic, historical, cultural, and even political meaning, as this study has sought to do. These objects are not lost to Russia, but have been passed on to American museums through one means or another to begin another life, demonstrating to a new public something of Russia's artistic and material culture. They are a reminder that man's creations tell us a lot about life lived in another era.

NOTES

1. See V. Skurlov and G. Smorodinova, *Faberzhe i russkie pridvornye iuveliry* (Moscow: Terra, 1992), 79–110; *Carl Fabergé and his Contemporaries* (Helsinki: Oy A. Tillander Ab, 1980).

2. See Anne Odom and Wendy R. Salmond, *Treasures into Tractors: The Selling of Russia's Cultural Heritage, 1918–1938* (Washington, D.C.: Hillwood Estate, Museum & Gardens, 2009) for essays on the reasons and methods of the sales of the 1920s and 1930s.

3. This document can be found translated in full in Richard Pipes, ed., *The Unknown Lenin* (New Haven: Yale University Press, 1996), 152–53.

4. L. Matsulevich, "Vesti iz Petrograda: Vystavka tserkovnoi stariny v Ermitazhe," *Sredi kollektsionerov* Jan./Feb. 1–2 (1923), 45–47.

5. Sir Martin Conway, *Art Treasures in Soviet Russia* (London: Edward Arnold & Co., 1925), 26–27.

6. Under the pseudonym M. J. Larsons, Moisei Iakolevich Lazerson published *Expert in the Service of the Soviet*, trans. Angelo S. Rappoport (London: Ernest Benn, 1929), 79.

7. Ibid., 157.

8. Conway, *Art Treasures*, 29.

9. Elena Solomakha, "Verkäufe aus der Ermitazhe, 1926–1933," in Waltraud Bayer, ed., *Verkaufte Kultur* (Frankfurt am Main: Peter Lang, 2001), 42. The Winter Palace as the former residence of the imperial family was particularly vulnerable to confiscation.

10. Nikolas Il'in and Natal'ia Semenova, *Prodannye sokrovishcha Rossii* (Moscow: Trilistnik, 2000), 21.

11. Odom and Salmond, eds., *Treasures into Tractors*, 159. For documents regarding 3,652 pieces of silver confiscated from the Hermitage between 1926 and 1929, see E. Iu. Solomakha, ed., *Gosudarstvennyi Ermitazh: muzeinye rasprodazhi 1928–1929 godov: arkhivnye dokumenty* (St. Petersburg: Gosudarstvennogo Ermitazh, 2006), 104, 148, 319–20.

12. *KTZ*, Coronation of Alexander III, May 15, 1883. RGIA, *fond* 516, *opis* (206/2703), *delo* 29, *list* 141and 143.

13. Natal'ja Semenova, "Verluste der Moskauer Museen," in *Verkaufte Kultur*, 91.

14. Ibid., 95.

15. For more on Antikvariat and the creation of a market, see Odom and Salmond, "Introduction," *Treasures into Tractors*, 3–31.

16. Rifat Gaififullin, "Kunst und Antiquitäten aus der Leningrader Schlossmuseen, 1926–1934," *Verkaufte Kultur*, 80.

Detail of fig. 71

COMMENTS ON MARKS

THE FOLLOWING REMARKS are intended to explain some of the changes that appeared in the marks over the years in order to better understand the primary dictionaries of marks published by Marina Postnikova-Loseva and Aleksandr Ivanov.[1] Hallmarking silver began in Western Europe in the thirteenth century. It became an essential requirement of gold- and silversmithing because precious metals were always alloyed with other metals to give objects their durability; pure silver and gold were too soft for daily use. In addition precious metals were linked with currency, making it essential that standards be maintained. An assay mark ensured the quality of the metal. One always needs to remember, however, that decrees were not always rigorously followed and marks may or may not have been applied. By the mid-nineteenth century not all the required marks necessarily appeared on any given object. There has been widespread faking of Russian enamels, works by Fabergé, and even silver. It is therefore more important to study carefully the quality of the work than the application of the mark. The provenance of the object should also be studied as thoroughly as possible.

Russian marks for purity only date from 1650/51. The first mark to appear was a city mark—the double-headed eagle—to which were added date marks and assay marks in the 1680s. Initially the city mark denoted purity because the master had to have the object tested to apply the mark. Sometimes, as in the case of a *bratina* at the Boston Museum of Fine Arts, its total weight was written onto the bottom (fig. 162). The incised numbers were added at a later date. The addition of the maker's mark along with the city mark was one of Peter's reforms in 1700. The mark of the aldermen verified that the metal was at the minimum standard allowed, and silversmiths were

ABOVE: *Fig. 162*
Russia, 17th century
Marks from a bratina *(see fig. 17)*

ABOVE RIGHT: *Fig. 163*
St. Petersburg, 1730s
Coffee pot (see fig. 34)

taxed accordingly. The objects made in the Silver Chambers of the Armory were not subject to these regulations; their objects were exempt from being marked. One should not conclude, however, that an unmarked object means it was made in the Kremlin workshops. Many silversmiths just ignored the regulations in order to avoid paying the duty levied on the weight of the silver.[2] Silver standards were reset several times in the late seventeenth century. It is clear that silversmiths in Moscow were at least informally organized already by the 1670s, when they protested the high silver standard set by the treasury as being too costly.[3]

Despite reforms and new regulations, it was rare for objects in the first half of the eighteenth century to be marked. According to Curator Irina Kostina, only 248 of the 400 objects from this period in the Kremlin Armory collection are marked, and only half of these appear in Postnikova-Loseva. In addition most of the marks are indecipherable.[4] Kostina has also raised the problem, mentioned earlier, of deciphering makers with the same initials. On the bottom of the coffee pot made for Empress Anna, there is only a maker's mark, but there are also the inventory marks of the Winter Palace (fig. 163). This mark is both stamped ND and stippled in *dona* (that is, by Don). The stippled *dona* was added later in the eighteenth century, probably by a *Silberdiener*, as the imperial silver was collected from various locations and assembled in the Winter Palace.

In 1731 the lowest silver standard was fixed at 72 and the higher at 77. These marks for silver content remained in effect until 1792 when the lowest silver quantity allowed was raised to 84. This meant that there were 84 *zolotniki* of pure silver out of 96. A *zolotnik* was an old measure of weight, equivalent of 1/96 of a Russian pound. This

ABOVE LEFT: *Fig. 164*
Moscow, 1781
Icon of the Annunciation
(see fig. 84)

ABOVE: *Fig. 165*
St. Petersburg, 1829
Mug (see fig. 101)

remained the minimum silver content for the rest of the empire. These marks rarely appeared on objects until the nineteenth century. More commonly the assayers' initials appeared with the date, as can be seen on the icon of the *Annunciation* (fig. 164). In Moscow the alderman's initials appeared in a heart-shaped stamp, primarily in the second half of the eighteenth century. On the icon the maker's mark I F in Cyrillic for Iakov Frolov also appears, but a mark for silver content does not. Provincial cities used their own coats-of-arms. The location of marks on an object is not necessarily consistent. On icons they can be right on the front in the midst of the decoration, as this one is. On a mug, made in 1829 there is the 84 for the silver content, the crossed anchors of St. Petersburg, and the maker's mark *P. Möller* is spelled out (fig. 165).

In 1845 the standards for silver were set at 84, 88, and 91. In practice, it appears that the higher quality silver—91—was used only for objects for export, when they were competing with Sterling. One of the most significant things to look for in the nineteenth and early twentieth century is that the city marks and makers' marks agree. If a maker worked in St. Petersburg, his initials could not appear with a Moscow city mark. An exception to this rule appears to be work by Fabergé silversmiths Julius Rappoport and Antti (Anders) Nevaleinen. Their initials have been found with both Moscow and St. Petersburg city marks. Those silversmiths, like Sazikov, Ovchinnikov, Khlebnikov, Fabergé and others, who had received the imperial warrant, that is they were purveyors to the court, could place the double-headed eagle over their mark or beside the firm name, which was usually spelled out, in this case Sazikov (fig. 166).

There has been a constant debate over the next change of marks at the end of the nineteenth century, when the *kokoshnik,* a woman's head with a typical peasant

ABOVE: *Fig. 166*
St. Petersburg, 1851
Tall covered cup (see fig. 110)

ABOVE RIGHT: *Fig. 167*
Moscow, 1899–1908
Kovsh (see fig. 156)

headdress, replaced the city mark (fig. 167). The assayer's initials, different for each assay district, appeared behind the head. Here they are I L in Cyrillic for Ivan Lebedkin, the Moscow assayer. In 1983, Postnikova-Loseva published the second edition of her dictionary of marks and noted in it that the law passed in 1896 about the change to this new mark mandated that the change be made by 1899. This is the date that Russian curators have used ever since. Kenneth Snowman and Marvin Ross, however, had both used the date 1896.[5] Knowing nothing about any documents, they had to base their interpretations on an examination of the objects. They found that there were no objects with date marks of 1896, 1897, 1898, or 1899, which should have been stamped together with the city mark. They therefore assumed that the mark must have been changed in 1896, the assayers putting the new law into effect immediately.[6]

Valentin Skurlov, an avid archives researcher, however, has argued that if it had been changed right away the assayer's initials for St. Petersburg would have been those of Nikolai V. Kulakov; these do not appear.[7] Skurlov, himself, raises a question he does not adequately answer, which is, what exactly was the mark in the intervening years? Was the date part of the mark just dropped? Was just the city mark and the silver content mark used, as Skurlov states, basing his conclusion on an encyclopedia entry of 1898, but not cited? It would appear that the question is still open. At this point in the discussion, curators of large collections need to collaborate and record as many marks between 1895 and 1900 as possible to see what the trends are. Is there a surge of objects without date marks? Are there any date marks from 1896 to 1899, or any other anomalies? One could begin with objects made for specific events in those years, with inscriptions, or presented in those years, especially those made for the coronation of

Nicholas II in 1896. While all of these methods are extremely unreliable because objects were often made earlier than a presentation or an inscription was added, it would at least be a start. The documentation, unfortunately, does not tell us what the assayers actually did. I have in this publication turned to the 1899 date, but I still remain skeptical that this is completely accurate.

In 1908 the mark changed again. The *kokoshnik* was turned to face right. Instead of the assayer's initials, Greek letters (alpha for St. Petersburg and delta for Moscow, etc.) were added to indicate the assay district. This mark continued in use until about 1920 when the first Soviet mark appeared.

NOTES

1. The main sources for information on marks are M. M. Postnikova-Loseva, N. G. Platonova, and B. L. Ul'ianova, *Zolotoe i serebrianoe delo XV–XX vekov* (Moscow: Nauka, 1983), and Aleksandr Nikolaevich Ivanov, *Probirnoe delo v Rossii (1700–1946). Rykovodstvo dlia ekspertov-iskusstvovedov* (Moscow: Russkii national'nyi muzei, 2002).

2. I. D. Kostina, *Proizvedeniia Moskovskikh serebrianikov pervoi poloviny XVIII veka* (Moscow: Moscow Kremlin, 2003), 10.

3. T. G. Goldberg, "Ocherki po istorii serebriannogo delo v Rossii v pervoi poloviny XVIII vv.," *Trudy gosudarstvennogo istoricheskogo muzeia vypusk XVIII* (Moscow: Izdanie Gosudarstvennogo istoricheskogo muzeia, 1947), 12.

4. Kostina, *Proizvedeniia Moskovskikh*, 11.

5. A. Kenneth Snowman, *The Art of Carl Fabergé* (London: Faber and Faber Limited, 1955), 109.

6. Anne Odom, "The *Kokoshnik* Faces Left," in Géza von Habsburg and Marina Lopato, *Fabergé: Imperial Jeweler* (Washington, D.C.: Fabergé Arts Foundation, 1993), 443.

7. Valentin Skurlov, "Russian Hallmarks at the Turn of the 19th Century," in Géza von Habsburg, *Fabergé: Imperial Craftsman and his World* (London: Booth-Clibborn Editions, 2000), 404–05.

ROMANOV DYNASTY 1613-1917 (REIGN DATES)

MICHAEL I
1613–1645

ALEKSEI I
1645–1676

FEDOR III
1672–1682

IVAN V
1682–1689

PETER I
"the Great"
1682–1725

2nd m. CATHERINE I
1725–1727

Catherine

ANNA I
1730–1740

Aleksei

ELIZABETH I
1741–1761

Anna

Anna

PETER II
1727–1730

CATHERINE II m. PETER III
"the Great" 1762
1762–1796

IVAN VI
1740–1741

PAUL I
1796–1801

ALEXANDER I
1801–1825

NICHOLAS I
1825–1855

ALEXANDER II
1855–1881

ALEXANDER III
1881–1894

NICHOLAS II
1894–1917

GLOSSARY

Bratina (*bratina*) A round bulbous bowl or loving cup for drinking and proposing toasts.

Casting (*lit'e*) Pouring hot metal into a mold to form a given shape.

Charka (*charka*) A flat porringer-shaped vessel with a flat handle. Used for toasting and drinking strong beverages.

Chasha (*chasha*) A bowl, sometimes used interchangeably with a *charka*.

Chasing (*chekanka*) Tooling done on the surface of the metal to shape it and create relief ornament or to enhance *repoussé*. The Russians use the same word for shaping the metal both underneath and on the surface.

Embossing (*shtampovka*) Process of stamping a metal with a die.

Engraving (*gravirovka*) Cutting the surface with a sharp instrument to engrave an image, usually copied from an engraving or to make detail lines on a chased surface.

Filigree (*skan'*) The wires used to separate enamels are twisted instead of smooth. Twisted wires can also be left open to create a lace-like pattern.

Gilding (*zolochenie*) Covering the whole surface or the interior of an object with a thin layer of gold. On the interior of salts or bowls, the gilding prevents tarnishing.

Kovsh (*kovsh*) A ladle with a flat handle at one end and a point at the other for serving or drinking of a beverage. It was inspired by a Viking ship or a swimming bird and was used decoratively in the late nineteenth century.

Niello (*chern'*) An alloy containing silver, copper, lead, and sulfur. It is rubbed into an engraving on gold or silver to create a black background pattern or to define the engraved design. Rarely used in the west after the Renaissance, niello remained in widespread use in Russia.

Parcel gilt (*pozolota*) Term for when only part of the object, like the inscription, is gilded.

Piercing (*rez'ba*) Creating openwork or pierced decoration by cutting with a saw or cutting die.

Repoussé (*chekanka*) The metal for an object is punched or hammered from the underside to create a relief decoration. See **chasing**.

Stippling (*kanfarenie*) Process of punching the ground metal with tiny pinpricks to create a roughened surface.

BIBLIOGRAPHY

Baumstark, Reinhold, and Helmut Selig, eds., *Silber und Gold: Augsburger Goldschmiedkunst für die Höfe Europas*. Munich: Hirmer Verlag, 1994.

Berniakovich, Zoya, "The Collection of Russian Silver," *Apollo* 100 (Dec.1974): 496–503.

—. *Russkoe khudozhestvennoe serebro XVIII–nachala XX veka*. Leningrad: Khudozhnik RSFSR, 1977.

Dmitrieva, Olga, and Natalya Abramova. *Britannia & Muscovy: English Silver at the Court of the Tsars*. New Haven and London: Yale University Press, 2006.

Ehrnrooth, Carl, ed. *Silver Treasures from Livonia, Estonia*. Stockholm: Frenckellin Kirjapaino Oy, 1991.

El'kova, Elena. "Posol zhelatel'nyi ili 'Simvoly i Emblemata' russkii oloviannoi posudy XVIII vela," *Antikvariat. Predmety iskusstva i kollektsionerovaniia* 11 (22), November 2004.

Fabergé Silver from the Forbes Collection: A Loan Exhibition. New York: Sotheby's, 1991.

The Fabulous Epoch of Fabergé: St. Petersburg-Paris-Moscow, ed. Vyacheslav Mukhin. Moscow: Nord, 1992.

Fel'kerzam, A.E. *Alfavitiyi ukazatel' S.-Peterburgskikh zolotykh i serebrianykh del masterov iuvelirov, gravёrov i proch. 1714–1814*. St. Petersburg: Starye gody, 1907.

—. "Inostrannye mastera zolotogo i serebrianago dela," *Starye gody* 3 (1911): 95–113.

—. "Nekotoriia svedeniia o S-Peterburgskikh zolotykh i serebrianykh del masterov za 100 let," *Starye gody* 1 (1907): 7ff.

—. *Opisi serebra dvora Ego Imperatorskago Velihchestva*, 2 vols. St. Petersburg: R. Golicke & A. Willborg, 1907.

Gilodo, Andrei. *Russian Silver: Mid-19th Century–Beginning of the 20th Century*. Moscow: Beresta, 1994.

Glanville, Philippa, ed. *Silver: History & Design*. New York: Harry N. Abrams, Inc., 1996.

—, and Sophie Lee, eds. *The Art of Drinking*. London: V&A Publications, 2007.

—, and Hilary Young. *Elegant Eating: Four Hundred Years of Dining in Style*. London: V&A Publications, 2002.

Goldberg, T.G. "Ocherki po istorii serebrianogo delo v Rossii v pervoi polovine XVIII veka," *Stat'i po istorii material'noi kul'tury VII–XIX vv. Trudy gosudarstvennogo istoricheskogo muzeia vypusk XVIII*. Moscow: Izdanie Gosudarstvennogo istroicheskogo muzeia, 1947.

Habsburg, Géza von. *Fabergé in America*. San Francisco: Thames and Hudson, 1996.

—. *Fabergé: Imperial Craftsman and his World*. London: Booth-Clibborn Editions, 2000.

—, and Marina Lopato. *Fabergé: Imperial Jeweler*, Washington, D.C.: Fabergé Arts Foundation, 1993.

Hittle, J. Michael, *The Service City: State and Townsmen in Russia 1600–1800*. Cambridge, MA: Harvard University Press, 1979.

Hughes, Lindsey, A. J., "The Russian Armoury and Innovations in Seventeenth-Century Muscovite Art," *Canadian-American Slavic Studies* 13 (1979): 204–223.

Istorizm v Rossii. Stil' i epokha v decorativnom iskusstve 1820–e–1890 gody. St. Petersburg: A. O. "Slaviia," 1996.

Ivanov, Aleksandr Nikolaevich. *Mastera zolotogo i serebri-annogo dela v Rossii (1600–1926)*. Moscow: Russkii natsional'nyi muzei, 2002.

—. *Probirnoe delo v Rossii (1700–1946). Rykovodstvo dlia ekspertov-iskusstvovedov*. Moscow: Russkii natsional'nyi muzei, 2002.

Kaliazina, N. V., G. N. Komelova, N. D. Kostochkina, O. G. Kostiuk, and K. A. Orlova. *Russkaia emal' XII–nachala XX veka iz sobraniia Gosudarstvennogo Ermitazha*. Leningrad: Khudozhnik RSFSR, 1987.

Katalog rossiiskim proizvedeniiam otpravlennym 1851 goda. St. Petersburg: V tipografii departamenta vneshei torgovli, 1851.

Kirichenko, Evgeniia I. *Russian Design and the Fine Arts 1750–1917*. New York: Harry N. Abrams, Inc. 1991.

—, *Russkii stil'. Poiski vyrazheniia natsional'noi samobytnosti. Narodnost', Traditsii drevne-russkogo i narodnogo iskusstva v russkom iskusstve XVIII–nachala XX veka*. Moscow: Galart, 1997

Korsh, E. "Russkoe serebrianoe delo XVII veka i ego ornamentatsiia," *Starye gody* (July–September 1909): 404–24.

Kostina, I. D. *Proizvedeniia Moskovskikh serebrianikov pervoi poloviny XVIII veka*. Moscow: Gosudarstvennyi istoriko-kul'turnyi muzei-zapovednik "Moskovskii Kreml'," 2003.

—, T. N. Muntian, and E. V. Shakurova, *Russkoe serebro XVI–nachala XX veka*. St. Petersburg: Slaviia, 2004.

Kovarskaia, S. Ia. "Izobrazhenie Pamiatnikov arkhitekhtury na serebrianykh izdeliiakh XIX veka iz sobraniia muzeev Kremliia," *Dekorativno-prikladnogo iskusstvo: Materialy i issledovaniia IX*. Moscow: Gosudarstvennyi istoriko-kul'turnyi muzei-zapovednik "Moskovskii Kreml'," 1993.

—. *Proizvedeniia Moskovskoi iuvelirnoi firmy Khlebnikova. Katalog*. Moscow: Gosudarstvennyi istoriko-kul'turnyi muzei-zapovednik "Moskovskii Kreml'," 2001.

—, I. D. Kostina, and E. V. Shakurova, *Russkoe serebro XIV–nachala XX veka iz fondov Gosudarstvennykh muzeev Moskovskogo Kremlia*. Moscow: Sovetskaia Rossiia, 1984.

Lopato, Marina N. "Catherine II's Collection of French Silver," *Catherine the Great & Gustav III*. Stockholm: National Museum, 1999.

—. "English Silver in St. Petersburg," in *British Art Treasures from Russian Imperial Collections in the Hermitage*, ed. Brian Allen and Larissa Dukelskaya. New Haven and London: Yale University Press, 1996.

—. *Iuveliry starogo Peterburga*. St. Petersburg: Russkii Iuvelir, 2004.

—. *Iuveliry starogo Peterburga*, St. Petersburg: Izdatel'stvo gosudarstvennogo Ermitazha, 2006.

—. *Nemetskoe khudozhestvennoe serebro v Ermitazhe*, St. Petersburg: Slaviia, 2002.

Markova, G. A. *Nemetskoe khudozhestvennoe serebro XVI–XVIII vekov v sobranii gosudarstvennoi oruzhennoi palaty*. Moscow: Iskusstvo, 1975.

Martynova, M. V. "Russian Jewelry Arts of the Twelfth to the Seventeenth Century," *Kremlin Gold: 1000 Years of Russian Gold and Gems and Jewels*. New York: Harry N. Abrams, Inc., 2000.

McNab, Jessie. *Silver*. Washington, D.C.: Smithsonian Institution, 1981.

Die Mitgift einer Zarentochter: Meisterwerke russischer Kunst des Historismus aus dem Besitz der Hessischen Hausstiftung Museum Schloss Fasanerie. Eurasburg: Minerva, 1997.

Mukhin, Vyacheslav, "The Petersburg Branch of the Sazikov Firm and Russian Silverware of the 19th and Early 20th Centuries," in *The Fabulous Epoch of Fabergé: St. Petersburg-Paris-Moscow*. Moscow: Nord, 1992, 43–51.

Odom, Anne. *Russian Enamels: From Kievan Rus to Fabergé*. London: Philip Wilson Publishers, 1996.

—. "Solntsev's Legacy in Russian Decorative Art," *Russia Visualized*, ed. Cynthia H. Whittaker. Leiden: Brill, 2010.

—, and Liana Paredes Arend, *A Taste for Splendor: Russian Imperial and European Treasures from the Hillwood Museum*. Alexandria, VA: Art Services International, 1998.

—, and Wendy R. Salmond, eds. *Treasures into Tractors: The Selling of Russia's Cultural Heritage, 1918–1938*, Washington, D.C.: Hillwood Museum and Gardens, 2009.

Official Descriptive and Illustrated Catalogue: Great Exhibition of the Works of Industry of All Nations, 1851, vol. 3, *Foreign States*. London: Spicer Brothers, 1851.

Orlova, K. A. "Izdeliia firmy P. A. Ovchinnikova v sobranii Ermitazha,"*Dekorativno-prikladnoe iskusstvo Rossii i zapadnoi Evropa*. Leningrad: Gosudarstvennyi ermitazha, 1986, 86–90.

Postnikova-Loseva, M. M. "Prikladnoe iskusstvo XVI–XVII vv.," *Istoriia russkogo iskusstva*, vol. 4, I. E. Grabar, ed. Moscow: Akademiia Nauk, SSSR, 1953.

—. *Russkie serebriananie i zolotie kovshi*. Moscow: Gosudarstvennoe izdatel'stvo kulturno-prosvetitel'noi literatury, 1953.

—, N. G. Platonova, and B. L. Ul'ianova. *Russkoe chernevoe iskusstvo*. Moscow: Iskusstvo, 1972.

—, N. G. Platonova, and B. L. Ul'ianova. *Zolotoe i serebrianoe delo XV–XX vekov*. Moscow: Nauka, 1983.

Schroder, Timothy B. *The Francis E. Fowler, Jr. Collection of Silver*. Los Angeles: Fowler Museum of Cultural History, University of California, Los Angeles, 1991.

Selezneva, I. A. *Zolotaia i serebrianaia palaty: Kremlevskie dvortsovye masterskie XVII veka*. Moscow: Drevlekhranilische, 2001.

—. "K voprosu o postanovke obucheniia v zolotom i serebrianom dele Moskvy XVII v.," F. V. Alekseeva, ed., *Ot srednevekov'ia k novamu vremeni i materialy i issledovaniia po russkom iskusstva XVIII pervoi poloviny XIX veka*. Moscow: Nauka, 1984.

Shifman, Barry, and Guy Walton, eds. *Gifts to the Tsars: Treasures from the Kremlin*. New York: Harry N. Abrams, Inc. 2001.

Shitova, Liubov', "Serebrianye masterskie Troitse-Sergievoi lavry," *Antikvariat. Predmety iskusstva i kollektsionirovaniia* 70 (September, 2004).

Skurlov, V., and G. Smorodinova. *Faberzhe i Russkie pridvornye iuveliry*. Moscow: Terra, 1992.

Smith, R. E. F., and David Christian. *Bread and Salt: A Social and Economic History of Food and Drink in Russia*. Cambridge: Cambridge University Press, 1984.

Smorodinova, G. G. "Iuveliry serebrianogo veka, *Russkii stil'*," *Sobranie Gosudartsvennogo Istroicheskogo muzeia. Katalog*. Moscow: Gosudarstvennyi istoricheskii muzei, 1998, 158–201.

—. "Pavel Ovchinnikov and Russian Gold- and Silversmithery," in *The Fabulous Epoch of Fabergé*, 57–60.

—. "Zolotoe i serebrianoe delo Moskvy rubezha XIX i XX vekov," *Muzei 10*. Moscow, Sovetskii khudozhnik, 1989, 58–71.

Solodkoff, Alexander von. *Russian Gold and Silverwork 17th–19th Century*. New York: Rizzoli, 1981.

Taylor, Katrina V. H., *Russian Art at Hillwood*. Washington, D.C.: Hillwood Museum, 1988.

Tillander-Godenhielm, Ulla. "The Finnish Silversmiths of St. Petersburg, From 1703–1917," in *Finnish Silver*, ed. Tuula Poutasuo. Helsinki: Kirjahtymä, 1989.

Trésors des Tzars. Paris: J. Kugel, 1998.

Ukhanova, Irina. "Khudozhestvennye izdeliia iz kokosa russkikh maserov XVII–XIX vekov," *Antikvariat. Predmety iskusva i kollektsionervaniia* 50 (Sept. 2007): 6–21.

Venable, Charles L. *Silver in America, 1840–1940: a Century of Splendor*. New York: Harry N. Abrams, Inc., 1995.

Verdier, Philippe. *Russian Art*. Baltimore, MD: The Walters Art Gallery, 1959.

Wortman, Richard S. *Scenarios of Power: Myth and Ceremony in Russian Monarchy*, 2 vols. Princeton: Princeton University Press, 1995–2000.

Der Zarenschatz der Romanov: Meisterwerk aus der Ermitazh St. Petersburg. Speyer: Verlag Gerd Hatje, 1994.

Zavadskaya, Larissa, "Angliiskii magazine v Peterburge i serebrinanye velikokniazheskie servizy 1830–1840-godov," *Rosiia-Angliia. Stranitsy dialoga: kratkoe soderzhanie dokladov. V Tsarskosel'skoi nauchnoi konferentsii*. St. Petersburg: Tsarskoe Selo, 1999.

—. "Gold and Silver in St. Petersburg 1830–1850," in Géza von Habsburg, *Fabergé: Imperial Craftsman and His World*, 48–51.

Zolotaia kladovaia Russkogo muzeia. St. Petersburg: Palace Editions, 1998.

INDEX

PHOTOGRAPHIC CREDITS

Hillwood Estate, Museum & Gardens; Photography by
Edward Owen
Cover, Frontispiece, Table of Contents page, 7, 10, 14,
18–19, 32, 36, 38–41, 44, 46–47, 50–53, 55–59,
61–64, 69–71, 73–79, 81, 83–84, 86–87, 96, 100–10,
112–19, 121, 123–25, 127–38, 143, 148, 152, 157,
159, 161–67, 170, 172, 174–77, 182, 185, 187–93,
195, 201, 203, 206, 217–19
Photographs © 2011 Museum of Fine Arts, Boston
pp. 11, 41, 45, 93, 217
Hillwood Estate, Museum & Gardens Library;
Photography by Ed Owen
pp. 13, 16–17, 75, 88, 153, 156, 178–79, 203, 212
Associated Press
p. 20
Hillwood Estate, Museum & Gardens Archives
p. 21–22, 24, 92
Hoover Institution Library and Archives, Stanford
University
pp. 23, 208–09
Hillwood Estate, Museum & Gardens Library
pp. 27, 155
Collection of the Author
pp. 28, 92, 133
Photos © The Walters Art Museum, Baltimore
pp. 33, 42–43, 66, 82
Slavic and Baltic Division, The New York Public Library,
Astor, Lenox and Tilden Foundations
p. 35

Hood Museum of Art, Dartmouth College
pp. 49, 60, 91–92, 95
Images © The Metropolitan Museum of Art
pp. 65, 68, 72, 90, 94, 103
Library of Congress
pp. 69, 72, 171
Courtesy of the National Museum of Racing and Hall of
Fame
p. 97
Frick Art & Historical Center, Pittsburgh
pp. 99, 215
The Philadelphia Museum of Art
pp. 140–42, 144, 149, 154
Fowler Museum at UCLA; Photography by Denis Nervig
pp. 158, 160, 200
Middlebury College Museum of Art (Photos by Tad
Merrick, Middlebury, Vermont)
p. 168
Photos: Katherine Wetzel © Virginia Museum of Fine Arts
pp. 173, 181, 183, 190, 196–97
Middlebury College Museum of Art (Photos by Ken
Burris, Burlington, Vermont)
pp. 184, 202
Fine Arts Museums of San Francisco
p. 194
U.S. Naval Academy Museum; Images © John Dean
Photographer
pp. 198–99, 207

739.2

16-736